The Education of a Photographer

Edited by Charles H. Traub,
Steven Heller,
and Adam B. Bell

ALLWORTH PRESS
NEW YORK

School of
VISUAL ARTS

D0499155

11 10 09 08 07 6 5 4 3 2

Published by Allworth Press
An imprint of Allworth Communications, Inc.
10 East 23rd Street, New York, NY 10010

Cover and interior design by James Victore
Page composition/typography by Integra Software Services, Pondicherry, India

ISBN 10: 1-58115-450-X
ISBN 13: 978-1-58115-450-4

Library of Congress Cataloging-in-Publication Data
The Education of a photographer / edited by Charles H. Traub, Steven Heller, Adam B. Bell.
 p. cm.
 Includes bibliographical references and index.
 1. Photography—Study and teaching. 2. Photographers. I. Traub, Charles, 1945-
II. Heller, Steven. III. Bell, Adam B.

 TR161.E49 2006
 770.92'2—dc22
 2006016626

Printed in the United States of America

Contents

Section Two
How Others See Them: Considering the Photographer

WRITERS ON PHOTOGRAPHY

Section Three
Finding an Audience: Working with the Professionals

THE LEGENDS

PHOTOGRAPHY TODAY: INTERVIEWS

Section Four
Guides for the Uneducated: Higher Education and Photography

SHARED WISDOM

A PHOTOGRAPHIC THESIS

Afterword 223

Biographies 224

Index 235

Acknowledgments

Special thanks for cooperation and help in completing this publication are due to: *Aperture* and its editors, especially Andrea Smith; *Bomb* and Nell McClister; Peter Bunnell and the Minor White Archive; Commerce Graphics and the Berenice Abbott Estate; Martine Franck Cartier-Bresson and the Fondation Henri Cartier-Bresson; the Helen Gee Estate; Hattula Moholy-Nagy; *Blind Spot* and its editors; *European Photography* and Andreas Müller-Pohle; the Aaron Siskind Foundation; the Pace/MacGill Gallery; the Fraenkel Gallery; and the Gitterman Gallery.

The following individuals were particularly helpful in their counsel and guidance: Jill Bender, Natasha Chuk, Bob Lobe, Nathan Lyons, Deborah Hussey, and Randy West.

Thanks are also due to Tad Crawford, publisher; Nicole Potter-Talling, editor; and Monica Lugo, associate editor; and all at Allworth Press for their constant support and encouragement. And to James Victore for his splendid cover design.

Finally, special thanks are due to David Rhodes, president of the School of Visual Arts, for his unending support for photography education.

Berenice Abbott, "Photography at the Crossroads," from *Classic Essays on Photography*, ed. Alan Trachtenberg. © Berenice Abbott/Commerce Graphics, NYC. Reprinted with permission from Berenice Abbott Estate/Commerce Graphics, NYC.

Robert Adams, "Colleagues," from *Why People Photograph*, Aperture, 1996. Copyright © Aperture Foundation. Reprinted with permission from the Aperture Foundation and Robert Adams.

Foreword
Photo Literacy

In the eight years since the launch of "The Education of" series, it has focused on graphic design, digital design, illustration, comics art, design entrepreneurship, art direction, and typography—a rather wide swath through the visual communications field—but there has nonetheless been an embarrassing omission: photography. Although photography plays an immense role in the practice and study of applied art, it was assumed by this editor that its pedagogy had been already well covered in various books. It was the wrong assumption!

When I began exploring the feasibility of *The Education of a Photographer* with Charles Traub and Adam Bell, it quickly became crystal clear that while photography students had a wealth of material on the technique, technology, history, and theory of photography, there was a surfeit of inspirational and informative material on what it means to be a photographer. It also was evident that in the context of "The Education of" series, photography was a missing link that tied graphic design and illustration into a single creative totality.

Each discipline covered in this series has its own integral characteristics, but each is also part of an interdependent network. Thus, for a graphic designer to be ignorant of photography or vice versa suggests a lack of visual literacy. Many of the photographers whose texts you will read herein were (or are) also typographers, designers, art directors, and even illustrators. Alexey Brodovitch, legendary art director of *Harper's Bazaar*, was such a good mentor to photographers because he understood all the facets of visual composition and communications. Today, with high-tech image-making programs, the boundaries between practices are quickly blurring, if not evaporating. Even when specialties stay intact, image-makers and image-framers must be visually literate. A designer should be photographically literate, just as a photographer should understand illustration, typography, and art direction.

I admit that as an art director, I've been unduly intimidated by photography (and certain photographers), and more comfortable with composing a grand type

tableau and assigning illustration. So when I embarked on co-editing this book, I had a revelation: It would be as much of an education for me as for the photographers (and hopefully designers and illustrators) who will draw inspiration from it. The texts herein by the master photography teachers and practitioners, as well as art directors, editors, and designers who commission and work with great photography, form a critical mass of shared wisdom about everything from aesthetics to theory, content to context, style to philosophy. The authors and interviewees were selected for their reputations and experience, and the writings were chosen for how effectively they could educate even the knowledgeable. And frankly, I have become a beneficiary of ideas that are both inspiring and enlightening.

—Steven Heller

Introduction
Years of Teaching

In the decades I have been teaching, great changes in the medium and craft of photography have affected how an aspiring photographer learns. I will not say that teaching has always been the easiest of pursuits, particularly in the early days, when I instructed students about the simple math of ratios so that they could properly mix chemicals. Mastery of the craft and getting a sharp, well-composed image within a decisive moment were significant achievements thirty-five years ago. Few emerging photographers could really do it, but as more and more schools—primary, secondary, and university—institutionalized photography as part of their curricula, such skills became more commonplace. Today, adolescents using high-tech, autoexposure digital cameras and cellphones shoot photos effortlessly, then push them around the Internet with daunting agility.

However, with these highly developed twenty-first-century skills come some surprising deficits. Seemingly well-educated graduate students are unable to position the beginning of modernism on a historical timeline. "When was World War I?" I ask. Few students respond with the correct dates. I have also noticed an alarming tendency among photography students: an unshakable certainty of their own brilliance assures them that their work is the most original and that it demands immediate success in the marketplace, as well as constant, though as yet unmerited, attention. To these tendencies I add a third: technophiles—those infatuated with all things digital. The students in this group are direct descendents of the ever-present camera-club buffs of earlier generations. Nevertheless, photography must still be taught, even in this brave new twenty-first-century environment. Several fundamental questions must be confronted before considering where photographic education might be headed and where we might direct it.

The lens arts have always been about vision, about looking and seeing. How do we see now? What does it mean to see? How does the visual image impact our lives today? Is there any content there? There is no better way to explore and understand these concerns than to look through the lens in an educated and

deliberate manner. Furthermore, students and educators must seriously examine the changes outside the camera's viewfinder, the powerful forces beyond craft that are alerting and reshaping ways of seeing, showing, and distributing photographs. At the heart of these concerns is a basic understanding of the grammar and language of visual images and photographs. Visual literacy is essential to the educated person of the twenty-first century. "The illiterate of the future will be the person ignorant of the use of the camera as well as of the pen," László Moholy-Nagy wrote presciently. In the essay "Unprecedented Photography," he discusses the vital importance of learning the language of the camera. Likewise, Daile Kaplan, in her essay, "The Soul of the Image and Visual Literacy," emphasizes the need for visual literacy education in early childhood.

It is rare that one comes upon a hardwired talent, self-taught and ready to enter the fray of possibilities the medium offers. Those of us who pursue this profession are well aware that in teaching, we are rewarded by witnessing enthusiastic people gain understanding and the skills that enhance talent. All the better if they are successful, but more importantly, we know that in learning photography one learns to think, organize, create, and understand. It's a good discipline for learning how to learn. The best models are those who have done it and who do it passionately. Throughout this book, we have made selections that highlight photographers' obsessions over and enthusiasms for their pursuits.

Over the years, as photography grew in popularity and gained acceptance, the institutional structures that emerged helped shape photography and photography education. During the sixties and seventies, everybody wanted to be a photographer and do his or her "thing" with a camera—*Blowup* (1966) seduced the baby boomers with its iconic portrait of the photographer. A critical discourse with its own criteria of excellence grew in response to the mass of work produced by these new image-makers, and from that grew a new connoisseurship that understood photography as central to the discourse of creativity. Artists tested and breached the once-clear line between the fine arts and mass-media photography. Exhibitions of hybrid, genre-bending work sprang up everywhere in cutting-edge galleries and museums, soon to be absorbed by mainstream art establishments and collectors. The twentieth-century masters were introduced to the vocabulary of the inquiring and the aspiring through specialized and elegant publications such as *Aperture* and *Lustrum*, as well as major exhibition venues that included the Museum of Modern Art (MoMA), the Art Institute of Chicago, and new glamorous galleries of photography. Of paramount importance was the introduction of courses in the history of photography, initially in art departments and subsequently adopted by the liberal arts. The teaching of photography rose from the basement to the main floor.

By the late seventies, students packed into photography classes, and there were never enough courses to meet the demand. Something had changed. Photography education had arrived, but what started as a revolution

in art, photography's coming of age as fine art, became institutionalized in the academy. The masters of modernist photography became celebrities with sycophantic acolytes who were sure that they were also destined for greatness. The media—writers and critics alike—made cultural heroes of these image-makers. The fashion world exploded with new magazines, and an occupation that promised the photographer sex and glamour was born. The new galleries were the best pickup places in town. For the first time, it was possible for a sizable group of people to actually make a living on the sales of photographs as objects of display. Photography was now, among other things, an industry.

Photography was arguably the most important medium in the visual arts in the eighties, the medium that had the most far-reaching impact on the largest number of people in our culture. Photography was the buzzword. Everybody was reading the big thinkers—Benjamin, Sontag, Barthes, Berger, Foucault, various French and German theorists. Institutions emphasized theory to such a degree that no self-respecting student could possibly pursue serious photography without backing it with appropriate references to a theoretical framework. Education in the medium became essential, and that need spawned more MFA programs.

The question was, what is practice without theory? Perhaps it wasn't even necessary to make pictures; perhaps photographs could just be reappropriated and recontextualized. This was an essential strategy—and a guiding belief—of postmodernism, which embraced conceptualism, minimalism, and appropriation, dominated contemporary art theory, and influenced concurrent trends in photography. "Craft" and "talent" became dirty words, or at least irrelevant ones. One could be considered an artist quite simply by calling oneself an artist. But soon, the word and the lofty theories it articulated began to kill the image. The visual and visceral experiences, both of the image-makers and the image-viewers, were subjugated to theoretical and political import of the work. Cultural wars dominated the critical discourse in the academia, media, and art world in the late eighties and the early nineties. The in-class critique, once the centerpiece between mentor and student, became more a theory-based seminar than an exploration of the visual. (See the essay by Ralph Hattersley for how it was done in an earlier time.)

Art had become big business: a commodity to be traded, like gold. There were insiders, brokers, and consultants, consorting and colluding in all sorts of ways. This environment reshaped the old job description of the "working photographer" and altered the ambitions and goals of many emerging photographers. Make it huge! Print it with the latest technology! Laminate it, and create an edition to hang in the "hottest" gallery by the river! A student could easily be overwhelmed by the chance to really make it big. Today, the potential prize at the end of the rainbow—money, art, fame, rock-star status—has become far greater than any twentieth-century master could have imagined.

At this juncture, while we are conducting the fight to reclaim photography from pure theory in higher education, we run the risk of winning the battle and losing the war. On the way toward earning one's MFA—and toward art-world recognition—an image-maker's personal motivations are losing out under pressure to conform to a set of critically approved, validated, and institutionalized creative practices. More often, such students present undeveloped portfolios that are more informed by contemporary art-magazine discourse than by experience and sustained exploration of the history of the medium and the precedents of image-making. For better or worse, one is unlikely to make it in Chelsea without the MFA degree. If this perspective seems sardonic or glib, I offer it to emphasize the loss of a set of values that a talented and ambitious image-maker might really need to know to be truly visually literate—and to navigate the contemporary photography environment. (Have things really changed? See the essay by Berenice Abbott.) In her interview, Charlotte Cotton addresses the often contentious relationship between the demands of the art market and the personal creative practice of photography.

The traditional bulwarks of the modernist photography world—the white walls and metal-section frames for "fine-art" photographs and ubiquitous news magazines like *Look* and *Life* for photojournalism—are historical footnotes. As both Robert Pledge and Susan Meiselas explain in their respective interviews, the role of the documentarian has changed radically. Broadcast journalism has replaced the traditional primacy of the concerned photographer as a "real-world" witness. This is also true for the formally aspiring art photographer: Twenty-first century hybrid art forms—video, multimedia, installation art—have eclipsed art photography. The challenges for the emerging photographic image-maker are many: finding supportive environments to prosper creatively and professionally, locating venues and viewers that appreciate his/her work, and transcending current fixations and temporal rewards of the art world.

This book is a collection of writings assembled to help students navigate the contemporary photography landscape. Our goal is to inspire a new generation of image-makers and to convey a sense of what it means to be a photographer. In the end, we hope to help them reap intellectual and visceral rewards not only from the act of seeing, but also from the commitment to their photographic pursuits. We have avoided discussions about individual photographs, per se, and we have largely omitted theoretical and social commentary. Instead, we have selected writings that speak to how photographers think and work—hence the section "Reflections on the Medium." There is indeed a mind-set—a set of conditions, needs, ideas—that motivate image-makers in a profound and enduring way. These motivations are distinct from external forces—the market, the whims and fashions of the art world—that can shape or compromise creativity. We have chosen these essays from the wealth of writing on photography, from early twentieth-century masters to the postmoderns. Without a doubt, the image-makers' individual works tell their story best, but it is also important to hear their voices describe the

journey from one point to the next. It is particularly important for the student to understand that a hero is also human.

The sections "How Others See Them" and "Finding an Audience" will help the reader understand the role of the photographer/mentor and how those close to them experienced these legends. Some of these great writers illustrate here how the photographers themselves became iconographic figures. The nonphotographers who are interviewed, such as Gael Towey and Yolonda Cuomo, follow in the tradition of great art direction of Alexey Brodovitch and hold an important position in the medium not only as teachers, but also as practitioners who shaped how photography is used and seen and how it influences its audience. The relationship between the audience and the creator of photographic images—and between these two and those in the photo industry who choose, select, edit, curate, and kill pictures—constantly changes and therefore must be reassessed continually. Our understanding and appreciation of the medium is also shaped by individuals who work outside the medium. In the section "Writers on Photography," the photographer and photography is examined with wit and poetic eloquence.

Teachers play a crucial role in the education of a photographer. However, they cannot tell someone what to do; they can only explain how something was done, how they got where they are, and then offer methods and examples to help one go forward and solve problems encountered on the way. (The models have not changed very much.) As emphasized in the section "Shared Wisdom," in the interviews with Sarah Charlesworth and Penelope Umbrico in particular, art-making is about work—and about working. Garry Winogrand, quoted in Leo Rubinfien's essay, put it more bluntly: "Your typical artist is a mule."

A minority of today's prominent curators, gallerists, and even historians are schooled in the diverse currents of the sixties and seventies, which form the foundation of today's creative practice. Fortunately, several in this minority, including László Moholy-Nagy, Nathan Lyons, and John Szarkowski have made a conscious effort to nurture and chronicle the development of seminal issues. They have championed other photographers and artists—published their work and curated their exhibitions—and their efforts have furthered our very awareness of the potential of photography as an expressive medium. We acknowledge and honor their legacy in the section "Guides for the Uneducated," which chronicles some of this history and responsibility.

We intend this book to function loosely as a series of "master classes." All too often in today's learning experience, historical or contemporary masters are beyond the reach of the student. Many of those included here—Alexander Rodchenko, Minor White, Aaron Siskind—supplemented their creative work with teaching. Their contemporaries—image-makers such as Gregory Crewdson and Clarissa Sligh, whose reflections and insights we have included—have contributed greatly not only to the photographic art as creators, but also to

critical discussions of the medium as thinkers. Unquestionably, for anyone who creates visually, it is important to have a forum and a community in which to articulate ideas. The environment is best when there is reciprocity between the teacher and the student. We hope that *The Education of a Photographer* becomes a useful tool for building that environment.

In a little over 150 years, photography has come to inform everything we do in modern society. Understanding it is no simple matter. What a student must master today to be fluent in the language of pictures is much more complex than what my generation learned in the art academies of the sixties. One can no longer master it all, nor can one wear the many hats that photographers once did. Today, we are specialists—artist, illustrator, journalist—and it is hard to cross over into different categories, except if one ascends to the very peak of the profession. Yet practice in any of these disciplines does affect how we see and understand the world. Each unique and important photographer develops new techniques and strategies that can be appropriated and adapted by any photographer. There are lessons to be learned from all of these roles, and each has particular disciplines and principles with which the student must be acquainted.

—Charles H. Traub

Section One

Reflections on the Medium:
What It Means to
Photograph

THE PATHS OF MODERN PHOTOGRAPHY
Alexander Rodchenko

This is an open letter, dated 1928, to Boris Kushner, a critic and theorist, who was Rodchenko's main opponent in an ongoing debate in the journal *Novyi lef*. In this letter, Rodchenko responds to Kushner's skepticism about the value of experimental photography and articulates the revolutionary potential of photography, its need to break away from its imitation of painting, and its ability to transform our vision.

Dear Kushner,

You touched upon an interesting question concerning "from below up and from above down," and I feel obliged to respond, inasmuch as these photographic viewpoints have been "foisted upon" me (if I may use the "literate" language of the journal *Sovetskoe foto*).

I do, indeed, support the use of these viewpoints above all others. Here's why:

Look at the history of art or the history of painting of all countries, and you'll see that all paintings, with some very minor exceptions, have been painted either from the belly button level or from eye level.

Don't take the impression apparently created in icons and primitive paintings to be a bird's-eye view. The horizon has simply been raised so that a lot of figures can be put in, but each of these figures is presented at eye level. The whole thing taken together corresponds neither to reality nor to the bird's-eye view.

Although the figures seem to be looking upward, each one has a correctly drawn front view and profile. Except—they are placed *one above the other, and not one behind the other* as in realist pictures.

The same with Chinese artists. True, they have one advantage—all possible declivities of an object are recorded in their moments of movement (foreshortenings)—but the point of observation is always at mid-level.

Take a look at old journals carrying photographs—you'll see the same thing. It's only over recent years that you'll sometimes come across different vantage points. I underline the word *sometimes*, since these new viewpoints are few and far between.

I buy a lot of foreign journals and I collect photographs, but I have managed to put together only about three dozen pieces of this kind.

Behind this dangerous stereotype lies the biased, conventional routine that educates man's visual perception, the one-sided approach that distorts the process of visual reason.

How did the history of pictorial invention evolve? At first there was the desire to make something look "like life," as in Vereshchagin's pictures[1] or Denner's portaits[2]—which were about to crawl out of their frames and in which the very pores of the skin were painted. But instead of being praised, these painters were censured for being "photographers."

The second path of pictorial invention followed an individualistic and psychological conception of the world. Variations on exactly the same type are depicted in the paintings of Leonardo da Vinci, Rubens, etc. Leonardo da Vinci uses the Mona Lisa, Rubens his wife.

The third path was stylization, painting for painting's sake: van Gogh, Cézanne, Matisse, Picasso, Braque.

And the last path was abstraction, non-objectivity: when virtually the only interest the object held was scientific. Composition, texture, space, weight, etc.

But the paths exploring new viewpoints, perspectives, and methods of foreshortening remained quite untrodden.

It seemed that painting was finished. But if in the opinion of AKhRR[3] it was not yet finished, still no one paid any attention to the question of viewpoint.

Photography—the new, rapid, concrete reflector of the world—should surely undertake to show the world from all vantage points, and to develop people's capacity to see from all sides. It has the capacity to do this. But it's at this juncture that the psychology of the "pictorial belly button," with its authority of the ages, comes down on the modern photographer; it instructs him through countless articles in photographic journals, such as "The Paths of Photo-Culture" in *Sovetskoe foto*, providing him with such models as oil paintings of madonnas and countesses.

What kind of Soviet photographer or reporter will we have if his visual reason is clogged with the examples set by world authorities on the compositions of archangels, Christs, and lords?

When I began photography, after I had rejected painting, I did not then realize that painting had laid its heavy hand upon photography.

Do you understand now that the most interesting viewpoints for modern photography are from above down and from below up, and any others rather than the belly-button level? In this way the photographer has moved a bit farther away from painting.

I have difficulty writing; my thought process is visual, only separate fragments of ideas come to me. Still, no one has written about this matter, there

are no articles on photography, its tasks and successes. Even leftist photographers such as Moholy-Nagy write personal articles such as "How I Work," "My Path," etc. Editors of photographic journals invite painters to write about developments in photography, and maintain an inert, bureaucratic attitude when dealing with amateur photographers and press photographers.

As a result, press photographers give up sending photographs to photographic journals, and the photographic journals itself is turning into some kind of *Mir iskusstva* [World of art].[4]

The letter about me in *Sovetskoe foto* is not just a piece of ridiculous slander. It is also a kind of bomb dropped on the new photography. While discrediting me, it aims as well to frighten off any photographers who are using new viewpoints.

Sovetskoe foto, in the person of Mikulin, informs young photographers that they are looking "à la Rodchenko," and therefore that their photographs cannot be accepted.

But in order to show how cultured they themselves are, the journals publish one or two photographs by modern, foreign photographers—although without the artist's signature and with no indication as to the source.

But let us return to the main question.

The modern city with its multi-story buildings, the specially designed factories and plants, the two- and three-story store windows, the streetcars, automobiles, illuminated signs and billboards, the ocean liners and airplanes—all those things that you described so wonderfully in your *One Hundred and Three Days in the West*[5]—have redirected (only a little, it's true) the normal psychology of visual perceptions.

It would seem that only the camera is capable of reflecting contemporary life. But....

The antediluvian laws of visual rationality recognize the photograph as merely some kind of low-grade painting, etching or engraving, possessing their same reactionary perspective. From the force of this tradition, a sixty-eight-story building in America is photographed from the belly button. But this belly button is on the thirty-fourth floor. So they climb up inside an adjacent building, and from the thirty-fourth story they photography the sixty-eight story giant.

And if there is no adjacent building they still get the same head-on, sectional view.

When you walk along the street you see buildings from below up. From their upper stories you look down at the automobiles and pedestrians scurrying along the street.

Everything you glimpse from the streetcar window or the automobile, the view you get from above down when you sit in the theater auditorium—all are transformed and straightened into the classical "belly button" view.

As he watches *Uncle Vanya* from the gallery, i.e., from above down, the spectator transforms what he sees. From his mental mid-view *Uncle Vanya* progresses as if in real life.

I remember when I was in Paris and saw the Eiffel Tower for the first time from afar, I didn't like it at all.[6] But once I passed very close to it in a bus, and through the window I saw those lines of iron receding upward right and left; this viewpoint gave me an impression of its massiveness and constructiveness. The belly-button view gives you just the sweet kind of blob that you see reproduced on all the postcards ad nauseam.

Why bother to look at a factory if you only observe it from afar and from the middle viewpoint, instead of examining everything in detail—from inside, from above down, and from below up?

The camera itself is equipped so that it will not distort perspective, even when perspective is distorted in reality.

If a street is narrow and gives you no room to step off to the side, then, according to the "rules," you are supposed to raise the front of the camera with its lens and incline the back, etc., etc.

All this is to ensure the "correct" projectional perspective.

Only recently, and in so-called amateur cameras, have short-focus lenses been employed.

Millions of stereotyped photographs are floating around. The only difference between them is that one might be more successful than the other, or that some might imitate an etching, others a Japanese engraving, and still others a "Rembrandt."

Landscapes, heads, and naked women are called artistic photography, while photographs of current events are called press photography.

Press photography is considered to be something of a lower order.

But this applied photography, this lower order, has brought about a revolution in photography—by the competition among journals and newspapers, by its vital and much-needed endeavors, and by performing when it is essential to photograph at all costs, in every kind of lighting and from every viewpoint.

There is now a new struggle: between pure and applied photography, artistic photography and press photography.

All is not well in photo-reporting. Here too, in this very genuine activity, stereotype and false realism have divided the workers. At a picnic I once saw reporters staging dances and arranging picturesque groups of people on a hillock.

It's interesting how the girls who hastened to join the "picturesque" group first hid in the car to do their hair and make-up.

"Let's go and get photographed!"

It's not the photographer who takes his camera to his subject, but the subject who comes to the camera; and the photographer gives the right pose in accordance with the canons of painting.

Here are some photographs from the journal *Die Koralle*:[7] they constitute a chronicle, a piece of ethnography, a document. But everyone's posing. Yet the minute before the photographer came along these people were doing their own work and were in their own places.

Imagine the scene the photographer would have captured if he had taken them unexpectedly, unawares.

But you see, it's difficult to photograph unawares, whereas it's quick and easy to use a system of posing. And no misunderstandings with your customer.

In journals you can see photographs of small animals and insects taken close up, bigger than life size. But it's not the photographer who takes the camera close to them, it's they who are brought up to the camera.

New photographic subjects are being sought, but they are being photographed according to bygone traditions.

Mosquitoes will be photographed from the belly button and according to the pictorial cannon of Repin's *Zaporozhtsy*.[8]

But it is possible to show an object according to the point of view from which we look at it rather than the one from which we see it.

I am not speaking of those everyday objects which can be shown in quite an unusual way.

You write about Flach's bridge. Yes, it's great. But it is so because it's taken from the ground, not from the belly button.

You write that Kaufman's and Fridliand's photographs of the Shukhov radio tower are bad, that they resemble a bread basket more than a really remarkable structure. I quite agree, but…any viewpoint can violate the real appearance of an object if the object is new and is not fully revealed to you.

Only Fridliand is guilty of error here, not Kaufman. Kaufman's photograph is just one of several frames he took of the tower from various viewpoints. And in the movie, these views are in motion: the camera revolves and clouds fly above the tower.

Sovetskoe foto speaks of the "photo-picture" as if it were something exclusive and eternal.

On the contrary. One should shoot the subject from several different points and in varying positions in different photographs, as if encompassing it—not peer through one keyhole. Don't make photo-pictures, make photo-moments of documentary (not artistic) value.

To sum up: in order to accustom people to seeing from new viewpoints it is essential to take photographs of everyday, familiar subjects from completely unexpected vantage points and in completely unexpected positions. New subjects should also be photographed from various points, so as to present a complete impression of the subject.

In conclusion I include a few photographs to illustrate my assertions.

I have deliberately chosen photographs of the same building.

The first ones come from the American album *America*. These photographs have been taken in the most stereotyped manner. They were difficult to take, because the adjacent buildings got in the way; that's why they were touched up.

That's the way it is. Both Americans and Europeans brought up on the laws of correct perspective see America this way.

It's what, in reality, cannot possibly be seen.

The second set of photographs of the same building are by the German left-ist architect Mendelsohn.[9] He photographed them in an honest way, just as the man in the street could see them.

Here's a fireman. A very real viewpoint. That's how you might see him if you looked out the window. How striking it is. It's quite possible that we often look at things like this, but don't see them.

We don't see what we look at.

We don't see the extraordinary perspectives, the foreshortenings and posi-tions of objects.

We who are accustomed to seeing the usual, the accepted, must reveal the world of sight. We must revolutionize our visual reasoning.

"Photograph from all viewpoints except 'from the belly button,' until they all become acceptable."

"And the most interesting viewpoints today are those from above down and from below up and their diagonals."

August 18, 1928
Translated by John E. Bowlt

1 Vasilii Vasilievich Vereshchagin (1842–1904), a realist painter, was famous for his battle scenes and ethnographic compositions rendered with great accuracy of detail.

2 Balthasar Denner (1685–1749) was a portraitist and miniature painter known for his precision. He used a special varnish to render flesh tones in his portraits, and for this reason was nicknamed "Porendenner."

3 AKhRR: The Association of Artists of Revolutionary Russia.

4 World of Art was the name given in the 1890s to a group of artists, aesthetes, and writers led by Sergei Diaghilev and Alexandre Benois in St. Petersburg. They sought to renew old traditions of Russian art, devoting particular attention to the decorative arts. The circle published a journal (1898–1904) and organized a series of exhibitions (1899–1906) under the name *The World of Art*. After a break that began in 1906, a group bearing the same name resumed exhibition activity during 1910–24.

5 Boris Kushner published this book of descriptions and episodes, *Sto tri dnia na Zapade*, in Moscow in 1928.

6 Rodchenko's visit to Paris of March 19–June 10, 1925 coincided with the Exposition *internationale des arts décoratifs*; he designed a workers' reading room for the Soviet pavilion. His letters from Paris were published *Novyi lef*, no. 2 (1927).

7 *Die Koralle* was a popular illustrated scientific magazine published in Berlin 1925–41.

8 *The Zaporozhtsy* (1878–91), an exuberant painting by the realist Ilia Efimovich Repin (1844–1930), illustrates an episode in which the Zaporozhe Cossacks refused the Turkish Ottoman's invitation to join his empire.

9 On Mendelsohn, see above.

PHOTOGRAPHY AT THE CROSSROADS
Berenice Abbott

This magazine article, written in 1951, makes the still-relevant argument for photography's role in documenting the real world at a time when fictitious and commercialized strategies have dominated the field.

The world today has been conditioned, overwhelmingly, to visualize. The *picture* has almost replaced the *word* as a means of communication. Tabloids, educational and documentary films, popular movies, magazines, and television surround us. It almost seems that the existence of the word is threatened. The picture is one of the principal mediums of interpretation, and its importance is thus growing ever vaster.

Today the challenge to photographers is great because we are living in a momentous period. History is pushing us to the brink of a realistic age as never before. I believe there is no more creative medium than photography to recreate the living world of our time.

Photography gladly accepts the challenge because it is at home and in its element: namely, realism—real life—the *now*. In fact, the photographic medium is standing at its own crossroads of history, possibly at the end of its first major cycle. A decision as to which direction it shall take is necessary, and a new chapter in photography is being made—as indeed many new chapters are now taking the place of many older ones.

The time comes when we progress, must go forward, must grow. Else we wither, decay, die. This is as true of photography as for every other human activity in this atom age. It is more important than ever to assess and value photography in the contemporary world. To understand the *now* with which photography is essentially concerned, it is necessary to look at its roots, to measure its past achievements, to learn the lessons of its tradition. Let us briefly span its beginnings—they were truly spectacular.

The people who were interested in photography and who contributed to its childhood success were most serious and capable. In the early years of the nineteenth century, a tremendous amount of creativeness and intelligence was invested in the new invention. Enthusiasm among artists, scientists, intellectuals of all kinds, and the lay public, was at a high pitch. Because of the interest in and demand for a new picture-making medium, technical development was astonishingly rapid.

The aesthetic counterpart of such rapid growth is to be seen in photographers like Brady, Jackson, O'Sullivan, Nadar, and their contemporaries. There was such a boom in technical progress, as has not been surpassed even today. The recently published *History of Photography* by J. M. Eder, translated by Edward Epstean, documents this acceleration in detail.

America played a healthy and vital part in the rise of photography. American genius took to the new medium like the proverbial duck to water. An extremely

interesting study of photography in the United States—an important book for everyone—is Robert Taft's *Photography and the American Scene*. Here the material and significant growth of the medium is integrated with the social and economic growth of our country.

In photography, America neither lagged nor slavishly imitated, and we can boast of a sound American tradition. Portraits flourished as in no other country. The Civil War created a demand for millions of "likenesses" of the young men marching off to the front. The newness of our country was of course another stimulus to growth, with many people sending pictures of themselves to relatives left behind in the westward movement, or to prospective brides and husbands in the "Old Country." The migratory, restless population of the United States flowed west, over the Alleghenies from Pennsylvania into Ohio and other states of the Western Reserve, past the Mississippi and into the west; and wherever they went, they left little hoards, little treasures of old photographs—invaluable archives for the historian today. In the winning of the frontier, photographers also played their part, going with U.S. Geologic Survey expeditions after the Civil War. Among these, William H. Jackson stands as a shining example.

This organic use of photography produced thousands of straight-forward, competent operators, whereas in England there were comparatively few; apparently because a monopoly of all patents tied up the photographic process and prevented the spread of interest in and use of the new invention. Here in the United States, it was virtually impossible to make such a monopoly stick.

This ferment and enthusiasm produced fine results. Our daguerreotypes were superb. They were acclaimed all over Europe and systematically won all the first prizes at the international exhibitions. People were wild with enthusiasm for these realistic "speaking likenesses," and everybody was doing it. In fact, anyone could afford the photograph, whereas before only the wealthy could pay the price to have their portraits painted. As a result, the photographic business flourished.

After a whole-hearted start with Yankee ingenuity, money got into photography along with pseudo-artists; commercialism developed with a bang. And as with any business, which, as it grows, serves the greatest common denominator, so with photography. Cash took over. Instead of the honest, realistic likeness, artificial props with phony settings began to be used. A period of imitating the unreal set in. Supply houses sprang up with elaborate Grecian urns and columns and fancy backdrops—all for the greatest possible show and ostentation. Retouching and brush work also set in. What was thought to be imitation or emulation of painting became rampant.

It need not be added that the imitation was of bad painting, because it had to be bad, dealing largely or wholly with the sentimental, the trite and pretty, the picturesque. Thus photography was torn from its moorings, the whole essence of which is realism.

Much of this was due to a terrible plague, imported from England in the form of Henry Peach Robinson. He became the shining light of photography, charged large prices, took ribbon after ribbon. He lifted composition bodily from painting, but the ones he chose were probably some of the worst examples in history. Greatest disaster of all, he wrote a book in 1869 entitled *Pictorial Photography*. His system was to flatter everything. He sought to correct what the camera saw. The inherent genius and dignity of the human subject was denied.

Typical of his sentimental pictures were his titles, and titles of other photographers of the period: "Poor Joe," "Hard Times," "Fading Away," "Here Comes Father," "Intimate Friends," "Romantic Landscape," "By the Stream," "End of a Winter's Day," "Kiss of Dew," "Fingers of Morning." If some of the subject matter and titles are not too far removed from some of today's crop of pictorialists, then obviously the coincidence of similar thinking has the same sentimental unrealistic foundation in common. This Robinsonian school had an influence second to none—it stuck, simply, because it made the practice and theory of photography *easy*. In other words, flattery pays off. Thus today there are still many photographers of the Pictorial School who continue to emulate the "master" of 1869.

As a popular art form, photography has expanded and intensified its activity in recent years. The most noticeable trend has been the widespread distribution which gives photography much of its strength and power, demands that there be a greater sense of awareness on the part of photographers and editors alike.

Unfortunately, along with growth and the strength it signifies, goes the possibility of a decline in our photographic sensibilities and output. Actually, the progress of photography is frequently delayed by inadequate equipment, which needs fundamental, far-reaching improvement. This is not to condemn the industry as a whole, but rather certain segments of it, for their stationary outlook and lack of proper perspective. Photography gains much of its strength from the vast participation of the amateur, and of course this is the market where mass production thrives.

But—it is high time industry paid attention to the serious and expert opinion of experienced photographers, and to the needs of the professional worker as well. This is important because a good photographer cannot fulfill the potential of contemporary photography if he is handicapped with equipment and materials made for amateurs only, or simply for a quick turnover. The camera, the tripod, and other picture-taking necessities, too often designed by draftsmen who never took a serious picture in their lives, must be vastly better machines if they are to free the photographer creatively, instead of dominating his thinking.

Many photographers spend too much time in the darkroom, with the result that creative camera work is seriously interfered with. The stale vogue of drowning in technique and ignoring content adds to the pestilence and has become, for

many, part of today's general hysteria. "*... and craftsmanship I set up as a pedestal for art became the merest craftsman; to my fingers I lent a docile, cold agility, and sureness to my ear. I stifled sounds and then dissected music like a corpse, checked harmony by algebraic rules.*"

Apart from the foregoing gripes, what then makes a picture a creative piece of work? We know it cannot be just technique. Is it content—and if so, what is content? These are basic questions that enlightened photographers must answer for themselves.

Let us first say what photography is *not*. A photograph is not a painting, a poem, a symphony, a dance. It is not just a pretty picture, not an exercise in contortionist techniques and sheer print quality. It is or should be a significant document, a penetrating statement, which can be described in a very simple term—selectivity.

To define selection, one may say that it should be focused on the kind of subject matter which hits you hard with its impact and excites your imagination to the extent that you are forced to take it. Pictures are wasted unless the motive power which impelled you to action is strong and stirring. The motives or points of view are bound to differ with each photographer, and herein lies the important difference which separates one approach from another. Selection of proper picture content comes from a fine union of trained eye and imaginative mind.

To chart a course, one must have a direction. In reality, the eye is no better than the philosophy behind it. The photographer creates, evolves a better, more selective, more acute seeing eye by looking ever more sharply at what is going on in the world. Like every other means of expression, photography, if it is to be utterly honest and direct, should be related to the life of the times—the pulse of today. The photograph may be presented as finely and artistically as you will; but to merit serious consideration, must be directly connected with the world we live in.

What we need is a return, on a mounting spiral of historic understanding, to the great tradition of realism. Since ultimately the photograph is a statement, a document of the *now*, a greater responsibility is put on us. Today, we are confronted with reality on the vastest scale mankind has known. Some people are still unaware that reality contains unparalleled beauties. The fantastic and unexpected, the ever-changing and renewing is nowhere so exemplified as in real life itself. Once we understand this, it exercises a dynamic compulsion on us, and a photo-document is born.

The term "documentary" is sometimes applied in a rather derogatory sense to the type of photography which to me seems logical. To connect the term "documentary" with only the "ash-can school" is so much sheer nonsense, and probably stems from the bad habit of pigeon-holing and labeling everything like the well-known 57 varieties. Actually, documentary pictures include every subject in the world—good, bad, indifferent. I have yet to see a fine photograph

which is not a good document. Those that survive from the past invariably are, and can be recognized in the work of Brady, Jackson, Nadar, Atget, and many others. Great photographs have "magic"—a revealing word that comes from Steichen. I believe the "magic" photographers are documentarians only in the broadest sense of the word.

According to Webster, anything "documentary" is: "that which is taught, evidence, truth, conveying information, authentic judgment." Add to that a dash of imagination, take for granted adequate technique to realize the intention, and a photographer's grasp will eventually equal his reach—as he turns in the right direction at the crossroads.

UNTITLED
Henri Cartier-Bresson

This is the piece that defines the "decisive moment."

There is nothing in this world without a decisive moment.

—Cardinal Retz

I, like many another boy, burst into the world of photography with a Box Brownie, which I used for taking holiday snapshots. Even as a child, I had a passion for painting, which I "did" on Thursdays and Sundays, the days when French school children don't have to go to school. Gradually, I set myself to try to discover the various ways in which I could play with a camera. From the moment that I began to use the camera and to think about it, however, there was an end to holiday snaps and silly pictures of my friends. I became serious. I was on the scent of something, and I was busy smelling it out.

Then there were the movies. From some of the great films, I learned to look, and to see. *Mysteries of New York*, with Pearl White; the great films of D. W. Griffith—*Broken Blossoms*; the first films of Stroheim; *Greed*; Eisenstien's *Potemkin*; and Dreyer's *Jeanne d'Arc*—these were some of the things that impressed me deeply.

Later I met photographers who had some of Atget's prints. These I considered remarkable and, accordingly, I bought myself a tripod, a black cloth, and a polished walnut camera three by four inches. The camera was fitted with—instead of a shutter—a lens cap, which one took off and then put on to make the exposure. This last detail, of course, confined my challenge to the static world. Other photographic subjects seemed to me to be too complicated, or else to be "amateur stuff." And by this time I fancied that by disregarding them, I was dedicating myself to Art with a capital "A."

Next I took to developing this Art of mine in my washbasin. I found the business of being a photographic Jack-of-all-trades quite entertaining. I knew nothing about printing, and had no inkling that certain kinds of paper produced soft prints and certain others highly contrasted ones. I didn't bother much about such things, though I invariably got mad when the images didn't come out right on the paper.

In 1931, when I was twenty-two, I went to Africa. On the Ivory Coast I bought a miniature camera of a kind I have never seen before or since, made by the French firm Krauss. It used film of a size that 35mm would be without the sprocket holes. For a year I took pictures with it. On my return to France I had my pictures developed—it was not possible before, for I lived in the bush, isolated, during most of that year—and I discovered that the damp had got into the camera and that all my photographs were embellished with the superimposed patterns of giant ferns.

I had had blackwater fever in Africa, and was now obliged to convalesce. I went to Marseille. A small allowance enabled me to get along, and I worked with enjoyment. I had just discovered the Leica. It became the extension of my eye, and I have never been separated from it since I found it. I prowled the streets all day, feeling very strung-up and ready to pounce, determined to "trap" life—to preserve life in the act of living. Above all, I craved to seize, in the confines of one single photograph, the whole essence of some situation that was in the process of unrolling itself before my eyes.

The idea of making a photographic reportage, that is to say, of telling a story in a sequence of pictures, never entered my head at that time. I began to understand more about it later, as a result of looking at the work of my colleagues and at the illustrated magazines. In fact, it was only in the process of working for them that I eventually learned, bit by bit, how to make a reportage with a camera, how to make a picture-story.

I have traveled a good deal, though I don't really know how to travel. I like to take my time about it, leaving between one country and the next an interval in which to digest what I've seen. Once I have arrived in a new country, I feel almost like settling down there so as to live on proper terms with the country. I could never be a globetrotter.

In 1947, five freelance photographers, of whom I was one, founded our cooperative enterprise called "Magnum Photos." This cooperative enterprise distributes our picture-stories to magazines in various countries.

Twenty-five years have passed since I started to look through my view-finder. But I regard myself still as an amateur, though I am no longer a dilettante.

THE PICTURE STORY

What actually *is* a photographic reportage, a picture story? Sometimes there is one unique picture whose composition possesses such vigor and richness, and whose content so radiates outward from it, that this single picture is a whole story in itself. But this rarely happens. The elements which, together, can strike sparks from a subject, are often scattered—either in terms of space or time—and bringing them together by force is "stage management," and, I feel, cheating. But if it is possible to make pictures of the "core" as well as the struck-off sparks of the subject, this is a picture-story. The page serves to reunite the complementary elements which are dispersed throughout several photographs.

The picture-story involves a joint operation of the brain, the eye, and the heart. The objective of this joint operation is to depict the content of some event which is in the process of unfolding, and to communicate impressions. Sometimes a single event can be so rich in itself and its facets that it is necessary to move all around it in your search for the solution to the problems it poses—for the world is movement, and you cannot be stationary in your attitude toward something that is moving. Sometimes you light upon the picture in seconds; it

might also require hours or days. But there is no standard plan, no pattern from which to work. You must be on alert with the brain, the eye, the heart, and have a suppleness of body.

Things-As-They-Are offer such an abundance of material that a photographer must guard against the temptation of trying to do everything. It is essential to cut from the raw material of life—to cut and cut, but to cut with discrimination. While working, a photographer must reach a precise awareness of what he is trying to do. Sometimes you have the feeling that you have already taken the strongest possible picture of a particular situation or scene; nevertheless, you find yourself compulsively shooting, because you cannot be sure in advance exactly how the situation, the scene, is going to unfold. You must stay with the scene, just in case the elements of the situation shoot off from the core again. At the same time, it's essential to avoid shooting like a machine-gunner and burdening yourself with useless recordings which clutter your memory and spoil the exactness of the reportage as a whole.

Memory is very important, particularly in respect to the recollection of every picture you've taken while you've been galloping at the speed of the scene itself. The photographer must make sure, while he is still in the presence of the unfolding scene, that he hasn't left any gaps, that he has really given expression to the meaning of the scene in its entirety, for afterward it is too late. He is never able to wind the scene backward in order to photograph it all over again.

For photographers, there are two kinds of selection to be made, and either of them can lead to eventual regrets. There is the selection we make when we look through the view-finder at the subject; and there is the one we make after the films have been developed and printed. After developing and printing, you must go about separating the pictures which, though they are all right, aren't the strongest. When it's too late, then you know with a terrible clarity exactly where you failed; and at this point you often recall the telltale feeling you had while you were actually making the pictures. Was it a feeling of hesitation due to uncertainty? Was it because of some physical gulf between yourself and the unfolding event? Was it simply that you did not take into account a certain detail in relation to the whole setup? Or was it (and this is more frequent) that your glance became vague, your eye wandered off?

For each of us space begins and slants off from our own eye, and from there enlarges itself progressively toward infinity. Space, in the present, strikes us with greater or lesser intensity and then leaves us, visually, to be closed in our memory and to modify itself there. Of all the means of expression, photography is the only one that fixes forever the precise and transitory instant. We photographers deal in things that are continually vanishing, and when they have vanished, there is no contrivance on earth that can make them come back again. We cannot develop and print a memory. The writer has time to reflect. He can accept and reject, accept again; and before committing his thoughts to paper he is able

to tie the several relevant elements together. There is also a period when his brain "forgets," and his subconscious works on classifying his thoughts. But for photographers, what has gone is gone forever. From that fact stem the anxieties and strength of our profession. We cannot do our story over again once we've got back to the hotel. Our task is to perceive reality, almost simultaneously record-ing it in the sketchbook which is our camera. We must neither try to manipulate reality while we are shooting, nor manipulate the results in the darkroom. These tricks are patently discernible to those who have eyes to see.

In shooting a picture-story we must count the points and the rounds, rather like a boxing referee. In whatever picture-story we try to do, we are bound to arrive as intruders. It is essential, therefore, to approach the subject on tiptoe—even if the subject is still-life. A velvet hand, a hawk's eye—these we should all have. It's no good jostling or elbowing. And no photographs taken with the aid of flashlight either, if only out of respect of the actual light—even when there isn't any of it. Unless a photographer observes such conditions as these, he may become an intolerably aggressive character.

The profession depends so much upon the relations the photographer estab-lishes with the people he's photographing, that a false relationship, a wrong word or attitude, can ruin everything. When the subject is in any way uneasy, the per-sonality goes away where the camera can't reach it. There are no systems, for each case is individual and demands that we be unobtrusive, though we must be at close range. Reactions of people differ much from country to country and from one social group to another. Throughout the whole of the Orient, for example, an impatient photographer—or one who is simply pressed for time—is subject to ridicule. If you have made yourself obvious, even just by getting your light-meter out, the only thing to do is to forget about photography for the moment, and accommodatingly allow the children who come rushing at you to cling to your knees like burrs.

THE SUBJECT
There is subject in all that takes place in the world, as well as in our personal universe. We cannot negate subject. It is everywhere. So we must be lucid toward what is going on in the world, and honest about what we feel.

Subject does not consist of a collection of facts, for facts in themselves offer little interest. Through facts, however, we can reach an understanding of the laws that govern them, and be better able to select the essential ones which communi-cate reality.

In photography, the smallest thing can be a great subject. The little, human detail can become leitmotiv. We see and show the world around us, but it is an event itself which provokes the organic rhythm of forms.

There are thousands of ways to distill the essence of something that capti-vates us; let's not catalogue them. We will, instead, leave it in all its freshness....

There is a whole territory which is no longer exploited by painting. Some say it is because of the discovery of photography. However it came about, photography has taken over a part of this territory in the form of illustration.

One kind of subject matter greatly derided by present-day painters is the portrait. The frock coat, the soldier's cap, the horse now repel even the most academic of painters. They feel suffocated by all the gaiter buttons of the Victorian portrait makers. For photographers—perhaps because we are reaching for something much less lasting in value than the painters—this is not so much irritating as amusing, because we accept life in all its reality.

People have an urge to perpetuate themselves by means of a portrait, and they put their best profiles forward for posterity. Mingled with this urge, though, is a certain fear of black magic; a feeling that by sitting for a camera portrait they are exposing themselves to the workings of witchcraft of a sort.

One of the fascinating things about portraits is the way they enable us to trace the sameness of man. Man's continuity somehow comes through all the external things that constitute him—even if it is only to the extent of someone's mistaking Uncle for Little Nephew in the family album. If the photographer is to have a chance of achieving a true reflection of a person's world—which is as much outside him as inside him—it is necessary that the subject of the portrait should be in a situation normal to him. We must respect the atmosphere which surrounds the human being, and integrate into the portrait the individual's habitat—for man, no less than animals, has his habitat. Above all, the sitter must be made to forget about the camera and the photographer who is handling it. Complicated equipment and light reflectors and various other items of hardware are enough, to my mind, to prevent the birdie from coming out.

What is there more fugitive and transitory than the expression on a human face? The first impression given by a particular face is often the right one; but the photographer should try always to substantiate the first impression by "living" with the person concerned. The decisive moment and psychology, no less than camera position, are the principal factors in the making of a good portrait. It seems to me it would be pretty difficult to be a portrait photographer for customers who order and pay since, apart from a Maecenas or two, they want to be flattered, and the result is no longer real. The sitter is suspicious of the objectivity of the camera, while the photographer is after an acute psychological study of the sitter.

It is true, too, that a certain identity is manifest in all the portraits taken by one photographer. The photographer is searching for identity of his sitter, and is also trying to fulfill an expression of himself. The true portrait emphasizes neither the suave nor the grotesque, but reflects the personality.

I infinitely prefer, to contrived portraits, those little identity-card photos which are pasted side by side, row after row, in the windows of passport photographers. At least there is on these faces something that raises a question, a simple factual testimony—this in place of the poetic identification we look for.

COMPOSITION

If a photograph is to communicate its subject in all its intensity, the relationship of form must be rigorously established. Photography implies the recognition of a rhythm in the world of real things. What the eye does is to find and focus on the particular subject within the mass of reality; what the camera does is simply to register upon film the decision made by the eye. We look at and perceive a photograph, as we do a painting, in its entirety and all in one glance. In a photograph, composition is the result of a simultaneous coalition, the organic coordination of elements seen by the eye. One does not add composition as though it were an afterthought superimposed on the basic subject material, since it is impossible to separate content from form. Composition must have its own inevitability about it.

In photography there is a new kind of plasticity, the product of instantaneous lines made by movements of the subject. We work in unison with movement as though it were a presentiment of the way in which life itself unfolds. But inside movement there is one moment at which the elements in motion are in balance. Photography must seize upon this moment and hold immobile the equilibrium of it.

The photographer's eye is perpetually evaluating. A photographer can bring coincidence of line simply by moving his head a fraction of a millimeter. He can modify perspectives by a slight bending of the knees. By placing the camera closer or farther from the subject, he draws a detail—and it can be subordinated, or he can be tyrannized by it. But he composes a picture in very nearly the same amount of time it takes to click the shutter, at the speed of a reflex action.

Sometimes it happens that you stall, delay, wait for something to happen. Sometimes you have the feeling that here are all the makings of a picture—except for just one thing that seems to be missing. But what one thing? Perhaps someone suddenly walks into your range of view. You follow his progress through the viewfinder. You wait and wait and then finally you press the button—and you depart with the feeling (though you don't know why) that you've really got something. Later, to substantiate this, you can take a print of this picture, trace on it the geometric figures which come up under analysis, and you'll observe that, if the shutter was released at the decisive moment, you have instinctively fixed a geometric pattern without which the photograph would have been both formless and lifeless.

Composition must be one of our constant preoccupations, but at the moment of shooting it can stem only from our intuition, for we are out to capture the fugitive moment, and all the interrelationships involved are on the move. In applying the Golden Rule, the only pair of compasses at the photographer's disposal is his own pair of eyes. Any geometrical analysis, any reducing of the picture to a schema, can be done only (because of its very nature) after the photograph had been taken, developed, and printed—and then it can be used only for post-mortem examination of the picture. I hope we never see the day

when photo shops sell little schema grills to clamp onto our viewfinders; and the Golden Rule will never be found etched on our ground glass.

If you start cutting or cropping a good photograph, it means death to the geometrically correct interplay of proportions. Besides, it very rarely happens that a photograph which was feebly composed can be saved by reconstruction of its composition under the darkroom's enlarger; the integrity of vision is no longer there. There is a lot of talk about camera angles; but the only valid angles in existence are the angles of the geometry of composition and not the ones fabricated by the photographer who falls flat on his stomach or performs other antics to procure his effects.

Color

In talking about composition we have been so far thinking only in terms of that symbolic color called black. Black-and-white photography is a deformation, that is to say, an abstraction. In it, all the values are transposed; and this leaves the possibility of choice.

Color photography brings with it a number of problems that are hard to resolve today, and some of which are difficult even to foresee, owning to its complexity and its relative immaturity. At present [1952], color film emulsions are still very slow. Consequently, photographers using color have a tendency to confine themselves to static subjects; or else to use ferociously strong artificial lights. The slow speed of color film reduces the depth of focus in the field of vision in relatively close shots; and this cramping often makes for dull composition. On top of that, blurred backgrounds in color photographs are distinctly displeasing.

Color photographs in the form of transparencies seem quite pleasing sometimes. But then the engraver takes over; and a complete understanding with the engraver would appear to be as desirable in this business as it is in lithography. Finally, there are the inks and the paper, both of which are capable of acting capriciously. A color photograph reproduced in a magazine or semi-luxury edition sometimes gives the impression of an anatomical dissection which has been badly bungled.

It is true that color reproductions of pictures and documents have already achieved a certain fidelity to the original; but when the color proceeds to take on real life, it's another matter. We are only in the infancy of color photography. But all this is not to say that we should take no further interest in the question, or sit by waiting for the perfect color film—packaged with the talent necessary to use it—to drop into our laps. We must continue to try to feel our way.

Though it is difficult to foresee exactly how color photography is going to grow in photo-reporting, it seems certain that it requires a new attitude of mind, an approach different than that which is appropriate for black-and-white.

Personally, I am half afraid that this complex new element may tend to prejudice the achievement of the life and movement which is often caught by black-and-white.

To really be able to create in the field of color photography, we should transform and modulate colors, and thus achieve liberty of expression within the framework of the laws which were codified by the Impressionists and from which even a photograph cannot shy away. (The law, for instance, of simultaneous contrast: the law that every color tends to tinge the space next to it with its complementary color; that if two tones contain a color which is common to them both, that common color is attenuated by placing the two tones side by side; that two complementary colors placed side by side emphasize both, but mixed together they annihilate each other; and so on.)

The operation of bringing the color of nature in space to a printed surface poses a series of extremely complex problems. To the eye, certain colors advance, others recede. So we would have to be able to adjust the relations of the color one to the other, for colors, which in nature place themselves in the depth of space, claim a different placing on a plane surface—whether it is the flat surface of a painting or a photograph.

The difficulties involved in snapshooting are precisely that we cannot control the movement of the subject; and in color-photography reporting, the real difficulty is that we are unable to control the interrelation of colors within the subject. It wouldn't be hard to add to the list of difficulties involved, but it is quite certain that the development of photography is tied up with the development of its technique.

TECHNIQUE

Constant new discoveries in chemistry and optics are widening our field of action considerably. It is up to us to apply them to our technique, to improve ourselves, but there is a whole group of fetishes which have developed on the subject of technique.

Technique is important only insofar as you must master it in order to communicate what you see. Your own personal technique has to be created and adapted solely in order to make your vision effective on film. But only the results count, and the conclusive evidence is the finished photographic print; otherwise there would be no end to the number of tales photographers would tell about pictures which they ever-so-nearly got—but which are merely a memory in the eye of the nostalgia.

Our trade of photo-reporting has been in existence only about thirty years. It came to maturity due to the development of easily handled cameras, faster lenses, and fast fine-grain films produced for the movie industry. The camera is for us a tool, not a pretty mechanical toy. In the precise functioning of the mechanical object perhaps there is an unconscious compensation for the anxieties

and uncertainties of daily endeavor. In any case, people think far too much about techniques and not enough about seeing.

It is enough if the photographer feels at ease with his camera, and if it is appropriate to the job he wants to do. The actual handling of the camera, its stops, its exposure-speeds and all the rest of it are the things which should be as automatic as the changing of gears in an automobile. It is no part of my business to go into the details or refinements of any of these operations, even the most complicated ones, for they are all set forth with military precision in the manuals which the manufacturers provide along with the cameras and the nice orange calf-skin case. If the camera is a beautiful gadget, we should progress beyond that stage at least in conversation. The same applies to the hows and whys of making pretty prints in the darkroom.

During the process of enlarging, it is essential to re-create the values and mood of the time the picture was taken; or even to modify the print so as to bring it into line with the intentions of the photographer at the moment he shot it. It is necessary also to re-establish the balance which the eye is continually establishing between light and shadow. And it is for these reasons that the final act of creating in photography takes place in the darkroom.

I am constantly amused by the notion that some people have about photographic technique—a notion which reveals itself in an insatiable craving for sharpness of images. Is this the passion of an obsession? Or do these people hope, by this *trompe l'oeil* technique, to get to closer grips with reality? In either case, they are just as far away from the real problem as those of that other generation which used to endow all its photographic anecdotes with an intentional unsharpness such as was deemed to be "artistic."

THE CUSTOMERS

The camera enables us to keep a sort of visual chronicle. For me, it is my diary. We photo-reporters are people who supply information to a world in a hurry, a world weighted down with preoccupations, prone to cacophony, and full of beings with a hunger for information and needing the companionship of images. We photographers, in the course of taking pictures, inevitably make a judgment on what we see, and that implies a great responsibility. We are, however, dependent on printing, since it is to the illustrated magazines that we, as artisans, deliver raw material.

It was indeed an emotional experience for me when I sold my first photograph (to the French magazine *Vu*). That was the start of a long alliance with magazines. The magazines produce for us a public, and introduce us to that public; and they know how to get picture-stories across in the way the photographer intended. But sometimes, unhappily, they distort them. The magazine can publish exactly what the photographer wanted to show; but the photographer

runs the risk of letting himself be molded by the taste or requirements of the magazine.

In a picture-story, the captions should invest the pictures with verbal context, and should illuminate whatever relevant thing it may have been beyond the power of camera to reach. Unfortunately, in the sub-editor's room, mistakes sometimes slip in that are not just simple misspellings or malapropisms. For these mistakes the reader often holds the photographer responsible. Such things do happen.

The pictures pass through the hands of the editor and the layout man. The editor has to make his choice from the thirty or so pictures of which the average picture-story consists. (It is rather as though he had to cut a text article to pieces in order to end up with a series of quotations!) For a picture-story, as for a novel, there are certain set forms. The pictures of the editor's choice have to be laid out within the space of two, three, or four pages, according to the amount of interest he thinks they are likely to arouse, or according to the current state of paper shortage.

The great art of the layout man lies in his knowing how to pick from this pile of pictures the particular one which deserves a full-page or a double-page spread; in his knowing where to insert the small picture which must serve as an indispensable link in the story. (The photographer, when he is actually taking the picture for his story, should never give a thought to the ways in which it will be possible to lay out those pictures to the most advantage.) The layout man will often have to crop one picture so as to leave only the most important section of it—since, for him, it is the unity of the whole page or of the whole spread that counts above all else. A photographer can scarcely be too appreciative of the layout man who gives his work a beautiful presentation of a kind which keeps the full import of the story; a display in which the pictures have spatially correct margins and stand out as they should; and in which each page possesses its own architecture and rhythm.

There is a third anguish for a photographer—when he looks for his story in a magazine.

There are ways of communicating our photographs other than through the publication in magazines. Exhibitions, for instance; the book form, which is almost a form of permanent exhibition.

I have talked at some length, but of only one kind of photography. There are many kinds. Certainly the fading snapshot carried in the back of a wallet, the glossy advertising catalog, and the great range of things in between are photography. I don't attempt to define it for everyone. I only attempt to define it to myself:

To me, photography is the simultaneous recognition, in a fraction of a second, of the significance of an event as well as of a precise organization of forms which give that event its proper expression.

I believe that, through the act of living, the discovery of oneself is made concurrently with the discovery of the world around us, which can mold us, but which can also be affected by us. A balance must be established between these two worlds—the one inside us and the one outside us. As the result of a constant reciprocal process, both these worlds come to form a single one. And it is this world that we must communicate.

But this takes care only of the content of the picture. For me, content cannot be separated from form. By form, I mean a rigorous organization of the interplay of surfaces, lines, and values. It is in this organization alone that our conceptions and emotions become concrete and communicable. In photography, visual organization can stem only from a developed instinct.

THE CAMERA MIND AND EYE
Minor White

Like a Zen master, Minor White expounds on the metaphorical relationship between seeing and intentionality.

If we had no words perhaps we could understand one another better. The burden is ours, however. So in using the word "creative" to refer to a state of mind in photographers, I expect to be fully misunderstood.

It is no longer news that a cameraman is faced with a very different situation from that of a painter starting a new canvas. The latter has a bare surface to support an invented image, or a blank space in which to spin invented volumes or, as probably some artists feel, free space in which to live, dance, think—leaving marks where a thought passed or a tactile muscle felt a color. And as he is inventive, he is creative—or so it is popularly thought.

The photographer starts from an image already whole. Superficially it looks as whole as a finished painting, although it is rarely completed. The photographer completes the whole or total image by analyzing a variety of whole images. So the photographer invents nothing; everything is there and visible from the start. Here I should, I suppose, be worried to find that I have written that a photographer invents nothing, since in the recurrent discussions over the creative possibilities of the camera medium, the fact that the photographer invents little if anything is a point the cons labor and the pros fumble trying to circumvent. (Not that it is necessary, of course; the photographs of Stieglitz and Weston provide all the evidence needed.) However, still other evidence has accumulated—the work of the great documentary photographers, for instance—which shows very well that our continual linking of the word "inventive" with "creativeness" has kept us from remembering that creativeness is expressed in many ways. It is time that we in aesthetic fields remember that analysis in scientific fields is often as inspired or creative as a work of art. We should also remember that the camera is a definitive link between science and art, or, if not a link, that it partakes of both. It is time we recalled that "man seen" or "man found" is just as expressive of creativeness as "man made." It is time to remember (the period of discovery is long past) that the camera lures, then compels, a man to create through seeing. It demands that he learn to make the realm of his responses to the world the raw material of his creative activity. Creative understating is more camera-like than invention.

A young man looking at a photograph of mine—in the midst of experiencing and before he could weigh his words, said, "This is like a painting." Since this did not sound very much like what he had in mind he tried again. "It is obviously a photograph. But the placement—looks—as if a man—as if a man

had invented them—things are where a man would put—them—it looks man-made—not like nature—not found."

Yet it had been found, "seen," and merely recorded by the camera. (Because a man trains himself to see like a camera, it is only more appropriate that he uses a camera to record his seeing.) That the picture causes a reaction in a young painter that he can talk about only in terms of painting does not mean that an "aesthetic reaction" is taking place. Perhaps it began with little more than an impact of recognition of something *like* a painting. We must remember, however, that recognition is frequently the start of the "aesthetic" chain reaction.

If he was only surprised at the likeness, consider where he found the likeness: in the perceptive realm of man, not in the camera's imitation of some aspect of painting surfaces. His reaction is important because it shows that we are so conditioned to painting as the criterion of the visual aesthetic experience that the possibility of a photograph's being another path to aesthetic experience, like a piece of sculpture or a poem, has been overlooked or not realized—if not actually denied or pushed out of the realm of possibilities.

Yet to "see," to "find," is a human activity linked to human creativeness. The fact that this particular young man related a "found" picture to his experience of the "made" object is a simple demonstration of how human the "seeing" of photographers is. And, if one would stretch the demonstration slightly, of how inventive "seeing camerawise" is.

The state of mind of the photographer while creating is a blank. I might add that this condition exists only at special times, namely when looking for pictures. (Something keeps him from falling off curbs, down open manholes or into the bumpers of skidding trucks while he is in this condition but goes off duty at all other times.) For those who would equate "blank" with a kind of static emptiness, I must explain that this is a special kind of blank. It is a very active state of mind really, a very receptive state of mind, ready at an instant to grasp an image, yet with no image pre-formed in it at any time. We should note that the lack of a pre-formed pattern or preconceived idea of how anything ought to look is essential to this blank condition. Such a state of mind is not unlike a sheet of film itself—seemingly inert, yet so sensitive that a fraction of a second's exposure conceives a life in it. (Not just life, but *a* life.)

In a way the blank state of mind is a little like the blank canvas of the painter—that is, if we must have an analogy and insist that art must have a point of departure from nothing. (If a blank sheet of paper can be called nothing.) Poets buy a ream of paper and wonder what obscurity will darken the sheets or what revelation will illuminate the mind reading his black marks. But the paper's blankness has little to do with his creative action. Or to the sculptor feeling somehow the form lying in a block of stone, the stone is not a blank so much as a wrapping that only he can unwind.

The photographer is probably more akin to the sculptor in wood or stone than to painters, as far as his mental creative state goes. The whole visual world, the whole world of events are wraps and coverings he feels and believes to be underneath. Often he passes a corner, saying to himself, "There is a picture here"; and if he cannot find it, considers himself the insensitive one. He can look day after day—and one day the picture is visible! Nothing has changed except himself; although, to be fair, sometimes he had to wait till the light performed the magic.

A mind specially blank—how can we describe it to one who has not experienced it? "Sensitive" is one word. "Sensitized" is better, because there is not only a sensitive mind at work but there is effort on the part of the photographer to reach such a condition. "Sympathetic" is fair, if we mean by it an openness of mind which in turn leads to comprehending, understanding everything seen. The photographer projects himself into everything he sees, identifying himself with everything in order to know it and feel it better. To reach such a blank state of mind requires effort, perhaps discipline. Out of such a state of mind he loves much, hates much, and is aware of the areas of his indifference. He photographs what he loves because he loves it, what he hates out of protest; the indifferent he can pass over or photograph with whatever craftsmanship of technique and composition he commands.

If he were to walk a block in a state of sensitized sympathy to everything to be seen, he would be exhausted before the block was up and out of film long before that.

Perhaps the blank state of mind can be likened to a pot of water almost at the boiling point. A little more heat—an image seen—and the surface breaks into turbulence.

Possibly the creative work of the photographer consists in part of putting himself into this state of mind. Reaching it, at any rate, is not automatic. It can be aided by always using one's camera for serious work so that the association of the camera in one's hands always leads to taking pictures. But certainly once the mood is reached, that which happens can get out of control, as it seems it should. We have heard of inspired singing, of inspired poetry, of inspired painting—of production during moments of intensity or lucidity when one feels as if one is an instrument of transmission like a narrow channel between two oceans. (Do telephones feel this way?) The feeling is akin to the mystic and to ecstasy; why deny it? And in this condition the question of whether photography is or is not art is laughable. One feels, one sees on the ground glass into a world beyond surfaces. The square of glass becomes like the words of a prayer or a poem, like fingers or rockets into two infinites—one into the subconscious and the other into the visual-tactile universe.

Afterwards one can look at the photographs and try to find in them some-thing by which to explain what happened. In the illustration titled 51-248, I can

point out that the light seems to come from inside the photograph, which is certainly not at all like the condition which my reason tells me prevailed at the time, though exactly like what I saw in a moment of highly charged vision. I can also say this symbolizes the emotion felt when making it, and know only how little of the vision the picture must cause in others. Feeling and photographing what causes feeling is no assurance that others will feel. But after once discovering what one wants to arouse in other people, the knowledge that one may frequently fumble in trying is only a challenge.

The picture mentioned above climaxed an afternoon's work in which I started out by saying to myself, "What shall I be given today?" It progressed by stages of a growing awareness of absorption into place. Exposure after exposure were sketches leading—in no very conscious way—towards this final one. The same shapes, forms, designs recurred with a growing tension. When this was seen on the ground glass, anything separating man and place had been dissolved.

This is no isolated experience, occurring only with nature; I can parallel it with many experiences in photographing people. The duration of a session is one of growing *rapport*, of a deepening friendship. The camera is hardly more than a recording device for an experience between two people. They create in one another—only the photographer is conditioned to see like a camera, so the end result is a photograph.

This is not so much a scholarly discussion of the photographer's state of mind as it is a first-hand report. The scientist using the camera as an instrument will probably not have much idea of what I am talking about; however, photographers using the camera as a deeply expressive medium or those using it to document human situations will have experienced the sensation of the camera dissolving in an accord between subject and photographer. And what impresses me now is that I no longer care to prove that some photographers can do the same thing for people that paintings do. (They call it "art.") I merely want to cause in others some degree of experience: shall we call it spirituality? identification? by using photographs as the excitant. The photographs, may I add, *not* the object photographed. While the photographer cannot eliminate the object (nor does he want to destroy the experience of the visual world transforming into an unconscious world, the very source of his excitement), he still wants the photograph to be the main source of the spectator's feeling. While he cannot erase from the viewer's mind the implications of the subject, he prefers to depend for his effect on the visual relations that are present in the print itself.

"Blank" as the creative photographer's state of mind is, uncritical as it is while photographing, as sensitized, as prepared for anything to happen, afterwards with the prints safely in hand he needs to practice the most conscious criticism. Is what he saw present in the photograph? If not, does the photograph open his eyes to something he could not see himself? If so, will he take the responsibility for the accident and show it as his own, or will he consider it

as a sketch for his subconscious to digest? He needs to study further the reactions of the viewers: do they match his own? come close? or depart in amazing directions? In a sense, this is the activity that brings the creative state of mind near the boiling point: conscious criticism of new prints, digestion of what the prints do, as compared to what he wanted them to do. Without the siege of analytical work, the state of sympathetic sensitivity, the "blank" state of mind will not recur.

WORLDS IN A SMALL ROOM
Irving Penn

In this short introduction, the great master of the studio examines the relationship of the photographer with his subject. It is a classic example of one's understanding of one's own intentions.

I share with many people the feeling that there is a sweetness and constancy to light that falls into a studio from the north sky that sets it beyond any other illumination. It is a light of such penetrating clarity that even a simple object lying by chance in such a light takes on an inner glow, almost a voluptuousness. This cold north light has a quality which painters have always admired, and which the early studio photographers made the fullest use of. It is this light that makes some of these early studio portraits sing with an intensity not bettered by later photography with more sophisticated means at hand. Electric lights are a convenience, but they are used, I believe, at the expense of that simple three-dimensional clarity, that *absolute existence* that a subject has standing before a camera in a north-light studio.

In my early years as a photographer my studio was in a New York office building, in an enclosed windowless area where electric light simulated the light of sky. In this confinement I would often find myself daydreaming of being mysteriously deposited (with my ideal north-light studio) among the disappearing aborigines in remote parts of the earth. These remarkable strangers would come to me and place themselves in front of my camera, and in this clear north skylight I would make records of their physical presence. The pictures would survive us both, and at least to that extent something of their already dissolving cultures would be preserved forever.

I can say that even at that time I found pictures trying to show people in their natural circumstances generally disappointing. At least I knew that to accomplish such a result convincingly was beyond *my* strength and capabilities. I had come to enjoy and feel secure in the artificial circumstances of the studio, and had even developed a taste for pictures that were somewhat contrived. I had accepted for myself a stylization that I felt was more valid than a simulated naturalism. In this fantasy of mine that would take me and my studio to far places, I preferred the limited task of dealing only with the person himself, away from the accidentals of his daily life, simply in his own clothes and adornments, isolated in my studio. From himself alone I would distill the image I wanted, and the cold light of day would put it onto the film.

This book is a record of ten variations of that fantasy come true. Some were only tentative and partial accomplishments of the original thought; on those occasions I was lucky to be able to take advantage of daylight studios already in existence. Several other times it was possible to alter existing spaces into reasonably

usable north-light studios. But at least five times over a number of years I was able to come close to the full extent of the daydream. I was able to put up in remote parts of the world a portable studio always open to the light of the north, among people who were not at all prepared for this happening. I set up camp in the foothills of the Himalayas, in the villages and savannas of West Africa, in the Atlas Mountains on the edge of the Sahara, and a number of times among the tribesmen of New Guinea. And what each experience had in common with the others, although in varying degrees, was what became for me the most surprising and fascinating fact. Taking people away from their natural circumstances and putting them into the studio in front of a camera did not simply isolate them, *it transformed them.* Sometimes the change was subtle; sometimes it was great enough to be almost shocking. But always there *was* transformation. As they crossed the threshold of the studio, they left behind some of the manners of their community, taking on a seriousness of self-presentation that would not have been expected of simple people. As I look back through these essays I am struck by the fact that the one characteristic all these various people seem to have in common is that they rose to the experience of being looked at by a stranger, in most cases from another culture, with dignity and a seriousness of concentration that they would never have had ten or fifteen feet away, outside the studio, in their own surroundings.

The studio became, for each of us, a sort of neutral area. It was not *their* home, as I had brought this alien enclosure into their lives; it was not *my* home, as I had obviously come from elsewhere, from far away. But in this limbo there was for us both the possibility of contact that was a revelation to me and often, I could tell, a moving experience for the subjects themselves, who without words—by only their stance and their concentration—were able to say much that spanned the gulf between our different worlds.

INTERVIEW WITH LEE FRIEDLANDER (EXCERPT)
David Harris

In the mid-nineties, Lee Friedlander, along with fellow photographers Robert Burley and Geoffrey James, was commissioned to photograph the parks and landscaping designed by Frederick Law Olmsted. This excerpted piece is Friedlander's own words about how he works—rarely does he speak about this topic.

If you take somebody like Michael Jordan, and if you said to him, "Michael, at a certain point when you are running down the field and the ball comes to you, what are you going to do?" he would look at you as if you were crazy. Because there are a thousand things he could do: he could move almost anywhere or he could pass off or he could shoot or he could dribble. He wouldn't even have a clue because he would have to see what was happening. And I think that's very similar to photography, which I don't think is similar to painting or writing in most cases. That little tiny moment is a beginning and an end and it has something to do with the same kind of mentality that an athlete has to use. I was watching tennis, for example. The tricks that good tennis players use, especially what happens when the ball bounces and does odd things. You couldn't predict what you're going to do. He's going to serve to you; what are you going to do? Try to hit it back. Not only try to hit it back, try to hit it back in a weird way. Or in some articulate way. And I think photography is stuck with those same kinds of moments, especially if you're not a studio photographer. You don't have much control.

If the sun goes behind a cloud, the whole place looks different. You have to regroup in a sense. If the sun changes you have to regroup in all kinds of ways, exposure-wise, how you might develop it, you have to juggle things around technically. A great day is really one of those days where there are a few clouds because here you are looking at something and you could make two different pictures from the same standpoint within a minute because of the wonderful changes that happen. So it's not so unusual that you would go back to the same tree because it interests you. And because you're going to hit it at a different time, you might not even recognize it. When I work in the desert, which is even more remote, I'll have five pictures from five different years of the same cactus. And I don't even know it until I start to print. I just go there and every time it looms up as the interesting thing.

Sometimes working with a camera, somebody does something that's just beyond belief. Garry Winogrand takes pictures of things that in your wildest dreams you wouldn't think could exist in the world. There's a picture of a cow's tongue in a cowboy's hat that becomes a beautiful thing; it looks like a piece of architecture. In your wildest dreams you wouldn't come up with that and that's just because he was aware that it might be possible. He was there when it

happened and his head worked that way. Or that couple on Fifth Avenue with the monkey that looks like a family. Nutty pictures, but the most imaginative person in the world would not come up with that set of things.

The question of where to stand is interesting. What we're really talking about is a vantage point. If you look at amateurs or people taking pictures, they do funny things. Most people obviously don't know where to stand. They're standing too close, they're contorted. They're humorous to watch, people who photograph, especially people who aren't in tune with their equipment, because they don't know when they pick it up what it will do. If you work with the same equipment for a long time, you get more in tune to what is possible. But within that there are still surprises. But using a camera day after day after day, within a framework, I'll do the same thing. I'll back up and I'll go forward with my body.

You don't have to be a fancy photographer to learn where to stand. Basically you're stuck with the frame and just like the person taking a picture of his family, who needs to go half a foot back—well, he doesn't step half a foot back—but on the other hand, he knows where to be if he hits it right. Now when you watch tennis you not only have the commentators, you also have the best of the old pros. You know how they repeatedly say, "Look at the way his back was formed when he took that shot." It really is important to them. They see that as a possibility of where the thing went. Probably the same thing is true of all of us.

You can pick at it, especially this project. I don't think anyone is capable of doing the definitive Central Park. In some ways we all—Bob and Geoffrey and myself—probably felt a relief, thinking, if I didn't get it somebody else did. Going out with those guys was fun because the ironies were just so hilarious. I could go out with them and you could almost have tied us so we were back to back, and one of us could be totally interested in one area and the other one the complete opposite. It was really funny that could happen. I don't think any of us who went out there together were ever interested in the same thing. Very rare. Maybe a monument or some major object: I know there was a monument [the Maryland Monument] in Prospect I think we all photographed. That explains why I didn't need to read about Olmsted too.

COLLEAGUES
Robert Adams

Your own photography is never enough. Every photographer who has lasted has depended on other people's pictures too—photographs that may be public or private, serious or funny, but that carry with them a reminder of community.

Nicholas Nixon made one that I especially treasure of our Airedale. It is a perfect record of her intense gaze, and was included in a show at the Museum of Modern Art in New York, although I prize it as much for the recollection it affords of first meeting the photographer. The dog had barged ahead at our front door, and when Nick saw her through the screen his delight was so undisguised that Kerstin and I and then he started laughing; in the confusion he gave up on words, but managed to find in his billfold a snapshot of himself as a child with an Airedale. All of which—the dog, Nick's enjoyment of the moment, his sense of humor, his gift as a photographer—returns to me now as I look at the picture that he eventually made that day.

I rely on the photograph just as I do on those of others' enthusiasms—baseball, cottonwoods, children, grain elevators, basalt, petroglyphs, the wonders of Peru, Japan, Greece, India... And though the photographers' fondness for these subjects is evident in their pictures, I am especially strengthened by those where I can also recall it in their letters and conversation.

If I like many photographers, and I do, I account for this by noting a quality they share—animation. They may or may not make a living by photography, but they are alive by it.

I think for example of a friend who, when he was a young man, sometimes took pictures along country roads while sitting half up out of the sun roof of his moving car, steering with his feet. You couldn't argue him out of this practice because the rationale was to him so clear—the view. And apparently he was meant to do it, because over the years he went on to assemble a vast photographic celebration of Colorado life. When I hear his voice on the phone now, full of avidity even in old age, I promise myself that I will take grand, unsafe pictures.

I remember too an acquaintance who, when he was asked by a dealer to autograph a book, wrote his name and then, burning his bridges, "NOT FOR RESALE." It was a reckless thing to do, but also a kind of life insurance. Many photographers in fact remind me in temperament of Thomas Hart Benton; in addition to painting, he said, what he liked was to "drink whiskey and talk big."

Why is photography, like the other arts, that kind of intoxication? And a quieter pleasure too, so that occasionally photographers discover tears in their eyes for the joy of seeing. I think it is because they've known a miracle. They've been given what they did not earn, and as is the way with unexpected gifts, the surprise carries an emotional blessing. When photographers get beyond copying the achievements of others, or just repeating their own accidental first successes,

they learn that they do not know where in the world they will find pictures. Nobody does. Each photograph that works is a revelation to its supposed creator. Yes, photographers do position themselves to take advantage of good fortune, sensing for instance when to stop the car and walk, but this is only the beginning. As William Stafford wrote, calculation gets you just so far—"Smart is okay, but lucky is better." Days of searching can go by without any need to reload film holders, and then abruptly, sometimes back in their own yards, photographers use up every sheet.

I have to admit that there is another reason I like photographers—they don't tempt me to envy. The profession is short on dignity: Nearly everyone has fallen down, been the target of condescension (the stereotypical image of a photographer being that of a mildly contemptible, self-indulgent dilettante), been harassed by security guards, and dropped expensive equipment. Almost all photographers have incurred large expenses in the pursuit of tiny audiences, finding that the wonder they'd hoped to share is something few want to receive. Nothing is so clarifying, for instance, as to stand through the opening of an exhibition to which only officials have come.

Experiences like that do encourage defiance, however. Why quit while you're losing? And so there's room for idealism. There was no fortune or reputation to be made, for example, when Alex Harris arranged to publish a book of views by an elderly, obscure photographer in Chiapas, Mexico (*Gertrude Blom: Bearing Witness*, University of North Carolina Press, 1984). The only conceivable rationale was to share an understanding of a subject—contemporary Mayans—that both he and she believed was important. Similar motives have brought photographers Richard Benson and David Wing to help along others' efforts (see, for instance, Benson's *The Face of Lincoln*, published by Viking Press in 1979, a book that reproduces all the known portraits of Lincoln, and look up *Eugene Buechel, S.J.: Rosebud and Pine Ridge Photographs*, 1922–1942, published by Grossmont College in 1974, a volume that was assembled by Wing and a group of his students to make available remarkable views of Lakota reservation life). In the company of photographers like Harris, Benson, and Wing we discover a galvanizing sense of purpose.

I respect many photographers for their courage. Sometimes this quality is undramatic and private—the grit to fight bad odds with discipline. "I feel like I have been living in a small hole somewhere," one writes in good-humored self-mockery, "ever busy with problems of nest management." An aspect of that is likely to be, of course, the threat of insolvency, something with which the unlucky have to learn to live as they would with a chronic disease. One photographer I admire, for instance, had to go back to cleaning houses when her Guggenheim fellowship ran out.

There can be physical danger as well. Two acquaintances have while working been injured by livestock, and one when he fell from a railroad car. Several are making pictures at hazardous waste sites, and another has been recording the no-man's-land beneath Los Angeles freeways.

Photographers must also withstand, with the help of their families and friends, the psychic battering that comes from what they see. In order to make pictures that no one has made before, they have to be attentive and imaginative, qualities partly assigned and partly chosen, but in any case ones that leave them vulnerable. When Robert Frank put down his camera after photographing *The Americans* he could not so readily escape the sadness of the world he recorded as could we when we closed the book.

Paradoxically, photographers must also face the threat that their vision may one day be denied them. Their capacity to find their way to art, which is their consolation—to see things whole—may fail for an hour or a month or forever because of fatigue or misjudgment or some shift in spirit that cannot be predicted or understood or even recognized until it has happened past correction. For every Atget, Stieglitz, Weston, or Brandt who remains visionary to the end, there is an Ansel Adams who, after a period of extraordinary creativity, lapses into formula.

A bravery I respect in many photographers, especially now, is their courage for orderly retreat, that hardest of tactical maneuvers—the intelligence to see prob- abilities, the nerve to wait until the last possible minute to give ground, and then the will to turn and hold again until the next uneven confrontation. Consider, for example, those photographers who once worked in Glen Canyon to try to mobilize public opinion against building a dam there, and who, after it was built, continued to photograph the Southwest. I saw Glen Canyon only briefly in its final days, before I became a photographer, but the glimpse I had of it suggested a place that was in some respects as remarkable as the Grand Canyon—more intense, even, for its intimacy. How commendable to have known this geography well enough to have made hundreds of pictures there—to have loved it that much—and then to go on working without it. And without illusions about human beings.

One additional quality that I admire in my colleagues is a basis for the others: their awareness of finalities and of our place in nature. Years ago I enjoyed a winter day with a friend who was taking pictures along the Washington coast; he wrote later of a cove that we had explored: "I think now of the blackened driftwood—of the air and light, of the sea, rocks, surf, and trees—it was a world largely com- plete—for a moment, in that good air, it was perfect."

Garry Winogrand's subject was, I now believe, also perfection, though many of his street scenes appear to tip under the weight of roiling confusion—so much so that for a long time I did not appreciate his accomplishment. I even wondered if I would like him in person, though when I met him one afternoon at a confer- ence in Carmel I certainly did, as anyone would have. He was cheerful, ardent, and without pretense.

After Winogrand died, a mutual acquaintance told me that he had said he wanted to make pictures related to mine. I could hardly believe it because our work seemed so far apart, but later when I saw views that he had recorded in Los Angeles I realized that we had in fact hoped to make some of the same discoveries.

Since then I have begun to suspect that aspects of my work might be changing, becoming a little more like his (the shift is puzzling to me, which I hope may excuse the presumption in speaking of it). If so, I welcome it, because he was accepting of complexity in ways that I admire.

The second time I talked with Garry Winogrand, and the last, was during an informal lunch at the Fraenkel Gallery in San Francisco. Photographers, curators, and teachers had seated themselves on the carpeted floor of the gallery's office, a room suffused with indirect natural light; conversation was animated as people shared their enthusiasm for pictures and enjoyed French bread and wine. Winogrand had to leave early to catch a plane, but before the party closed in over the space he'd occupied there was visible a humorously untidy ring of bread crumbs where he'd been. He had, as he did when he photographed, turned to everyone, taking pleasure in their company and in the good food. It makes me smile to think of him there in that halo made from the staff of life.

TEACHING PHOTOGRAPHY: NOTES ASSEMBLED (EXCERPT)
Philip Perkis

Perkis's *Teaching Photography: Notes Assembled* is now a classic, which needs to be read in whole. It is a simple meditation on how to think photographically.

EXERCISE #2 PUSHPIN
Put two pushpins in the wall about six inches apart. Sit 15 feet away and relax for a minute or so. Look at the pushpin on the right. Look hard. Now shift your attention to the pushpin on the left. You will notice that the pushpin that you are not paying attention to appears less distinct. A bit out of focus.

EXERCISE #3 HOW TO LOOK
Sit back and relax the muscles of your eyes so that you see the "field" more completely and your eyes jump from object to object a little less. This requires a purposeful effort, but it helps photographic practice a great deal.

When I was a child, maybe nine or ten, one of the cubbyholes that they pushed learning into was called "science." I think they pushed things into these cubbyholes so that young people would never get a sense of the connectedness of things. If they did, they might not sit still long enough to be fed through the system we call "culture" and become "productive citizens."

Anyway, back to this "science." The teacher is seldom the person who loves science and runs home after school to the basement to do experiments and research.

The teacher explains that the human eye is just like a camera; light goes through the lens, stimulates the rods and cones and sends signals up the optic nerve to the brain, which then interprets what is seen. It's a one-way street.

There are even charts and diagrams to make it more understandable. It's really neat, except it's not true.

If I sit quietly for a moment on a park bench or on a rock in the forest and start to pay attention to how I see, I begin to realize that what is happening is that my vision shifts from point to point at an incredible speed. I focus my attention from object to object. In other words, I am "looking around." My mind is assembling a picture that I experience as a whole. So something quite different from that silly chart is going on. Somehow my brain and eyes are in cahoots. It's a two-way street.

§§§§§§§§

I am walking down the street and see someone interesting on the other side. I quickly raise my camera and click. The picture reveals four cars, three buildings,

two dogs and 18 people other than the one who caught my fancy. The camera did what the "science" teacher said the eye does.

Is there a way out of this? Maybe. Yes. A few possibilities:

Run across the street and get close to the subject. The problem here is that when I get there it's too late or the other person has seen me and the picture is then a portrait—or they get angry and turn away. This method, as well as the telescopic lens solution, also eliminates the context in which the subject exists, which is what probably attracted me in the first place.

It is not possible for anyone to create a coherent, intelligent and possibly emotive photograph from most of what is seen—meaningful or not.

Yogi Berra was in a slump. The coach told him to think about what he was doing when he was batting. He got up to the plate and struck out. Returning to the dugout, he said, "You can't bat and think at the same time."

When I photograph, I am trying to grasp the "whole." This requires me to trust my instinct and impulse of the moment. I cannot do it with thinking alone.

It helps to use the same lens all the time because one gets used to the field of vision of that lens and can grasp the whole more quickly.

Zoom lenses are the work of the devil. They are seldom sharp on the edges, and more importantly they don't encourage a person to establish a real "point of view."

The genius of Eugène Atget is that he always knew exactly where to place the camera. This is a perfect blending of the physical, aesthetic and philosophical aspects of art-making.

Position is where everything happens from.

—Frederick Sommer

It helps to realize that the frame is not a natural thing at all, it is an imposition on vision. The paradox, of course, is that the frame is a very important contributor to the content in a photograph. What is included, what is left out, and what is cut can be, and frequently is, the central meaning in a photograph.

A FLUTTERING KNUCKLEBALL:
LUNCH WITH STEPHEN SHORE AND TIM DAVIS
Stephen Shore and Tim Davis

In this interview, Tim Davis, an important contemporary, discusses photography and photographic practice with the influential Stephen Shore.

In the waning days of 2003, Stephen Shore and I met for lunch at Tabla, a Goan bazaar in one of New York's art deco masterpieces. Art is all about errands and it was a pleasure, on this mild, flat, gray day, to take time from the regime and sit and talk about Stephen's work. I had a pile of prints due to the mounter and Stephen had a magazine interview lined up immediately after. In the meanwhile we had two hours of oasis to talk about the latest developments.

Tim Davis: Your best-known pictures, the view camera landscapes from Uncommon Places *through the Hudson Valley, Texas, Montana and Scotland projects, possess, above their other qualities, a deep and fathomable resolve. The pictures feel whole, all their nuances present and accounted for, as if the photograph was a great galley ship with all hands straining toward a unified goal: the depiction of photographic space. Most photographs are technically "whole"—made in a single lens-centered instant, they deal overwhelmingly with fragmentation—but your view camera images bestow a thoroughgoing and sensual wholeness on an American landscape devoted to flux and fragment. They stare through the social landscape to a vein of visual pleasure and truth. These new books you're producing, made with a small digital camera and edited on your computer, seem less interested in resolution. What has taken place?*

Stephen Shore: All of this new work you refer to is intended to be seen as small books. These are limited edition books, produced with print-on-demand technology and made with Apple's iPhoto application. Each book has between nine and fifteen pages of pictures. I'm approaching each book as a unified group of images and playing with different ways the images can relate to each other. One aspect of these books that interests me is the weight each image is accorded. They don't demand the completeness you've described. They have a light touch, not unlike that seen in SX-70 pictures. Also, they are fun to make.

TD: You refer to this "light touch" as the license an artist gains at some point in his career to make something frivolous; almost as if the weight to make a pointed argument with each picture lessens as you go. You mentioned Evans' Polaroids and I was thinking of Philip Guston's decision in the late sixties to turn from his passionate abstractions to what is called "crapola"—or even a baseball pitcher learning to throw the fluttering knuckleball. What interests me is that your career

*as an artist began with similar serial images. Do you feel the new books relate to
the older, more conceptual project?*

SS: Yes. I think the new books relate to the conceptual work you refer to. In fact,
I've made several books of some of the conceptual projects from the late six-
ties. They are small sequences that fit perfectly in this new form. There are also
images in the new work that have the same notational quality as the pictures
in *American Surfaces*, a group of my 35mm work from 1972. At that time I was
thinking about how to make photographs that look "natural," i.e., unforced,
like seeing. I've seen my work go through several formal cycles: after *American
Surfaces*, I moved to a view camera and my images became progressively more
formally complex until, at one point, I again began a process of making them
transparent (but now reflecting the new formal understanding) and there have
been more cycles since. One other thing occurs to me. When I teach, I have to
put myself in each student's shoes and get of sense of where their work should
head. I do this each semester for twenty or more students, each with different
interests and inclinations. It's possible that my doing this for years has led me
to have a range of photographic ideas that are not bound together externally by
a single style. For the past ten years or so I've been putting these different ideas
into play. I've been doing color work with a 6 × 7cm camera that aims at some
of the completeness you referred to in your first question. I've been making
black & white New York street photographs with an 8 × 10 camera (masked to
4 × 10) and now I've been making these books. A few months ago, an art critic
asked me about my "signature style." Well, this question startled me. I've never
thought in those terms. My work from the seventies, which to this critic exem-
plified my "signature style," was made by me in response to certain questions
and problems I needed to pursue. I never thought in terms of style. The style was
a result of my exploration.

*TD: I've been reading about the creation of the hydrogen bomb and how the
development of the first electronic digital computer enabled physicists to solve the
hundreds of thousands of calculations needed to turn atomic theory into devastat-
ing power. Photography is also a kind of calculator, a way of solving problems of
awareness with thoroughness and aplomb. A photograph is a problem-solving
machine. Of course each photographic image, no matter how proscribed, contains a
huge amount of unintended information in the "dark matter" of photography. I'm
wondering if some of your new books, such as the one reproduced here, are ways to
back away from "signature style" by pointing out elements in your own pictures
that might have been beyond your awareness at the time they were made?*

SS: I agree with what you said about a photograph being a problem-solving
machine. A photographer may have questions and problems that he or she
brings to the picture-making situation. At the same time, the specific situation
can generate new ideas, possibilities, and problems. I'm not sure that "Jigsaw

Puzzle" has to do with "dark matter." It's more simply a response to the puzzle photograph in terms of the possibilities and constraints of the book form.

TD: I still maintain that photographers generate this astounding paper trail of thorough works, making it very rational to go back to images and reassess their place in the world. Is part of that reassessment for you the thrill of generating a photo book out of thin air? Before the gallery binge on photography in the nineties, it was the apotheosis of a photographer's career to publish a book. Now photography books are a healthy handful of dimes a dozen. Is it thrilling somehow to sneak these books into the marketplace?

SS: I think that's part of it. But, with an edition of 20, which is what they're printed in, it's hardly putting them in print. However I think there's something aesthetically very satisfying about these books and some of that may derive from my past experience with other books. There's simply the experience of seeing the images in a book as opposed to, say, a portfolio: it recalls past book experiences; it is a cultural object. And, in these small (short) volumes, there's the mind's ability to hold the whole book at once. The book becomes a single, unified work. The ease of making these books allows for experimentation: trying out different approaches, different strategies. One thing I found interesting is that when these books were exhibited at 303 Gallery this past fall, five were sold and they were all different ones. *Blind Spot* is reproducing a sixth one, again no duplication. The Sprengel Museum in Hanover, Germany, will be showing this winter all 17 books that were in the 303 show and a catalog will be reproducing five of them. One of these five was one of the books purchased from 303, otherwise again no duplication.

TD: Photographers are like fundamentalists. With so much uncertainty at the heart of their practice, they tend to overplay the certainty of their decisions. I'm thinking particularly of print size. Most photographers I know are adamant about the size they choose. I suppose they are saying "size does matter," and the market agrees, saying you can charge more for a larger print. All are of course flattered to have their work reproduced in books (and magazines I might add) at whatever size. I think the variability of the photographic image is an essential part of its power: it is surfaceless, filmy and barely materializes as an object. It can change sizes. It is fleeting and alterable, like a memory. The book is the perfect form for the photograph for all the reasons you cited and also because it destabilizes the ability to grasp at any one image. It invites us to see the image as the artist did, as something plucked from a continuum.

SS: Painters are used to seeing their works reduced in scale in reproduction as well as seeing the surface neutralized. Photography in reproduction is, as you suggest, different. Even in ordinary reproduction it verges on facsimile. The surface is similar and the close scrutiny a book allows blurs the scale issue (with some exceptions in

extreme cases). I like your phrase "plucked from a continuum." It is, of course, what a photographer does. Photography—straight photography—is an analytic activity.

TD: Making a book is analytic but it is also additive. Your new books remind me of something the filmmaker Robert Bresson said of film-making: "Don't strain after poetry; it penetrates unaided through the joins." In other words, expression is achieved (in film, anyway) through the sheer conjunction of images and doesn't need to be overstated in the images themselves.

CENTRAL AMERICA AND HUMAN RIGHTS:
AN INTERVIEW WITH SUSAN MEISELAS
Ken Light

Being a documentary photographer myself, I have come to believe that documentary photography offers a voice to the dispossessed and a view of the past to future generations. It bears witness in an age when individual expression is often drowned out by huge media companies, when publications turn toward entertainment and celebrity photography, when what we see on television and in the movies holds more power than what we see with our own eyes. But I believe that the humanist vision in photography has had a way of triumphing by offering meaning and a way for people to connect with their own experiences. As Susan's work and voice show us, the need to inquire, to express, and to witness one's world will always endure, even under the most dangerous and economically difficult times. It continues to amaze me that one individual with a camera and a few rolls of film still has a powerful and enduring voice. —Ken Light

For my first project, *Carnival Strippers*, I spent three summers traveling with women who were doing striptease in state and local country fairs. I developed relationships with women who were often transient. Sometimes they would start working on one weekend and end the next because their boyfriends would pull them off the show. My relationships with the managers as well as a few of the girls extended over more than one summer. I wanted to assimilate into their working environment and portray what was happening. It was as important to me to capture their ideas about what they were doing as it was to photograph them in the process of their working lives.

I showed my work in small galleries right from the beginning, putting photographs and text on the walls. The most successful installation included sound. Everyone was represented—the various managers, the clients, the women, their boyfriends—by mixtures of voices that you could hear floating in the background as you were looking at the photographs. The sound wasn't precisely liked, neither were the texts placed alongside the photographs of specific people. I wanted to recreate the feeling of the environment. In the case of the book, which I produced later, I built a parallel narrative so that those voices, when read, would bring you into the process of experiencing that world in a different way than the photographs alone could.

During the five years I was working with carnival strippers, I taught in the public schools as an artist-in-residence. I trained teachers to work with kids using photography, and I worked in the classroom myself to develop a curriculum using photography to teach reading and writing. In 1975–1976, while I was

beginning to edit *Carnival Strippers*, I chose not to continue as a public school teacher and tried to figure out how I was going to make a living as a photographer.

It was with two pieces of work, both with a documentary approach, that I went to Magnum. I showed them the *Carnival Strippers* portfolio and another essay on the basic training of women in the army, from one of the few jobs that I had managed to get—the *Daily News*, of all places. I became a Magnum "nominee" and started to work in the world of photojournalism, but I've always kept my documentary approach.

Magnum is about family in a strange way. There's something about being inside a collective of artists who continue to create and invent ways of surviving—sometimes sharing out of self-interest and sometimes not. Echoing exactly the human experience. This could happen within or outside of Magnum. For me, it just happens to be a little harbor. It's kind of a place where I go out from, out into the seas with all the torrential rains and currents and unpredictability that are out there at sea. This is a place that I come back to, one that's always there for me. There may not be a friendship with each member, but many have shaped my thinking.

My life changed radically when, two years later, I headed off to Nicaragua. By chance, my arrival coincided with a crisis inside the country; I decided to stay, not to hit and run. I wanted to go beyond the news event and document what I saw as history. I was fascinated and felt that I had to explore everywhere. It was knowing back roads. It was knowing neighborhoods. It was knowing people in places, so I could get a sense from them as to what was going on. Those relationships are not sources exactly, as writers always have to have, but they help shape your perception of what's important.

You don't always know where you're going or what something is going to lead to. It's discovered, not planned for. I never went to Central America looking for a guerilla or an army officer or this and that to juxtapose. Very often newspaper photographers are forced to work in much tighter time frames and have to illustrate certain kinds of stories. I was capturing the world I was seeing, completely following my own sense of what was important.

Assignments were very erratic. I was living cheaply, for five dollars a night throughout most of the period, until the war got intense, and it was really unsafe to live alone in a small place. It was rare that people would hire me to do a specific thing during the time I covered the war in Nicaragua in 1978 and 1979. Later, in the early eighties, I would be assigned to work with a particular writer to do a certain story elsewhere in Latin America.

The difference between my work in Central America and the earlier documentary work was that I could be on the road with the carnival strippers, come home, process the film, bring it back, show them the contact sheets, and then bring them prints of the images they wanted to give their fathers or their husbands or lovers. There was a much closer, more intimate relationship with the carnival strippers.

43

I came up against different sets of problems in Nicaragua, partly because it was a war. I couldn't always get back to the subject. I couldn't find them again. Very often I didn't see the photographs, because I had to send the film out of the country to have it processed. Magnum was distributing to several international publications, and they were editing work that I hadn't always seen before shipping the film. I shot black and white as a sketchbook, to keep a record when the boxes of color slides were dispersed.

It was powerful to suddenly discover an image that I had made on the cover of the *New York Times Magazine*, reporting the insurrection in Nicaragua, before the war actually began. I was excited about that, but I started to feel some caution about what was implied by that power—the responsibility that comes with that power—to get it right. There is an illusion of control that we all have. For me, getting the names, the places, and the details of what is in fact going on is so important. But beyond my own books, the images are out of my control.

Magnum participates as an intermediary in shaping what magazines are given to work with and in helping make sure they get the details right. But once the material goes to the magazines, difficulties can develop. There were definitely examples of images used to accompany text that misrepresented the feeling I had at the time I photographed. Some were just mistakes and some were intentional. Part of the struggle of being a photojournalist is dealing with a medium that moves very fast: then, we shipped film out by plane, while now everyone is digital.

When I finally put together the book, *Nicaragua*, it was very hard for me to see what pictures I had in relation to what I had missed. The enormity of the experience was so much greater than whatever I could render in seventy-two images. That is always the biggest challenge in making a book. That process is completely different than shooting stories or watching how what you shoot gets edited into illustrated magazine stories.

Though we might have more control through bookmaking, the distribution of photography books is still pathetic. There are many reasons for small audiences. In some cases it's the tendency to believe that the photograph carries all the meaning and therefore there's no other kind of text that might be helpful to a reader. Sometimes it's because the publishers themselves are isolated and not connected to enough sectors that might value the work. It's still a very primitive business. Sometimes I've felt like, "Why don't I just put the books in the trunk of my car and go door to door selling them?" I remember when we did take a lot of the El Salvador books to a major demonstration in Washington, D.C. We were selling the books to people who already knew about the issues—an obvious audience. But making books should be about creating a new audience.

I don't know if Amazon.com or web sites will help generate another kind of global community that we could never reach before. Is independent-authored production going to be supported or smothered out? Can small archives with limited resources compete against the capital that creates bigger conglomerates

and then pressures to further control serial rights? These are critical questions for our survival in the future.

We need to continue to push traditional boundaries. As a documentarian, I have also been concerned about the aesthetics of an image. But if a photograph is in a gallery and it's sold to hang on a wall, does that make it fine art? Or, is it fine art because we're no longer interested in its caption and/or the context from which it came? I believe that the important question is how to seize opportunities to expose our work to a broader audience. If there's a gallery that's interested in the work, can you render the complexity of what you know through the installation? There are moments where the formal is of less concern to me than the narrative function of a photograph, but I'm always looking for that thin line that I'm walking between form and content.

I shot *Carnival Strippers* in color and in black and white until I decided which I preferred. At that time, I was shooting recording film and experiencing many problems with exposure. There was no color negative with high speed at that time, so I worked in black and white. I liked the grainy feel of the pushed film.

In Nicaragua I again shot color and black and white, using two cameras, but I progressively felt that the work should be in color. It was expressive of the way people dressed and painted their houses. It caught the spirit of optimism about what was happening. This was quite different from El Salvador. In El Salvador I shot with two cameras, because at that time magazines expected color, but I really saw the brutality there in black and white.

There were criticisms when the Nicaraguan photographs first appeared. There were people who felt that I was aesthetisizing violence in Central America. There were people who just thought color was inappropriate. But it was not the first time people had used color. In Vietnam, there was fabulous color by Larry Burrows. I saw that, but I don't think I was thinking about it in the abstract. I was looking at the world I was in and trying to figure out the appropriate translation to capture what I felt about that place at that moment.

There is an ongoing challenge for us, as documentarians, to continue to be committed and engaged, while at the same time innovative. I fear we have deadened out. You see this in exhibitions, which are often handled in precisely the same manner, or with similar variations. The same is true in magazines. There is a huge amount that still can be done in print, despite the efforts made by Alex Harris and Bob Coles with *DoubleTake*, or Colin Jacobson's *Reportage*, or, going back a few years, Peter Howe's *Outtakes* [a project of trying to print work that was shot, but never published]. Only one of them has survived. Why?

A lot of people buy cameras and film, and a lot of people buy photo books of a certain kind. The obvious example is the "Day in the Life of" series. Now, what's the problem? Why aren't people interested in what we documentarians are passionate about? Why are we in such a small ghetto?

Doing documentary work is not just building the relationships and shooting. It's also finding the spaces, be they magazine pages, books, or exhibition spaces, to transform and present the world we see differently. To get work into a public space is not easy. But we have to figure out how to do that effectively, not to mention the biggest problem, which is finding the sponsorship and the support.

We cannot always assume people are going to be interested in what we are involved in. We have to find ways of taking people someplace they don't expect to go. There was a time when we could surprise people. They would go to an exhibition in a museum and discover that it was so-called "photojournalism." That period was quite exciting. We were creating another environment, transforming the walls into a different experience for people who were going to museums in the traditional way.

When working with the material from El Salvador, I wanted to get the photographs into any kind of environment I could, from public libraries to storefronts, to the Museum of Photographic Arts in San Diego or the International Center for Photography in New York. The greatest success was in a public library in Rochester, New York. In order to go anywhere in the library you had to pass by a photographic display about El Salvador, at a time when U.S. military aid was intensely supporting that war.

I was trying to figure out what happens when this work is on different kinds of walls. What dialogue can it open up? Those are the kinds of explorations that we need to continue to do, and this involves partnerships. It's not just the photographer's problem. We've got to find partners willing to experiment with ways of getting people involved with "other" people and distant places.

The book that I've just done on Kurdistan is about encounter—the encounter of a variety of Westerners, be they missionaries or anthropologists or photojournalists—looking at how they saw the Kurds and how they shaped the way the Kurds were seen. I see myself in that tradition of encounter and witness—a "witness" who sees the photograph as evidence. A lot of my work has been based on a concern about human rights violations. That's where that word is the most appropriate. But the other side of "witness" is that we do intervene, and we intervene by the fact of our presence in a particular place. We change how people see themselves sometimes and how others may come to see them. I'm also concerned about how we see ourselves in the process of our role as witnesses.

When some of us began working in the early seventies, already the magazines of the sixties weren't hiring people to do what we dreamed we were going to do. We read the stories about Margaret Bourke-White or Robert Capa going off on long assignments and being guaranteed fifteen-page spreads, no matter what the subject. For my generation, those expectations weren't met. It is still tough for many of us with a lot of experience to get work today. Our production can no longer be sustained by editorial work alone. Does that mean that we give

workshops and inspire people to do what we do, creating a geometric relation-ship of greater difficulty for all?

I don't see a major revival of documentary, although the current generation of students is again interested, after going through a decade where there was a tremendous assault against or controversy about documentary and the validity of documentary. I think there were issues that came out of that period that put some things in question, which was very, very positive, although it paralyzed production for many people.

The interesting question is, will there be a further extension of the vocabulary and the language of documentary? Can we go further than we've gone? That's what I still find myself excited to think about.

PICTURES FROM HOME
Larry Sultan

Perhaps better than anyone, Sultan describes the drive to photograph that which is most familiar—the family.

The house is quiet. They have gone to bed, leaving me alone, and the electric timer has just switched off the living-room lights. It feels like the house has settled in and finally turned on its side to fall asleep. Years ago I would have gone through my mother's purse for one of her cigarettes and smoked in the dark. It was a magical time that the house was mine.

Tonight, however, I'm restless. I sit at the dining-room table; rummage through the refrigerator. What am I looking for?

All day I've been scavenging, poking around in rooms and closets, peering at their things, studying them. I arrange my rolls of exposed film into long rows and count and recount them as if they were loot. There are twenty-eight.

I can hear my mother snoring through the closed bedroom door. Without my asking, she has left a Valium tablet for me. It is sitting on the bathroom counter, next to a full glass of water. I don't sleep well here. The pillow is too high and spongy, the sheets polyester, the blanket too thin. I wake up in the middle of the night filled with the confusion of motels. This is not my house.

The house where I grew up was sold long ago. Of the three houses that they have lived in since they moved to California from Brooklyn, this one, with its twenty-foot cathedral ceilings and Italian tile floor, is the least alive for me. At the same time, it seems to have a life of its own: the radio turns itself on in the morning with the sprinklers; the lights go on in the evening and turn themselves off at eleven. Everything is under control.

Sitting finally on the couch in the dark living room, I begin to sink. I feel chills moving up my back and along my arms. I become sensitive to night sounds: the stirring of the dog, the refrigerator, a neighbor's car and automatic garage door, my parents in their bedroom. My body seems to grow smaller as if it is finally adjusting itself to the age I feel whenever I'm in their house. It's like I'm releasing the air from an inflatable image and shrinking back down to an essential form. Is that why I've come here? To find myself by photographing them?

Every few months I visit, loaded down with camera gear and ideas for pictures. It takes a day or two for most of these ideas to seem strained or foolish and then I'm left with cases of unexposed film and a feeling of desperation. I bargain with my father, trading him hours of weeding in his garden for minutes of his time posing for me. When I finally begin to photograph him, I feel so anxious that I retake the same pictures I made years ago. After a few days of this I become so distracted that I miss most of the wonderful, daily things and instead I begin to act like an anthropologist or a cop, photographing shoes,

papers, the surfaces of dressers. Evidence. It's only when I give up trying to make pictures and begin to enjoy the time spent with them that anything of value ever happens.

The other day my father asked me, "What do you do with all those pictures that you make? You must have thousands of them by now." When he takes pictures he has the entire roll printed and keeps all of the three-by-five-inch prints in envelopes that one day he plans to put into albums. A few years ago he presented me and my two brothers with scrapbooks filled with pictures that he had made of us over the years. Our snapshot biographies.

I tell him that most of my photographs aren't very interesting and so I just file the negatives away in boxes.

He can't believe it. "You shoot thirty rolls of film to get one or two pictures that you like. Doesn't that worry you?" He has a knack for finding the sore spot.

"No. I love making pictures, even if most of the results are lousy." The real issue is that many of the pictures that I do like trouble me more than all the ones that are filed away. I worry that they will trouble him as well.

I remember arguing with him over fifteen years ago about a photograph I made of my mother. It was a very simple and direct picture of her standing in front of a sliding glass door holding a cooked turkey on a silver platter. He accused me of creating an image that had less to do with her than with my own stereotypes of how people age. I argued that our conflicting notions about who mom is and how she should be represented are based on our different relationships to her. She is my mother but his wife. I pointed out that in almost every picture of her that he has taken she is posed like a model selling one thing or another.

"Look," I said, "I don't see her in that way. I don't glamorize her with my photographs and that's why you claim that the pictures undermine her vitality. It's your image of her vitality that they counter."

"All I know is that you have some stake in making us look older and more despairing than we really feel," he answers. "I really don't know what you are trying to get at."

I can remember when I first conceived of this project. It was in 1982 and I was in Los Angeles visiting my parents. One night, instead of renting a videotape, we pulled out the box of home movies that none of us had seen in years. Sitting in the living room, we watched thirty years of folktales—epic celebrations of the family. They were remarkable, more like a record of hopes and fantasies than of actual events. It was as if my parents had projected their dreams onto film emulsion. I was in my mid-thirties and longing for the intimacy, security, and comfort that I associated with home. But whose home? Which version of the family?

When I began to photograph, I thought of this work as a portrait of my father. In many ways, I still do. I can remember the peculiar feeling I had looking

at the first pictures that I made of him. I was recreating him and, like a parent with an infant, I had the power to observe him knowing that I would not be observed myself. Photographing my father became a way of confronting my confusion about what it is to be a man in this culture. Unaware of deeper impulses, I convinced myself that I wanted to show what happens when—as I interpreted my father's fate—corporations discard their no-longer-young employees, and how the resulting frustrations and feelings of powerlessness find their way into family relations. These were the Reagan years, when the image and the institution of the family were being used as an inspirational symbol by resurgent conservatives. I wanted to puncture this mythology of the family and to show what happens when we are driven by images of success. And I was willing to use my family to prove a point.

What drives me to continue this work is difficult to name. It was more to do with love than with sociology, with being a subject in the drama rather than a witness. And in the odd and jumbled process of working everything shifts; the boundaries blur, my distance slips, the arrogance and illusion of immunity falters. I wake up in the middle of the night, stunned and anguished. These are my parents. From that simple fact, everything follows. I realize that beyond the rolls of film and the few good pictures, the demands of my project and my confusion about its meaning, is the wish to take photography literally. To stop time. I want my parents to live forever.

THE PLAINTIFF SPEAKS (EXCERPT)
Clarissa T. Sligh

A plaintiff in a classic civil-rights case, Sligh explains how racism constructed her own creative vision.

I was a teenager when I first saw this group of photographs and the article that they appeared with, on June 1, 1956, in the *Washington Post and Times Herald*, the major daily newspaper in the Washington, D.C. area. Since I was one of the people in the pictures, I knew that they were to be published and had been looking forward to seeing them with great anticipation for several months. Now, as I recall the time when I first saw the photographs and read the words, I remember how I felt very disappointed and let down. I felt that I had been used, although back then, I had no one to whom I could try to articulate why I felt that I had been "wronged."

The difference between right and wrong had been etched in my mind, in large measure, at the neighborhood Baptist church that we attended. At the Mt. Salvation Baptist Church, you were either on one side of the line or the other; there was never any "maybe" about it. The article appeared during the development of my second great period of cynicism. The first began at the early age of four years old, when it dawned on me that my oldest brother, Clarence Junior, controlled our household. No amount of telling my momma the mean things he did could protect me.

I did not trust anyone except my brother Stephen, who was three years younger than me. But now that I had begun menstruating, more and more things in my life seemed too complicated and shameful to talk with him about.

I did not know anyone else who would understand me, who would not respond with blank looks or harsh disapproving words. The thoughts that ran through my mind were something like, "Be grateful! What do you expect? You are lucky to get any photograph in the *Washington Post* at all!" It was a newspaper for which we blacks were usually invisible, except as criminals or welfare recipients.

The mingled voices in my head were of my grandma, momma, daddy, the black preacher, and teachers all trying to teach me how to live in the world with a broken heart. As a young black female growing up in the American South of the 1940s and 1950s, I was taught, in words and by example, how to stand on my own two feet and not expect too much from anybody, no matter how sincere they appeared.

They were trying to teach me how to survive. My grandmother's father and my mother's grandmother had been slaves in this country. They were afraid that if I didn't "get it," I would end up in a madhouse or get myself killed. My father, however, didn't want me to become *too* independent. He would say that nobody would want to marry me....

My father's only goal for me was to get a husband. He made it pretty clear to me that if I didn't remain a virgin, or worse, if I got pregnant, no man would ever want to touch me. He made it sound like I would spend the rest of my life wandering through hell....

I knew my mother resented the isolated, tedious drudgery of raising babies and doing housework all the time. As the oldest girl, I was the only one who heard her complaints. Neither of us liked her life, and I knew she wanted more for me. So Momma and I were pretty excited when we found out that my picture was to be taken as part of a story about efforts to desegregate schools in Arlington, Virginia. But Daddy did not want any part of it.

Two years earlier, in 1954, when the Supreme Court ruled that racially segregated schools were unconstitutional, it was like an invisible bomb dropping on our neighborhood. We lived in one of four black communities in the county that was totally surrounded by whites. Since the time when I was about eight, my mother had been taking me to state and national NAACP meetings where people gave reports on civil rights work that was going on throughout the South and discussed strategies and ways to raise money for the legal work.

I did not believe that things would ever change. Momma, however, would quietly sit and listen. She was not one of those people who asked questions or spoke out in public, but I could tell she was intensely interested, because when she wasn't, she would be sound asleep, even while sitting upright in her chair....

Prior to the Supreme Court decision, I was "bussed" to the black high school on the south side of the county when I entered the seventh grade. One night while lying awake in bed, I heard my parents talk about how I was not getting much out of my education. My bed was against the wall. I could hear that they were not considering any plans to send me someplace else. I figured that it must have been because I was a girl. My two older brothers, Clarence Junior and Carroll, had been enrolled in the "better" schools in Washington, D.C....

My high school was being remodeled, but when I started there two years earlier, the school barely met the state of Virginia's minimum requirements for black students. There had been no gymnasium, cafeteria, science lab, or rooms to take home economics and shop classes in. When it rained, we put buckets around the room in our physical education class to catch the water that poured in. We did not have a library, and all our textbooks were used books sent over to us from the local white schools. I remember opening up the books and seeing the names of the white kids who had used them before they were handed down to us. When we complained about it to Mrs. Mackley, our math teacher, she would say, "Count your blessings. You are lucky to get anything at all."

My mother had thought that the Supreme Court decision would mean that I would begin tenth grade at the white high school that was located near us. I had been pushed by my teachers, and I got good grades. However, I felt a little nervous about going, and I wondered how I would fare. After all, everybody

knew that our black school was "not as good." Also, I did not think I was very smart. There were a lot of kids in my neighborhood who felt they were smarter than me, but who got lower grades. School was boring, there was no doubt about that. They essentially refused to read or discuss the totally racist materials we were given. It made us feel bad about who we were. They did not believe that I was going to make their lives any different or better. I did not believe it would either, but I was hoping that it might.

Some schools in nearby D.C. and Maryland were desegregated the following fall. In Arlington, however, we were sent back to our segregated schools.

This, however, did not deter my momma, who wanted more for her children than she had for herself. I still recall the determination with which she went to meetings with people from the local NAACP and other black parents from our neighborhood to see what they could do about it. This was after being on her feet all day as a domestic worker. All us kids had to help make dinner, but she saw that we sat down to eat. The following spring, when I was completing tenth grade, she asked me if was willing to be part of a school integration court case with other kids from the neighborhood, and I agreed to do it. I figured it wouldn't be too bad if we all went together.

This, however, was the summer of 1955, when Emmett Till, a fourteen-year-old black boy, was lynched in Mississippi for "speaking to a white woman." It was in all the papers, but the local black newspaper and *Ebony* and *Jet* magazines, which we followed carefully for the latest developments on school desegregation, wrote about it in great detail. I had grown up hearing about whites lynching black men, but because he was so near me in age, the horror of this truly seeped into my bones.

During the fall of 1955, as I returned for the 11th grade to my old school on the south side, the Virginia Legislature passed something called the "massive resistance laws," which gave the governor the power to close down any school system that attempted to desegregate. I tried to talk to my momma about it, but she would say nothing to me about it. Still, she continued going to the NAACP meetings with the other parents form the neighborhood.

Meanwhile, miles away in Montgomery, Alabama, Rosa Parks was being arrested for not moving to the back of a city bus. The bus boycott that followed was exciting news to us. We saw news photographs of elderly black people walking many miles to work. It inspired us to see that our people, who were further south than us and in a more hostile environment, were determined not to take it anymore....

The month after the bus boycott began in Montgomery, whites rioted on the campus of the University of Alabama for three days after Autherine Lucy, a black woman, enrolled there. Because I, too, was going to be a desegregation plaintiff, I wanted to know everything that was going on. After all, I might find myself in her shoes.

A few months later, my mother asked me if I was willing to be lead plaintiff in the Arlington desegregation case. She explained to me that some of the students who had been previously selected were about to graduate and that another student withdrew because her father was going to be fired from his job if she stayed in. I never expected that the court case would take over a year to be put together. And I had definitely never expected to be singled out from what was originally a group of over 25 black students. I could only imagine that my life would be in a shambles.

I remember thinking, "Here I am already finishing the 11th grade. Why would I want to go to a white school for my senior year?"

Although Momma said I didn't have to do it if I didn't want to, I could tell she wanted me to agree. Terrible images flashed through my adolescent mind: of Emmett Till being killed for saying something to a white woman; of Rosa Parks going to jail rather than giving up her seat to a white man; of all those elderly black folks walking miles to their jobs in Montgomery; of Autherine Lucy at the University of Alabama. I swallowed hard and told her that I would. Since the age of eight, I had been "in it"; I knew what I was expected to do.

On May 17, 1956, the NAACP attorneys filed our lawsuit: *Clarissa Thompson et al. v. the Arlington County School Board et al.* I had no idea what sort of changes it would make to my life. What was happening did not really sink in until the newspaper let us know that they wanted to come out and take our pictures for an article about the case.

The photographs were taken by a newspaper photographer who accompanied the reporter to the home of Mrs. Barbara Marx, a white woman who was the vice president of the local NAACP chapter. The group had asked my mother beforehand to have me prepare a statement.

During the interview, I was very nervous. I tried to act cool, but the underarms of my blouse were soaking wet. Cold sweat ran down the inside of my clothes. I sat and listened as the newspaper reporter interviewed the adults who were present; they included Edwin Brown, an attorney for the NAACP, and James Browne, the local NAACP chapter president. When the reporter asked me why I wanted to go to a white school, I remember saying something about wanting equality and an end to being a second-class citizen.

Afterward, the reporter directed the staff photographer to take pictures of us. Then, the reporter, looking at eight-year-old Ann, said, "Isn't she included in the case too? Let's include her in the photographs!"

The photographer began by taking pictures of Mrs. Marx and her daughter, Ann. He asked her to hold up a piece of paper as though she were reading something. I remember her fumbling around in a drawer until she found an envelope, took out a letter, and held it up. It is only now, looking back, that I realize how nervous she must have been.

Next, the photographer decided to take photographs of Ann and me outdoors. I felt very stiff. I recall I was very surprised that Ann and I would be photographed

together. As I listened to the adults talk, it was the first time that I heard that her mother had included her and her sister Claire, who was about to graduate from high school, in the suit. She was one of three white students in the class-action suit of 22 students. I was one of 19 black students. It hardly seemed equal to me.

The photographer shot a number of pictures of Ann and me together. By now she seemed to be enjoying the attention and was very relaxed. I on the other hand, was freaking out. Here I was, a 16-year-old, very self-conscious black female, with these white folks up in this white neighborhood, and I'm supposed to be relaxed? They killed Emmett Till. In addition to trying to keep myself together, I felt very awkward towering above this little girl, in height, as the photographer took shots of us standing together. I was 16 years old and she was eight, not 12 as stated in the newspaper photo caption. Somehow, it seemed insulting to me to be photographed with an eight-year-old. At the same time, I felt bad that the other black students in the suit weren't there. Despite the feelings I had, I tried hard to look agreeable and pleasant, so that people would think I was an "all right" person. After taking several shots, he asked us to walk toward him. Then he asked for us to carry a book in our hands as we walked toward him. Finally, he said, "Okay, that's it." I was glad when it was over.

When the photographs were published, a picture of Barbara and Ann Marx appeared at the top of the page, just above the headline, which read: "Suit Charges Bias Against White Pupils." The photograph, which was taken at fairly close range, was shot at just about eye level. Ann is standing next to her mother, who is seated at what appears to be a desk or table. This makes Ann's head a little higher than her mother's. The edges around both their heads appear to have been painted in order to make them stand out against the background. The shape of the shadows cast by their heads suggest circular forms, giving the effect of halos behind their heads similar to those in the Christian religious art of the Middle Ages.

The mother and daughter are holding a piece of paper, supposedly a page from the papers filed in the suit; they are both smiling, as if they are happy and satisfied with what they have done. If I am a viewer who is at all sympathetic with what they have done, I look at this image without thinking how wonderfully honorable and courageous they must be. If I am a viewer who is angered by what they have done, I will be aware that any action I take against them is going to make me look like a "bad guy," so I am not going to express my feelings very publicly.

The second photograph, a closely cropped headshot of me, was placed in the upper right of the picture described above. It was shot from below my eye level, so that I appear to be looking down at the camera. You can tell by the shadow areas under my eyes, nose, and face that the light source comes from the upper left hand side. This cropped headshot reminds me of the way photographs of "monsters" are lighted and shot. The angle of the lens, pointing up into my nostrils, also suggest to me certain European paintings of horses being ridden into

battle. Moreover, the placement of the picture seems to suggest that the mother and daughter are placing themselves at risk by taking the moral action and putting themselves into this position, and I am their "white man's burden." The caption read: "Clarissa Thompson…asks for equality." The small amount of white background does not give the viewer any clues as to where the picture was taken.

My head was printed larger than that of Barbara or Ann Marx, and the placement of the top of the photograph just above the top of their picture makes it pop off the page more than the other image. Even though the photograph of me is about one-third the size of the photograph of Barbara and Ann Marx, the angle of the shot of my dark-skinned face puts my blackness in opposition to their whiteness. The relative placement of the photographs seems to suggest that people who are white are human and nice and that people who are black are threatening to those nice white people.

This meant that whites would only be able to see that generic black face they carried around in their minds. They would not have to wonder about the life, aspirations, the universal humanity hidden behind my dark skin. They would not be forced to examine, in a personal way, the injustice of the life I was forced to live.

The third photograph was printed on a different page. It was a picture of me and Ann walking toward the photographer, and he was crouching down when he shot it. It is close to evening. The photographer has his back to the sun. In the picture, I am on the left, Ann is on the right. We are both smiling and we each carry a book. The image is cropped to show our full bodies, but my right arm is nevertheless cut off. It looks as though I am walking out of the frame. It may even suggest that I am less than a whole person. Portions of the areas around our heads and shoulders have been painted to make us stand out from the background.

This photograph of me and Ann reminds me of similar images of young whites pictured with older, usually adult, blacks. Three references that immediately come to mind are Huckleberry Finn with the slave Jim; various movies with Shirley Temple in which she shows benevolence to an older, black, white-haired male servant/slave; and of course, images from *Uncle Tom's Cabin*.

The article itself was written about the few whites who worked with us on the school desegregation case. None of the adults from my neighborhood, who had worked on the case for over a year, and who were parents of the 25 black students, were even mentioned. In the photographs and words, Barbara Marx and her daughter, a white mother and child, were thus highlighted and elevated to a position of significance over all the black people involved in the case.

If I had not been there on the two occasions where the reporter interviewed us, I would have never known that black adults participated in those meetings. I remember how seriously and carefully they made sure that what they said to the reporter was accurate and correct; how they helped each other find the words

to describe exactly what they meant. How they sometimes told jokes to break the tension. Why was none of what they said included?

Except for me, none of the other black students was named in the article. The next to last sentence states, "The case will be known as *Clarissa Thompson et al. v. the Arlington County School Board et al.* because the 11th grade Negro girl leads the list of plaintiffs." It was made clear that my photograph was there only because my name was at the top of a list. Simply by looking at the photographs, both whites and blacks would think the suit was initiated by whites.

Today, I can still remember the safety I felt being surrounded by the black adults from my community during the interview. I remember all their faces but only a few of their names. By leaving them out of the article and photographs, the newspaper made them invisible. Their being left out also made me feel unprotected and more vulnerable than ever as time went by. Their courage had been devalued. Their lack of power, of control over the situation, was magnified before my eyes. Even then it was clear to me that the readers of the newspaper would get the message that it was whites, not blacks, who were leading the inter-racial group to fight racial segregation in Virginia. It reinforced the stereotype that we had to be led by whites.

Today, I ask myself how those meetings with the reporter and photographer might have been different. Why were the interviews held at Barbara Marx's rather than the NAACP president James Browne's house? Both their homes were equally convenient from the highway. If the group had not made the decision beforehand to include Barbara Marx's daughter in the photo session, why didn't they object when the reporter suggested it? Were the black adults afraid to give the appearance of "slighting" a little white girl? Had they in some way gone along with their exclusion from the decision-making process? Had we blacks been excluded from participating in the so-called democratic decision-making process for so long, and in so many ways, that any ordinary white person took our exclusion for granted—and so, perhaps, did we?

Today, I also ask myself about the motivations of the reporter. I remember her as being a white woman; yet the reporter's name, as published, appears to be masculine. Was it a pseudonym? As a southern white, would she have been capable of writing a news article that included a black person's point of view? Was she able or willing to hear any of the things we blacks were saying? Did she come there intending to write a story about white people? Certainly a story about the Civil Rights Movement that included whites got more attention than one about blacks alone. It later became a tactic which the black leaders in the Movement, themselves, took advantage of. They saw that photographs of whites being beaten up while exercising their civil rights got much more attention; here was something unbelieving American whites could identify with, much more so than with photographs of black protestors being beaten up by whites.

When the article was printed, I felt betrayed. I had thought that it was really going to be a piece of investigative reporting about our work to win our civil rights under the Supreme Court ruling *Brown v. Board of Education*. I wanted terribly to believe that I could have rights under the 14th Amendment to the Constitution, which guarantees equal protection under the law. I wanted to believe in the Pledge of Allegiance, the National Anthem, the Bible, and all the other shit I had to regurgitate in school, even though I knew it clearly did not apply to me. I wanted the article to show that black people from my neighborhood were part of the struggle against legalized racial segregation too.

My mother did not say much to me about the article after it appeared. She did mention, in passing, that some of the people from the community who had met with the reporter were not happy with the way the article turned out. Still, she seemed happy and satisfied that her daughter's picture was in the *Washington Post*. It was a big thing that would elevate her status in the neighborhood and beyond. She did not seem to fear that she would lose any of her domestic work; on the contrary, she seemed to be looking forward to the reaction of her employers.

The publication of those photographs, however, placed me in a new relationship to both the white and black worlds. It wrenched me from what I considered to be the safety and security of my anonymous family in the spotlight of the hostile public's scrutiny. People began to notice me. I could no longer be just another black girl, or just myself. I had to mind my *p*'s and *q*'s. My behavior, my grades and test scores, my interest and accomplishments became public information.

I began to be expected to address groups of liberal white people, whose support was being solicited for our case. As a young black person, my personal contact with whites had been minimal before this. In fact, I had heard mostly bad things about them, so I was always scared to be with them. In Arlington we were barred from the movies, restaurants, white churches, and most other public places. I could check out a book from the public library, but I could not sit down to read it. On my way home from the District of Columbia I often sat alone on the bus, even when it was crowded, because none of the whites would sit beside me. I used to get upset about it, but then I tried to act like I didn't see them.

Before I had been invisible. Now I was being scrutinized, not only by whites, but also by the black adults who took me into these new situations. I went along with it, but I tried really hard to hide what I thought and who I really was....

The state of tension was the beginning of my learning to live a divided and alienated life. Even as a young person, I knew I had made the decision to allow myself to be used in a way that was unpleasant and uncomfortable to me. It is true that I had been trained for it, but I could have opted out. I was hoping that

it would lead to opportunities that would give me more economic independence and make my life better than my mother's. I learned how to hide myself and my thoughts by keeping my mouth shut, by covering my terror with a smile and by acting as if everything was going to be all right. In order to get through it, I searched for support, for meaning in my life, at the Mt. Salvation Baptist Church. Whenever tough times came, rather than argue or fight, I turned inward and prayed very hard. Later, when the church disappointed me, as it surely had to, I began to smoke and drink. Fortunately for me, stronger drugs were not as available to young people as they are now.

Since those days, the non-objective reporting of newspaper journalism has been of interest to me. To the average person, news photographs represent reality, but I ask "Whose reality?" and "Why?" As I travel from city to city and from country to country, I see how newspapers vary tremendously in their points of view. Placing one photograph beside another changes the way the viewer reads it. Adding words to a photograph can make it say almost anything.

It is hard for photographers not to base the photographs they make on pictures they already have in their minds. Even so, their specific intent can easily be altered by an editor's intent, which may be controlled, in turn, by the newspaper's publisher. And then, of course, advertisers often influence what publishers "feel comfortable" including in their pages.

I became a photographer partly in response to the continuous omission and misrepresentation of me and my point of view as a black working-class female who grew up poor. I know I can make a photograph say a lot of different things. However, I hope that the way I make images helps the viewer become better aware of how photographs are really abstracted constructions.

THE SOUL OF THE IMAGE AND VISUAL LITERACY
Daile Kaplan

As a curator, historian, and a champion of photography's vernacular images, Daile Kaplan bemoans the loss of visual literacy in education and reassesses its necessity.

Our experiences of most things in the world are mediated by photography, which shows us culture at work. The necessity of responding to images may increase exponentially during a person's lifetime but, surprisingly, the general public is not visually oriented. This lack of fundamental visual literacy skills may be traced to a public educational system that does not instruct students in visual discernment as well as a culture that exploits the role of pictures while simultaneously disregarding their inherent value. Even sophisticated collectors who, while keenly aware of the social currency of beautiful objects, demonstrate a lack of critical thinking in their misguided focus on a work's price, or the artist's reputation, rather than its aesthetic merit and personal meaning. In this way, inadequate visual intelligence skills transcend demographics, class, race, and gender. A discussion of photography and visual literacy is inevitably complex in order to address photography's multiple roles as a media-driven vehicle of communication, as a tool to enhance language arts skills, and as a rarefied fine art form.

Everyone recognizes the signs of a literate person but what defines visual literacy? Visual intelligence is defined as the ability to both understand and express an image's significance. Yet, it connotes a great deal more. Imagination. Curiosity. Discovery. The facility to think creatively is a crucial common aptitude associated with lifelong learning. Although educators have long known that more than half of what students learn they know visually, even today, pictorial materials are not typically integrated in learning environments. It is well-known fact that photographs can stimulate a viewer's imagination to access their beliefs or values. How may photography's heuristic utilities best be explored?

Visual intelligence draws upon the dynamic relationship between cognitive skills and photographic images. Photographer and educator László Moholy-Nagy's *The New Vision* (1934), which emphasized the emerging dominance of photography in popular culture, demonstrated how pictures provoke meaning. Yet, Moholy clearly indicated that for photographers to succeed they themselves must first be visually well educated. The modernist volume co-authored by Franz Roh and Jan Tschihold, *Photo-Auge* [*Photo-Eye*] (1929), a collaboration between a photographer and designer, addressed how photographs were "a weapon against the mechanization of spirit." Gyorgy Kepes, a photographer on the faculty of the Art Institute in Chicago, who was concerned with perception, articulated the idea of "active looking" in his book, *Language of Vision* (1944). Kepes postulated the then radical notion that photographic meaning is dictated by context; that

the viewer's emotional experience invariably presents new ways of knowing. He characterized this dynamic as a "creative act of integration" in which "…to perceive a visual image implies the beholder's participation in a process of [mental] organization." This heady approach to pictorial observation references the significance of personal engagement and its ultimate reward, the excitement visual culture can induce.

For a brief halcyon period of the late 1960s and early 1970s, academic interest in the field of visual literacy flourished to reflect how intellectual inquiry into history, anthropology, science, literature, and technology was animated by the introduction of pictures. John Debbes III coined the term in 1968, and was a founder of the Visual Literacy Association—still in existence today—which challenged the Department of Education to recognize that verbal literacy is achieved through visual competency. But, the national education system responded slowly, if at all. As a result, metropolitan museums offered special "Learning through the Arts" programs for public- and middle-school children that explored the museum environment effectively. Artists-cum-teachers incorporated artwork to inspire young adults with deficient reading and writing skills. Strategies were developed whereby art was introduced amidst a setting of "careful looking," with open-ended questions about an artwork's technique or content that encouraged students to think abstractly. Art-making activities in which children were given the materials to draw or paint and subsequently discussed their artwork helped them develop both verbal and visual literacy aptitudes.

During this same period, cultural thinkers like Susan Sontag championed the notion that, due to its prominence in everyday life, the family of photographic images demanded rigorous analytical examination. Concomitantly, Marshall McLuhan, a Canadian literature professor, investigated print and media advertisements in *The Medium Is the Message*. The direct relationship between photographic expression and critical thinking that Sontag, McLuhan, and later Michel Foucault and Roland Barthes expounded triggered intense public debates. With this heightened awareness of the medium's transparency photography's status profoundly changed. Elevated to high-art discourse post-modernist theoreticians ultimately repositioned the medium from a universally accepted form of representing reality to a customized conveyor of cultural messages.

A reexamination of photography's social utilities may be useful so that we may better understand how it may be engaged. John Whiting, a charismatic journalist and picture editor at *Life* magazine in the 1940s–60s, used the expression "photography is a language"—which was also the title of his groundbreaking book—noting "the photographer…first learns to see with his camera and think with his eyes." Whiting's book articulated the grammar of photojournalism, that is, how the photo story was a created through editing, sizing, sequencing, and designing individual photographs. This process of structuring was not unlike crafting a sentence. The notion of how photography mimicked language

was introduced even earlier, by the preeminent photojournalist Lewis Hine. A social documentary photographer who actually coined the term "photo story," Hine was influenced by the pioneering educator John Dewey. Hine wrote eloquently about how the camera might be employed "as an indispensable adjunct to modern society." For Hine and later generations of artist-photographers who recognized that images were socially constructed, engaging with art was a means to live an enhanced life.

Photographs, like other creative works, communicate certain effects in the mind's eye of a viewer. They not only provide access to historical moments but a greater awareness of oneself. A collector friend of mine succinctly described the experience: "Photographs transport me to places I would like to be." Psychologist Mihaly Csikszentmihalyi has written extensively on the concept of creativity as the entry point into evolution. Best known for introducing the concept of "flow"—the feeling of optimal fulfillment and engagement—Czikszentmihalyi notes, "Communication with the work of art is often a multidimensional experience, one that integrates the visual with the emotional and intellectual." This powerful, oftentimes transformative, personal encounter with art has collective benefits as well. Who would not want to live in a culture where aesthetics and social action trump celebrity worship and consumerism?

Although visual literacy should not be conflated with art appreciation, the fine art community already has a network of visual learning centers, known as museums, that are vastly underutilized. Many American institutions are in the midst of major physical expansion projects. Yet, the general public is afraid of the museum experience—notwithstanding the occasional media-driven blockbuster exhibition—which demands a level of visual engagement it is generally unprepared to meet. Museums can tap their remarkable resources—artwork in all media, in-house education programs, libraries, volunteer staff, technology, and financial support—to create pilot programs directed at teachers while maintaining special projects for children and adults.

Young students would benefit greatly from visual literacy classes, which would essentially teach them how to evaluate visual culture so they may function more dynamically in society. Aesthetic objects provide a concrete point of reference from which children can learn to think critically. Deliberate looking, which is linked with improved cognitive ability and imagination is the highest form of thought. Museum of Modern Art educator Phillip Yenawine espouses visual awareness as a vital social asset, implementing art programs involving "visual thinking strategies" to help students develop skills for coping with multifaceted information. Yenawine called this approach a "questioning strategy," one in which there are many right answers because it relies on personal experience.

The necessity of a nation-wide initiative to implement visual literacy programs from elementary through high school can broaden that base. With

the severe reduction in pubic funds for art and education programs, local artists, educators, and writers are taking direct action. The dearth of public resources in California inspired the celebrated novelist Dave Eggers to found his successful storefront, 826 Valencia. This San Francisco–based tutoring project staffed by neighborhood volunteers is a wonderful model for our field. Inspiration may also be found on the Internet, where select sites counter the insidiously homogenous and numbing effects of the mainstream media. Twentieth-century social documentary photography has historically been an instrument for education. Today, Fifty Crows (*www.fiftycrows.org*), a foundation dedicated to promoting cultural understanding and social action via the distribution of photo essays to reach a large and diverse public, funds works by emerging and mid-career photojournalists worldwide. The vanguard site, Pixel Press (*www.pixelpress.org*), which is dedicated "to vision and intuition," also highlights select visual stories to address digital photography as "a revolution in consciousness not commerce."

Throughout the nation a fledgling network of local organizations support visual literacy projects. Programs such as Denise Felice's "Picture My World" (sponsored by the Palm Beach Photographic Centre), in which students maintain personal diaries and shoot digital pictures, not only teaches photographic and language arts proficiencies but instructs students in how to apply these skills to practice tolerance. After-school programs funded by the Children's Aid Society in New York City have benefited from the expertise of School of Visual Arts' graduate students supervised by Charles Traub. Giving children cameras so that they can create photographs is empowering, allowing them to create their own reality. Set twenty photographers loose in a small room and they'll make twenty very different pictures. Young adults who participate in mentoring programs with photographers cultivate visual acumen and critical thinking skills, which leads to a deeper awareness of themselves. My personal contribution was to team teach the first course in the university system, "The Photograph as Historical Document," with Maren Stange. The class, which was directed towards graduate and doctoral programs historians at New York University, was initially met with marked prejudice by the traditionally trained (read visually illiterate) students. A successful model that has since become a feature of the graduate program, it addressed photography's crossover capabilities. Today, as director of photographs at Swann Auction Galleries, I work with new and mature collectors who are passionate about photography but frequently unable to articulate why. In seminars collecting artworks my staff and I offer important lessons about photographic history and techniques while encouraging our clients to develop visual discernment.

Photography is a key to unleashing the decisive role of critical thinking in relation to visual literacy. It is a special form of creative expression because it effortlessly lends itself to different types of educational inquiry. And, its various

genres, as a documentary, commercial, editorial, fine art, or vernacular practices, can secure a broad base. Working together gallerists, specialists, curators, educators, foundations, photojournalists, and photographers can cultivate a new generation of visually literate students by initiating partnerships with local schools or not-for-profit institutions. Discovering innovative ways for educators and professionals to interface and advance visual intelligence can effect change in our communities. What will you do?

TOWARDS A PHILOSOPHY OF
PHOTOGRAPHY (EXCERPT)
Vilém Flusser

In this excerpt from *Towards a Philosophy of Photography*, a book every student should read, Flusser makes it clear that human intentions through the eye can turn the photographic apparatus into a freeing device of expression.

We can observe nearly everywhere how apparatus of every sort tend towards programming our lives for a kind of dumb automation. Or how work is being taken from the hands of man and transferred to apparatus. Or, how the majority of men begin to be occupied in the "tertiary sector" of playing with empty symbols. Or, how existential interest begins to shift from the world of objects to the world of symbols. How our values begin to shift from things to information. How our thoughts, sentiments, desires and actions begin to assume the structure of automatons. How "to live" is coming to mean "to feed apparatus and to be fed by them." In short, we can see all around us how everything is becoming absurd. Where, then, is there any room left for human freedom?

We then discover people who would seem to have an answer to the question: the photographer in the sense meant in this essay. They are, in miniature, men of the apparatus future living now. Their gestures are programmed by camera functions. They play with symbols. They are occupied in the "tertiary sector." They are interested in information. They produce objects devoid of inherent value. And despite all this, they do not seem to believe that their activity is absurd, and they believe that their actions are informed by freedom. Thus, the task of a philosophy of photography is to question these photographers about their freedom, and to investigate their search for freedom.

This is precisely what this essay attempted to do, and several answers did appear in the course of our investigation: one, that it is possible to outwit the stupidity of the apparatus. Two, that it is possible surreptitiously to inject human intentions in the apparatus program. Three, that it is possible to force the apparatus to produce something impossible to see in advance, something improbable, something informative. Four, that is possible to hold the apparatus and its products in contempt, to deviate one's attentions from "subjects" in general and to concentrate on information. In sum: Photographers seem to be saying that freedom is a strategy by which chance and necessity are submitted to human intention. In other words, that freedom "equals playing against the apparatus."

Photographers do not give this answer spontaneously. They do so only if pressed by philosophical analysis. If they speak spontaneously, they might affirm that what they are doing is making traditional images using nontraditional methods. They might affirm that they are producing works of art, or

that they are contributing to science, or that they are politically committed. If we read what the photographers have to say about their activity, or if we read the traditional books on the history of photography, we find the generalized opinion that nothing much has changed through the invention of photography, and that everything continues to occur very much as it occurred before the invention of photography—except that, along with all the other histories, there is now also a history of photography. Despite the fact that photographers live—thanks to their own activities—in a post-historical context, the "second industrial revolution"—such as it manifests itself in the camera, for the first time—has bypassed them.

The following three image-makers (Vera Lutter, Jeff Wall, and Vik Muniz), who work in constructive modalities, speak about their work and motivations.

INTERVIEW WITH VERA LUTTER
Peter Wollen

According to most accounts, the camera obscura was developed in Europe during the thirteenth and fourteenth centuries, although versions of the device may have been used even earlier in China and the Arab world. It consisted of a large boxlike space within which an image of the world outside was projected onto a wall by means of a carefully placed aperture that admitted light. The image's scale depended on its distance from the aperture. It was not until the sixteenth century that the camera obscura was perfected as an instrument of vision. The first known illustration was published in 1544 to demonstrate its use in the observation of a solar eclipse. In 1558 Giovanni Batista Della Porta explained how the camera obscura could be used to show battle scenes on the wall inside the device. It is possible that Vermeer too used a camera obscura to paint his *View of Delft*, and Canaletto may well have used one for his views of Venice.

Vera Lutter has revived and modified the camera obscura in unusual and intriguing ways. At the time of the Renaissance a typical camera obscura was room size. In the eighteenth century it was the size of a sedan chair, while in the nineteenth century it shrank to the size of a packing box. In sharp contrast, Lutter's camera obscura of choice is the size of a shipping container. (In fact, it often is a shipping container.) Her work is also differentiated from her predecessors' in that she prints extremely large, sometimes wall-size images as the end product. The photographic images are exposed over several hours or even months, capturing trace of movement and creating a ghostly sense of temporality. Vera Lutter's work has not only revived the camera obscura but also reinvented photography itself, creating a new sensitivity to both time and space.

Peter Wollen: How did you become interested in camera obscura?
Vera Lutter: I was trained in Munich as a sculptor, but I had come to a point where I didn't really quite know how to continue or what direction to take. It was actually a rather serious crisis. When I started to resurface from it, as it turned out, I received a [Deutsher Akademischer Austausch Dienst (DAAD)] grant for New York and moved into an old high-rise in the Garment District. Living in a wonderful loft on the 27th floor, an illegal sublet in a commercial building, I had a great start. I was overwhelmed and incredibly impressed by the city, the light, the sound, the busyness of the streets. It was fantastic. Through windows, the outside world flooded the space inside and penetrated my body. It

was really an impressive experience on all levels, and I decided to turn it into an art piece: the space, the room inside which I had this experience, would become the container to transform that very experience. The room would become a transfer station from outside to inside, the window itself the eye that sees from inside out. I placed a pinhole on the window surface and replaced my body with a sensitive material, and that was the photographic paper. This setup was meant to record my experience, in place of myself. My intention was not to make a photograph as such but to make a conceptual piece that in its own way repeated and transformed what I had observed. Conceptual art was the spirit in which I was trained in art school. At the same time, I wanted to keep process as immediate and direct as possible. That's why I decided to work with the pinhole and not a lens, and to project immediately onto photographic paper and not to use the intermediary of the negative, which conventionally is printed and editioned in photography. The scale was a given, as the space I was working with was architectural, and the wall onto which I projected was the wall of the room.

Anyway, I darkened the loft, placed the pinhole on the window's surface and installed photographic paper on the wall opposite. It took me forever to get the traces of light onto the paper.

PW: I've been in a lot of camera obscuras and I was astonished by your idea that the camera obscura could really become a camera. Usually there's just a round table and the image is projected down onto it—
VL: And it's already altered, and removed from the most immediate experience. They often have a sort of telescopic lens above, and I have seen one that rotates so you get various views, but you don't have a firm eye, so to speak, or a pinhole. There was a great sense of innocence in those first pieces of mine. I didn't know a lot about the technique. The exposure time was roughly five hours, whereas I had expected it to be minutes. And when I finally made the first print, I was quite excited about the specific quality, and I have worked with this method ever since.

PW: How big was it?
VL: The first piece was 80 by 80 inches.

PW: That's quite big.
VL: Because of the DAAD grant, I was involved in art school, so I used the School of Visual Arts' photo lab to process it. I didn't even know how to mix chemicals. People said, "Well, maybe you should learn how to print an 8 × 10 first." But I didn't.

PW: (laughter) No. It wouldn't be the same.
VL: They looked wild, the first ones. I'm a little sad that I've become so tame.

68

PW: How do you mean "wild"?

VL: Oh, bold. Usually one uses a heavyweight paper because it resists the treatment in chemistry better, but I first used single-weight paper, which has a very thin paper body. When you process it in the chemicals, it tears and wrinkles easily. The paper was too big for the tray, so I just folded it up and stuffed it into the chemicals. The development was incredibly uneven, and of course photo dealers were horrified. (*laughter*) But over the years I've learned to appreciate the double-weight paper, and I've become good at rolling the paper through the chemical. Now they're archival and flat, not torn, not wrinkled.

PW: How big does the tray have to be?

VL: Well, I use a trough about 60 inches long, and approximately 10 by 10 inches deep and wide. You fill that up with five gallons of chemicals. Putting the paper in rolled up, you learn very quickly how to roll it from one end to the other. Then you pull it out and turn it around so the beginning is facing you and you roll again. It is anxiety driven: if you are too slow, you get developer marks. Knowing how long one turn takes helps you stop the process at the right moment. It's choreography.

PW: How did you go on to make your decisions about what to photograph? There are skyscrapers, harbors, and docks and bridges and everything that goes with them, and there are factories. Those categories seem to dominate.

VL: Industrial sites interest me tremendously, both the ones that are fully functional—they are the most monumental, impressive manifestations of mankind pushing for industrial fabrication—and the ones that are already over the edge, rotting, decaying and taking on a life of their own. Decay becomes a process. A big theme that I'm still working on centers on travel and transportation, transfer and exchange. Despite much talk about globalization, I am interested in the massive, physical, *awkward* act of people and merchandise being moved from one place to the other. I've been exploring the medium of transportation—ships, trains, zeppelins, oil rigs, planes—in the industrial environment they were built in, relating the transfer of merchandise to the transfer of light within the camera. You have a void and that very void allows for the change/exchange or the transfer. The empty body takes in people and brings them somewhere; it's the transfer of place and the exchange of goods. The void interior camera space allows the light to come in and transfers it into an image. So I got very interested in discussing these things with the medium of camera obscura. Coincidentally, I often use shipping containers now, which I rent—

PW: As cameras?

VL: Yes. Just like in the beginning when I appropriated a room to photograph architecture.

PW: As the subject matter becomes bigger, does the camera have to become bigger? Or is it not as simple as that?

VL: It's not quite so simple: by changing the focal length, which in my case is the distance between the pinhole and the photographic paper, I can affect the image size. The photo industry delivers a certain width of paper on a roll, and I piece sheets together to make my images match my ideas.

PW: How big are the sheets?

VL: They are 56 inches wide, and they vary between 90 and 110 inches in length. 56 times three makes almost 15 feet. It's become a standard size of mine. The shipping container just barely accommodates such an image size.

PW: I met a man at a friend's house quite a few years ago, and I asked him what he did professionally, and he said, "I don't have to do anything." And I said, "What do you mean?" And he said, "I've got so much money I don't have to work." So I said, "How did that happen?" And he said, "I invented the container."

VL: Oh really! I should meet this man.

PW: It was maybe 20 years ago.

VL: So he worked with railroads and ships and airports and made the container match everywhere. ... But I wonder if we should feel sorry for him that he doesn't have to work.

PW: He seemed quite happy.

VL: *(laughter)*

PW: Now, how about movement? Looking at the images, I'm not always sure whether everything looks still because everything you were photographing was still, or if things were actually moving and were captured as still.

VL: The speed of movement has to relate to the amount of light in the environment that I am photographing. The movement either registers as a blur or inscribes itself as a ghostlike figure. For instance, I photographed zeppelins inside a hangar where they had recently started to build them again. That was also my first use of a shipping container. I placed the container inside the hangar, ran tests inside it and understood that my exposure time for the image would be four days. The zeppelin was still being tested and corrected, and one day, during my exposure, the company decided to pull it out for a test flight. During the four days of exposure, the zeppelin was flying for two days and for two days it was parked in front of my camera. When the zeppelin was gone, whatever was behind and around it inscribed itself onto the photograph, but when it was placed in the hangar, the outline of the zeppelin imprinted itself. It was rather dark inside the hangar, so things inscribed themselves very slowly.

The result was this incredible image of a translucent zeppelin, which was half hangar and half zeppelin.

PW: When you're setting up an image, do you seek out subjects that will move, so that you can capture those traces in your photograph?

VL: I never know what is going to happen. My way of working is very hands-off. I install the apparatus of observation, the camera, and then endure the process of observation and record whatever happens. The work is essentially about the passage of time, not about ideas of representation.

PW: A lot of your spaces seem depopulated—either there was nobody in these spaces or you can't see anybody in them. Is that deliberate? Of course, you are there, but we can't see you, either. People don't seem to be in your airplane pictures, for instance, even though people move in and out of airplanes all the time.

VL: People move too fast. I'm not sure to what degree the fact that people are missing is coincidence and to what degree it is intention. It almost concerns me to what degree I *don't* intend to photograph people. I'm the polar opposite from a portrait photographer. If the interaction between human beings were my main interest, I would find a different form.

PW: I hadn't really expected interaction between human beings, but somehow I expected the phantom of human beings, or phantom baggage handlers (laughter) or whatever, but they weren't there.

VL: Well, what's there in reality after you move the luggage is one little person somewhere, at most. The open areas of airports are purposely depopulated.

PW: When you first started interacting with planes, what was the attitude of the people who work in the airport: the baggage handlers, the electrical people, the engineers—

VL: In Frankfurt I worked in three different locations. I had rented a shipping container and installed it on the very tip of what they call the fingerhead, which is a gate formation that looks like a hand; the planes go up into the fingers. Being outside on the roof of this building, my camera and I were on the level of the windows where the pilots sit. A 747 is about four stories high. Labor underneath the planes is mechanically structured. It all happens with the help of machines. The president of the board of Frankfurt airport had invited me to work there, and the rest of the operation cooperated. They were very friendly and helpful, for the most part. I had to make them understand what I was doing there to get some electricity for the container and to have a minimum of respect. It's very hard for people to understand that somebody spends her time with something that doesn't reveal any meaning to them.

PW: It is outside their world. Geographically, it is their world, but psychologically, it's another world completely. And it must be difficult, perhaps, for them to imagine what the purpose is.

VL: It's not something that's immediately clear and explicable, like some other more functional things in life. People struggle with it, especially people who come into the industrial sites where something is being manufactured or into an airport that has to be operated efficiently and every activity has an immediate and clear purpose. Also, security has been much tighter. I always wanted to gain access to a site where spaceships are launched into the universe, like Cape Canaveral, but September 11 and the Afghanistan war and then the Iraq war have discouraged me and the people who help me to do these things. I couldn't do this alone. Of course, there are even more security measures at a space center than at an airport. With the help of many other people, I was hoping to get access to Baikonur, the former Soviet space station....

PW: How do you decide how far to be from what you're photographing? How do you make the choice between things that should be close up and things that should be long shots, things that should be at eye level and things that shouldn't?

VL: There's always a very clear physical relationship to the scene that I'm photographing. For instance, I photographed a Pepsi-Cola sign on the roof of the Pepsi factory in Long Island City. This factory is right on the waterfront of the East River, facing Manhattan from the opposite shore. On the roof of this factory, maybe three or four stories up, is a huge logo reaching into the sky. Except for where the letters are fixed to the scaffold, it's translucent. I built a camera on the roof and photographed through the logo onto the island. My intention was to blend this pop-culture icon that is so descriptive of American life with a view of the metropolitan areas, which describes a different aspect of American life. Since I was behind it, the sign was reversed, but then I reverse it again in my negative image. However, that was not my reason for doing it. I wanted all of this at once—the logo, the translucency and the city—but it had the side effect of correcting the Pepsi logo so that it reads from left to right in my image. I wanted to show the letters of the logo in such magnification that it would almost seem threatening, as if it were tumbling down on you. These ideas dictated distance and closeness and representation of the object in the image.

PW: Some of your skyscraper photographs have the opposite perspective: you're looking down from above onto urban roofs.

VL: Yes. Being high above the world and seeing it that way is another idea that I worked with, as in the first photographs from my loft. I am stationary in one location, yet at the same time, I can observe an enormous part of the

world surrounding me, and this is true in two ways: I see the world through the window and I see it projected on the surface of the wall of the room. As the exterior world by way of light blends with the interior of the room that I inhabit at the moment, it appears as if I were appropriating the world through sight. Looking up from below is much more oppressive; the hierarchy is, in a way, reversed.

PW: You photograph a lot of glass; do you worry about reflections? Do you try to avoid them or do you welcome them?

VL: I welcome them. There's one project that I specifically did because of the reflections, and that happened to be at my second home in New York. Living across the street from a huge high-rise, I could only inform myself about the world outside by looking at the reflections in the windows opposite my building. I could see the sky, the clouds, the traffic, people walking on the street level. The windows weren't just reflecting, but also allowed for some translucency. I had the view *into* the building, the view of the building and the reflected view of myself, or better, of the building I was in, all at once. Multilayered information in one image is what I'm really interested in. I have to capture the reflection at a moment where each of the different elements has enough of a presence to not overpower the others, which is difficult, because you have to photograph reflections when the light is opposite yourself. The light shines onto the object that reflects it, and you are the opposite of the object. And, as everyone knows, you can't photograph *into* the light.

PW: With your exterior shots of buildings, you're often at quite a long distance from the building, but it's still central.

VL: Being far away and having a central viewpoint takes me back to that idea of appropriating the world through sight.

PW: Master of all you survey.

VL: Exactly. A medieval concept, or maybe even older? I think that's where the wide views come from—I like to relate these thing with one another, the manifestation of the great, grandiose outside world and the rather great dimension of my cameras. The interior images are a newer subject matter, and I wouldn't have dared approach them were it not for Dia's inviting me to work with the museum. I was asked to drive to Beacon to see if there were something that I could work with. It was the first time that I had support in making an image. The Dia's museum in Beacon is the largest enclosed space I've ever seen, so even though it's an interior it's still a very grand view. The first image that I did there, *Nabisco Factory, Beacon I*, has a central perspective point of view of the ground floor; the building has a choreography of columns and sequential places; a very classical perspective suggested itself. The basement, on the other hand, is huge

and dark and the light is very dim. One of my exposures there lasted for three and a half months.

PW: Three and a half months?
VL: Yes. It is interesting for me to get traces of this time that passed; it becomes such an essential factor. I think of Andy Warhol's films, like *Sleeping* or *24-hour Empire State Building*, where he points the camera in one direction and the camera records. What goes into many frames in his film would go into one frame of my image.

PW: It's strange, that aspect of time. There are three variables, time, movement, and light, that have very complex and very different kinds of relationships with each other. You must know this better than I do.
VL: You explained it very well. It's a triangle, a dynamic relationship, it's never the same. In the basement of Dia Beacon, very few things happened. A musician came every once in a while—he liked the acoustics of that place—and installed an entire band in front of my camera and played. In a way all of that is in the image, because it was there while my camera recorded, but none of it remains visible because in that case the dynamic relationship is very little light, very long exposure time and movement that needs to be incredibly slow. If a chair stood there for two or three weeks, and then was moved, it would probably leave some interesting traces.

PW: Which of your works has the most movement?
VL: The Frankfurt airport series. I observed planes coming into a gate over time, and I tried to achieve an overlapping of airplanes in one place. There was no way of knowing what the schedule on that particular gate would be for a certain day. With the last print that I did there, *Airport VII*, I was able to record five or six different airplanes coming into the gate and overlapping just long enough to leave an imprint, and just short enough so that no one plane would overpower all the others. So you see a little plane inside a big one in the outline of an even bigger one, and the wing of another one slightly out of focus. That is one image where I think the idea of movement and the characteristics of the object that I photographed are successfully shown in the work.

PW: Again, there are no people, right?
VL: Yes, it's a depopulated world. I do have a ghost in one image, I remember now, a picture I did in Cleveland on July Fourth, a hot and sunny day. In the foreground are a waterfront lawn and somebody sunbathing. A funny imprint of that person remained. The camera is looking down from high up on to his body lying on the ground. He had his legs pulled up and bent knees, so it's a very recreational, relaxed and comfortable position. It contributes further to the abstraction of that figure.

74

PW: How high above him was the camera?
VL: Maybe six or eight stories. The image wasn't recorded straight down, but still with a relatively steep angle. So when people really decide not to move for a long time in bright sunlight they have a chance to be in the picture. (*laughter*)

PW: So they could be asleep, or they could be very disciplined, or they could be dead.
VL: Yes, I've thought about that, too, a scary idea.

PW: Do you ever shoot your subjects at eye level?
VL: Not really. One of the interesting aspects in my work is that the image tends to take on a perspective that the human being seldom has. Rarely do you lie on your back looking up.

A CONVERSATION WITH JEFF WALL
David Shapiro

David Shapiro: I have admired your work for a long time, and particularly because you work both as an art theorist and as an artist. I'd like to start out by asking how that happened—how you came to be doing both?

Jeff Wall: First of all, I don't really see myself as really an art theorist or anything like that; more as a kind of occasional writer. My writing partly emerged from problems or occasions in teaching. I've taught for many years, my main subject being a sort of combination of contemporary or modern art history and some reflections on aesthetics. Writing things like lectures becomes a way of putting something on paper; so, that's been one of the frameworks. The other is having been invited to write essays, mostly for catalogues. I've never really had a plan to do any serious writing in fact.

DS: So, it grew out of working as an artist?

JW: Yes, and out of teaching, and so, it turned out, I had some ideas that I thought were interesting, and maybe even original, and they had to be expressed in writing, since there's no other really viable form for them. So, I had to accept the fact that I have to try to write sometimes. But as I said, I don't consider myself a writer; I don't think I'm a very good writer, but I felt that the ideas were interesting enough to me that they would probably be interesting to other people, and I sort of forced myself to find a way to write. So it's all been, in a way, circumstantial and accidental, although by now I kind of feel like it's a part of what I like to do; if I get time, and if I had more time, I would probably write a little bit more.

DS: So you're saying that there are certain things that can't be expressed visually—in the form of art—that need to be expressed only through writing?

JW: I think that there's an intellectual element, an intellectual content to art, or an intellectual content to the way we relate to art. There's also what we call aesthetics, which is a philosophical attempt to understand the experience of art; that's something I've always been somewhat interested in, if not necessarily in an academic way, but just in a reader's way.

DS: In the aesthetic movement of the nineteenth century, Charles Baudelaire talked about being a painter of modern life. You've [often said] that you see [Baudelairian modern life painting] as a project in which you're engaged. So, is that how you got to the medium in which you work? Do you see [photography] as the most appropriate medium for today?

JW: No, I don't. I don't think that there's any "most appropriate medium." Photography has been an important phenomenon since it was invented, in both social and artistic ways. And it was inevitable that it would become central to art,

simply because it's a picture-making process, and art, Western art at least is, in a very major way, about making pictures, or images. But that doesn't make photography a more appropriate medium for our times, in my view. All media are interesting, depending on what's being done with them at the time; sometimes their field is a bit less energetic for one reason or another, but [they] usually come back.

The idea of the "painting of modern life," which I've liked very much for many years, seemed to me just the most open, flexible, and rich notion of what artistic aims might be like, meaning that Baudelaire was asking or calling for artists to pay close attention to the everyday and the now. This was still somewhat new in his time because the predominant idea about art was still that [it] was about treating time-honored themes in terms of the decorum of the established aesthetic ideas. The painting of modern life would be experimental, a clash between the very ancient standards of art and the immediate experiences that people were having in the modern world. I feel that that was the most durable, rich orientation, but the great thing about it is that it doesn't exclude any other view. It doesn't stand in contradiction to abstraction or any other experimental forms. It is part of them, and is always in some kind of dialogue with them, and also with other things that are happening, inside and outside of art....

DS: *Why essentially did you move from painting to photography?*
JW: I can't answer that. If I could answer that question, I'd know a lot.

DS: *Do you have any ideas on where painting is going, with the changing media today?*
JW: I think that painting is a permanent part of art, just like drawing is, because we have the kind of hands that we [have], because we have the kind of eyes that we have. We're always going to have drawing, and by extrapolation, painting. It's a consequence of what we are as organisms. Painting and drawing cannot disappear from serious art, cannot "die," as they say. [They] can go through all of the complex changes and developments [that they have] gone through, because they are permanent. And therefore, [drawing is] a kind of touchstone for all pictorial art, regardless, because it won't and can't be replaced with anything else. Painting as a medium and a form can't change very much. So, that makes it very interesting, and very open too. If it was not so simple and flexible and beautiful, it would be changing technologically, but it's too right just as it is to change, and so, it's going to stay there. I'm very involved with painting, always have been and always will be, not particularly because I want to paint, but because it is the most sophisticated, ancient practice.

DS: *And you look more towards painting than any other visual media?*
JW: No. I think painting is important, but I think they're all important. Painting, photography, cinema, literature, sculpture. The idea that I relate somehow very especially to painting is a kind of cliché that has come to be attached to my work.

DS: That you look towards particularly nineteenth century painting models?
JW: I know that I'm somewhat responsible for that because of some of the things that I've said. So, I can't complain about it too much, but [the claim has] gotten exaggerated. In the nineteenth century, with Manet and the others, there was such a high level of pictorial invention, such an interesting take on the now. They created something that is still very important to anyone concerned with pictures and so, I'm keeping in touch with that, but not in an exclusive way, not as a model for my own work. My work derives from photography also, that is, photography as photography, and from other art forms. But it also comes from things that I'm experiencing directly. So, I'm trying to use the nineteenth century, in a way, as one of the frames of reference for a pictorial practice. We could say that, in many ways, we are still experiencing the nineteenth century in art.

DS: About being a "painter of modern life," I see that in many of your works But does that hold true for a work like "The Giant" with its digital manipulation.
JW: I like the term "painting of modern life," but I don't use it as a formula, as total identity. It's a very interesting way to think about what you're doing. Basically it means using the standards that have emerged over a long time, very high standards one hopes, and the memory that recognizes the existence and importance of those standards, and applying it to the now. That doesn't mean that "painting of modern life" means just "scenes off the street." It means phenomena of the now that are configured as pictures by means of this accumulation of standards and skills and style and so on. That means that there are no single themes, genres, or anything else that [could] be called "painting of modern life." "Painting of modern life" is an attitude of looking, reflecting, and making. So I think that "The Giant," which is an imaginary scene, is a painting of modern life. It originated in my imagination, and my imagination is in the here and now, in the same way that something I might see in the street is here and now. Baudelaire's art ideal was a kind of fusion of reportage with what he thought of as the "high philosophical imagination" of older art.

DS: So, plausible and implausible imagery would be equally appropriate to you in terms of image-making?
JW: Yes.

DS: All right, I guess we'll switch gears a little. I was reading your interview with Arielle Pelenc, who said that your work has been criticized for lacking interruption, that is, for lacking fragmentation. Do you agree with that criticism? I wasn't sure that I did. Do you take gesture and interruption to be different phenomena? And I guess I don't really see that as a criticism if [your work] does lack a fragmentation,

*insofar as that I feel like there has for a long time been a sort of regime of the frag-
ment, and I don't know if you see your work as coming out of that.*

JW: I think that the demand that works of art appear immediately as frag-
mented, out of some kind of avant-garde and collage aesthetic background is
just an orthodoxy of the times. It's not that such a viewpoint has no validity,
but that it cannot be complete, cannot define what good art is, as such, even
for a moment. So, obviously, my work didn't really look like the kind of work
that was being approved of in that orthodox way. My reaction to that is that
my relation to the idea of fragmentation is, in a way, dialectical in that I'm not
oblivious to the whole phenomenon of what's being talked about, but I have
my own take on it.

DS: Which is?

JW: The aesthetic norm of fragmentation implies that the avant-garde movements
made a fundamental and irreversible break with the past. The art of the past is
defined as "organically unified," art that does not want to recognize its own contin-
gent character, its own fragile illusionism. It wants to revel in the illusionism, for
its own sake and for the sake of its audience, and it wants to seem to be inevitable
and complete, the creation of magicians. This is what is called the "genius ideology."
Tearing apart the organic work of art was the accomplishment of the avant-garde,
which revealed the inner mechanics of traditional illusionistic art, the stagecraft
of the masterpiece. To a great extent, I agree with that process, and I like a lot of
avant-garde art very much; it's very important to me. But I feel that it's an unfree
way of relating to it to erect it as an absolute standard, against the aspects of the
unified work which I like. I like the idea of the unified work because I like pictures,
and there is always a sense in which a picture exists as [such] through its unifica-
tion, [through] its precisely pictorial unification. I think the art of the past is not
as unified as the avant-garde polemic needed for it to be, or [made it] appear to
be. There are always acknowledgments of contingency and a sense of alternatives
in good work from earlier times, probably very far back in time. So, firstly, there
probably is no completely unified work, outside some very specific limits, at least,
none in the tradition that we've been talking about. But there is the phenomenon
of unity in a work, the way it might be experienced as a unity, even if, when you look
closer at it, it displays or at least indicates, or hints at, its own contingency. That phe-
nomenon, that moment of appearance, that moment of the experience of the work's
unity, remains important. That moment, that instant, will always be there when we
experience good art, even if we are experiencing a work which rejects the whole
idea of unity, like in radical avant-garde or neo-avant-garde art. So, I see the unity
of the work of art as an unavoidable moment of the making and of the experienc-
ing of any work. There is a dialectic in all of this, not two antithetical forms, each
complete in themselves, one coming after the other in time and rendering the first
one "obsolete"—a favorite polemical term of the proponents of the new orthodoxy.

And, just an aside, I would say that it was always my experience that the criticisms aimed against so-called pre-modern art were not terribly accurate, and they were tendentious, in that by trying so hard to break away from the past, a lot of avant-garde artists and writers, critics let's say, exaggerated the flaws or weaknesses of the art of the past so that they could get away from it. That's just a rhetoric of the avant-garde, and the times made it necessary; OK, but let's not live under that as some kind of law now. You look at so-called pre-modern art—I say "so-called" because I don't really think it's un-modern whether it's Caravaggio or Botticelli or Durer, it's not as unified as those writers made it out to be. The antithesis between avant-garde art and "museum art" is less pronounced than the avant-garde wanted it to be. Older art is much richer and more nuanced than a lot of the arguments give it credit for being. It's kind of obvious by now, how adolescent a lot of avant-gardist attitudes were—the "burn the museum" attitude from the 20's, from Dada through the 60's.

DS: It's still there though. It's still around.
JW: It's still here, but it's maybe not as dominant. Anyway, for these kinds of reasons, I could begin, in the 70's, to distance myself from that kind of avant-gardism, to try to find other qualities that would go somewhere, without in any way opposing the idea that all contemporary art has to experiment, and has not to follow formulae, no matter how correct the formulae might be. I don't think that that was accepted, at the beginning anyway, and my pictures were often looked at as a simple recovery of the Old Master artists, an unproblematic "return to tradition."

DS: Rather than growing out of their reaction; a reaction to their reaction?
JW: Only slightly a reaction to their reaction.

DS: That in a good way, that is, not just as a reneging of their reaction.
JW: I think that the critics, when they are triumphant, when their cause is dominant, are very unobservant. And that's probably the case with some of the reception of what I was doing and still am doing.

DS: But now, there's a lot of what I call "monumental photography." Surely there wasn't when you were starting. Do you see yourself as part of a zeitgeist?
JW: I hope not.

DS: Andreas Gursky and Wolfgang Tillmans are also making a sort of "monumental photography."
JW: I think that there's a lot of big photography. Photography's gotten a lot bigger in the last ten or twelve years, because it's become a kind of known thing that a photograph can look great on that scale. So that now it's become something

that everybody can do. The scale of the photograph has been experimented with, for decades, but it's now become a known and popular artistic phenomenon. I worked on it; lots of people worked on it. But I think it was inherent in the nature of photography for that to happen. It was inherent in the fact that once photography got taken more seriously, and was practiced in a more experimental way, a way that was more like the way people practiced other art forms, that newer elements of its nature would appear.

Classic art photography, which was very much the predominant language until about the 1970's, was based upon the documentary model. And it seemed to be satisfied with a small image, related to the world of book publications. There was no interest in larger scale photography, and there were no grounds for it. Only when people came from outside the classic domain of photography and started practicing photography, did some of these things that had been neglected get [reconsidered]. What I think is positive about that is that photography can function in the world very interestingly as art and can be experienced as art at a larger scale. But now anyone—all the art students do it, because it's just…done.

It doesn't mean anything anymore as experimentation, but it is now freely available as one of the actual capacities of the medium. The experimental work done since the 70's has unlocked a lot of aspects of photography that weren't really available, or were blocked in a way by the sort of perfected aesthetic of documentary-type photography.

DS: So you don't see yourself as a documentary photographer in any way?
JW: Sure I do. I think that all photography contains an element of reportage, just by nature, and so, everybody who practices it comes into relation with that aspect in one way or another. What's interesting is that there's no one way, anymore, to come into that relationship. I think in 1945 or 1955, it was clear that if you wanted to come into relation with reportage, you had to go out in the field and function like a photojournalist or documentary photographer in some way; that was expected and everyone expected it of themselves, and there was no very clear alternative. No other aspect of photography was really taken seriously, and that was great nevertheless, because classic documentary photography really is photography; it really does connect to the nature of the medium. But, still, it does not cover the horizon. There are other practices that are equally deeply connected to what photography is, and as well, there is no single way to satisfy the documentary demand. There's no one way to come into this relationship with reportage. I think that's what people in the 70's and 80's really worked on; not to deny the validity of documentary photography, but to investigate potentials that were blocked before, blocked by a kind of orthodoxy about what photography really was.

NATURA PICTRIX
Peter Galassi and Vik Muniz

Peter Galassi: I think it might be useful for people to know a little bit about what you did before you started making the work for which you have become known.
Vik Muniz: It would be easier to start listing things I didn't do before turning to art. Even though I have drawn compulsively since I was a child, it never occurred to me to become an artist. When you are born in Brazil in a working class family, you think of things like being a doctor, an engineer or TV repairman. I studied media with emphasis on advertising, I was involved with theater and taught life drawing. I also did an infinity of odd jobs to be able to support myself a nd although they are not worth mentioning, they are just as important a part of what informs my work today.

PG: For a while the medium of your finished work has been photography, but that hasn't always been true. What did you do before and what drew you to photography?
VM: I experimented with a lot of things but never felt like becoming a specialist in anything. Maybe because I was so involved with image-making in advertising and theater, I was drawn to sculpture and object-making. I always made things that had certain identity problems: a pre-Columbian coffee-maker, a game joystick disguised in an Ashanti figure or the entire *Encyclopædia Britannica* bound in a single volume. I had fun concocting these things but I did not see them as sculpture at all. They were more an exercise, and an excuse, to experiment with the greatest possible variety of media in a single context. Painting, drawing, and sculpture as single disciples had no meaning to me. I was really interested in how all these different manifestations get inserted into the make-up of culture as a whole, and I thought that by working on a single medium I would be perpetuating the habit of not looking at art as a system of relationships. In other words, I had a keen interest in art as a whole and not as a collection of independent disciplines. Photography appeared initially as a tool for documenting this confused array of experiences but, as I started to become conscious of its power of synthesizing many elements into a single structure, it gradually became the end result of most of my work. Once you photograph something you make, you not only document it but also idealize it. You take the most stupid snapshot and it will still be something that started in your mind. You make it look more like that image in your mind that led you to create that object. That somehow brings a sense of closure; an idea going full circle, a way to evidence how your own imagination survives being digested by the material world.

Photography is also the way that at least half of the knowledge—why not say the *feeling*—of the world comes to me on a daily basis. And since a great part of what I am is photographic, I felt that understanding photography a little better would help me to understand myself.

PG: Like many artists, you tend to work in series, and each series is made under a certain number of conditions and rules. What are the rules for each of the series you are exhibiting at the CNP?

VM: I think this game-like structure is as fundamental in the making of series as it is in the making of individual works. The difference is that the more you play the game the more chances you get to improve the score or to test different strategies. Most of the works chosen for this exhibition reflect a decade-long interest in creating interactions between photographic and non-photographic representations, mainly ones that are about drawing.

The Best of Life series, for example, are drawings of very famous photographs made entirely from memory. When the drawings were good enough to look like a bad reproduction of the original image, I photographed them and printed them with the same half tone pattern we usually see in these images for the first time in the papers. In these works I tried to find out what a photograph looks like in your head when you are not looking at it. They carried the structure of the famous news pictures but they were in fact very different.

PG: Allow me to interrupt you for a moment to say that I think that, if most people—including most curators of photography—performed the same exercise, your versions would look like masterpieces of Michelangelo in comparison.

VM: In fact I tried to make the drawings look like anyone could've done them. The body of work that started with the *Wire* series had a different focus because it was a way to fuse two seemingly contentious media, photography and drawing, in a single image. When you blend these two kinds of representation, you create a perceptual rift—you are not just looking at something, you are actually feeling vision itself. I started with the wire pieces because they conveyed the familiarity we share with pencil drawings. I always use images that appeal to something you think you already know. I tried to make landscapes with them but I realized I needed something with more volume to pass on a sense of perspective, that's how the thread series came about. I went on exploring different genres of representation and different rendering strategies. In the most recent series, I have gone from lines to dots and pixels. In the soil series for example, my interest was to experience drawing on a luminous surface rather than on an illuminated one, and try to make a conceptual connection with this and the idea of the negative in photography. Basically,

I am trying to compound an epistemology of flattened visual forms. All these things, while they remain photographic objects, they attempt to make the viewer examine the role of representation as an exchange and interaction of forms rather than an improvement on a specific one.

PG: You have said that you have tried many experiments, most of which have failed. Could you give an example or two of something that didn't work and explain why and what you think you learned from the failure?

VM: I learned to live with it with no hard feelings. Once I tried to produce a likeness of an unknown movie star with M&M's, trying to copy the dot pattern we are used to seeing on billboards. Well, because of the scale discrepancies and the unwillingness of such stubborn candy to stay in place, I did not get a picture and ended up in a mild depression cured only by the amount of M&M's I was left to eat. Good thing M&M's taste good and I wasn't drawing with cod liver oil. Failure is sort of background for things that miraculously manage to transcend their original meaning. When you look at a map, you see all the roads and cities, and then, the empty spaces that the mapmakers try to fill with silly icons and sea monsters so as not to look too boring. That's how I visualize failure: as this interstitial space that keeps the roads from coming together running in the same direction. Everything that successfully conquers any identity is surrounded by this wasteland of semi-developed forms. The purpose of science, for instance, is to extend the reach of these cities and roads in a linear way. The artist, on the other hand, works more like a surveyor of these empty spaces. Art is somehow like brain-science; you only get to know how something works by looking at things that have stopped working. I have failed so much that I now stand on failure itself. It has become my work place and where I harvest my best ideas.

PG: It might be said that you are not a photographer at all, in the conventional sense. After all, everything you present as your work is photography, but everything you have photographed is something you have made.

VM: I photograph what I paint and I paint what I can photograph. You have to be Man Ray to make good art based on principles. I am a photographer because my work ends up being a photo. Now, if the definition of a photo extends beyond this premise, we will be talking about different kinds of photographs. Still, I think that a photograph is always something that you made before you clicked the shutter button. Perhaps the first photo ever taken, Niépce's view of rooftops over Saint-Loup-de-Varennes, was a truly pure photograph. The second one he took, he was already comparing nature to the first photograph he had taken. When the concept of improvement enters the observation of reality, we can no longer separate mind from phenomenon, it all becomes a kind of collaboration, a conversation, a judgment. It's not that I don't believe in anything spontaneous

about a photograph. I simply think that any good picture should emphasize the photographic act as a part of its make-up. Some people may find it hard to call what I do photography, but I don't feel myself so very distant from the wedding photographer who asks people to smile before he takes a shot. I usually choose to work with perishable or unstable materials because I want to emphasize the temporal element in every picture. They are records of short performances, about a second long, enacted exclusively for the lenses of my camera, but they are nevertheless photographs of something that happened in time, like in any other photograph.

PG: *Part of the pleasures viewers get from your pictures is an appreciation of the skill and effort that went into making them. It's as if you had built a contraption the size and complexity of the Taj Mahal in order to boil a pot of water. On the other hand, if you succeeded perfectly, then your art would be a failure, wouldn't it?*

VM: Success is simply a failure to fail. You may not know this, but the Taj Mahal was actually made to boil water for tea, but since it didn't work, the Rajah gave it to his wife as a gift. I once had a car that had the most incredibly stupid design and as a consequence, nothing worked. I had to repair it every other day. That car did not take me anywhere but taught me all I know about car repairs. In a VCR manual, for example, a generic line drawing is supposed to describe something and in most cases it does so very well, and for that same reason I have never seen one of these drawings on anybody's wall. I always thought that people invented the movies because some photographs lacked the narrative flow that we find in paintings. They lacked the little mistakes and failures that make the mind of the viewer travel not only to the time of the picture but also to the moment of its making. A great picture describes an event while telling you how the artist felt and what he or she was thinking while the event was recorded. Like the old car I was talking about, it is designed to give a lesson on picture-making. The artist does enter the picture through a complex system of marks that are not necessarily part of the visual experience of the event. Skill is precisely the subtlety in which the artist enters the picture. It comes naturally and it is almost inevitable. An artist can only really fail if he imagines himself apart from what he is trying to describe.

PG: *You have said that there are two distinct threads in your work. On with what you called "interpretation"—with photography's power as a cultural symbol. Wouldn't it be fair to say one thread leads inward toward the labyrinth of art and the other leads outward toward the world outside the studio?*

VM: In one way or another my work aims at meeting the viewer halfway by betting on the assumption that the viewer will already have a preconception of what I am about to show him or her. In *The Best of Life* series, for example, the

viewer was fooled by what he thought he knew of the picture. In works such as the *Wire* series the effect is similar but based entirely on personal archetypes. One tendency of works such as *The Best of Life* series is to talk about the experience acquired through media. The effect of these works is based on previously acquired knowledge and their structure is essentially indexical, while other works such as the wire picture try to stay away from cultural references, concentrating primarily on the perceptual response of the viewer, their structure is of a more iconic order. Another distinction that can be drawn between these two trends is that one type of work deals with the illusion of a consolidated visual universe and the other with the idea of illusion itself. In both cases, however, I am still trying to gauge the effects of images by reducing their representational value to a bare minimum; in *The Best of Life*, I aimed at producing the worst possible picture that would still pass for the real one. In the wire, thread, and chocolate pictures, I tried to produce the most rudimentary form of illusion, one that was still capable of fooling the eyes of the viewer. I don't want the viewer to believe in my images; I want him or her to experience the extent of his or her own belief in images—period. That can only be done with images that can easily be taken for granted. I was once fooled by a street child in Rio. Anger past, that somehow made me feel like a child again.

PG: It's part of the historian's job to trace the evolution of artistic traditions, but of course the paths of creativity are always more complicated and quirky than the neat outlines we draw. In addition, I've noticed that in the messy variety of contemporary art, each artist seems to be obliged to assemble his or her own pantheon of creative ancestors. What does yours look like?

VM: It's even funny to think of it because I believe that if I had to list everyone who as influenced my work we would have to write another book. It would be called: *My Heroes from Aristotle to Wegman*. But there are a few special ones: I have always been interested in the circus and street magicians, the kind of entertainment that counts on the poorest kind of illusion-effects and demands enormous amounts of belief and imagination. Things that allow the viewer to exercise his human qualities rather than admire those of the artist. People like Federico Fellini, who could not only tell stories, but also show you how much we need to believe them. Man Ray, of course, is my role model, an artist of human scale, human skill, and superhuman curiosity. Max Ernst is another inescapable one. Warhol. There are also writers, the most special of all being Roger Caillois, whom I humbly consider a spiritual partner. Recently I discovered another great writer and I was thrilled to find out that he is my age—his name is James Elkins. As this list grows longer it becomes increasingly unfair. I would like to say that I have probably taken inspiration from anyone who had an idea that could have been one of mine. Complicity is always the fuel of veneration.

PG: You are a person of great kindness and generosity, so I suspect you will find a way
to dodge this question gracefully. But I wonder: is there any art you really hate?
VM: Hate is usually a great sign of interest, I can only hate things that I am somehow interested in and have a specific opinion about it. Bad art is usually the one that does not even deserve aversion. For that reason I don't know much bad art because I ignore it and don't remember it. Coming back to hate, interested hate, I hate art that attains the "look of art" by trying to be something other than art. This may sound old fashioned and retrograde but for me, if something doesn't look like art, it probably isn't.

Section Two

How Others See Them:
Considering the
Photographer

WILLIAM KLEIN
Brian Palmer, from Klein Symposium Statement

Herein, the student-assistant examines the manner of the master and what he learned.

I had neither training nor complexes. By necessity and choice, I decided that anything would have to go. A technique of no taboos: blur, grain, contrast, cock-eyed framing, accidents, whatever happens.
> —William Klein, 1954 (from William Klein, *New York: 1954–55*, Del Lewis Publishers, Manchester, England, 1995)

It's difficult to talk about what Bill Klein actually does, how he works. Klein's style—his attitude, and approach, if not his method—is so deceptively simple. Bill Klein was in New York early last March on a Guggenheim fellowship photographing for his latest book, *Close Up*. He was to be in New York only for a week; he hired me to handle the logistics of his New York shooting: finding interesting visual stuff, tracking down leads and ideas he'd come up with, arranging for passes, permissions, and tickets, figuring out transportation routes, and so on. I was to give him a no-frills menu of, in his words, "what's going on in the City." He gave me a brief, fairly vague list of people, things, and places he wanted to photograph—factory workers in their work environment, dancers, behind the stage during a performance of "Black and Blue," sports events at Madison Square Garden, demonstrations, the police. He used words like "action" and "energy" and phrases like "something pretty wild."

I'd been scheduling shoots for Klein for a few days before meeting him, though I'd spoken to him on the phone many times. I contrived a reason to tag along on a shoot I'd set up at CBGB. I implied that my presence would expedite matters downtown, get him in good with the band and all that. Klein

had been to CBGB, the infamous downtown club that's played host to such weighty personalities as Sid Vicious and Václav Havel, many times, he told me. He'd grown up in New York. He knew the place quite well. But he invited me along anyway. After short introductions in front of the club, which, because it was only 10 p.m., was empty, we headed up the block to a cheesy lounge-type restaurant to kill an hour until the first band. I can't remember exactly what we talked about, besides his shooting schedule. He told me about growing up, going to school, and photographing in New York and getting hassled for taking pictures. It really wasn't much of a conversation. I was nervous; Klein was preoccupied with the distressingly mediocre musical combo on the makeshift stage, directly behind me. The group had a Vegas-on-a-shoestring feel to them—tuxes for the guys, a recycled prom dress for the torch singing woman who fronted the group. Klein excused himself from our chat in midsentence and, Leica in hand, headed toward the band. He asked whether they'd mind if he photographed them. I assume they agreed. They started performing again. Klein watched them closely for a few long moments, made a few exposures, then he returned to the table, where we talked for a few more minutes about benefits, balls, Guardian Angels (the subway-riding kind), funerals, the Emergency Services Unit, Broadway musicals, and experimental dance troupes—people and situations he wanted to photograph in the coming days.

Back at CBGB, while the first band was wailing and screeching through their first set, Klein was moving around the club, which was still pretty empty, Leicas out, cigarette hanging from his lips. Klein had forgotten to charge his battery for his Vivitars, so I loaned him my Quantum. I felt a little more…useful. He made an occasional exposure, but seemed more engaged in sizing people up. One gets the impression from watching him work (and talking to him) that he's damn near self-sufficient, almost self-contained. He moves through space and among people with authority, as if he's moving through his own living room among guests. Klein assumes he has the right to be there, wherever *there* may be; and moreover, that he's got the right to photograph. He's relaxed when approaching people, thoroughly un-self-conscious and self-assured. Klein gets close to people, literally steps into their space; he comes close enough to intrude—and close enough to be turned away.

But no one turned him away at CBGB, at least not that I saw, which is a strange thing in New York, especially among the trendy, jaded downtown set. Klein's would-be subjects all looked flattered, curious, and, maybe, in one or two instances, mildly annoyed; but for some reason—his air of authority, physical stature, his ingratiating bemused smile—folks deferred to Klein, and allowed him to photograph them, to work with them—or on them.

Klein works like an irritant and a catalyst. He's bold, often intrusive, not surreptitious in the least. He's not after candids. Klein imposes himself on situations. And people perform for Klein; they primp, posture, clown, menace. People

go off for Klein. A fashionably dressed solitary young man (all black clothes and sunglasses, as I recall) affected an attitude of irritation at Klein—until Klein, again with that gracious smile, focused his Leica on the poseur, who, with equal grace, postured for his impending immortalization. I don't think Klein took that picture.

People hang all over the place, doing their thing all over the frame for Klein's camera. Though Klein is not in the picture, it's apparent that he has caused or provoked a particular situation into being; his presence is unmistakable in the photograph. Though it's clear that Klein fundamentally wields some sort of power over his "subjects" in the relationship—*the power to represent*—in a small way he gives people a little autonomy, which the typical photographer-subject relationship often denies the latter. Klein cajoles and occasionally directs but fundamentally, he lets people dictate the terms for their own photographic reduction.

It's interesting to hear Klein talk about photography and about culture. He's wonderfully frank about the ubiquity of images and their power to represent. Klein said of reading Susan Sontag's *On Photography*:

> So who can pin down photography? We're drunk with images. [Sontag's] sick of it. I'm sick of it. But we're moved by old amateur photographs because they aren't concerned about theories of photography or what a picture must be. They're just photographs without rules or dogma.

Perhaps his comment is a bit disingenuous. Klein's does have a dogma, if ill-defined or not explicitly (in much of his work) political, a powerfully witty and cynical worldview that dovetails with his strictly wild aesthetic. Klein is, as John Heilpern calls him, an "anarchist spirit." To that I'd add Klein's profound distaste for the staid, quotidian, and unquestioned, and his desire to manipulate and efface traditional boundaries and conventions.

The phrase "strict wildness" refers to a phrase used, and coined, by Peter Viereck in an article that appeared in *Poets & Writers* magazine in 1989 titled "Strict Wildness: The Biology of Poetry." In the piece, referred to in a *Village Voice* book review by poet/literary critic Verandah Porche, whose name I'm growing to love, Viereck weighs in on the side of Formalist poets, the defenders of iambic pentameter, couplets and quatrains, in what Porche calls the "Form vs. Free Verse fracas." Crossing media boundaries, Viereck's maxim, "no to formless wildness; no to the rigorous strictness of rigor mortis; yes to strict wildness," seems roughly applicable to Klein's photography. Klein combines absolute technical rigor with a seemingly anarchic aesthetic. Klein's control over the functional aspects of his photographic practice is near absolute, despite the wild, entropic appearance of his photographic compositions. Well-managed entropy. In the 1981 Aperture monograph on Klein, John Heilpern refers to Klein's "deliberate antitechnique."

Within these firm methodological parameters, however, representations collide and contradict each other in the same frame. Klein's work is so disturbingly subjective, the referents for his work are unclear in the canon of straight photography. Klein's photographs represent more than simple "decisive moments"; they are constructed moments that refer constantly to the role of the photographer not as documenter but as catalyst, and the fundamentally subjective nature of the photographic enterprise.

Klein has talked a lot about his work during his career, as have others, though folks seem to be talking about him quite a bit more these days. "Anybody who pretends to be objective isn't realistic," Klein said in an interview with Ian Cameron and Mark Shivason on cinéma vérité for *Movie 8*, quoted in Jonathan Rosenbaum's essay for the Walker Art Center publication on Klein and his films [from 1996].

> I liked Cartier-Bresson's pictures…but I didn't like his set of rules. So I reversed them. I thought his view that photography must be objective was nonsense. Because the photographer who pretends he's wiping all the slates clean in the name of objectivity doesn't exist. Take the picture of May Day in Moscow. With a fifty-millimeter lens jammed between the parade and the sidewalk, I would have been able to frame only the old lady in the middle. But what I wanted was the whole group—the Tartars, the Armenians, Ukrainians, Russians—an image of empire surrounding one old lady on a sidewalk as a parade goes by. In photography, I was interested in letting the machine loose, in taking risks, exploring the possibilities of films, paper, printing in different ways, playing with exposures, with compositions and accidents.

Klein's photographic work, for me, is curiously, and wonderfully, antiethnographic. To Klein, it seems, we're all others—Muscovites, New Yorkers, Parisians, black folk, white folk, Asian folk. The conventions of "objective" documentary photography—an isolated subject in her or his environment, crisp focus, "normal" perspective, candid or dignified posed moment—are thrown to the wind. Klein's work doesn't classify or taxonomize people beyond the camera's inevitable reduction of living folk to two-dimensional representations in silver.

Klein was working with a wide lens at CBGB, a 28 or a 35, I think. Watching him, I thought about my work, my concerns, the photographic strategies I use, and the way I relate or don't relate to the people I photograph. For me, photography represents an insoluble paradox. I take straight pictures. I embrace and fear the photographic processes' ability to represent things, the camera's inherent ability to analogically render the stuff of reality, decontextualized, on film. As an African American, an Other in lit crit/art crit speak, I think— *I obsess*—about representation, the ways in which pictures have been used

historically as tools to construct society rather than reflect it. I think of ethnography, Madison Avenue, and Hollywood. All of this intellectualizing and theorizing slows me down at times, and keeps me from making pictures. It's necessary (thinking) but I've chosen a medium, *a plastic medium*, whose limitations are precisely its strengths. At best, the photographic enterprise can be an exchange between photographer and photographed, perhaps not equal but at least collaborative. Ultimately, Klein's pictures—and, I believe his photographic practice—connect him to a worldview that embraces complexity and grapples with the abundant contradictions that make life interesting and "documentation" impossible. Klein's images, his words, and his methods speak directly to the infinite possibilities of photographic representation and the role of the photographer as an actively engaged director/participant/co-conspirator. As Klein said in that interview for the Aperture monograph, "Why must a photograph be a mirror?"

Klein didn't need anymore help after I lent him my Quantum. I introduced him to the band's drummer when they finished playing. He took it from there, pumped arms, made conversation, did some last minute skulking around the ersatz dressing rooms, and popped a few final exposures. He was completely in control and on his own. So I picked up my camera and started making pictures.

LISETTE MODEL
Max Kozloff, from *New York: Capital of Photography*

In his exploration of New York as a great center of photography, an important critic examines Model's seminal role as a teacher and her psychological break with the conventions of street photography.

Model had great compositional skills. She placed bulky presences in taut spaces, as if each had no further business than to be destined for the other. When she applied this resource consistently to pictures of different subjects, they acquired a grandeur of design, no matter how tacky the locale. New York itself did not inspire her photograph style, which had matured in Europe, but the city did give Model an enlarged stage for her encounters with social phenomena. Since she was prone to viewing them as theatrical events, the word "stage" is appropriate. Weegee, too, had a sense of theater, but it was centrifugal, whereas, Model's was centripetal, a drawing in toward the center. So accentuated is this centering that her pictures almost have the density of still lifes, even when movement is explicit in the scene. Yet Model cropped her photographs, to avoid symmetries. A staggered yet powerful rhythm marks her studies of New York feet in motion. They come close to abstraction in their cadence of shape and interval while also expressing the inexorable crunch of the street.

When she peered into store or restaurant windows, however, Lisette Model accomplished something even more original. Glass is a comprised surface: transparent yet also reflective, it picks up echoes of objects from behind the viewer and veils some that are before her. We find such visual disjunction in many photographs by this petite woman, who used to meditate on solitude in New York. The man in a Delancey Street restaurant becomes a figure estranged in a play of light and shadows projected from multiple sources. He's kind of *untermensch* hemmed in by a real interior, yet randomly camouflaged by a spectral urbanscape. In this photograph, the setting itself gets into the act as a reflective overlay on the man at the right.

Delancey Street, on the Lower East Side, a neighborhood filled with crypto-Europeans, reminded Model of Paris. Such a memory may be at work in the apparitional quality of *Reflection, New York* and other photographs she took of city windows, where near and far had their counterparts in present and past. During her European youth, Model had a long spell of psychotherapy; in New York, she was a displaced person living by her wits in a precarious field. Whatever they may reveal about perceptual aspects of New York streets, the windows also tell of the photographer's self-reflection. All those scurrying feet in her sidewalk pictures imply, perhaps, the impetus of a crowd that she could never understand, while all those ambiguous nuances associated with

glass windows may speak of those individual experiences that can never be retrieved. Almost as if these had to row against these wayward currents, Model developed a style that was simultaneously punchy in layout yet undecidable in content.

The art of Lisette Model signals a break in what might be called the psychological evolution of New York photography. It's manifested in her attitude toward the citizenry, so often interpreted as a misanthropic stance. She was unquestionably equipped with satirical impulses—as was Weegee. Both could give a caricaturist's wicked attention to the human face. One look at Model's picture of the cheaply jeweled and plumed denizens of Asti's restaurant is enough to show us how easily she could turn them into fools. This hostility runs through a number of brilliant, well-received pictures she took of vulgar, avaricious, and narcissistic behavior in chic New York nightspots. But when Model turned her gaze toward the destitute, she squeezed lemon juice on a few of them, too. And this, in some quarters, would be hard to forgive.

Just the same, a case for Model as an antihumanist photographer is hard to establish. It was human inwardness that concerned her and the lack of it that she attacked. This distinction would never have occurred to Weegee, the comedian. Model's art veers toward the tragic. Where he was a gymnast of disparagement, almost asking you not to take him seriously, she employed a selective malice. It is quite true that she took advantage of people—including poor ones—who could not imagine the unflattering guise in which she would portray them, but her photographs suggest that vacuous behavior, as much as a *spiritual state*, is not confined to just one class.

Model was the first socially conscious photographer of New York to operate beyond the gravitational field of Lewis Hine, whose faith in progress and in the camaraderie of work had had its day. Model came from a ravaged Europe in which the idea of social justice was temporarily obliterated, but she saw that American democracy did little to acculturate human deviance, or to help the destitute. Hers was less a dispirited or fatalist view than fascinated recognition: she depicted misfits, dropouts, and poseurs as charismatic, irrepressibly flawed beings in a cruel environment.

In her private teaching, which exerted and influenced deep and wide, Model emphasized that the greatest failing of the photographic practice was indifference. When she approached a reality or an oddness that could be sinister, it was as a fully engaged artist. In contrast, anecdotal or even reportorial photographers were likely to be disengaged, for it was the story that mattered to them, not their feeling. Where others might judge her beggars to be afflicted loners, she saw them as "strong personalities" with whom she identified, because her life either had been or could be like theirs.

DIANE ARBUS
Shelley Rice, from "Essential Differences: A Comparison of the Portraits of Lisette Model and Diane Arbus"

One of criticism's more enduring voices, Shelley Rice focuses on the essence of Model's greatest pupil.

In her introduction to the monograph entitled *Diane Arbus*, the artist stated: "I remember a long time ago when I first began to photograph I thought, there are an awful lot of people in the world and it's going to be terribly hard to photograph all of them, so if I photograph some kind of generalized human being, everybody'll recognize it. It'll be like what they used to call the common man or something. It was my teacher, Lisette Model, who finally made it clear to me that the more specific you are, the more general it'll be."[1]

Model's lessons were well learned by Arbus, but they were filtered through a sensibility which was as different from Model's as was Arbus' background. Born in New York City in 1923, Arbus was the second of three children, whose father, David Nemerov, owned a large Fifth Avenue department store called Russek's. Arbus grew up in an upper-middle-class Jewish environment, which in itself is not so extraordinary. What was unusual, however, was her response to her upbringing in this environment: "One of the things I felt I suffered from as a kid was I never felt adversity. I was confirmed in a sense of unreality which I could only feel as unreality. And the sense of being immune was, ludicrous as it seems, a painful one. It was as if I didn't inherit my own kingdom for a long time. The world seemed to me to belong to the world. I could learn things but they never seemed to be my own experience." This sense of separation from the world, of immunity from other people's experience, grew from a very personal, very specific childhood trauma into a general vision of people's unbridgeable isolation from each other—and as such it became the basis of the photographic vision which, more than any other, expresses the alienation and the disillusionment that surfaced in America during the 1960s.

This sense of isolation irrevocably separates Arbus' work from Model's. It also helps to clarify the difference in the way these two women use their cameras. Model's vision is penetrating; she wields her camera aggressively and uses her lens, like the cutting edge of a razor blade, to slice through social niceties and expose the people and personalities they conceal. There is a stinging harshness in Model's images, but implicit in the photographer's aggressive attitude is a deep-seated trust: that there is something essential to expose, some common denominator that binds all people, that runs deeper and is more profound than external mannerisms or circumstances—and that this essence can be uncovered through close scrutiny.

There is no such trust in Arbus' gaze; in fact, this photographer's camera continually negates the possibility of penetrating—or even understanding—the depths of another's experience. "What I'm trying to describe," she once said, "is that it's impossible to get out of your skin into somebody else's. And that's what all this is a little bit about. That somebody else's tragedy is not the same as your own." Feeling always like a "tourist" (Susan Sontag's word)[2] in her own life, Arbus took up the camera in order to gain license to become a tourist in the lives of other people.

The relationships that Arbus established with her sitters were complex. Unlike Model, who doesn't speak to her sitters before photographing them and therefore makes her assessments on visual data alone, Arbus made friends with her subjects and often, especially if they were social outcasts, became involved in their lives. Her ability to do this is often cited by critics as the reason why her portraits should be perceived as both compassionate and courageous, but the photographer's motives were not that simple. For no matter how friendly Arbus became with her sitters, she remained a socially acceptable member of the middle class—and as such was free to come and go, to enter into and then pull back from situations in which her sitters were trapped either by birth or by circumstance. And Arbus was well aware that her mobility gave her an edge in these relationships.

The artist's self-conscious awareness of her distance and her isolation allowed her to transform the voyeurism implicit in picture-taking into an assertion of power over her sitters. These people functioned as found objects for Arbus, providing her with ready-made access to vicarious experiences from which her camera both distanced and protected her. "I have this funny thing which is that I'm never afraid when I'm looking in the ground glass" she said. "But there's a kind of power thing about the camera. I mean every one knows you've got some edge. You're carrying some slight magic which does something to them. It fixes them in a way." She also said her vacillation between experiencing the ingratiation of her sitters and asserting control over them made her feel "kind of two-faced." Yet, ethics aside (for the moment), the disturbing impact of her images lies in their ability to communicate—simultaneously—both of these contradictory responses.

The complex ways in which Arbus used her camera parallel the complexities of her relationships with her sitters. Where Model is actively aggressive, Arbus was passive/aggressive, and she used her camera in a manner that was both tentative and quite manipulative. Her tentativeness is evident in the way she approached many of her sitters. Generally seen from nonthreatening social distance, her subjects are often posed. Aware of the camera's presence, they project their self-images quite consciously to the artist's lens, perhaps because Arbus was always careful not to probe beneath these external displays. In most of her photographs, in fact, Arbus' gaze rests on the surface; there is very little

penetration of inner motivations or individual personality within her oeuvre. And this is true in spite of the intimacy her portraits project. The intimacy projected by her photographs is, in large measure, the source of their manipulation—both of the sitters and of the viewers. This intimacy is communicated in several ways, and in all of these ways Arbus' images differ radically from Model's.

The younger artist, first of all, worked not only within public but more often within private spaces. Where Model's figures tend to dominate the picture plane, leaving little room for their environments to act as more than settings or elements within the compositional design, Arbus' subjects are often surrounded by paraphernalia which provides a great deal of information about their lifestyles and which takes up more space within the frame than the sitters themselves. Note for instance, an image taken of a window in her New York City bedroom, an image which depicts the sitter as small and almost overwhelmed by the lush draperies and the elaborate array of bric-a-brac that surrounds her. In fact, in Arbus' photographs the details of the sitters' life styles, the space they inhabit, the clothing they wear (or don't wear) are often more assertively described than the psychological and emotional characters of the sitters themselves—even though these people pose for the camera with an openness and trust that seems both touching and "intimate."

Arbus reinforces this feeling of intimacy by her choice of pictorial devices. Unlike Model, who chooses to photograph from a low vantage point and thus to exaggerate the scale—and aggrandize the emotional/physical stature—of her subjects, Arbus photographs her sitters head-on, from a conventional, eye-level point of view. There are no heroes in these pictures; there are "just plain folks," who candidly look out at the viewer. The sense of identification such a visual relationship provokes in us is strengthened by Arbus' straightforward "no-style." Whereas Model uses compositional elements to attain an esthetic distance, Arbus asserts the documentary, descriptive qualities of camera vision, emphasizing her subject matter and correspondingly de-emphasizing artifice. Her work thus achieves the "realistic," spontaneous look and feel often associated with family snapshots. In having chosen to work within the unpretentious "nonart" language of popular imagery, Arbus used the signifying power of her style to reinforce the sense of identification she consistently attempted to forge between her sitters and her viewers

Yet the irony of Arbus' work is that she tried to undermine the social order while working very much within its dictates; indeed, the very impact of her pictures depends on the existence of the norms she purports to challenge. Although the accepted social standards of normalcy are not immediately evident in her photographs, they are everywhere by implication; they function as the source of her vision and as the framework within which her rebellion achieves its meaning. These norms provided the negative impetus against which Arbus created—and against which she defined her vision of the world. And, most important, they

provided her with the negative standards by which she judged the worth—or lack thereof—of human lives. These inverted social definitions allowed her to make blanket assessments of whole classes and types of people that were startlingly simplistic and naïve, that had little to do with individual personality or situation and everything to do with the external mannerisms or appearances that defined position within the social order. By perceiving outcasts as "aristocrats" and the bourgeoisie as a sideshow of oddities, Arbus created new standards that were as shallow—and as stereotypic—as those that she despised.

ENDNOTES

1 This and all subsequent quotes by Arbus are from the introduction to the monograph, *Diane Arbus*, Aperture, 1972.
2 Susan Sontag, *On Photography*, Farrar, Straus and Giroux, 1977, p. 57.

ALEXEY BRODOVITCH
Kerry William Purcell, from *Ballet*

The biographer of Alexey Brodovitch sheds light on the designer/ photographer's opus book of photographs, *Ballet*, in which he captured the action and passion of the ballet on film as though it were produced with paint on canvas.

> *[For] Brodovitch . . . the Ballet Russes brought back impressions of his own boyhood in Russia, the memories of family theater parties and of poignantly butterfly-brilliant creatures on a magic stage. . . . He was not photographing strangers, he was photographing his family. . . .*
> —Edwin Denby, Introduction to *Ballet*

Fresh from the horrors of the Great War, Paris in 1920 marked the beginning of a decade-long experiment of artistic and cultural invention that forever changed our ways of seeing. The desire to awaken senses deadened through battle, to shake off the intolerable burden of the past by questioning the values of the present, led artists, intellectuals, and writers to make an immediate break with tradition in search of the modern and new. Over the coming decade the artistic energy emanating from the French capital operated as a creative magnet, attracting immigrants from all over the world. One such émigré was the twenty-two-year-old Alexey Brodovitch. As part of the mass exodus from the Bolshevik Revolution of 1917, Brodovitch, like many others, sought a part in this play of new perspectives and thoughts. Arriving in Paris, via Constantinople, in 1920, he had dreams of becoming a painter. After a number of menial jobs, it was a fortuitous meeting with the impresario of the Ballet Russes, Sergei Diaghilev, that assisted Brodovitch in his step towards realizing this ambition. As a fellow Russian immigrant, Diaghilev offered Brodovitch work painting stage sets for productions that would have ranged from Stravinsky's *The Rites of Spring* to Tchaikovsky's *Aurora's Wedding*. Working alongside such figures as Nijinsky and Massine, this experience had a major affect on the young Brodovitch, sparking a lifelong fascination with ballet that would never diminish. It was an enchantment with dance that culminated, twenty-four years later, in the production of one of the most groundbreaking photographic monographs of the twentieth century.

Eventually journeying from Paris to America in 1930, Brodovitch rejected painting to become one of the earliest proponents of the camera as a valid tool in the graphic arts. Influenced in Paris by the work of artists such as Man Ray and László Moholy-Nagy, in America he became a pioneer in combining photography and design, of bridging the gap between art and industry. Through celebrated

publications such as *Harper's Bazaar* (1934–1958) and *Portfolio* (1949–1951), Brodovitch's sensitivity toward, and treatment of, a photographer's work resulted in layouts that were both elegant and stylish in their simplicity. By allowing the internal dynamics of an image to direct the flow of a design, Brodovitch fused picture and page, type and image, creating a synthesis across a single spread, feature, or entire book; in such productions, the sweep of his layouts always compelled the reader's eye to follow this visual narrative through to its graphic denouement. The apotheosis of this approach was realized in Brodovitch's one and only book: *Ballet*.

Brodovitch himself never professed to being a photographer. Yet, between 1935 and 1937, he took pictures of several ballet companies—including the Ballet Russes de Monte Carlo—who were visiting New York on world tours. His intention, he modestly said, was to capture images "for souvenir purposes" only. Nonetheless, while the purpose of obtaining these photographs may have begun as a simple collection of mementos, the outcome was a body of work that signaled a radical departure from the pin-sharp imagery of the period. In the words of one colleague, Brodovitch's photographs "spat in the face of technique and pointed out a new way in which photographers could work."

Published in 1945 by the small New York publisher J. J. Augustin, *Ballet* was printed in a lavishly rich gravure style. It contains 104 photographs of various ballets and is divided into eleven segments, each one capturing a different ballet performance. The individual ballets depicted in the book are *Les Noces, Les Cent Baisers, Symphonie Fantastique, Le Tricone, La Boutique Fantastique, Cotillion, Choreartium, Septième Symphonie, Le Lac des Cygnes, Les Sylphides,* and *Concurrence.* Listed together on the contents page, Brodovitch takes as his influence the diversity of types that most probably appeared on the original posters promoting the inaugural performance of these ballets. By arranging them all on a single page, the eleven titles now seem to express, in material form, the emotional resonance of each individual dance. As a prelude to the stylistic photographs they announce, they are in turn elegant, fluid, robust, and flamboyant.

Ballet is an outstanding achievement of photographic invention. It seems that with the desire to capture images of his favorite ballet performers, Brodovitch gained access to all areas of the theater. Shot with a Contax 35mm camera, no flash, and, by today's standards, relatively slow film, Brodovitch's images would have probably been deemed disappointing by the average photographic teacher. However, as Christopher Phillips pointed out in his 1981 essay on ballet in *American Photographer* entitled "Brodovitch on Ballet," Brodovitch clearly perceived these first attempts as wonderful mistakes. Following the blurring of his first photographs Brodovitch might have turned to any variety of flash techniques, including Dr. Harold Edgerton's recently introduced electronic flash, as did Barbara Morgan and Gjon Mili in their dance photographs at this time. But Brodovitch had no interest in arresting motion; he knew that the

animal vitality and the suggestive power of the dancers' movements were at the very heart of ballet's unique stage atmosphere. In a leap of imagination, he suddenly saw the "mistakes" of his first photographs not as irredeemable defects, but as intriguing new visual possibilities. Instead of eliminating them, he determined to push them even further.

Brodovitch's images express the interior essence of the subject through an ability to capture pure movement. Setting the shutter speed at one-fifth of a second enabled him to trace the fluidity and gracefulness of the ballet dancers around the stage, amplifying their actions by "painting with light." Allowing the stage lights to flare and cause halation in the lens, he echoes the flashes and outbursts of music that would have accompanied these elegantly vivacious performances. Obviously thinking about his years in Paris with Diaghilev, Brodovitch's camera fizzes, erupts, leaps, and dives with the action of the performers. His "own performance as a photographer," Phillips observed, "is equally exhilarating and at the same time haunting. In these transient figures which swirl, swoop, spring, and spin through the pictures, we can catch a fleeting glimpse of Brodovitch's own memories stirring. Indeed, what these figurative shapes and unexpected transformations ultimately suggest is the phantasmagoria of memory itself." Reaching out beyond the decisive moment, *Ballet* strives to capture the before and after of the single snapshot. As Phillips intimates, in an attempt to reunite the false distinctions of space and movement in a profoundly radical way, Brodovitch's photographs mirror the fluidity of time in the unconscious. The trace-forms of the dancers; the waxing and changing of the dance; memories of his past and the continuity of the present: All merge on the pages of Brodovitch's *Ballet*.

Interspersed with Edwin Denby's introduction, *Ballet* begins with several images of dancers preparing backstage for the evenings performance. In the opening chapter, Brodovitch pictures Bronislava Nijinska's ballet *Les Cent Baisers*. Capturing the extended sweep of these performers, he signals his intention to produce a publication unlike any other. Joining two pages together to produce a unique graphic flow across the spread, the dynamic energy of the pictures are amplified by Brodovitch's treatment of them within the graphic space. By bleeding the images of the blurred spinning figures of *Les Cent Baisers* to the edge of the page, the photographs endeavor to break free and mirror the sensation and experiences of the dance. From this opening performance, the rhythm of *Ballet* gradually rises with the lyrical and vertiginous expression of the music, then descend to moments of quietude and softness. Page by page the orchestrated panorama compels our eye to follow the ethereal ballerinas of the *Les Sylphides* or the rush of the ghostlike characters of *Cotillon*. In *Le Tricone* we see jump cuts from one page to the next, the successive images seeming to elevate the heightened rapture of the dancers as they swirl to Manuel de Falla's score. Engaging the viewer's imagination, Brodovitch pursues within the viewfinder any graphic motif that would lend

the image added surprise value. For instance, throughout the early part of *Ballet* he frequently appropriates the backdrop to starkly crop events on stage. This is witnessed in a scene from George Balanchine's *Concurrence*. From the wings Brodovitch pictures two dancers in the same position. Flipping one of the negatives in the enlarger, the figures are made to mirror each other across the double-page spread. By bleeding the black vertical strip of the scenery into the gutter, these performers are brought into elegant relief by the "obstacle" of the set.

Viewed at the time of its publication, *Ballet* must have offered the reader an astonishing new vision. In his introduction to *Ballet*, the critic Edwin Denby appreciated the audacious nature of Brodovitch's imagery:

> When you first glance at them Alexey Brodovitch's photographs look strangely unconventional. Brodovitch, who knows as well as any of us the standardized Fifth Avenue kind of flawless prints, offers us as his own some that are blurred, distorted, too black and spectral, or too light and faded looking, and he has even intensified these qualities in the darkroom....What he took, what he watched for, it seems, were the unemphatic moments, the ones where the audience does not applaud but establish the spell of the evening.

As Denby acknowledges, Brodovitch sought to intensify the impression of movement in *Ballet* by manipulating the negatives in the darkroom. He enlarged just tiny fragments of the 35mm negative to stress the grainy and distorted properties of the image. He bleached out areas of the negative to heighten the solarization of the footlights and stage lights. He even covered the lens of the enlarger with cellophane, to produce a fade-out effect at the edges of the frame. The stylistic consequences of these techniques are witnessed in Brodovitch's depiction of Balanchine's *Cotillion*. Generating a delicate iris effect around the figure of Tamara Toumanova, the cellophane lends an hallucinogenic quality to the scene; glimpsed through a beclouded haze, Toumanova appears in a brief momentary illusion, a half-remembered vision from the evening's performance. As with the reverie of the blurred dancers, Brodovitch actively seized on the outcome of any beautiful "accidents" in the darkroom. "When the photographer Herman Landshoff was asked by Brodovitch to make the *Ballet* prints to be used for the book, he accidentally dropped a negative on the studio floor and stood on it. Quoted in Jane Livingston's monograph *The New York School: Photographs 1936–1963*, Richard Avedon remembers, Landshoff "was horrified and called Brodovitch and said a terrible thing had happened, one of the negatives fell and I stepped on it. And Brodovitch on the phone said, 'Print it exactly as it is. It's part of the medium, things like that.'"

Listening to Gioacchino Rossini's score for the Massine-choreographed *La Boutique Fantastique* (first performed by Diaghilev's Ballet Russes in 1919) while viewing this section of *Ballet*, we can almost see how Brodovitch's own movements with the camera are choreographed to the music. Shifting from staccato to adagio and then to andante, Brodovitch's photographs are harmonized with the score of the ballet. In the history of the medium there are only a handful of photographers who have attempted to push the visual potential of movement with the same level of intensity as Brodovitch does in *Ballet*. One of the earliest who did make a conscious attempt to examine the question of motion in his work, and whose compositions Brodovitch may have come across during his time in Paris, is the Futurist photographer Anton Giulio Bragaglia. As part of Futurism's philosophy, which proclaimed the death of all artistic forms of the past, Bragaglia coined the phrase "Photodynamism" to identify his novel approach to the photographic image. Bragaglia took photographs of various individuals in action that stressed the movement of the subject through an extended timeframe. With titles such as "Image in Motion" (1913) and "The Carpenter" (1913), Bragaglia's blurred imagery documents the physicality of movement rather than, as in the work of Eadweard Muybridge and Etiene-Jules Marey, frozen moments. In his 1911 manifesto "Futurist Photodynamism," Bragaglia's words have a resonance when viewing Brodovitch's *Ballet*:

> ... as things are dematerialized in motions they become idealized, while still retaining, deep down, a strong skeleton of truthIn this way, if we repeat the principal states of the action, the figure of a dancer—moving a foot, in midair, pirouetting—will, even when not possessing its own trajectory or offering a dynamic sensation, be much more like a dancer, and much more like dancing, than would a single figure frozen in just one of the states that build up a movement[These images] endeavor to extract not only the aesthetic expression of the motives, but also the inner sensorial, cerebral, and psychic emotions that we feel when an action leaves its superb, unbroken trace.

Bragaglia once said that "when a person gets up, the chair is still full of his soul." For the fashion photographer Irving Penn, the traces of light left by the dancers in *Ballet* represented, for the first time, the mystical value in photography.

Ballet was not given a widespread release by J. J. Augustin. The monograph only had a print run of around five hundred copies and it seems to have never been sold through any major bookstores. In fact, the only way that his colleagues and friends acquired copies of this rare book was through Brodovitch himself giving them away as gifts. The scarcity of the monograph was only exacerbated when, in 1956, a fire at Brodovitch's farmhouse in Phoenixville, Pennsylvania, destroyed the majority of the *Ballet* negatives, and thus, any chance of a reprint. However, even

with its comparative rareness, *Ballet* is still widely regarded as one of the most influential books in the history of photography. In the recent publication *The Book of 101 Books: Seminal Photographic Books of the Twentieth Century*, Vince Aletti noted that even "if the book's audience was limited, it was also quite select, and *Ballet* had an enormous impact among the design and photo cognoscenti." Its influence can still be felt today. As Aletti rightly notes: "No wonder; more than half a century later, the book still looks radical and still feels exciting."

AARON SISKIND
Charles H. Traub, from *Roadtrip*

Herein the editor celebrates his mentor and the humanism necessary for a great teacher and photographer.

And yet each piece of information about a place recalled to the emperor's mind that first gesture or object with which Marco had designated the place. The new fact received a meaning from that emblem and also added to the emblem a new meaning. Perhaps, Kublai thought, the empire is nothing but a zodiac of the mind's phantasms.

"On the day when I know all the emblems," he asked Marco, "shall I be able to possess my empire, at last?"

And the Venetian answered: "Sire, do not believe it. On that day you will be an emblem among emblems." *

Driving through Rhode Island with Aaron Siskind, I note with anticipation his intense observation of the patterns of interchange between mannered farmlands and the wild marshland that pass before us. I am hoping he will want to photograph, since he is not likely to go on his own at his age; I am anxious that he be productive. I point out a good vista, a likely subject for which to stop. I extol the virtues of this unspoiled state. The entangled roots in a grove of whitewashed trees will surely get his attention, I think. I slow the car down for his approval.

Finally he speaks. "I did something like that back in 1967." I remember that image, but this new situation seems to offer him many more possibilities. I stress that this is a remarkable bit of nature, but he retorts with a cutting chuckle, "The only nature that interests me is my own."

We continue our drive; he is content in examining all that goes by—stone fences, gnarled oaks, weathered barns. To me, they all contain perfect, transformed "Siskinds," but today, on this drive, he does not yet seem ready to work. He has not discovered the trigger of the phantasms.

The unique creative character of an artist is linked to the drive to rediscover the self in one's work. In Siskind's case, he is moved to generate from some random emblem or disfigured mark a means of ordering his universe. In his perceptions he discovers the magic of his energy and he renews himself. In a life like his, a number of elements must coalesce for the creative impulse to connect. It is not the subject alone or the site, certainly not any conjecture of mine or

* Excerpts from *Invisible Cities*, by Italo Calvino. © 1974 by Harcourt Brace Jovanovich, Inc. Reprinted by permission of the publisher.

of another, that determines when Siskind decides to stop. In his later years, he must find his rapport with what he sees as a "lively" place to work. His impulses are triggered by the meaning that he senses in places he visits, where many people come and go, where youth gather on street corners, where restaurants abound with talkative ladies, where workmen pass carrying loads of hardware, and the noise of a nearby market draws his attention in search of a souvenir, some trinket, preferably made by a local artisan. In a less active environment, there is not, perhaps, enough chaos to spark his need to photograph and thus order his perceptions. The "Old Man" lives vicariously on the energy of busy people.

The places described above may sound exotic, but while they are usually far away, they are not necessarily so. In recent years, Siskind has created images in some remarkable cities—Salvador, Lima, Naples, Barcelona, Vera Cruz, Marrakech—but he has also photographed in New York City; Providence, Rhode Island (his present home); and many "insignificant" places besides. Any specific working site of his is not what most would seek. There is a deliberate decision on his part not to be distracted by local temples of culture. Siskind's place of work is where the ordinary commerce of the community takes place. This might be an industrialized section of a large metropolis as well as a fish market in a rural village.

> *Isidora, therefore, is the city of his dreams; with one difference. The dreamed-of city contained him as a young man; he arrives at Isidora in his old age. In the square there is a wall where the old men sit and watch the young go by; he is seated in a row with them. Desires are already memories....*

The cities of Siskind's creative empire are essentially no different from the Lower East Side of New York, where he was born. Walking by the tailors' shops that line an old quarter in Naples, Aaron tells me of his father, who had also been a tailor, like the Neopolitans we were observing as they moved about their shop fronts. He discovers in the Italians a certain nobility that perhaps he had never seen in his father. Photographing in this vibrant city he abstracts in an image an emotion of re-experienced youth. He is captivated by the tailors' gesturing and mimics their indecipherable language. He is caught by the communication taking place between shop owners. A lift of the eyebrow, a wave of the hand produces a resplendent bolt of cloth, which, for some thousands of lira, can be made into a perfectly fitting short-sleeved, spread-collared shirt—the kind Aaron is accustomed to wearing. But he is uneasy with that sort of transaction and uses as an excuse that by tomorrow we may be photographing in some other locale and may not be able to return for the second fitting. It all seems to him a little too grandiose, a bespoken fantasy that exists for other people, but not for the tailor's son. Shortly thereafter he makes pictures of a stucco

sealant that holds together a hillside retaining wall. Memories are found in the transaction, not in the object.

The quantity of things that could be read in a little piece of smooth and empty wood overwhelmed Kublai; Polo was already talking about ebony forests, about rafts laden with logs that come down the rivers, of docks, of women at windows....

In another city of Siskind's dreams, Salvador, we pause daily to buy pastries from a native Brazilian woman in a bar. Stops at such places are frequent; while he often overdoes it, eating is a means of engaging the locals. This transaction takes place at a break in what has become a daily routine—photographing an almost infinite number of makeshift, oceanside bar concessions. After each night's closings, the primitive barstools are organized and stacked. Each proprietor has his own distinctly painted stools; the color and pattern mark each of them as individual property. Although the stools are basically the same in conception from one haunt to another, they are completely different in detail. Siskind sees in these wooden stools an endless number of configurations that relate to his own search for order. His vision is a kind if homage to the simplicity of the stools and their making. Inherent in his psyche there is some simple primitive identity of his own linked to the stools' reason for being—the festive carousing and release of a warm-blooded people. The "Old Man" is renewed by having made the images.

"Set out, explore every coast, and seek this city," the Kahn says to Marco. "Then come back and tell me if my dream corresponds to reality."

We might just as well have been in Isidora, Valdrada, or any of a number of the poetic cities. For Siskind, an excursion to photograph implies a notion that something exists away from home that will fulfill the self. It is a plan— an attempt to map the empire—that becomes a reality. For the 1982 trip to Marrakech, we considered a warm climate for a winter journey. The length was determined; a friend of a friend who was notified of Siskind's coming was asked to serve as an informant. The idea for going to Morocco emerged from a story told to Aaron by a young photographer recently returned from this exotic route. Aaron had seen in the photographer's peopled images the "lively" conditions. The ancient walls of the Medina were discussed as well as the local fish stew. There were tales of a day-and-a-half's journey to the hillside city of Goulimine, where the "Blue" people live and the desert town of Quarzate, where the best silver trinkets can be found. What motivated Aaron's calls to the travel agent and his willing coterie of young companions, who divided the needed responsibility of assisting him, was the promise that this new journey was going to be like the

previous one, but better! He had already imagined what it would be like to work in Marrakech, though he had no preconceptions of what he would find to photography. His anticipation of the journey to Morocco swept me away with him.

In the city called New York, we encountered a photographer shooting a nineteenth-century façade. Aaron overheard from the near distance my curious discussions with the self-confident image-maker, who told me he had made a "significant" photography by improving on a style of abstraction, compressing the façade into the flat plane of the ground glass. Impatient, Aaron motioned me away and remarked, "The difference between us and that guy is that we never believe our intentions. We don't discount the element of luck. You can't work without it." The scene closed as the young photographer turned quizzically, wondering what possible interest this old man could have had in his photographing. Aaron chortled his customary farewell salute, "Do-ooh, do-ooh, do-ooh!"

> Cities also believe they are the work of the mind or of chance, but neither the one nor the other suffices to hold up their walls. You take delight not in the city's seven or seventy wonders, but in the answer it gives to a question of yours.

For a few viewers, it is important to know how truly transformed a subject has become through Siskind's practiced eye. One can hardly imagine the scale of the wall in *Morocco, 93* unless one has passed within its bounds. It matters little to the content of the photograph that anyone should ever know, but there is an insider's bond in knowing how ambiguous and deceptive the camera's translation can be. The truth is in how you see it. We made the journey to the city of walls, Meknes, to see whether its battlements were in any way different from those in Marrakech. To me, one ancient wall looks much the same as another. I didn't understand why he didn't photograph the magnificent ones in Marrakech. Maybe he was just lazy? Perhaps the rain that day in Meknes transformed the absorbent surfaces of the wall so as to trigger Siskind's working energies. The walls are formidable barriers but penetrable by the imagination, which can reduce or enlarge them in scale, isolate a segment, recreate a mass. Likewise in the "Tar Series" one has no notion of the amount of road surface Siskind is passing over with his lens. A small dribble of asphalt has become a broad stroke of imagination. We are in Aaron's space, his wall, his pavement, his foreign city.

In yet another city in Brazil, Recife, I return every few minutes from photographing the sweltering beach crowd to observe Aaron meandering down a seawall intently photographing its weathered erosion. He is excited to show me the magic of time and, at the same moment, wink at the contortions of a pair of lovers on the beach. "It's a good place to work; lots of stuff here. You ought to go make that picture." He is commanding in his need to share through me the intimacy of the entangled couple. Most of the images

Siskind has made in the past ten years were made in the company of friends like myself. In these years, the desire to work alone must give way to the need for youthful assistant. The desire to escape routine is a necessary part of the personal creative act. Photographing now brings with it the shared joy of travel, although Siskind's intent is not to create a follower but to expand his energies through the help of another. He has retired from teaching; his print sales support him comfortably. These past years have stimulated freer wanderings. Though he seems to fatigue more easily, the journeys, which have become a needed constant in his life, have produced bodies of work that are complete in themselves. In this recent work, his creative time is concentrated, less disrupted, more focused in a specific situation of interest.

> *I am a prisoner of a gaudy and unlivable present where all forms of human society have reached an extreme of their cycle and there is no imagining what new forms they may assume. And I hear, from your voice, the invisible reasons which make cities live, through which perhaps, once dead, they will come to live again.*

In contrast to our present-day journeys to foreign cities, on my first road trip with Aaron we crossed the flat uninhabited Midwestern plains in search of pictorial forms in the American badlands. I was unsure about what we would find at our destination and mused about the photographic possibilities of more romantic places. I had recently been stimulated by *Living Egypt*, the most recent book by Paul Strand, whose rich "site-specific" documentary photographs were the most crafted I had seen to date. Imagining that the desert of Egypt was akin to our destination, I discussed the possibilities of Strand's approach to the subject at hand. I was taken aback by Aaron's consideration that each of Strand's later books had been made in exactly the same way, that they had failed to expand upon a notion of discovering new themes. For Aaron, Strand had worked from an ideological set of values which, in his later years, dictated a predictable set of pictures. "You have to work through a place to another." Today, some twenty years later, I analyze that discussion. Appraising my friend's late works now, I even conjecture whether his age has made him a victim of formula. As I labor over this dilemma, I discover, in scrutinizing the 1981 Vera Cruz and 1988 New York Series, that something has happened in these photographs that the young Siskind could never have produced.

Siskind's statement is no longer complete in the single image, though he might choose an archetypal one to represent it. A matured notion is distilled in a group of photographs constructed in or about the same or similar places or materials. The image or the representative idea is no longer a single photograph. The idea emanates from the flow and energy that rebounds from one photograph to another. A set of images found in one city allows for the departure to the next. We must see an imaginary city in a wall of photographs, or an entire

roadway in a series of black and white squares formatted by Siskind's camera for ease of imaginative traveling. The sequence of images in this book is a document of the photographer's wanderings. Ironically, the book form is not the ideal way to see the effort because its binding limits the number of reproductions and the infinite number of relationships and associations the roving eye can consume. To view it all properly, we should probably be in a huge convoluted gallery with numerous rooms; one, for example, which would contain themes of layered forms, another of iconographic marks that evidence man's passing. There would be the Moroccan room, the Brazilian room, and so on. Then and only then could we appreciate the subtle way in which Aaron Siskind has changed the scale of his thinking and our own as to what a photograph ought to be. His are no longer solitary remarks, but rather impulses from a continuous journey that stops at unique locales.

> *The catalogue of forms is endless: until every shape has found its city, new cities will continue to be born. When the forms exhaust their variety and come apart, the end of the city begins.*

These new works are complicated. Single objects do not get isolated. Faces appear within other forms. One stroke of paint is stacked upon another, and we tend to try to look *through* rather than *at* the subject. Form still dominates, but it is not contained; it breaks from the edge and wants to be seen in another dimension in the next photograph. There is motion in the pictures. It defines the form, which is not completely known until, in our contemplation, we have deciphered the entire body of work. In the city of Vera Cruz, around the town square, people assemble each evening to listen to the mariachi competitions. Music vibrates everywhere. Couples dance; shawl-shouldered grandmothers keep time rocking blanketed babies. The patterns of social intercourse change continuously. There is no picture taking for Aaron here, only observation and smiles. The next day, we stop by the boulevard leading to the square, where Aaron has discovered recently planted baby palm trees encased in burlap shrouds to protect them from the winds. Another series of photographs begins. The Vera Cruz series is only limited in possibilities by the amount and their relationships in endless ways. They are like the people milling in the square.

Siskind's imaginative journey of the past nine years winds from the boulevards of Vera Cruz to the highways of New England. At age 85, the road trips continue. His latest discoveries, the photographs in the "Tar Series," were made close to home, in fact from the road surface itself. An accident along the way, in Turkey, where he fell from a parapet, created multiple fractures of his right ankle and leg and resulted in months of hospitalization. There was fear that "Old Man" might never be creatively mobile again. Fear

lost out. The "Tar Series" visibly announces that Aaron is back on the road making pictures.

Today, the contrived is as much a norm in the photographic medium as the slice-of-time notion was the recent documentary past. Somehow, though, Aaron Siskind has remained uniquely faithful to a kind of photographic purity while moving beyond an immediate illusion to reality. He finds his vision in real time and space, each body of work is an assemblage of experience that transforms each focused locale, allowing for further travel in the mind's eye. This trip is a necessary passage for the photographer. Keep on traveling, Aaron, and thanks for taking us along.

Traveling, you realize that differences are lost: each city takes to resembling all cities, places exchange their form, order, distances, a shapeless dust cloud invades the continents. Your atlas preserves the differences intact: the assortment of qualities which are like the letters in a name.

GARRY WINOGRAND
Leo Rubinfien, from *Some Reminiscences*

Winogrand's great contribution to twentieth-century photography is still unfolding. In this lively personal reminiscence, he rightly emerges as a great mentor, sage, and friend.

I knew Garry Winogrand for the last decade of his life, from the year when I was twenty until the year when I was thirty. I met him when he came to Los Angeles to talk about his work at the art school where I was a student, and when Ben Lifson—the man in charge of the program there—couldn't do it, I went to pick Garry up at LAX. I'd like to say that I fell in love with him immediately, but I was halfway there before he arrived. I'd been fascinated by his work for months, though I doubt I understood it well. It's not easy to go back twenty-seven years, and recover much of the innocence of an earlier time in one's life, but I think that in those years—the early seventies—Garry's work looked very strange to most of the few people who saw it, myself among them; that it doesn't look strange now is a measure of how much it has made itself part our lives. In those days, he was commonly put into a box with Diane Arbus and Lee Friedlander—and many people became aware of him in the first place through that association—but no one had much trouble with either of them. Everyone got the sense of horrible, tragic failure and shame that permeates Arbus's work right away; everyone got Friedlander's irony, and the beautiful intricacy with which he constructed his pictures—but Garry's work was mysterious. It didn't help that not much of it had been published yet. At that moment, apart from his book *The Animals*—which had nothing like the epic reach of a full tray of his slides—there were only small groups of two or three or five photographs to be found in stray anthologies and journals: *Camera* came from Switzerland and was expensive for a student; *Creative Camera* came from London and was thrilling because it seemed really to have understood and to be promoting the work enthusiastically. The students who were interested in Garry's work—a small minority—collected these precious issues of European magazines rather as other students collected rare rock-and-roll records, and in the right circle, a set of them earned the owner a little bit of prestige.

The work never did what you expected it to do. It could well have seemed reasonable, for example, for somebody to make a picture of a baseball player signing an autograph for a boy admirer. You could imagine that—there is the boy gazing up at the hero, there is the hero carefully signing the ball—and you could imagine it with various shadings: with the rapture that the cloying Norman Rockwell would have put onto the boy's face; with the austere plainness Eugene Smith might have appreciated in the player's gaunt face and gristly, hard-trained body. But when Garry made the picture, the player was shoving his way through

a cluster of boys so roughly that the eyeglasses of the one nearest him were flying off. This was not supposed to be part of the story at all. Garry's baseball player was oblivious to the boys at the least—maybe he was even contemptuous of them—and in either case it would be all wrong, since heroes were supposed to be noble and gracious. Even worse, Garry's picture wouldn't really tell you what was going on. It would simply give you the nasty, violent facts of the collision, and just where you most wanted the photographer to step in and interpret them for you, to tell you whether the story would have a happy or unhappy ending, he would in fact step out, and leave you to reach your own conclusions. This could be frustrating, and it made many people angry at Garry, and made them denounce his work. I would like to think that, although I was only twenty, my instincts were a little better and that I recognized on some level that an artist who would let so much ambiguity into his pictures expected his audience to be intelligent. Perhaps, in fact, to be peers. But I don't really know if I recognized that. I do know that I found the mysterious quality that all of his best pictures had completely intoxicating.

Garry was more than old enough to be my father, and I was surprised (and am still surprised) that he took as much interest as he did in someone so much younger than he, and so very ignorant. I went to visit him in Austin a few months after we'd met. He was host, one week in March of 1974, to Walker Evans, who had come down from Connecticut and was being celebrated at the University of Texas—he was having a show, giving lectures, and so on. I told Garry that I wanted to be there for the Evans events, but in truth it was Garry I was going to see. For all my admiration for Evans's work, then and now, Evans at seventy-one seemed to be a man from whom the force and passion and mental strength had long since gone out, while in Garry they were fiercely alive. He surprised me again and again in those two or three days. I was sick with exhaustion from having sat up all night in Dallas-Fort Worth Airport, and we went for coffee. We were standing in line at the cash register, and as he took his money out I said, "That's all right, Garry, you don't have to pay for me," and he said, "I wasn't planning to." Now he didn't have to say that. The polite thing, where I came from, would have been to say nothing, or to pay after all. Well, clearly, he wasn't interested in being polite, but the surprising thing, the amazing thing, was that he wasn't being unkind either. In fact, a little later he apologized for not putting me up at his apartment. He said he'd have liked to, but that it was too small, and he'd arranged a bed for me someplace else, and that "I like to have a cup of coffee in the morning." He wasn't being unkind at all. "I wasn't planning to." His straightforwardness was fantastic.

I went to Garry's apartment, which was small and dark, and I was astonished to find his enlarger crammed into an alcove in the second bedroom, between the bed and the wall. He would darken the room, and stand there and expose a big stack of prints, then take them down to the darkroom in the art department at

the university and develop them in the communal trays, in which lots of students were doing their work at the same time. (It didn't seem to bother him to share their trough—in fact he seemed to enjoy shouldering in among them to land twenty of his prints in it for each one of theirs.) A typical professional photographer cherished his equipment and kept it meticulously; it was a mark of how seriously he took himself and his work. That Garry made prints in the bedroom was unimaginable. We sat in his living room and talked for a long time that chilly afternoon. I said something about the difference between people who were in love with the idea of being artists, and people who were really interested in making art, and I saw that at that moment I had won Garry's approval, and along with it came a confidence. He told me about his discomfort being Evans's host. Evans had never liked Garry's work—he had more than disliked it, while Garry admired Evans's above all else. Years before, in fact, Evans had wounded him painfully, and they had had no contact since then, but now Garry was at the height of his powers, and John Szarkowski—or perhaps Lee Friedlander—had urged him to show Evans his work again, during this visit, and a time had been set when he would do so, and he was approaching the moment with an amount of nervousness that I thought I had no right to see. Again he surprised me by letting me see it, and I could only think that he was strong enough to feel that he had nothing there to hide. I wish, I wish I could remember what in our conversation brought us, that afternoon, to the point where he said something astounding and beautiful. I had the feeling I was being given a gift, though he took no credit for this piece of wisdom. He was not its author; it had come to him. He said: "You have to realize you're nothing before you can be free."

I have never forgotten this. Of the many powerful things I heard him say over the years it was the most profound, and it explains a lot about him. It was also an injunction that I found very hard to follow in my own life. In fact, I would say that until a fairly recent time—many years after Garry died— when I was overtaken and heavily hit by life, I found it intolerable. I come from a bourgeois, well-educated family, and had grown up in prosperous cities and suburbs, and had been precious to my family and myself, and full of and surrounded by expectation that I would make my family proud. That I was *nothing*, or should have to become nothing, or realize that I had no value, before I could be free, before I might do anything of value? This seemed to be a horrible, unacceptable choice between pain and shallowness, that I could not, would not make—yet the truth of Garry's statement followed me down the years in spite of my most sentimental feelings about myself, and only later, I suppose, did I learn that there is a gentle element in that hard truth, a detail that he'd neglected to mention that afternoon in Texas—which is that *when* you realize you're nothing, it is not thanks to any choice that you have made. The realization is handed to you by life, and in spite of yourself; you do not achieve it, you are passive in the face of it, so that for a moment, you are

rather absolved of responsibility, and become lighter than you ever thought that you could be.

A lot of people in the world of photography hated Garry, and in one way or another they usually said that he was arrogant. All these years after his death, I was told this again five days ago by a photographer in New York, someone who happens to be quite talented. Personally, I don't think that people who said this understood what the word "arrogant" means, but this is neither here nor there. I suspect that if you could get most of those who complained about Garry's work to be truly honest—the meanest sometimes said that anyone could take his pictures, that if you gave a camera to a monkey you would get the same results—if you could get them to be honest you would find that they were really reacting not to the work at all, but to some incident in which, rightly or wrongly, they'd felt insulted by Garry. Garry *was* combative, and if you re-read the several published interviews he gave, and are able to hear his voice in your mind as you read, to hear how he says not "What does that mean?" but impatiently, as he bounces his knee at high speed, "What does *that* mean?" you will recognize the interviewers gulping and squirming, again and again, afraid to ask the next question, which they halfway know to be foolish. Afraid to give an opinion that would be conventional and innocuous in any other context, but for which Garry would land on them like a hammer. Tod Papageorge called him as a "talking lion," and I think that this is apt. "I'm a judge," he said; "I'm not a harsh judge, but I am a judge." At that particular moment he was talking about a Manhattan bus driver he had yelled at for being, he said, "unprofessional." But he was unforgiving of other photographers whose work was self-indulgent, or sentimental, or vague, or imprisoned by a rigid method of working, or built on cherished ideas rather than tried against experience. There is one celebrated photographer of whom he said "a bunch of pictures that almost make it as record covers"; there is another, a friend of his, of whom he said "Here's a guy who's brilliant, wild, an animal, but when it comes to his pictures he's a good boy for his mommy"; there is another, well-known for his moody portraits of his wife, pictures that were widely thought, quite inexactly, to be empathetic. Garry said of him, "You can tell he's a fascist. You can tell he *hates* his wife!" I went to graduate school at an eminent university the year after I met Garry, and insisted that he be invited up to talk to the students. He came up, and he and I and the department's three teachers had lunch. It was common for people there to say, when they liked a photograph, "Ah…that one is handsome. That's a very handsome piece…." and at lunch it was as if you had tied Garry to his chair. None of the three teachers knew what to say, so they said nothing. There were long silences on their side of the table, and they held the whole thing against me for months. For Garry's part, he said, out on the sidewalk, "Who are these people? They're dead!"

Why did his younger friends so love the way he would denounce one photographer or writer or another and say, "He doesn't know shit from Shinola!"—why would they so revel in his mercilessness toward the foolish, the sentimental, and those who lived to protect their vested interests? You know, there are no proofs in art, only assertions. Someone says that a particular piece of work is good, or bad, for any misguided or corrupt reason you might care to name, and there is no way to prove him otherwise. You can only say that he is wrong, and if he is well placed, you are alone. There is such a great danger in the arts, always, and especially to the young artist who has not yet found a core of truth from which he can work—there is such a danger of sinking into a swamp of subjectivity, of polite relativism. If you really believe in the functional importance—the importance in living—of the truths that pictures can contain, you will find many colleagues who give you every inducement to go take up some other line of work. If you really need pictures in your life—if you need them to work for you, to help you get through the day—then to hear "Ah, that's a very handsome piece..." or to hear that it's art if I call it art can make you very depressed. In a real way it is humiliating, for it says that pictures are less than you know and need them to be; that they are designs, decorations, bon-bons, or advertisements for yourself. At one talk he gave one year at the Museum of Modern Art, one careful member of the audience said to him tentatively, "Your pictures are very subtle," but Garry picked up that the young man was rather too pleased with himself for having chosen just the right word in a big room full of people, and he barked back, "What does that mean? They're as subtle as a sour pickle!"

Beyond this, it is worth straining a little to remember those years, the tail end of the 1960s, the opening of the 1970s. It was a time of god-awful pieties, on every side, of nauseating sincerity, of slogans that claimed to be truths but knew nothing of truth—and today it seems ironically fitting that in a time of such excessive sincerity Americans should have elected as their president a flagrant liar. At every moment, in his work, in his words, it seems to me that Garry struggled to return to the complexity of the world, with all its patternlessness and self-contradiction, as if the very act of stating a general idea falsified life. Those of you who knew him will remember how frequently he said, in conversation, "That's not what I said," correcting you as scrupulously as a lawyer to whom every single word had a precise meaning and could not be traded for a different one. This was not pedantry. It was an intense concern for protecting the real from our enthusiasms. One day in 1979 we watched a young woman walk down 53rd Street. She was wearing a skirt with a slit going up the side, almost to her hip, and as she walked, it revealed her thigh, and then concealed it, and then revealed it again, and then concealed it again, and we agreed that the excitement of it came from this hiding and showing. Garry said, quite rightly, that it was something that couldn't be photographed, except

with a movie camera. I said that it was better—sexier—than a miniskirt. "No!" he said, insisting always on precision, "No! A miniskirt is *just* as good."

He insisted that a picture was not the same as the things it showed. He insisted that the picture was not the same as the words people used to talk about it. He insisted that it was not the same as the intentions the photographer had when he made it. He insisted that the moment a particular picture trapped could tell you nothing about the moments that preceded and followed it. He insisted that what you knew about a photographer's life helped you not at all to understand his pictures. He insisted that what you knew about history helped very little and that you needed to know nothing about, say, the place you were in to make a good photograph there. He considered critics—with their love of the abstract theory—and criticism irrelevant, and after one panel discussion in Washington, D.C., whose host was a famous writer on art, he said furiously, "I'll never do that again. Each time you do that a little piece of you dies." He insisted that the photographer was only partly responsible for the picture that he made, and that the machine, the camera, was responsible for a great deal, perhaps most of it, and I think that there is implied in this the insistence that you do not know as much as you think that you know, or that you know what you know with different parts of the mind, and that only in some parts of the mind are we what we like to think of as conscious. In Texas, Walker Evans and Russell Lee joined Garry in the classroom one afternoon, fifty students were there for them, and one asked, "Uh, Mr. Evans, could you tell us how you teach photography?" and Evans really didn't want to talk about it and said something like that photography can't be taught, and then just wanted to get rid of the question and said, "Uh, Russell, why don't you tell them how you teach," and Russell Lee said, ponderously, "Well, Walker, usually I start them out with the 4 × 5, and then after they've done some work with that I let them have the 2 ¼, and then after that maybe they can have a 35mm…" and Evans cut him off sharply and said, "And Garry, how do you teach?" And Garry said, "Well, I'd say it's pretty much the blind leading the blind."

His well-known declaration, "I photograph to find out what things look like, photographed" baffled people, and was another thing that made some of them angry. I think I can identify two of the reasons why. One was that Garry was renouncing the idea that the artist is in control of the thing he makes. Photography is usually characterized (it always is, in Garry's work) by a delay between the making of a picture and the seeing of it. You only know what you have later, when you've been through the darkroom, and by that time you can do little to alter it, so to some extent you are working blind. Another was that he was refusing to claim large intentions for himself—to say *I photograph to bear witness to the grave events of my time; I photograph to set down on paper the essence of the spirit of America*—all he would say is that he photographed "to find out…" which seemed to some people to be at once a trivial aim and an ungenerously private one. If his

photographs are profound in their effect, which they are, I have to believe that they were also profound in their intention, but Garry was practically demure about his intentions, and it is curious that his detractors judged so modest a declaration to be arrogant. That they refused to hear the actual meaning of his words tells us how much they wanted artists to be makers of great pronouncements, geniuses, holy men, seers. That Garry refused to play any such caricaturish role tells us how resistant he was to conforming—in the way artists are expected to conform. It tells us how much he was truly committed to the primary job of the artist, which is to attempt to understand.

There was a terrific hunger in all this for—I want to say purity, but that word has so many connections to religion that we can't use it here, so I'll just say cleanness. For a way of knowing the world as uncorruptly as one could, as freely as possible of pretension and self-congratulation, of self-cherishing. Garry insisted that there was nothing glamorous about being an artist; that it consisted of putting one foot in front of the other for a very long time. "Your typical artist is a mule," he said, and if you complained that you were suffering from obscurity, from the want of recognition, he would tell you that you were deceived, that, no matter what you thought, "There's no band waiting to play." He would name photographers he thought highly of, but who cared too much about the love of the audience, and he would show you how they damaged themselves by so caring. He would refuse to give himself or anyone else too much credit for a great picture, and often said that "good photographs get made despite, not because." His hunger for an incorrupt way of knowing the world led Garry to renounce those beauties of design, and those beauties of the photographic print, for which other photographers strove, and in which they took much pride. There was in Garry a perverse refusal of the *idea* that the quality with which a picture was printed might make the photograph any better or worse (I say "the idea" because in fact his own prints are often beautiful). He would say that the legibility of the print was all that concerned him, and that he cared even less for the sequence in which one placed the pictures in a show or a book, or with the design of a book of one's work, and I have to believe that his inconclusiveness as an editor—and the inadequacy to his art of the five of his books that were published during his life—is connected with the same hunger. It is said of Kafka that he was loathe to bring his stories to an end because the ending of a story is so much an aesthetic device, so much a tying up for presentation, that it seems to serve the desires of the audience, which are outside the artist's fundamental search, and even, perhaps, opposed to it, and so the ending negates the work. And as, according to Kafka's logic, the ideal story would refuse itself a neat resolution, the ideal picture, according to Garry's logic, would refuse itself an obviously dramatic subject. In speaking of Robert Frank's work, which he loved, he often went back to the picture in *The Americans* of a gas station in the New Mexico desert, with

a sign overhead that says "Save." All there is in the picture is a rank of gas pumps, the sign, and the dusty bush that begins across the road. That it was so alive, when it had no obvious subject at all, thrilled Garry. Once in LA he drove with me to see a group show in which I had some pictures. There was one he particularly liked, and he said, "That's just beautiful. That's really a picture of nothing."

Though he made plenty of them, the pursuit of masterpieces would have seemed puerile to Garry, and in fact, the pursuit of anything that one could identify in advance seemed to him misconceived. I think that his best pictures must have given him pleasure, and made him feel what I call pride, but I have no evidence to show you. He was private about this, and, in any case, I don't think that that kind of satisfaction was really his objective. Yes, one photographed in order to get photographs, but not necessarily in order to get good photographs— one photographed in order to learn something. To discover something. And he said, "I could say that I'm a student of photography, and I am, but really I'm a student of America."

If you already knew what a good photograph was, you would be doing something you, or someone else, had done before, and in that case, what would be the point? The more things you recognized to be possibilities for pictures, he would say—the more varied these possibilities were—the less you were likely to be able to know in advance whether they'd work. You had to allow yourself to be led by pictures, your own or anyone else's, and the pronouncements of the Artiste, when he encountered them, filled him, I think, with disgust. His refusal to try to translate pictures into words was not, as one writer called it, anti-intellectualism, it came from the supremely intelligent awareness that sophisticated pictures cannot be summed up—that only they themselves can tell you what they mean, that if you could state their meanings in words there would be no need for them. At one point, if the right (that is, the wrong) person asked him for a definition of a photograph, he would say, "Some monkey business inside four edges." But Garry had also heard somewhere that Andre Kertesz, looking at the photograph he'd made on a hotel balcony in Martinique—where you see the ocean on one side and a frosted glass partition with the shadowy image of an aging man on the other—that Kertesz said that when he looked at this, he thought he was seeing his own death. This is something that Garry would never have said, could never have said, about one of his own pictures, but here it was Kertesz who'd said it, and Kertesz's achievement was high enough to support the statement, and far from ridiculing it, Garry passed it on to his students. I hope that this will put an end, at least in this room, to the frequently expressed idea that Garry was a so-called formalist—that he was not concerned with meanings. He was more concerned with meanings than any photographer I have met, but he would not stand for them to be trivialized with slogans or bad poetry, nor would he trust himself, most of the time, to do them justice with words.

There was so much *renunciation* of the self here that it enabled Garry to praise his own work without boasting. After a talk he gave at Queens College I told Garry how extraordinary were the 160 photographs he'd just shown, and he said, with genuine surprise in his voice, so that he seemed not self-aggrandizing, but humble, "And that's only the tip of the iceberg." It was as if his photographs were something outside himself, a vein of ore he'd been lucky enough to discover. I said that I loved his airport work. "It's amazing work," he said. He was not saying that he was proud of it. He was not, actually, saying that it was his. He was saying that he'd been amazed.

I never lived in the same city as Garry, and all our conversations took place in cars, in airports, hotel rooms, coffee shops, corridors in the halls of universities, his apartments in Austin and Los Angeles or mine in New York or someone else's; in streets, museums, Chinese restaurants, on beaches or on the phone, on the way from somewhere to somewhere. He would arrive in a city with a big Samsonite suitcase with WINOGRAND taped in eight inch capital letters across the side, and open it up in his hotel room and take out cartons of Pall Malls and a big bottle of whiskey, which he wanted you to know was cheap. One day in Manhattan we went through the revolving door at the Museum of Modern Art, where the low-ceilinged lobby was full of damp, milling people, and as soon as he got out of the chamber into the crowd he shouted, "We're here!!!!" Once, toward the end of a book party for *Women are Beautiful* at the old Light Gallery, I was collecting some friends to go back downtown to Greenwich Village, and they included a prudish girl who'd once been a student of Garry's, and I was working out who would go in which taxi and said to her—I must have been rather loud, because Garry was on the other side of the room—I said, "OK, and you'll go down with…" and suddenly he was bulling through the crowd grinning and yelling out, "Who's she going down on?" There are a lot of stories like this, many people can tell them…And then there was one time when we were again in the lobby of the Museum of Modern Art, some cold, wet day, and an aging woman in a heavy coat, trembling, was trying to make her way through the revolving door, but she was nervous and flustered, and tripping over herself a little. She had in her hands a small packet of postcards she'd just bought in the museum bookstore, and as she was spun rapidly forward inside the turning door, she lost her grip on the cards and they fell to the floor. Most people would have bent over quickly and snatched them up, or would have stopped the door, but she was too timid. Possibly she wasn't strong enough, but really it looked as if she was simply afraid to assert herself against the pressure of the people behind her, and so she put her foot down on her cards, forcing them forward along the muddy stone as she shuddered through, until she got out onto the sidewalk and onto her husband's arm, and by then, of course, they were completely ruined. Garry and I noticed this at exactly the same moment, and watched helplessly through the glass in fascination and horror and amazement, and then we began

to laugh. It wasn't giggling, but real, uncontrollable laughter, the kind that leaves you gasping. But you will misunderstand if you think that we were ridiculing her, though this is not to say that she wasn't ridiculous, because she was, of course. No, it was worse than that. It was that she was ourselves. That was the thing. She was a mirror. She was utterly, pathetically, trapped—trapped in her case by convention, only there is no convention that governs what you should do when you're stuck in a revolving door and you drop your postcards, so it wasn't exactly convention that she was trapped in either, it was the rock-bottom fear of other people. It was the pure failure to stand up and act, and we loved that because that was exactly how it is, how hard life is, just exactly that awful, and funny, and sad. (When people got too pious Garry sometimes said "Ah!…Herman Condition!") It was the unbelievable truth, which you can't get to if you're taken up, not with living your life, but with any of a thousand seductive, and foolish, and ultimately meaningless ideas about how you would like to look.

There is an extraordinary picture by Garry, two of whose four principal char- acters look as good as movie stars. As a matter of fact, the man has the splendid nobility of Sidney Poitier, while the woman, who has some of the delicacy of Ingrid Bergman, is feminine, dignified, alert, careful, lovely—she is perfect. They look like a couple (though who knows what they really were)—they have two children in their arms, and carrying them their posture is erect, their deportment grave, and they are altogether heroic in their aspect except that their two children are chimpanzees. Some people have complained about this picture on what they self-righteously claim are moral grounds—they say more or less that the picture says that a black man and a white woman who have a child will produce a chimp, and this is racist, or at least gives people bad ideas, etc., etc.—but this expresses a kind of sanctimonious thinking that Garry abhorred, and it condescends to the viewer and is worthy of everyone's disdain. It is a tragicomical *picture*, not an amateur's essay on genetics, and if it begins with a black joke about miscegena- tion, it says a lot of other things too, and its real meaning is in the combination of questions that it asks, not in the answers that it gives those questions, which it doesn't, because there aren't any. Is this what happens to people who are as rich, as favored with beauty as that, that fate rewards them with apes for kids? That's one question. Are these improbably perfect people really apes themselves, are their children their true face and their beauty just a mask? That's another. Look at how nobly they protect the babies—is that how blind we are? That we will protect as treasure that thing that mercilessly exposes us as ridiculous? Or, perhaps, are we not blind at all? Maybe we're not, but are, instead, authentically beautiful, protect- ing the thing that mocks us because this is our duty, which we will honor whether we want to or not. How much we love our progeny, no matter how pathetic it is! And look at how the chimpanzees burrow into the shoulders of the man and the woman, as loving, and as secure in their parents' love as any human being on the best day of his childhood. They know nothing of the anarchy and absurdity and

madness and terror of the world they have been born into—they ride on an ocean of love—or, again, is what we see here that the very idea of such love is an evil joke, that our parents are Gods to us, but in reality clowns? Or is it, in the end, that we cannot know if any of these things is the truth? That we are beautiful and ugly and deluded and noble and blind and loving and cruel, and that, before we can begin to find answers, or even complete the list of questions, the spectacle at which we look and of which we are also a part is already changing, and will throw up at us a new story, a new set of mysteries, and then another. We can run away from the vertigo this makes us feel, except that there is also something exciting about it, something fantastic. That something enables the seer, if he grasps it willingly, to become conscious—to *live*, as Garry put it, not merely exist, and his work is hungry—really, it's ravenous—for life. On Columbus Avenue, in some cafe, we were denouncing all the photographers who make collages of their pictures, or paint on or excessively control their pictures, who have to show their hands to prove to the world that they're artists, and that their pictures weren't just made by machines. I said something like that they were afraid to confront the world head on and find nothing there, and Garry said, "Yes, it's all a question of how much freedom they can stand." There was another panel discussion, on some stage at some museum somewhere, where Garry was asked by one more prominent interlocutor whether such-and-such marked a period in his work. He thought for only a second, I'm told, and then he said, "No, I'd say it was a comma."

LUIGI GHIRRI
Luigi Ghirri/Charles H. Traub, from *Statement/A Remembrance*

Since his death, Ghirri has been recognized as a giant of post twentieth-century European photography. How he got there is best understood in his own words, which the editor includes with his own appreciation.

The little man on the brink of the ravine.

Ever since childhood, the photographs I like best have been the ones of landscapes, which I used to find interspersed with the maps in Atlases. I was particularly fascinated by those inevitable photographs in which a little man appeared, immobile, dwarfed by the Niagara Falls, by mountains, rocks, very tall trees, majestic palms, or on the brink of a ravine.

I would find this little fellow in postcards depicting more or less famous squares, perched on historical monuments, lost among the ruins of the Roman Forum, or gazing up at the tower of Pisa.

This little man was in a state of continual contemplation of the world, and his presence lent a particular fascination to the pictures. Not only did he serve as a unit of measure for the wonders depicted, but this human unit of measure gave me back a sense of space; I saw him in this way and I believed that it was possible to understand the world and space through this little man.

I also liked the idea that the photographer was never alone in these spaces, but always had a friend or acquaintance at hand, who would travel the world with the photographer to discover and to represent it. I never managed to look one in the face, to give him an identity; the little fellow remained unknown, yet he accompanied me in the most fascinating and unfamiliar places, places which he observed, contemplated and measured.

Later on, when I started to take pictures myself, I went on looking at pictures of landscapes, but I couldn't find him any longer. Stupendous scenes, back-drops, increasingly deserted and incomprehensible spaces succeeded one another, broke up into pieces, multiplied in an increasingly dizzied fashion. But it all looked inhabitable to me, or rather the places had been dissipated; all that remained were magnificent back-drops in black and white or Technicolor; the little man had disappeared. He had gone away, taking with him the representation of places and leaving their simulacrum.

—Luigi Ghirri, 1988

It is always great folly to write about photographs, for the visual experience always transcends any description that words might tell. Particularly truly enigmatic photographs—like those of Luigi Ghirri. Like all good art, Ghirri's work is not about specific things. Instead they transform the experience that made them into something about themselves. Thus I cannot address them individually

but ask the viewer to really look carefully at them, particularly in relation to each other. The statement of a single image can never be as powerful as a body of work. This is particularly true of Ghirri's *oeuvre*, as he photographed in complex sequences and patterns, making the meaning of the photographs the collective synergistic experience of their themes.

Ghirri's subject, for lack of a better way to describe it, is the travelogue of Italy in the late twentieth century. As Heinrich Heine put it in *Journeys Into Italy*, "there is nothing so stupid on the face of the Earth as to read a book of travels in Italy—unless it is to write one." Ghirri reminds me of Heine, he mocks his own *Viaggio in Italia*, disclaiming the wonders for the pedestrian delights.

For me, Ghirri represents in his persona and his remarkable but short-lived life all that is wondrous in Italian culture. I first met him over twenty years ago when he guided me in my own photographic adventures through Italy. He was then as his legacy is now the catalyst for serious photographic activity in that country. He introduced me and other foreigners interested in the activities of our fellow photographers to a large number of young energetic image-makers, who, like Ghirri, were dissecting the physical and cultural topography of their environs. Like Don Quixote, Ghirri traveled relentlessly by car or train around his country madly in quest of his own inspiration but also for a livelihood through freelance commissions, consulting jobs and curatorial work. I saw him unshaven, elegantly wrinkled in the way that only an intellectual Italian can be. His persona was reflective of the frenetic incongruities he depicted. We are good friends, simpatico, totally in sync, but not understanding a word of each others' language. He was an unfailingly energy, seriously snapshotting to the end.

In the eighties, with fellow writer, Luigi Ballerini, I embarked on a visual and literary look at Italy in my book *Italy Observed*. Ghirri opened the doors to the rich contemporary photographic work ignored by the American cognoscenti (Mimmo Jodice, Olivo Barbieri, Gabriele Basilico and many others). Ghirri's work itself stands significantly besides his better know American contemporaries, such as Stephen Shore, William Eggleston and Robert Adams. Perhaps during the decade and a half when Ghirri worked, curatorial interests favored the detached dispassionate, cool eye rather then favoring wit. Although Ghirri's work manifested some of those same photographic interests, it anticipated something else. His concerns were postmodern before those words were bandied about in photographic circles. He believed photographic truths but in the act of photographing as a social phenomenon, a means of deconstructing the landscape and reinventing a hyper realistic space. Remarkably too in his work is the prescience of another genre to come. His images are diaristic notations in his own passage through the typologies of a collector's mania. However, unlike many works today which are obscurely narcissistic, Ghirri's vision does not require the presence of his physical self to understand the cultural life and the muse of postmodern Italy which drove him.

WRITERS ON PHOTOGRAPHY

In the following, these great writers offer vignettes on photographers, their culture and their practice. They help us to understand the image-maker as hero and antihero.

THE UNFORESEEN WILDERNESS
Wendell Berry

The mollusk-shell of civilization, in which we more and more completely enclose ourselves, is lined on the inside with a nacreous layer that is opaque, rainbow-tinted, and an inch thick. It is impossible to see through it to the world; it works, rather, as a reflecting surface upon which we cast the self-flattering outlines and the optimistic tints of our preconceptions of what the world is.

These obscuring preconceptions were once superstitious or religious. Now they are mechanical. The figure representative of the earlier era was that of the otherworldly man who thought and said much more about where he would go when he died than about where he was living. Now we have the figure of the tourist-photographer who, one gathers, will never know where he is, but only, looking at this pictures, where he *was*. Between his eye and the world is interposed the mechanism of the camera—and also, perhaps, the mechanism of economics: having bought the camera, he has to keep using it to get his money's worth. For him the camera will never work as an instrument of perception or discovery. Looking through it, he is not likely to see anything that will surprise or delight or frighten him, or change his sense of things. As he uses it, the camera is in bondage to the self-oriented assumptions that thrive within the social enclosure. It is an extension of his living room in which his pictures will finally be shown. And if you think the aspect or the atmosphere of his living room might be changed somewhat by the pictures of foreign places and wonders that he has visited, then look, won't you, at the pictures themselves. He has photographed only what he has been prepared to see by other people's photographs. He has gone religiously and taken a picture of what he saw pictured in the travel brochures before he left home. He has photographed scenes that he could have bought on postcards or prepared slides at the nearest drug store, the major difference being the frequent appearance in his photographs of himself, or his wife and kids. He poses the members of his household on the brink of a canyon that the wind and water have been carving at for sixty million years as if there were an absolute equality between them, as if there were no precipice for the body and no abyss for the mind. And before he leaves he adds to the view his empty film cartons and the ruins of his picnic. He is blinded by the device by

which he has sought to preserve his vision. He has, in effect, been no place and seen nothing; the awesomest wonders rest against his walls, deprived of mystery and immensity, reduced to his comprehension and his size, affirmative of his assumptions, as tame and predictable as a shelf of whatnots.

Throughout their history there, most white men have moved across the North American continent following the fictive coordinates of their own self-affirming assumptions. They have followed maps, memories, dreams, plans, hopes, schemes, greeds. Seldom have they looked beyond the enclosure of preconception and desire to see where they were; and the few who have looked beyond have seldom been changed by what they saw. Blind to where they were, it was inevitable that they should become the destroyers of what was there....

What will cure us? At this point it seems useless to outline yet another idea of a better community, or to invoke yet another anthropological model. These already abound, and we fail to make use of them for the same reason that we continue to destroy the earth: we remain for the most part blind to our surroundings. What the world was, or *what we have agreed that it was*, obtrudes between our sight and what the world *is*. If we do not see clearly what the nature of our place is, we destroy our place. If we don't see where we are, we are more dead than alive; if we cannot see how our own lives are drawn from the life of the world, and how they are involved and joined with that greater life, then we live in a deathly sleep, and such efforts as we may make to preserve the greater life will be inept and perhaps destructive. If like John Swift we do not know the country and its landmarks, if we are unable to see where we are in relation to it, then we lose it and lose its promised abundance. We lose our lives.

The effort to clarify our sight cannot begin in the society, but only in the eye and in the mind. It is a spiritual quest, not a political function. Each man must confront the world alone, and learn to see it for himself: "first cast out the beam out of thine own eye; and then shalt thou see clearly to cast the mote out of thy brother's eye."

And so from the figure of the silver hunter John Swift, I turn to the figure of the photographic artist—not the tourist-photographer who goes to a place, bound by his intentions and preconceptions, to record what has already been recorded and what he therefore *expects* to find, but the photographer who goes into a place in search of the real news of it.

His search is a pilgrimage, for he goes along ways he does not fully understand, in search of what he does not expect and cannot anticipate. His understanding involves a profound humility, for he has effaced himself; he has done away with his expectations; he has ceased to make demands upon the place. He keeps only the discipline of his art that informs and sharpens his vision—he keeps, that is, the practice of observation—for before a man can be a seer he must be a looker. His camera is a dark room, and he has made a dark place in his mind, exultant and fearful, by which he accepts that he does not know what

he is going to see, he does not know the next picture. He has entered into the darkness—in order to see! But for the moment the dark lens holds only a vague potency, like a lentil seed, still one with the mystery if what will come next, which is one with the mystery of the wilderness and of the creation.

And then there comes a breaking of the light—and there is another shore to step out of the dark upon, lighted by a blooming flower like a candelabra. We are invited on! We are led on as by the promise of a feast spread for us that we do not yet know. In the shadows a little stream steps down over a ledge of rock into the light. Beyond the trees, and the darkness again.

Knowing the heaviness of the dead-end search for wealth and ease, what a relief and a joy it is to consider the photographer's pilgrimage to the earth. He is seeking, not the ultimate form of the creation, for he cannot hope to find that, but rather the inexhaustible manifestations of form within creation. Walking through the woods, he finds within the apparent clutter of trunks and branches a row of trees, leading the eye on. He sees the entrance of the sun upon a rock face. Among the dark trees, time and again, there appears suddenly a tree of light. In the early morning the mist is white and thick in the valley so that the ridgetops seem to float in the sky; looking, one's eyes receive a kinship with the eyes of a sage in the mountains of China a thousand years ago. The light withholds itself from the darkness inside the earth, and the darkness in the earth opens out to the light. The paths and streams clamber through notches in the cliffs. In the narrow ravines the water flashes over the rock lip, enters the great calm and ease of falling, descending into shadow; and the trees strain up out of the tumbled rocks into the light. In the midst of its ageless turmoil in the Roughs of the Upper Gorge, the river breaks out of the rocks, collects in an open pool, and stands still. A small stream is flowing out of the dark tunnel it has followed down through the woods, entering the greater opening of the river—and a man is standing there, not the uproarious creature of machines, but just a man standing quietly there, almost hidden by the leaves. The photographer is nowhere to be seen. These images are the record of his pilgrimage, and he has moved on. Once, these served him as landmarks, each one defining his whereabouts and leading him on to the next, and thence on again. It is an endless quest, for it is going nowhere in terms of space and time, but only drawing deeper into the presence, and into the mystery, of what is underfoot and overhead and all around. Its grace is the grace of knowing that our consciousness and the light are always arriving in the world together.

The camera is a point of reference, a bit like a compass though not nearly so predictable. It is the discipline and the opportunity of vision. In relation to the enclosure we call civilization, these pictures are not ornaments or relics, but windows and doors, enlargements of our living space, entrances into the mysterious world outside the walls, lessons in what to look for and how to see. They limit our comfort; they drain away the subtle corruption of being smug;

they make us a little afraid, for they suggest always the presence of the unknown, what lies outside the picture and beyond eyesight; they suggest the possibility of the sudden accesses of delight, vision, beauty, joy that entice us to keep alive and reward us for living; they can serve as spiritual landmarks in the pilgrimage to the earth that each one of us must undertake alone.

Always in big woods when you leave familiar ground and step off alone into a new place there will be, along with the feelings of curiosity and excitement, a little nagging of dread. It is the ancient fear of the Unknown, and it is your first bond with the wilderness you are going into. What you are doing is exploring. You are undertaking the first experience, not of the place, but of yourself in that place. It is an experience of our essential loneliness, for nobody can discover the world for anybody else. It is only after we have discovered it for ourselves that it becomes a common ground and a common bond, and we cease to be alone.

And the world cannot be discovered by a journey of miles, no matter how long, but only by a spiritual journey, a journey of one inch, very arduous and humbling and joyful, by which we arrive at the ground at our feet, and learn to be at home. It is a journey we can make only by the acceptance of mystery and of mystification— by yielding to the condition that what we have expected is not there.

SHOTS
Cynthia Ozick

I came to photography as I came to infatuation—with no special talent for it, and with no point of view. Taking pictures—when *I* take them, I mean—has nothing to do with art and less to do with reality. I'm blind to what intelligent people call "composition," I revile every emanation of "grain," and any drag through a gallery makes me want to die. As for the camera as *machine*—well, I know how to press down with my finger. The rest is thingamajig. What brought me to my ingenious profession was no idea of the Photograph as successor to the Painting, and no pleasure in darkrooms, or in any accumulation of clanking detritus....

The truth is, I'm looked on as a close-mouthed professional, serious about my trade, who intends to shut up and keep secrets when necessary. I repel all "technical" questions—if someone wants to discuss the make of my camera (it's Japanese), or my favorite lens, or some trick I might have in developing, or what grade of paper I like, I'll stare her down. Moonings on Minor White's theories I regard as absolutely demeaning. I have a grasp on what I am about, and it isn't any of that.

WOMAN WAITING TO TAKE A PHOTOGRAPH
Dave Eggers

The woman is a young woman. She wants to make a living as a photographer, but at the moment she is temping at a company that publishes books about wetlands preservation. On her days off she takes pictures, and today she is sitting in her car, across the street from a small grocery store called "The Go-Getters Market." The store is located in a very poor neighborhood of her city—the windows are barred and at night a roll-down steel door covers the storefront. The woman thus finds the name "Go-Getters" an interesting one, because it is clear that the customers of the market are anything but go-getters. They are drunkards and prostitutes and transients, and the young photographer thinks that if she can get the right picture of some of these people entering the store, she will make a picture that would be considered trenchant, or even poignant—either way the product of a sharp and observant eye. So she sits in her Toyota Camry, which her parents gave her because it was two years old and they wanted something new, and she waits for the right poor person to enter or leave the store. She has her window closed, but will open it when the right person appears, and then shoot that person under the sign that says "Go-Getters." This, for the viewer of her photograph when it is displayed—first in a gallery, then in the hallway of a collector's home, and later in a museum when she has her retrospective—will prove that she, the photographer, has a good eye for irony and hypocrisy, for the inequities and injustices of life, its perfect and unmitigated absurdity.

Section Three

Finding an Audience:
Working with the
Professionals

THE LEGENDS

ALEXEY BRODOVITCH
Brodovitch on Photography

The art director who launched the careers of great photographers talks about his keen eye and great passion.

What is a good journalistic photograph? I cannot say. A photograph is tied to its time—what is good today may be a cliché tomorrow.

There are many so-called schools of photography but I really hate to put labels on things. Every photograph is really giving a personal visual report on something. Whether it's Smirnoff's [vodka] or the model Mercedes-Benz or some event on the street or something in the headlines, the problem of the photographer is to discover his own language, a visual ABC's to explain this event. The photograph is not only a pictorial report; it is also a psychological report. It represents the feelings and point of view of the intelligence behind the camera.

Each day the audience for photographs sees hundreds of pictures of high technical quality. The public is being spoiled by good technical quality photographs in magazines, on television, in the movies, and they have become bored. The disease of our age is this boredom and a good photographer must successfully combat it. The only way to do this is by invention—by surprise. The quality of surprise, in our profession of graphic journalism, is our major capital.

When I say that a good picture has surprise quality or shock appeal, I do not mean that it is a loud or vulgar picture but, instead, that it stimulates my thinking and intrigues me. Sometimes a very quiet and unspectacular picture can have surprise quality because of some stimulating and intriguing element.

Surprise quality can be achieved in many ways. It may be produced by a certain stimulating geometrical relationship between elements in the picture or through the human interest of the situation photographed or by calling our attention to some commonplace but fascinating thing we have never noticed before or it can be achieved by looking at an everyday thing in a new interesting way.

The best way to achieve surprise quality is by avoiding photographic cliches. Many photographers fail to produce stimulating work because they take the same picture over and over again or ones that have been taken many times before by other photographers. Imitation is the greatest danger of the young photographer. The greatest danger of the older photographer who has found approval and has become commercially successful is that he will fall into the trap of endlessly repeating himself.

All young photographers imitate others to some degree when they are first starting on but they must know when to stop and discover their own visual language. It is every photographer's responsibility to discover new images and a new personal way of looking at things. If he can do this his pictures will command attention and have surprise quality.

Everything is in constant evolution. We live in a dynamic age of atomic energy, exploration of space, miracle drugs and television. I feel strongly that mass communication, particularly visual communication, must keep pace and develop a new vocabulary; new ways to analyze, to report and to convince.

When I emphasize the importance of up-to-dateness in photography I do not mean that photographs which were done in the past are not important. Outstanding past work in photography, and in fact in all the arts, is very important to today's photographers. But it should be used for inspiration and not for imitation. These works should be something to be built upon, not to be repeated.

I really believe in progress and in revolt in every generation. Just sitting and admiring the work of the masters and then going out and doing the same sort of thing will not lead to progress. For this reason the work of a photographer like Karsh, which is a throwback to nineteenth century portraiture, is not very exciting to me. In the same way I am more stimulated and intrigued by Avedon's fashion pictures of models against the rockets at Cape Canaveral than I am by Bert Stern's fashion pictures of little girls in Victorian settings which seem to me very old fashioned.

I believe that the trend in today's photography is away from the obviously theatrical and staged photograph and toward the more spontaneous and sincere way of seeing. For example, in advertising there was a long cycle of very pictorial and artificial illustrations. It was the era of the martini glass against the background of the pyramids, or the other liquor ad which used a background similar to a famous Chirico painting. I think that the day of this type of photograph is over. Some of the new young photographers (Art Kane is a good example) have

broken the ice for a more spontaneous and casual approach to advertising photography. The new approach is more sincere and much more philosophical—it gets under your skin. I value shock appeal, but things should be used which could happen, not things which are obviously posed, obviously artificial only to meet the needs of that ad.

Every young photographer should understand that technique is only a means to an end. Anyone can learn to take a technically proficient picture and, once having learned this, all that counts is the taste and the personal viewpoint of the person behind the camera. Sometimes a revolutionary technique is used to express this, but this technique, for its own sake, cannot be imitated without producing a cliché. For example, I have recently seen a very intriguing book of nudes by the excellent English photographer Bill Brandt, photographed with an unusual wide angle technique. I do not think that photographers should go out and imitate the technique of Bill Brandt. These pictures should be used for inspiration not imitation. Technique as an end in itself is much too easy to imitate, but pictures with unusual techniques like the Brandt nudes are a good thing to go through a young photographer's system. I believe that any technique in photography is permissible if it contributes to the personal report being given by the photographer. All of the tools of the photographer should be used to this end. For example, one of the photographer's most important tools is cropping. I know there are some photographers who believe that the dimensions of the picture should not be changed in any way after it is shot but, generally speaking, I believe this is very limiting. I know that Henri Cartier-Bresson does not approve of anyone cropping his pictures. This may work very well for his particular personality and method of working. Bresson is a very great photographer and near to being a genius. For most photographers, however, I believe that it is a mistake to refuse to crop.

Photographers should make three or four prints from one negative and then crop them differently. When I was art director at *Harper's Bazaar* and at several agencies as a consultant, young photographers would bring me their portfolios and all the prints would be in the same standard proportions, either for the Leica or the Rolleiflex. Many times, by limiting themselves in this way, they missed the true potentialities of their photographs.

It is an excellent exercise for photographers to experiment with different croppings of their pictures. The cropping very often can create your new vision and help to discover and to explain your new language. Cropping is like all other techniques which can be used in shooting and in the darkroom. If they result in a more powerful expression in the final picture, the photographer should use them. I read in a profile in *The New Yorker* that the violinist Yehudi Menuhin is interested in yoga and that before each of his concerts he stands on his head. I don't care if he does this, if he plays beautiful music. It is the end result which counts.

ON SEEING

There are two phases of seeing in the making of a picture. The first takes place when the photograph is actually shot. This is when the instinctive decision is made which results in the picture being recorded on the film. The second seeing comes in examining the contact prints of the pictures. It is important to be able to recognize the pictures which express your viewpoint and also how these pictures can be printed and cropped to bring out that view point. It is also important to be able to recognize the lucky accidents which can often result in good pictures. When a photographer takes a picture, he does it because something has interested and excited him. He must become expert at studying his contact sheets to discover what caused that excitement.

The journalistic photographer must not only be a master of the technical skill which will allow him to get his personal vision on to the film but he must also be his own picture editor and art director. When he is shooting a commercial problem the art director and picture editor of the magazine or agency are there to help hint but they should never be a substitute for the photographer's thinking in these areas.

When he looks into his groundglass, he should see not only the picture, but also four pages or eight pages.

It is the photographer's decisions at the two levels of seeing the picture—when it is shot and when it is chosen and printed that determines his personal style.

When a beginning photographer first starts taking pictures, he generally shoots haphazardly and carries his camera about shooting everything that interests him. Sometimes a few of these pictures are very interesting because he has not yet become bogged down in technique, nor has he learned to copy anyone. There comes a time, however, when the beginner must crystalize his ideas and set off in a particular direction. He must learn that shooting just for the sake of shooting is dull and unprofitable and he must develop a general tendency in his work. With this maturity the photographer will begin to develop his own photographic vocabulary to express new discoveries of vision and understanding.

The pictures which a mature photographer takes are interpretations of their subject in terms of the photographer's own particular personality and interest. If he has inventiveness, photography can be completely rediscovered in his own terms. The precise still lifes of Irving Penn are very much an expression of Penn's personality, just as the emotional quality of Richard Avedon is expressed in his photographs. It is not necessary to be emotionally involved with your subject to photograph it. Some photographers, like Andreas Feininger, take very good pictures which are an expression of their detached, intellectual approach to their subject matter. I do not think that this lack of emotional involvement has a detrimental effect on a picture. It is the unexpected and the surprise quality of a personal vision, rather than the emotion, which make people respond to a photograph.

136

The personality and style of a photographer usually limit the type of subject with which he deals best. For example, Cartier-Bresson is very interested in people and in travel; these things plus his precise feeling for geometrical relationships determine the type of pictures he takes best.

When I was on *Harper's Bazaar*, I introduced Lisette Model. Her particular genius was on photographing the bizarre quality of human beings and finding beauty in the grotesque. If she were asked to photograph a boy and girl kissing she would be a complete failure but when photographing fat ladies on the beach she was wonderful. This is her style.

When Richard Avedon was guest speaker in my class, he said he could put a camera on a tripod in Times Square and push the button by remote control in his studio and still from a thousand negatives he would have one or two very good photographs. He pointed out that these pictures would not be a personal expression. What is of value is that a particular photographer sees the subject differently than I do. A good picture must be a completely individual expression which intrigues the viewer and forces him to think.

On Teaching

Although I have become known as both an art director and a teacher of photography, I really do not teach. My classes are not for the purpose of learning the technical aspects of photography nor are they concerned with a particular style of photography. They are really laboratories in which photographers are free to experiment and to find a direction for their work. In these sessions I am much more of a student than a teacher.

Learning Clichés

I, personally, am very much against, in principle, any art or visual education. It seems to me that education of this kind is potentially very dangerous and is likely to develop certain cliches. In my experience as an art director, students have come to me from different schools, from the Chicago Institute of Design, from the Art Institute, and from photographic schools. Everybody who came to my office would bring a certain type of picture—even mounted exactly alike. From the pictures I could immediately tell which school the student came from. This is a tragedy. Students must certainly go through a certain basic training to discover facility of self-expression. Certainly they must know technique. But the instructor or teacher should not be a pedant. Rather than a teacher in the accepted sense, what is required is someone to tease or irritate the student and to help him discover himself.

My classes are not a lecture or a club meeting. They are for the photographer who wants to work. In each session I give a "problem," which, over the course of the next week, the photographers will photograph. This problem is always general enough so that each photographer can interpret it in terms of his own interest and personal direction.

For example, one assignment I gave was "The United Nations." It was up to each photographer to tackle it according to his own particular approach. Some who were instructed in fashion photography used the United Nations as a setting for a fashion photograph. Others did architectural photographs or advertising photographs based on the U.N. Still others did reportage assignments on the people who work there or the visitors who come to see it. It is up to each photographer to discover the angle from which he will approach the subject.

Essence Captured

When we examine the pictures in class, they are first passed around so everyone is familiar with them and then they are discussed from the standpoint of creating a new vision and finding a personal direction. Many of these photographs are not completed work, but are a sort of "sketch" or preliminary experiment in a photographer's finding a new way to say something. Finally, I don't care if the student produces a photograph, or a design, or a collage or a sculpture. If he has avoided the cliche and captured the essence of the problem, this is the important thing.

Sometimes I give an assignment where the students experiment in photographing a simple geometrical shape. An excellent thing to use for this are the conical paper drinking cups which can be bought for a few pennies. The student can make constructions with them or hang them from wires or do anything he wants. If the students spend a week doing this, experimenting with the effect of light and shade upon this beautiful geometrical shape, they will learn a great deal about still life photography.

In my classes we talk not only about the students' work but also about graphic design in magazines, books, and newspapers. We discuss current examples. When we see an interesting picture in a magazine, the idea is not to copy it but to be stimulated by it to go out and discover something different.

On Photography Today

Most of the photography which we see today in magazines and newspapers is stereotyped and cliche ridden. In America everything is imitated so quickly and we see the same type of pictures over and over again. A dozen photographers working for a magazine like *Life* will bring back pictures which all look alike.

If a photographer sincerely tries to put the product of his reporting in such a magazine, he will probably be fired or forced to walk out as [was] Gene Smith. It is up to the photographer to decide whether he will be the slave of *Life*, *Look*, *Vogue*, or *Bazaar* or will they be his slave. This depends on his character and the strength of his determination. It is the responsibility of the art director of a magazine to have a concept of his audience and to find photographers to fit that audience. When I was art director of *Harper's Bazaar* I picked pictures for one audience. When I was art director of *Portfolio* (which was a magazine for graphic artists) I picked an entirely different type of picture.

A Photographer's Responsibility

Just as it is the art director who must be responsible to an audience, the photographer, if he is to maintain his integrity, must be responsible to himself. He must seek an audience which will accept his vision rather than pervert his vision to fit an audience. Unfortunately, many fine photographers never find this audience and are virtually unemployable in the commercial field.

The creative life of a commercial photographer is like the life of a butterfly. Very seldom do we see a photographer who continues to be really productive for more than eight or ten years.

Most advertising photography has remained static in a dynamic world. If the photographer is to survive, change is very important. Even if a photographer has been fortunate enough to find his place in the commercial world, he must constantly experiment to find new ways to say things and he must constantly go forward.

HELEN GEE
Limelight (Excerpt)

Helen Gee was an original—the seminal gallerist. In her own words, she describes how it was back in the day.

There's no telling what an empty stomach can lead to. Had I eaten breakfast that morning, cereal and eggs instead of toast and black coffee, Limelight might never have been born. I would have gone on with my own photography and left the pioneering to others.

Opening a gallery for photography had never occurred to me, and certainly, never a coffeehouse. All I had in mind on that fine Sunday morning in the fall of 1953 was getting in a good day's shooting. It was the week of the St. Gennaro festival on the Lower East Side, a perfect opportunity to start using color. I rushed through my morning rituals—walked the dog, fed the cat, and after seeing my daughter off for her weekly visit to her father, grabbed my camera and took the subway downtown.

The festival was in full swing when I got there. Mulberry Street had been cordoned off and for a half-mile stretch, from Chinatown north through the heart of Little Italy, the streets were alive with color. People came from all over, to eat, to stroll, to play carnival games, but it was the neighborhood Italians, dressed in their Sunday best, that gave the festival its flavor.

I fell in with the crowd honoring the good saint and for the first few blocks did nothing but savor the sights and the smells, trying to get the feel of things. I had studied photography with Lisette Model and was determined to follow her advice: "Don't shoot until you feel it in your gut."

Alongside the food stalls there were games of chance, where for as little as a dime and a bit of luck, you could choose from an array of prizes, everything from Hula-Hoops and Kewpie dolls to plastic Madonnas and bottles of scotch. I was tempted by a teddy bear, having my daughter Li-lan in mind, but I'd never had much luck with a roulette wheel, and preferred playing games of skill. I toyed with the idea of pitching pennies into a goldfish bowl and coming away with a goldfish. But the fish looked sickly, and if I won, could I handle a camera and a goldfish too?

Besides, it was time to start taking pictures; I was beginning to get that gut feeling. I strolled along, camera poised, and the first to catch my eye was a pot-bellied man in a gaudy Hawaiian shirt. I stepped back to take in his enormous girth and clicked the shutter at the "decisive moment" (a la Cartier-Bresson), just as he bit into a pizza. Next I spotted a Franciscan monk who, with his long brown robe and tonsured pate, looked like he'd stepped from an old engraving; he was happily munching popcorn. (I could smell the butter as I focused.) Then I stopped at a stall where a man was shucking oysters (they looked so pretty

in the half-shell on a bed of ice) and took a few shots of him. Farther down the block, teenagers were jitterbugging to the beat of a jazz combo. But they moved so fast and color film was slow, so I focused on a baggy-pants zoot-suiter slouching on the sidelines, his pompadour gleaming in the sun. He was swigging a Coke.

Wherever I looked, there was something good to eat. Within the space of a single block, I saw (and resisted) a whole smorgasbord of culinary delights: ravioli, lasagna, manicotti, pizzas; corn on the cob, stuffed peppers, and artichoke hearts; spumoni, cannoli, and racks of Neapolitan pastries. But the most tantalizing of all were the Italian sausages, sizzling away on the grills.

Did artists *really* work better on empty stomachs? After several more shots I decided they did not and headed for the nearest barbecue stand. I watched as the man behind the counter arranged the sausages on the grill. I watched as he turned them, gently, so as not to disturb the juices, and watched the skins burst as they browned. I watched as he forked the sausages on to thick slabs of Italian bread and heaped them with peppers and onions. Then I stopped watching and ordered one. First the "sweet" kind—pale-skinned, flecked with fennel and parsley. Next, the "hot" kind—pink-skinned, seasoned with pepper and paprika. And then, just as I bit into this second sausage, the idea struck.

Why not combine food and photography? Why not open a European-style coffeehouse and combine it with a gallery devoted exclusively to photography? Photographers had never had a gallery of their own, and perhaps it was time they did. There were galleries in New York for almost everything—painting, sculpture, graphics, ceramics—yet none for photography, although the medium was already a hundred years old. Not that it had never been tried. When Alfred Stieglitz opened his gallery "291" in 1905, he had that very thing in mind. But he was eventually seduced by modern art, and photography took second place. Julien Levy had occasionally shown photographs in his gallery in the 1930s, but he never succeeded in selling a print to a client, only a few to friends at ten dollars each.

Hardly anyone bought photographs, but almost everyone drank coffee—so why not subsidize a gallery with coffee beans? Clutching my half-eaten sausage, I wandered off to a side street and pondered the idea.

Coffeehouses—the kind where you could meet friends, read newspapers, write a novel—were catching on in New York. Two had recently opened, the Rienzi on MacDougal Street run by a group of nine artists, and the Coffee Mill in midtown owned by two psychoanalysts. They were based on the idea of the Parisian cafes, where artists and writers made cultural history over coffee and croissants. I thought of Picasso, Modigliani, Jean-Paul Sartre, Simone de Beauvoir—could I create the same kind of place for photographers? But this one would have a double purpose: It would be a place to exhibit, a place to meet.

I put my camera in my gadget bag and took the subway back home. And that night, between bouts of indigestion and gulps of Alka-Seltzer, I made plans for bringing the idea to life.

But had I known what the next seven years would be like as I grappled with the problems of running the biggest and busiest coffeehouse in New York and the first photography gallery in the country, I would never have bitten into that sausage.

PHOTOGRAPHY TODAY: INTERVIEWS

In this section, contemporary luminaries who shape the uses and implementation of the medium speak about their role and interaction with photographers.

THE PRIVILEGE TO WORK FOR ARTISTS
An Interview with Peter MacGill, Director, Pace/MacGill Gallery

Adam Bell: Beginning with your experience at Light Gallery to your current position at Pace/MacGill, you have had the opportunity to work with some of the greatest photographers—from Robert Frank to Philip-Lorca diCorcia and Irving Penn. What is essential to the photographers you admire and represent?

Peter McGill: It is our privilege to work for artists who have made original and unique contributions to the field of photography over a prolonged period of time—not an easy thing for an artist to do.

AB: As a curator and gallerist, you have helped nurture numerous artists and photographers throughout their careers. What strategies do you recommend to emerging photographers in order to survive and maintain a career as an artist within an increasingly crowded and commercialized art market?

PM: Make photographs because you believe in what you are doing, not because you think people might want to buy them. Stay away from what you have seen or done before. Nurture your convictions. If you find yourself in a corner, photograph your way out.

AB: From print-based media—magazines and books—to new digital media—Web sites, etc.—photography is a matrix for so many forms of discourse and communication. What is the gallery's role in presenting photography? How do you see the gallery's role evolving?

PM: A gallery's job is not very complicated. It should provide a place where people can come to look carefully and think about what an artist has done. It should, ideally, take its job as seriously as the artists do when they make their pictures. A gallery should always take the lead from its artists—the real visionaries—and try to attract a wide range of visitors. Look at what Lucas Samaras, at 69, just did with software that is available to everyone.

AB: Keeping in mind that this book is meant to be a source book for aspiring photographers and artists seeking to engage the world via lens-based mediums, do you have any final thoughts you'd like to share?

PM: There has been a big transition in photography in the last decade or so. It seems that many artists follow trends and make pictures for the marketplace. Typically, they make large prints in limited editions because that is what they think people are interested in.

Prior to this shift, photographers made work because they had to. They had no choice. Making art was their job and the challenge of trying to be a good photographer was enough. If they were lucky, they could strike up a dialogue with their peers and a viewing public and this was enough to sustain them. The best artists are committed to the development of their ideas and the advancement of aesthetics—not a bad ambition which, if developed properly, will have great impact.

VISUALIZING MARTHA
An Interview with Gael Towey, Creative Director, Martha Stewart Omnimedia

Steven Heller: The images for Martha Stewart Living *convey mood and mode. What are the key traits you look for in a Martha Stewart photograph?*
Gael Towey: Through photography, we transport our audience—a reader, a shopper, a viewer, or someone online—into our world. Photography allows them to dream, and that dream can motivate and create possibilities. It allows people to connect with our ideas and forges an intimacy with our audience, bringing them, one viewer at a time, into our community of creativity. Photography is inclusive. Through photography, we can transform a humble object or an everyday moment into something memorable. Through this powerful medium, we demonstrate our respect for our audience, presenting information clearly, and inspiration beautifully.

SH: Is this process handled by one person or a group of people?
GT: Photography is a team effort. Our art directors work with the editors and stylists to conceive each story visually. Next, they collaborate with a photographer to execute that vision and create a photographic narrative that tells the story. Our art directors and photo editors select a photographer because of his or her vision, and the appropriateness of that vision for the editorial idea. Our photographers are fine artists, whose own personal work often overlaps in subject or style with the images we create for our magazine. Each of our photographers has a unique style, technique, and ability, and each views a story and the world differently. The photographers bring their own sensitivity toward light, color, composition, and humanity to the collaboration. To put out a good magazine, we respect each artist's voice even as we use it to best advantage. As a story is developed within the company, we keep in mind the demands that will come about as it is shot; an entertaining story during the holidays asks for festivity, a gardening story might want a bit more moodiness. Anticipating those needs and pairing them with a photographer's strength is a critical part of our creative process. In playing to our collaborators' abilities, the photography in the magazine solves problems, and more importantly, tells stories that inspire our audience. Its rewards are a sense of accomplishment and pride, but it also gives expression to individuality and uniqueness.

SH: As creative and design director, did you go looking for photographers who would conform to your vision, or did you incorporate the visions of photographers into your style?
GT: The answer is both. Originally we found photographers who fit our sense of what *Martha Stewart Living* should feel like. Gradually, our photographers created a visual identity that became associated with the brand. Matching the

145

subject matter to the best photographer ensures that the art director's vision will appear on the page. Each photographer brings his or her own passions and particular expertise and vision to a story.

SH: Can you give some examples?
GT: William Abranowicz is one of our most technically skilled photographers. He can handle a tricky dusk shot for "Ghost Story," where the glow of the pumpkins on the porch, the lights from the house, and the night sky are all balanced perfectly. Bill also has the ability to light and shoot interiors with ease, organizing the information through his lens and bringing order to the photograph.

We admire Christopher Baker for his versatility and ability to solve visual problems in unique ways. In our story of making goat cheese, we see that not only is he happy to document a process, but he also loves to shoot portraits. In "Making Stock" we see striking compositions that organize the information in a clear, logical way. It is interesting to note this story was photographed on the beach, quite literally, so that Chris would have blue sky reflected in the metal surfaces. In a studio story on collecting lab ware, Christopher used a clean and slick lighting technique that mimics the sterile laboratory environment where the objects were originally used.

Victoria Pearson is the doyenne of natural light. She began her career shooting people and fashion. By treating still life like a living object moving around her subject, or by moving her subject around in the light, she gives light and life to scenes that would otherwise feel static. She shoots in daylight and backlights her subject whenever possible, shooting directly into the sun. Her work is always light-filled and airy and has a dreamy quality.

Victor Schrager is a fine artist whose work is influenced by historical photography techniques. In a glossary about ferns, Victor was inspired by Anna Atkins, an early pioneer of Victorian photography. He used the actual ferns to create sun print cyanotypes without a camera. Two magazine stories, "Chickens" and "Bats," are inspired by his passion for photographing birds. Originally, Victor devised the cloth background device when photographing poultry at state fairs. It helped him edit out the confusion of the fairgrounds beyond. Today it has become part of his trademark style, and he has gone on to photograph cows, bears, fox, and seals for our kids' magazine. In his portrait of a crabapple tree, Victor evokes the spirit of William Henry Fox Talbot, another pioneer of early photography. He achieves a sepia effect by cross-processing color positive and black-and-white negative Polaroid film.

Martin Hyers and Andrea Gentl are known for their use of color and composition. They shot a beautiful story on 4H at the Dutchess County Fair for our kids' magazine. Not only are these photos rich and colorful, they also capture the tough yet vulnerable side of these kids and their attachment to their beloved

animals. In addition, the images are humorous, because these kids really do resemble their animals.

SH: Do you have different photographic styles for the different magazines you direct?

GT: We use different photographic approaches to help differentiate and focus our magazines. While *Living* is seductive and sophisticated, *Kids* is colorful and graphic. *Weddings* is elegant, and *Everyday Food* is bold and simple. At *Everyday Food*, finding the right photographic style was a challenge. We wanted to build on *Living*'s esteemed photographic style, yet the physical size of the magazine dictated that the photographs be pared down to the essentials. The focus of the photography is kept sharp in contrast to the occasionally softer, more romantic style established by *Living*. *Everyday Food* reduces the props and focuses on what to eat. While the photography is not meant to be revolutionary, it is meant to feel modern and streamlined without being austere.

SH: How much art direction goes into a photo shoot?

GT: The designers are involved from the early stages; they organize and color-ize everything, from icing, room decorations, wrapping paper, and stationery, to Christmas tree ornaments and flower arrangements.

Design begins, for our art directors and stylists, in a laboratory atmosphere where ideas are created from scratch. Then we make, build, or grow the craft, recipe, decorating idea, or garden; we choose or build backgrounds, choose colors, and design the story as it is being photographed. Design is the creation and execution of the idea, from start to finish.

Our editors are known for fastidious research, finding, tasting—when appropriate—analyzing, and writing about flowers, food, and nature. The art directors then work with their team of editors, photographers, and stylists to provide each story with an organizing narrative so that each image is informa-tive and useful and piques the reader's curiosity. Color, shape, and texture are all carefully considered. As each story is created, the team strives for a composition that is beautifully balanced and in which the captions and images are easy to navigate.

SH: Do you encourage experimentation in shoots for the magazine or other materials?

GT: Every shoot feels like an experiment, since each story is created from scratch and needs to be invented each time. This is an expensive way to put together a magazine, so the stress of keeping within budget forces the art direc-tor to be absolutely sure he or she will bring back a story. For that reason, careful planning and research are imperative. Taking chances requires a leap of faith and confidence and experience.

We have had many moments of experimentation that are now considered part of our brand "look" or esthetic. For our story on how to make puff pastry, photographer Hans Gissinger worked with art director James Dunlinson to create a black-and-white sequence of artful photographs of the process of making pastry. Each photograph is beautifully composed and so simple that it looks incredibly modern. Together the spread is startling and unexpected when you come to it in the issue.

Every time we start a new magazine like *Kids* or *Everyday Food*, we are experimenting, looking for a new way to reach different readers and stand out in the crowded field of publishing as a clear, unique voice.

Publishing a magazine over and over again allows the design process to become liquid. One's first idea is usually just a drop in the bucket. As the team begins to collaborate and inspire one another a little ripple of an idea might transform itself into a wave of new and exciting possibilities. With that in mind, we look forward to what we may improve, discover, and invent along the way.

SH: Your photographs reinforce an atmosphere that is aesthetically pleasing and projects an ideal that puts the viewer in a pleasing place. What are you specifically trying to achieve through photography?

GT: Designers are storytellers who craft the visual language of the brand. We use color and photography to teach, inspire, and express the personality of each story and ultimately our brand. Photography and video are our primary communication tools, powered by the ideas created in a team setting, which are the basis for our design process.

I have heard that a brand could be defined as a cluster of values. Included in our list, then, would be: Respect our audience—never talk down, never design down. Encourage excellence. Assume that the audience is sophisticated. Be active, be encouraging, be curious, be real. Deliver quality at whatever price. Service, honesty, the physicality of life. A glorification of the humble and everyday.

SH: What would you say are the areas uniquely defined by Martha Stewart photography?

GT: One form of "how-to" is our glossaries, which work like visual encyclopedias. We try to be as comprehensive as a scientific journal, fueled by our curiosity about everything we can get our hands on. Most glossaries are an in-depth study of a particular fruit, vegetable, or flower. As reference, we have used antique botanical books, Edwardian plant and garden photography, Dutch still-life paintings and our own imaginations to come up with different ways to create a glossary. To create our silk glossary, we wanted to be both factual and evocative. Silk is made from the cocoon of the *Bombyx mori* moth, so we cut the different varieties of silk into the shape of the moth. The image as a whole evokes exuberance, delicacy, summer, and sensuality.

At *Kids*, because the art directors are involved in conceiving the story from the beginning, we began having a lot of fun putting the title into the actual photo. This technique not only feels modern and appropriate but also allowed us the flexibility with fonts we needed in the well without feeling out of format.

Product photography is about turning the product into a hero. In keeping with our desire to be informative and useful as well as beautiful, even our seed packages are a teaching tool. To create the seed packaging, we grew the plants at Martha's garden in Westport, then photographed each bouquet held in hands: all kinds of hands, real hands. You immediately understand the scale of each flower. And the photographs represent the hands-on values for which our brand has become famous.

DOCUMENTING IN THE TWENTY-FIRST CENTURY
An Interview with Robert Pledge, President and Co-Founder, Contact Press Images

Charles Traub: Contact Press Images is perhaps the most important active agency of its kind working with creative photojournalists in the world. You want to talk to us a little bit about its conception?

Robert Pledge: We were naïve when we started, but we had two sources of inspiration: Magnum and Gamma. Formed in 1947 and in 1967, respectively, they both began as a small and dynamic group of photographers who looked at the world in a different way. Our mission was to gather a small group of people that had something to say. We were interested in *everything*—in issues and events, in political, economic, social, and cultural trends.

CT: Who were the original photographers?

RP: David Burnett, Alon Reininger, Rick Smolan, Dilip Mehta, and a few others. The agency drew together people with very different backgrounds, nationalities, and interests, but who·had something in common. Maybe it was typical of that generation in their late twenties. We wanted to understand what was going on around us, in China, or Central America, or South Africa. There wasn't the free-flow of information like today with the Internet and 24/7 television and so much media in general. We felt photography could make a difference because it made the public at large visually aware of what was going on. You don't need photographs for that anymore, but in the 1970s there were three networks. They started at six in the morning and signed off at about eleven at night. That was it. Today, by contrast, hundreds of highly specialized channels instantly and endlessly disseminate footage shot by an army of freelancers around the globe.

CT: So, what is the role of the agency today? You're almost thirty.

RP: One important aim is to keep the work alive, to maximize its educational and cultural usefulness. That's become a major activity at Contact: books, exhibitions, and special projects. Another is to try to always look at things differently, to move away from the easy formulas of television news. The fact is, the media all over the world was interested in Hurricane Katrina and New Orleans in part because of the anger at George W. Bush. Yet there are similar, and even more catastrophic events happening in India and Bangladesh and China and other parts of the world no one cares much about. I was reading a piece in the *South China Morning News* about global warming and the situation in the arctic, which will affect us all. This is even much more fundamental. There are different layers to what is happening in the world.

CT: How do you cover that?

RP: Making certain that several photographers have a similar interest in the issue, and deal with it in one form or another without dropping other projects. Often

150

photographers are heavily involved in major issues in different parts of the world that have a collective function. Because this coverage is often so specific, three or four or five bodies of work combined can really give us something quite complete.

The dramatic repercussions on the environment, on the economy, of happenings such as the deforestation of parts of Asia—stories that Sebastião Salgado is doing in Brazil and other regions—this is important stuff. We're trying to weave them together around themes and ideas that relate to issues and trends in today's societies. That's what we've always tried to do. We once engaged these matters with a more conventional journalistic point of view. This was before the Internet and television became the source of visual information for anybody wanting to instantly find out what's going on.

CT: In 1972, when Life *magazine closed, they said there was no future for photojournalism, yet your agency carried on. Photographers are sort of daunted by the fact that there aren't any outlets for expressive personal documentary. And the gallery world doesn't seem to want it either.*

RP: Yes, it did seem that everybody was saying, "Photojournalism is dead." That was the expression. But I think it wasn't quite true yet. What happened is that newsweekly magazines like *Time* and *Newsweek* expanded their use of photography. It gave a new life to photojournalism and documentary photography for a period of time. This is when agencies like Gamma, Sygma, and Sipa came about. Contact was born a decade later, in 1976. And we thrived on newsweeklies for almost twenty years, I would say, from 1973 all the way to the first Gulf War in 1991.

Over the years, I've seen a lot of very talented people to whom we said, "We can't take you on." We just cannot take care of too many people who need serious long-term commitments to their project.

CT: How many photographers do you work with, more or less?

RP: Well, all in all, we handle the work of about thirty photographers, including fifteen active members and associate photographers involved in news-related issues. The other half includes some who have worked on specific topics for a long or short period of time, like Li Zhensheng, who covered the ten years of China's Cultural Revolution. That is a body of work of immense historical importance by a photographer until recently unknown. I met Li Zhensheng in Beijing in 1988 and he possessed something so unique, so close to matters that interested us, we took on the work and helped shape it into a book, *Red-Color News Soldier*, which was published by Phaidon, and an exhibition. It's very specific.

CT: I don't mean to be crass. Is it able to pay for itself?

RP: In this case, it did. The book exists in six editions right now: English, French, Spanish, Italian, German, and Japanese. Hopefully there will be a Chinese edition one day. Two sister exhibitions are touring Europe and Latin America. Li Zhensheng has spoken at Harvard, Princeton, and at the University

of California at Berkeley. He's been invited to the Asian Art Institute in Denver, and other places around the world.

CT: And what are the outlets for your kind of photography?
RP: Besides the traditional venues—weekly illustrated newsmagazines and other periodicals? Fundamentally, technology has revolutionized our role. Computers came into the picture fifteen or twenty years ago and changed the grammar. I think the first images beamed live were from Ronald Reagan's assassination attempt in Washington in 1981. One minute later the whole world saw them. I couldn't believe it. And then the Shuttle disaster in 1986, and of course Tiananmen Square in 1989.

I was mesmerized. Now, there's no way of getting anywhere close to that with still photographs, and when there is anything spectacular it is usually done by amateurs; it's not the professional photographers. Yet the general level in photography has gone up tremendously and the picture is changing dramatically. The informative general news print world is shrinking. Most newspapers are laying people off.

Newspapers are behind the Internet and television in relating the news, yet because of digital transmission they're able to stay pretty close. But newsweeklies like *Time* and *Newsweek* are three or four or five or six days behind. There still some hope in the next five years, because there's enough of a generation of people, myself included, who read dailies and magazines and spend less time on the Internet. But the younger generations are online and don't want to get their hands dirty with newspaper ink! A newspaper isn't interactive, it doesn't move and jump. For still imagery this is a huge problem. The moving image just has more to offer in this context. The decisive moments are fewer and far between.

CT: Is the future of documentary photojournalism in the book, the film, or the exhibition?
RP: I think it's a combination for now. There is one thing that won't change, though: the icon value of existing images. Let's say photography was to vanish in ten years from now as a pure form of visual investigation of the reality because new laser digital recorders with their immediacy have taken over. Photography will become a classical form of representation—appreciated like a virtuoso violin. There is so much photography that has to do with people's own personal life. The camera is speaking about who's taking the picture as much as what is being looked at.

CT: Well, you can get stills from video. There is art in its whole process of selection.
RP: True, but the whole psychological process is different—putting the eye, mind, heart, and idea into the process. I've always said that photography is a silent medium. It is what mime is to the performing arts. Photographers are the Marcel Marceaus of the visual world. It is a very tight, spare way of trying to say a lot with very little—no sound or special effects or anything to accompany it but

a caption. The minute you attempt to something else with it—which is totally legitimate and I'm not saying one shouldn't—it becomes a different medium.

Now, learning about the world or understanding it, I don't think that is the role of photography anymore. In some ways it's more complex: psychological and emotional elements are confronted. It's more introspective, more emotional. Its purpose is less to educate, to inform. The "mission" of the traditional documentary photographers seems to be disappearing because there are other ways to educate and inform that are possibly more efficient. Photography is more like poetry now. It's in a different dimension. It's like jazz. Even newspapers are trying to be "creative." They're trying not to be news, at least in their aesthetic concepts. I think photojournalism has become more of an applied photography with a more conceptual approach and less "instinctive."

CT: What is it today's photographers need to have? They have to have an obsession for sure …

RP: They still have to be deeply curious and passionate about something. They have to want to know for themselves and want to share. They need a sense of anger that motivates them to reveal something. Zana Briski went to Kolkata college to produce a black-and-white essay on the condition of the prostitutes. And it became something else. And it became something else because she was open to it, because she wasn't simply trying to make a career, to get a feature published in some magazine. She got caught up in something that went far beyond what she initially envisioned. There are more and more women photographers in the field who do bring a different approach. They have a different sense of these realities and are less competitive for its own sake. But in any case, one needs to be obsessed.

Twenty years ago or so, it was also easier to get started. There was less competition. If you were able to build up basic trust in a relationship, there was a lot of loyalty on the part of publications. At *Time* David Burnett started as an intern. They liked his personality and his style. Before he went to Vietnam as a freelancer, he went to see the magazine. They gave him five hundred bucks, which paid his airfare. They also gave him a hundred rolls of film. That was it.

The only problem today is that thousands of people want to do this. And it's not just in the U.S. You see hundreds and hundreds of photographers from all different countries. Ten years ago, fifteen years ago, it was almost exclusively Americans, French, and British, and a few Germans. Today, they're from every corner of the world. They're Japanese. They're Australians. They're from Finland, Denmark, from Mexico or India. There are fifteen times more people and not that many more publications. In addition you have the competition of television and the Internet. It's a very difficult situation. If somebody has talent, is willing to tighten the belt tremendously, works very hard, and is creative about finding the resources through grants, donations, or from family and friends who might have money, they might make it.

CT: I don't think you used the word "pessimistic" and I didn't really hear you being pessimistic. Despite the fact that you talk about how hard all this is, doesn't this change something? What happens to all that work? How does the culture absorb that work? The interest is there and the knowledge is there. These young people are better educated than our generation, in a way, the best of them anyway.

RP: I think the younger generations, and a growing number of people, want to know more. We hear for instance about AIDS. We now hear about it in a much broader context. Even in China today they are starting to speak about it. Environmental issues, global warming—all these topics I think are generating a lot of interest and concern.

I'm not pessimistic, to the contrary. I think there's something phenomenal happening. I'm a little bit apprehensive in terms of the medium and its ability to do things, but it's never been written that it would be around forever to do that kind of work. If you can say things just as well in some other way, if you produce moving images rather than still images, that's fine. Or a combination. You can marry things and put them together and be more creative in a way, mixing different media. As experienced practitioners, we can't always give great advice to the newer generations. The only thing you can really do is explain the way it was and why it worked that way, not out of nostalgia, but for someone to understand that you don't have to replicate, duplicate, or repeat. You can invent something different.

We have to explain who Eadweard Muybridge, Henri Cartier-Bresson, or W. Eugene Smith were without ever implying that students should imitate, replicate, or duplicate their work. Emulate to some extent, get inspiration—but I think there is the need for new practitioners of photography and new visions.

The medium has created new channels of dissemination of visual information and you have to understand that. For example, *National Geographic* has used photography to get readers involved and to communicate about unknown worlds and global issues. But who would want to replicate what *Geographic* did for fifty or more years? No one should. In China, *National Geographic* is the bible. It served its purpose well, and in a time when people didn't know much about the world, what it looked like. Now people travel more, and they are more knowledgeable. It's about choice. I know people, who are profoundly ignorant despite having all the tools at their disposal and the education. But they don't know because they don't want to know. It is a choice. It's an option.

CT: It's thrown in front of us. We have an educated, albeit often ignorant culture, in this country that veils poverty and other realities. What can documentarians do?

RP: We are often critical of the U.S., but at the same time, it is one of the most resourceful societies on the face of this planet. It's the world at large that should concern us. Yes, America is a better-formed country and so should have more interest in changing things than others, but I think in the end humankind is pretty blind. We've got to use every tool that exists and the lens certainly helps.

154

CT: This brings me to my other question. If you want to change the politics of America, you have to do more than protest: you have to go to the grassroots—town hall meetings, community boards, etc. One problem is that we're not using new channels, except for MoveOn.org and others. What we are often missing is ways to use the technology and an essential understanding of distribution and media communication. We need billboards in front of Wal-Marts with bullet-points on them. We're not reaching the right people—we're just conversing with the people who already agree with us. It seems to me that the younger generation must understand the channels of distribution for their imagery, whether it's moving, still, voice, or music, and reinvent those channels as well. I guess my question is, how do we get them to get to that? I often find photographers, in particular, are very resistant to the technology. They're very, very enamored and almost hypnotized by the traditions that you and I once struggled to overturn.

RP: That's really a language problem, and a complex one. I think it's a very essential question. Photographers today, many photographers, come out of schools. That's a huge difference. It's become much more institutionalized and professionalized. People go to schools, they graduate together and stay in touch. There's a lot of networking and inbreeding of sorts. Ideas don't always venture beyond these small communities. Photographers don't always confront themselves and their worldviews as much. Zana Briski and others went to schools to acquire knowledge, not to "build a career," but to acquire some specific knowledge from which they could develop their work. They knew beforehand pretty much what they wanted to do. Giorgia Fiorio, for instance, was a successful pop singer. She could've had a great career. Yet at the age of twenty she decided she wanted to be a photographer. Zana Briski did a similar thing. She graduated from Cambridge in England with a degree in Theology. She wanted to see the world and wanted to use a camera to say something. So the more impressive people in the field come with their own obsessions. Some went to schools or workshops, others didn't. It can be useful. It's not indispensable. The thing is what people have in their heads, in their guts, that's what really matters. And then it's using one's abilities and one's talent to make something out of it. Education can help. Learning to be critical, to never take things for granted— I think these are the key ingredients.

People do tend to speak to each other within their own groups. The same thing happens in schools. People speak about themselves as if afraid of what is beyond. These fears are very strong.

CT: We the educators, press, the photo community, etc., have created an academy. It is inevitable that we get used to what is familiar.

RP: There are no pre-set rules here. Let's go back to the Chinese Cultural Revolution: I know several other photographers who have images of that period of time. Since we came out with the book I bump into people who say, "I too

have pictures. I was in this place." I'm sure it's true. The thing is, none of them have anything remotely as exhaustive or of the pure photographic talent of Li Zhensheng. I think in this case there is greater merit in seeing the whole story through the eyes of one person. In the beginning, Li was very enthusiastic about this revolution, especially when Mao said there would be a revolution every seven or eight years. "My God, I'm twenty-three years old. My career is made," he thought. He said that. Then he realized things weren't turning out so great. He went on documenting even when he wasn't supposed to. And he wasn't supposed to have kept his pictures, but he did. His single voice and his experience lend that period a special dimension. We have to be innovative, to find the right way of saying things, whether a little violin here or symphonic music there.

CT: You should be open to those changes and possibilities.
RP: Absolutely. That's why I'm always hesitant to give advice. There are no formulas. We have to invent them all the time. But it's true that if you can meet somebody who can become a mentor or somebody in the business who likes your work and personality and can help guide you and push you and make it happen, that's great. That is probably one of the most invaluable things. Don't find someone who will give you the answers, but who will help you to look for them, and then find them by yourself.

CT: I call that person the Creative Interlocutor. Those people like yourself who create by enabling others. Maybe in fact they are the ultimate artists. Ideas are easy to come by—getting them together is something else. There are people who know how to organize and organize creatively. Often photographers don't quite have that. It's another aspect. An artist sometimes has it, or they are so focused on something they're not focused on the other important things. There are people and networks and people who create networks, because networks are about people who make things come together in new ways.
RP: To shape something or to ping-pong back—I think that's very important. I know I enjoy it. Some people respond very well, some don't. Sometimes you have to tip-toe around them, but if you work at it you can make it happen.

CT: They may be the ultimate artists, in my opinion. I'm really serious about that. I think people like you who have a kind of holistic worldview of the medium, of the reason for using this medium, you connect people in a world outside the old network. You globalize photography and the idea. It's essential because otherwise you're the lone ego working in a vacuum and somebody's got to fill that vacuum.
RP: But there's also the danger of the so-called guru who shapes other people in a very controlling way. I sometimes act more forcefully, sometimes less, depending on the level of maturity and intention of the person in search of help. People have an idea, they're not quite sure it's a good idea yet other people have told

them it is. They need to be convinced themselves. They've got to first become knowledgeable. In that sense, the brain and the guts and the eyes have to work together.

I know I have as many questions as these students do. Whether I'm in China, Turkey, Mali, Hungary, or Korea, the questions are the same. Everyone wants to know how you can advise them, how you can help make things happen for them, because they are all aware how difficult it is. For people working in the rather narrow field of documentary—not illustrative—journalism, it is so hard. They have the feeling that there are so many layers of glass that they have to break through, or so many hurdles and obstacles, that it's difficult for them to complete their project. And then unavoidably they speak about people who have been successful and envy them, like Salgado. And I say to them every time: When I met Salgado in 1974 he was twenty-nine years old and only just starting photography. He had an idea of what the business was like. He took some hits early on. But he really knew where he wanted to go. The first time I met him we went to a café and he told me what he wanted to do, and I walked out of there thinking that this guy would become a giant. But he also had an education, which is essential to his work. He studied economics and geography. So, he was aware of many things. When you look back at what he's done, you see he knew where he was headed.

CT: I always say that if you have the will and you really have the talent and you do good work, whatever that is, then it will eventually get recognized.
RP: It's a matter of time, yes, a few years or twenty years. The best people who work often feel very solitary. People like Jane Evelyn Atwood, people like Salgado, people like Don McCullin, all the people I know—Giorgia Fiorio, Zana Briski—are very solitary in their work. They are not seeking anybody's approval or pats on the shoulder. Don McCullin explains very well in his autobiography, *Unreasonable Behavior,* how he became a photographer rather than a gangster. His brother joined the French Foreign Legion because he was in trouble with the law. Don didn't want to get in trouble himself so he turned to photography. The camera protected him and he thought it was a great tool for adventure. And then he went to war. He was born at the time of the ascent of Hitler, then he lived under the bombs and understood war. It was part of his environment. When he first went to cover war he thought it would be exciting. But very quickly, like Li Zhensheng with the Cultural Revolution, he realized it wasn't at all what he expected—and got serious about it.

THE PHOTO BOOK
An Interview with Yolanda Cuomo, one of the medium's most distinguished and enduring designers

Charles Traub: Why don't you start off by talking a little about your background and schooling?

Yolonda Cuomo: I went to Cooper Union and studied film and photography. I took some design classes—but Cooper design was all about Helvetica, good taste, and Bauhaus. It turned me off. So I went and hung out with all kinds of artists. I studied with sculptor Hans Haacke and with filmmaker Robert Breer. During that time, I began making photo books of my own photos, because I didn't want to put them on the wall.

I am still making photo books. I can't stop. I tell my students: whatever you love to do, just keep doing it. I think you should just stick to what feels good, what your inner soul says.

CT: Did your teachers give you trouble for being different?

YC: In design class, yes, absolutely. I became a jerk in my design class. I became a rebel just for the sake of being a rebel. I didn't want to hear about rules and good taste—I mean, at that time I was going to CBGB to see the Ramones and Patti Smith. And I walked into a design class where every kid came in with their own look, and walked out with the teacher's look. And I thought, there's something wrong here. I really feel you shouldn't do something because you think it's what somebody *else* wants you to do. You should do things because you want to. And it feels good, and it feels right for you.

CT: But there is the other side of it; there are some skills and things you do have to have.

YC: Oh, that's different. I studied color photography—I loved learning how to print color. It was so beautiful, and so hard to make a good print. I took a typography class and we worked with metal type; that's how I learned about type. It was very physical. You used your hands and your eyes. I took architecture classes and loved reading about Le Corbusier. But I didn't want all those rules—I wanted to mix typefaces.

When I met Marvin Israel, he liked that I didn't know the rules, because he didn't have to unlearn me. He used to say to me that learning how to design was like learning how to make a bed: anybody can do it.

I also studied with John Czerkowicz at Montclair State, and he just opened my mind. I'd thought I was such a cool artist, and I would never do something like watch TV—it seemed so middle class. But the TV series *Mary Hartman, Mary Hartman* was running, and Czerkowicz, in one breath, would talk about Delacroix drawings and Mary Hartman…and I thought, wow! You know, this is great.

CT: Do you think it's important, as a designer or as a photographer, that you have the other experience? Obviously you did, and your success is exemplary.

YC: I think my love of photography, and being a photographer and a filmmaker, that's all very important to have when I look at work and edit it. It just comes to form the core of really understanding what I'm working with. And not just designing, because I think of myself really as a visual editor.

CT: Can you describe what you mean by "visual editor"?

YC: People often say, "What do you do?" I'm not a graphic designer, because I really don't care about the way things *look*. I like to form things. Photographers will come here and they'll have a box of work. I feel like a documentary film-maker, editing, researching. I feel like all of our books, the look of them, comes right from the content of the photos. So every book we do is different because the material is completely different. It's almost like being a therapist. You know: "What do *you* want this book to be?" I help them edit and I help them form its structure.

There's a need for a conversation and collaboration. We always have meetings beforehand to see how to work together, because it's such a personal thing. And it's like with every book you work on, you give a little part of your soul, a little part of your heart.

I can't fake it. If I don't like the work, I can't do it. If the work is really great and we can have a collaboration, then it's interesting. The least interesting books are the ones that somebody has edited already and sequenced. We don't do a lot of those, because it's like you're just a production person. That's not interesting.

The process of book-making goes through many steps. At first, we'll work on the floor, laying out photographs and pairing them to make sequences. Then we'll put our layouts into the computer. From that, we'll make a small "thumb-nail"—a miniature—of the book. It's like a bird's-eye view. And that, to me, is great because it's like you're an architect and you're looking at a floor plan. At this point, you can refine your sequences and chapters. I worked with someone once who wanted to put all the pictures of the people *looking up* on the same spread. And I was like: oh, my God; that's so terrible! Because the pictures would have just canceled each other out. So it's learning to put things together with soul. If photographers start to do it, they'll see themselves. You can kill a photo-graph or you can have it come alive by what it's paired with, what comes before and what comes after.

I think that now, because of technology, it is easier for people to make their own books. You can digitally print books that look fantastic and don't cost a for-tune. The democracy of photography really lends itself to the book. It is hard to print a book about painting because you have to experience its texture. But with photography, the printing process really works well. Books can be better than

exhibitions, because you don't have glass between you and the photo. You can be very intimate with the image.

CT: You prefer not to have a photographer's preconceived notion.
YC: No. I just like when a photographer says, "I want this book to be great. I want to make something that has *resonance*."

The exchange is important, because it teaches photographers how to edit their own work, and how to think about a book. (Some photographers are really gifted at editing. And others aren't.) And publishers usually like to be involved. So, you can't make something too...finished. It's really hard.

Sometimes I fall in love with a project, and put it together and *then* we shop around for a publisher. But I try not to do that anymore, because you give so much to the prototype, and then it's really sad if it doesn't get published. It's almost like you're in labor and the child is never born.

It's good for new photographers to make a *maquette*—a book dummy—just for themselves, to see if they even have a book in them. A book works on a lot of different levels. A lot of times, people will come to me and they'll show me a box of work and say, "I want to make a book." And I can see it's just not there. I mean, it's not ready for a book.

It can be such a long and difficult process, so as a photographer you have to really stick to your guns. Like, you don't just give a box of your prints to a publisher, and they design it, and then you feel funny about it—"Oh, I don't like that." No, this is *your work*. Once it's out there you can't pull it back and republish it. I love it when photographers are involved. It's much more interesting.

We just finished working on Michael Nichols's new book, *The Last Place on Earth*, published by National Geographic. He was tired of having his pictures always surrounded by text. So we designed his book almost like a film. He came to the studio over the course of two weeks, and we laid all the pictures out on the floor to work. Nothing could be taken for granted with that book. The photographer brought the best possible creative team together: the editors, us, and production, too. We made sure we had the best press supervisor for the printing; we worked together on the separations.

This is what I have to say to young photographers: you have to be involved in every single step. The selection of paper, everything. So it goes on and on.

There are also different kinds of books. Ed Ruscha's book *Every Building On Sunset Strip* (1966), that's one idea. It's fantastic. He photographed, literally, every house and building along Sunset Strip! And there are other concepts for books. You can make a short book, or a multilayered one.

For example, Diane Arbus's book *Revelations*. We started from the material. We spent a year of Thursdays editing *seven thousand* rolls of film. I would go and meet Doon Arbus at a warehouse uptown. We'd go into this cold room and

we'd have our coats on, and we would each have a loupe to look at the contacts. It was so beautiful—but after four hours you couldn't do it anymore. We found the most incredible things! The cover was an inadvertent double exposure: Arbus's face over Times Square. I was afraid people would think it was a Photoshop thing, so that's why we showed the contact print in the book and exhibition. When the original film was processed and developed, the contact strip was cut. So at first we just found one half of the image, her eyes. For some reason, we went back a week later to revisit the contact, and it was only then that we found the bottom of the image, her mouth. We pieced it together, it was magical. Perfect. It became the cover of the book *Revelations*. I felt like an archaeologist on a dig.

Another strange thing: As we were looking through Arbus's contact sheets, I found this picture of the corner where I grew up in West New York, New Jersey. I'm looking at this roll of film, and for half of the roll Arbus is in New York, then she is at Palisades Park. Then she is on the bus, the 22 Hillside in West New York…and there is a picture of *my corner*—66th Street and Bergenline Avenue! She's in West New York for five minutes of her life, and she shoots the corner where I grew up. This is so weird. I'm not a spooky person, but I thought that was cool.

CT: You talked about collaboration, and of a filmlike kind of relationship of a director to the maker and all the component parts. You talked about sequence or the book having a beginning and a structure through it. Could you talk about the "design narrative," if there is such a thing?
YC: I believe that books have to have different "beats" through them, just like exhibitions. Monotony, the same beat and tempo, is bad. I think of music and also of made-up narratives: they move from dark to light, they have peaks and valleys, slow movements, choppy movements, then upbeat ones.

I think about that doing exhibition design, because the last thing you want to do when you go to a museum is get that daze in your eye when you go from one white room to the next white room, and the tempo is all the same. You have to *push* when you just want somebody to look at pictures, and they're big pictures, and the room's white and there's no information. You have to direct the viewer to get more intimate. It is all about thought processing and materials and the smell of things, and what the artist was thinking, or what they were surrounded with. It's important to have different moods, and to have different tempos and paces within a piece. I want a book to do the same.

CT: What are the things that you would tell a young photographer, or for that matter a young designer, to look at as learning models for that kind of thinking?
YC: Well, look at great books. Look at *Aperture* magazine. Look at the work of Sylvia Plachy. I think they should look at Diane Arbus's *Revelations*. I know we made it, but they should definitely look at it, because that was like a five-year

project for us and it has everything that I love, which is juxtapositions of photographs, then there is the chronology section and other components. There is a beautiful reading section, great typography, etcetera.

CT: Could you talk about the relation of photography and text?
YC: The early section of *Revelations* has no text. It just has little quotes from Arbus. It's just her work. You want to look at the photographs first. If you have to explain from the beginning of the book what you're trying to do, then you haven't visually done it. If you use words, you don't use them to *illustrate* your pictures: the words and the images must work in tandem. Words should be a jumping-off point. For instance, I always think there should be a great short story in a photo book, something that just puts you in the mood to look at pictures. If you do have text, it should be just a mood-setting one.

CT: The Nichols book you mentioned earlier is special—the dream of every photographer. There's also clearly a visual narrative in that book. I have been saying to students for years: You have to start thinking about the bigger meaning of the word "narrative." But they always take it literally. There are many forms of narrative. They always think it's A, B, C, D, E, F, G, but it's not.
YC: You don't have to have a linear narrative. You can have an emotional narrative even if nobody else knows about it. You *have* to have one—like going from somber to bright, or from gritty to calm. There are movements and sections. We'll often work on movements within a movement.

I think students should really listen to music and see films. I used to go to the Thalia theater to see a Truffaut doubleheader, but now you can get a DVD and stop it to examine a cut! Oh, lord, how great! And book-making is just like cutting. So I look a lot at films. I love Rossellini, Godard, Fellini, De Sica. I can't get enough of the neo-Realists. I'll watch them over and over.

As for books, the Brodovitch books are great to study. *Ballet* is fantastic, too. I love Avedon's books. I love the books Marvin Israel did; the Lisette Model book; Peter Beard's books. I always tell my kids to look at these books.

Gilles Peress also makes great books. He really *thinks*. He's a great editor, and he really thinks like a cinematographer in that he knows how to structure a beginning, middle, and end. He knows how to sequence photographs.

CT: What is it that you want to tell a future generation of aspiring photographers and designers about the photographic experience?
YC: Well, that it's not a surface thing! That it's about humanity. Photographs are about feeling, about real life, and it's not about fashion or galleries or surface bullshit. It's about *real stuff*. If they have stuff in their soul they should be true to their experience if they want to communicate. If they don't have anything in there, then they're not going to get anything out.

CT: The dilemma, I think, for the contemporary aspirant to our world is you have this art-world structure, like Chelsea, which can make a superstar out of a young person in about a minute, or can just cast away years of work. So it's very hard for students just to say, "I make this because I love it."

YC: I say to them, "The only person who's going to stop you is *you*. You have to figure it out." I was not born with a silver spoon in my mouth. I had to figure it out. I tell them, "Go to a bookstore and look at a ton of books, and pick up books you love. If you find that there's a publisher and you love everything they do, or almost everything, go see them and tell them you'll do anything to gain experience." I say, "Swallow your pride and just get an entry-level position. Just go in there and say, 'I'll be an intern.' Because chances are you're going to meet other people there that are just as intelligent and driven."

It's very important to have a community. I was really lucky when I met Paula Grief, my first art director at *Mademoiselle* magazine. Then I met Marvin Israel, and within two months he had me quitting my job at Condé Nast. I worked for him at a film magazine. Once he called me up at noon, saying, "Get in a cab. Come to 407 East 75th Street. Bring that envelope on my desk." It was Avedon's studio. I walked in, and there was Dick Avedon. "Hi, Yo." They started calling me Yo…and New York suddenly became a small, family place. This can be a big, old, bad, scary city, but if you get into a little community, like a little piazza of thought, where you find people like you, it can be less scary and you can pursue your dream.

You can get together with a bunch of your buddies. Somebody writes, somebody photographs. You make a sixteen-page book, staple-bound. And you send it to people. There are a lot of independent magazines that start like this.

I also think it is important to surround yourself not only with interesting people, but also with interesting work. It is important to have a "vision wall": a wall you can put things on. It's important to surround yourself with what you love, and with what you find interesting, because that's your mirror. That's your soundboard. We think…we think *visually*. You have to live with your work. It becomes part of your unconscious. And that's your base. It's like a musician going into a sound studio. You have to have a place where you put your work, where you really live with it. You can put other people's work there too, other things you find, because they help define your aesthetic—and map your experience.

You know that Joseph Campbell thing: "Follow your bliss." You've just got to keep doing it. Just keep doing it.

EDITING VISUALS
An Interview with Elisabeth Biondi, Visuals Editor, *The New Yorker*

IMAGE

I think of our photographs as "intelligent" photographs, i.e., it starts out with an intelligent photographer thinking about what information, both concrete and implied, should be incorporated into the image. Once this has been established, it is the photographer's talent and esthetics that determine the quality of the resulting picture. Along the way, of course, we need the cooperation and goodwill of the subject as the best thought-out plan can go awry without it. Our picture should both work with the article and at the same work independently as a strong image without caption or text. It should entice to read the story and without giving it away or contradicting it. A successful *New Yorker* picture is a photograph that catches your attention, stops you, and makes you want to read the story that follows. After finishing the piece you should feel compelled to look at the picture again and still find it satisfying. *New Yorker* pictures are "pure," unadorned by "creative" layout. They must be strong as the layout does not add (or subtract from, as the case may be) to them, no headlines, no fancy typography, no colored borders, just the image.

CLASSICS

There are no instant classical pictures. Each new decade produces them but they become classics in retrospect only. They reflect their period in composition, style, tone, framing, color, and content. There is the iconic 1960s picture and it looks different from a photograph taken in the 1990s. I can distinguish a Helmut Newton photograph taken in 1970 from one taken in 2001 without looking at the date. They both clearly are "Newton's" by the way he frames the picture, the composition, the light. Both reflect the time in which they were taken. Few images exist that are truly timeless, which in my opinion is not a bad thing.

When I speak of "classic with a twist," the twist is the contemporary quality today's photographer brings to the picture. Technology (whether or not digital equipment is used) has changed the way photographs look—the way we look at pictures now, movies/television/computer, the way we live—it all influences the way we see and the way a photographer takes his pictures. Trends will pass but the pictures that genuinely update photography will be remembered. Philip-Lorca diCorcia has been taking "cinematic pictures" for years. Cinematographic images became trendy. The trendy ones will disappear while the best and most genuine will become the "classics" that survive. There are many young photographers who know their classics, who are curious about the photographic past and life today, they are confident about their individual view and trust their intuition. These talented photographers I want to encourage.

STRATEGIES

Clearly, I believe in briefing a photographer before a shoot. It becomes even more essential when I work with a photographer for the first time. For our latest food issue we worked with Hans Gissinger for the first time. He had been assigned all the shoots for the issue based on his personal work he had shown us. As we started working together I first explained what is important to the *New Yorker* and then tried to find out how he works, his creative process, and how best to communicate about the various stories. This actually was quite difficult as Hans has wonderful ideas but he is a man of few words. There were a lot of monologues on my part wanting to make sure that his ideas would work for us; there was also uncertainty about whether I had made myself clear.

The first assignment Hans embarked on was our story about fruit grown on ancient trees in Tuscany. Hans did a wonderful renaissance triptych of a plate of fruit framed by the two "fruit anthropologists." Everyone was happy.

One of the "well" stories was on Las Vegas short-order cooks who turn out thousands of breakfasts every morning, rushing about the kitchen like a speeding bullet. We determined that speed was the core of the picture, identified the fastest morning chef, the busiest hour, and determined that it should be a journalistic picture, but left it open whether it should be color or black and white. Hans came back with a photo where you literally feel the heat, tension, and speed of a frantic hellhole kitchen. Perfect.

Next was a picture of Esca chef David Pasternak, who loves fishing, a good thing as Esca is one of the finest fish restaurants in town. We agreed that David should be photographed in the context of fish and I told Hans that I was hoping for a witty picture. We went back and forth on the concept "giant fish and chef" and how to add the funny twist. Should we have props? Should there be a knife, should we reduce the picture to just Pasternak and a big fish or did we need to introduce another element? Alas, when the perfectly executed picture of Pasternak holding a very big bass came in, we all agreed that it was okay but no more. Since we are perfectionists we decided to have another go and tried for a journalistic picture of Pasternak in fishing action on his boat. Bad luck, however, only tiny fish were biting that morning, Pasternak was unhappy, the pictures consequently did not work. For the third picture we thought that a hybrid of the two situations might work. Bingo! Pasternak showed up at the dock with a giant shark model that normally hangs in his fishing buddy's fish store. We had our witty David Pasternak with fish photograph. As we continued with more pictures we both gained a better understanding, I learned how Hans' mind works, that he is a perfectionist and technically superb, and he gained more insight into what pictures work for the magazine.

REQUIREMENTS

I have been blessed with working for very different publications requiring me to work with many different photographers: photojournalists, portraitists, fashion,

and still life photographers, architectural and fine-art photographers, the entire range of disciplines. I always started with picking a photographer who, I was convinced, would give me the kind of picture I envisioned ever so vaguely in my mind. The next step always is the collaborative process.

At *Stern,* a fat newsweekly with many pages of stories, every story had to be accompanied by an image, and deadlines were instant; speed was essential. I worked a great deal with photojournalists, obviously many German photographers. Conceptual photography was less valued than journalistic or documentary photography. We told stories, whenever possible, and story had to have a beginning, middle, and end. Consequently I discussed how the story would visually evolve with the assigned photographer. Speed was of essence but it never stopped me from making sure that I briefed every photographer. I made it my business to find the perfect match between photographer and story. *Stern* had fifteen staff photographers who knew the magazine inside out and I saw it as my job to motivate them to enthusiastically approach each story. Even after working for the publication for so many years; for many it was a challenge. However, I could rely on them to be available at whatever short notice they were needed. Of course, I was not limited to assign staff photographers and was happy to work with graduates of the many excellent photography schools in Germany.

Before *Stern* I had worked at *Vanity Fair* under Tina Brown, a strong editor who took a great interest in the look of the magazine. She balanced words and pictures and gave priority to whatever was stronger. The look of the magazine played an important part in its success and "surprise" was an essential ingredient. Celebrity shoots with intricate logistics demanded many discussions and close collaboration between photographer, stylist, myself, and whoever else was involved in the shoot. It was before e-mail and my phone did not stop ringing. Cover shoots were nerve-racking especially when they had to be done at the last minute. I worked with a group of contract and freelance photographers, constantly looking for fresh talent. They would start working for the front of the magazine section and then moved on to "well" assignments. Celebrity shoots were the most demanding shoots and they were, more often than not, the cover stories. Access to the star and coming up with a fresh concepts made the story either successful or an instant failure.

Many meetings and telephone conversations with the photographers made sure that everyone was on the same page conceptually and logistically. Success was when many pages of surprising, often somewhat irreverent pictures got published. While I did work on journalistic stories where we dispatched photographers to tell a story in pictures, for the most part our photographers were asked to create images that were energetic and fun; fantasy was the important ingredient.

My work at *GEO* had in no way prepared me for the *Vanity Fair* experience. Our first creative director was a photographer, Thomas Hoepker, and his

way of approaching photographers and photography still is the basis for the way I work today. We made it our business to know which story we wanted to tell visually and we matched it with the ideal photographer (this meant that we had to know the previous work our photographer had done and his interests). We met with the photographer and he often worked on location with the writer (sometimes that worked out, sometimes not). When the assignment was completed the photographer came in to make a presentation. A layout would then be done with the photographer's input. Pictures were not to be cropped. The photographer was an "author." At that time, especially in the beginning, most of the shoots were photojournalistic and setting up situations was strictly "verboten." Later on we added profiles and became more flexible in terms of using portraiture and still life and scientific photography. It all was very solid, very grounded.

I strongly believe that communication between photographer and editor is crucial. The editor knows the magazine and is familiar with its vision and requirements. It is the editor's job to communicate this to the photographer so he can do his best picture for the magazine. At the same time, a good editor should make it her business to understand the photographer's talent and make use of it for the magazine to everyone's benefit. This seems logical, the picture editor as the bridge between magazine and individual photographer, but when a situation becomes difficult and complex, which it often does, it is not just logical, it is essential for difficulties to be resolved positively. Photographers should make it their business to understand the magazine, to make sure they understand the assignment and to ask as many questions as possible. When, where, what, and why should all have been asked and answered before the photographer starts shooting.

THE ARTIST IN THE MARKETPLACE
An Interview with Charlotte Cotton, Director of Cultural Programming, Art+Commerce

Charles Traub: Charlotte, you are new to New York and Art+ Commerce, from London. I'd like to ask you a little bit about your previous involvement with photography. Tell us about how you came to the field, about your background and what your interests are.

Charlotte Cotton: I was in my third year at university studying art history when I became interested in photography and film. I realized that my education was making me profoundly unemployable. I did not want to be a photographer but I wanted to be with photography. I knew that I had no skills anyone would pay me for so just before I graduated I went to the Victoria and Albert Museum looking for volunteer work in the photography collection. I went into the Print Room at the Museum for my interview and that was it for me—I wanted to work in this place that was open to the public five days a week, no need for appointments or letters of recommendation. I felt it was what public access to art really means, and I wanted to be part of that. So, I waitressed during the evenings and for three days a week for eight months I was a volunteer cataloguing the photography collection. It was probably the most enjoyable job I ever had because I had access to objects and knowledge and no real responsibility. It was a pivotal moment for me—I switched from being someone who was coming to photography from an academic standpoint where, often, photographs are illustrations of arguments rather than the objects at the center of your thinking. I learned how to look. I don't take photographs, I don't buy photographs, I don't accept photographs as gifts. That period was a very pure time to look at photographs in terms of where they fitted within that collection's history and within the history of photography. I went on to be assistant curator of photographs, then curator of photographs at the V&A and worked there for twelve years.

CT: You mentioned a delight with the public access of the Victoria and Albert collection. Can you expound upon that?

CC: Part of it is being a British Liberal with a strong belief in public ownership, something like our national healthcare, but also an ongoing debate about state support of culture. I think the potential difficulty with the current idea of photography as a contemporary art medium is that it aligns the medium with the essentially elitist discourse of art. I enjoy these discourses but I want to keep the appeal of photography as a medium that everyone can have an opinion about. One of the most important things about public access is that you can decide the importance of what you're looking at. That's a really unusual thing to feel such a degree of ownership of visual culture.

CT: There was a time in my generation when photography literally was in the basement of such institutions. Photography didn't have the cache it has today.

CC: We can easily criticize the traditionalism of collections and the history of photography—its chronology, its canon—as well as institutions with their decades of indifference to photography. Certainly, I had read thoughtful critiques of institutional ideologies by writers like Christopher Phillips and Douglas Crimp before I went to work in precisely the kind of a traditional place that was under their microscope. At the same time as appreciating this intellectual critique, a culture can't really explore a medium like photography without such institutions or their histories—you have to have something to critique.

CT: You talked about the democracy of photography. Those of us who shoot in the real world greatly cherish that. On the other hand there is "art photography." What happens to that democracy when the medium gets so codified?

CC: I wonder if there's an element of cultural amnesia, which isn't very helpful to practitioners who've emerged in the last few years. One of the things forgotten in institutional acceptance of photography is that photographers have always had to work out their own take on the ever-shifting idea of what constitutes photographic practice. Independent practice, which is maybe the epitome of photographic democracy, is about what a photographer creates when no one is paying for it, there is no guaranteed round of applause, but you will to create it anyway. Commissioned work, work that involves the opinions of other people, the possibility of earning your living through the thing that you love, and all the issues that it raises about whether that helps you or damages what you feel is the most important thing to you—that's been the perennial set of issues for photographers. Currently, the locus and the center of attention of photographic practice is contemporary art. New practitioners are more likely to couch their photographic expressions in art world language and production values and associate cultural visibility with galleries rather than other photographic contexts such as magazines.

CT: The magazine work was once a brilliant opportunity for certain kinds of photography—the documentary or essay.

CC: I think you're right, but there are a number of factors there. There's the devalued state of magazine publishing and the increase in number of large publishing houses taking on many titles. A title could exist one month and then, depending on the market research of a large company, disappear. So, it makes magazine culture fugitive and market-driven. Although some of the best magazines were short-lived, historically its longevity depended on the energies and creative scope of its makers and not, as is the case now, on its market position or its ability to meet the demands of advertisers. There is also the decline of picture magazines over many decades, photography's diminutive relationship

to television, etc. We have seen the end of the idea of someone making a living through editorial work. All practitioners, particularly the emerging practitioner, are subsidizing what they produce editorially. That aside, there is nothing stopping any group that is motivated to create their own magazine. That is the true history of the birth of a lot of magazines. And I think if someone wants to see their work in magazines, why not think about what sort of magazine you would create? Those possibilities are not dead.

> *CT: They are cheaper and the process of production is much more enabled through the digital world. So, you're encouraging photographers to take an initiative and to conceive their own production. What about galleries?*

CC: Absolutely. I know no truly supported, emerging photographer who is not part of a network of artists who inform each other about what is going on and, together, create exhibiting and publishing opportunities. I noticed when I was a relatively junior curator that most photographers who were beginning their careers really wanted to meet my boss. He is a gorgeous human being and everyone should meet him, but they thought that his validation was the most important. But it's a mistake to think that it will be the most senior person who will support you most or even offer the best dialogue with you and your work. You need to find at least a few people from the same generation and who see you as their equal. There are writers, curators, and art directors, as well as fellow artists who share parallel aims at a certain point of time and perhaps think better as a group than they might alone. Your chance of getting validation from someone of a different generation is not the same. Networks are very important—finding people who share your values—where else can real dialogue happen? Where else can you find the critique after you stop paying for your education? Where do you go for an honest opinion?

One of the other things your question raises is the importance of thinking of magazines, or other forms of dissemination such as galleries, not as the goal but simply the context where you can place your work. You cannot afford to wait for that moment where context somehow accepts you. It's your context—create it.

> *CT: In other words, don't wait to be anointed. And, going back to democracy, it is more democratic when the maker can be his/her own distributor and producer. Technology has made that possible.*

CC: I don't think there's ever been a time more pressurized for someone in the early stages of practice to tailor what they do to a gallery market—a system where artists are not the most powerful characters a lot of the time. This can be damaging to the nature of photographic practice in the sense that you can literally see the difference between someone making decisions that are best for their work and someone making decisions where they are creating their work

according to the right terms, right forms and fashionability of recognized galleries. The latter is especially prevalent in New York, it has to be said. I don't think the pressures are as strong in other centers of practice where the market is less developed. Here you definitely see more work that is *about* the New York gallery world rather than anything else.

CT: What about some of the other alternatives? You mentioned magazines with a positive feeling about them. How about the assignment itself? There are people who seek to become fashion or high-end illustrative photographers who are smart and creative. Where do they go?

CC: I would separate documentary photography from fashion and advertising photography. In terms of documentary photography in newspapers and magazines, I find it very problematic because I think something has shifted in how we look at images of real events in still form. In a weird way, the best place for a photographer who wants to bring actual, real social issues into focus may be the gallery, because I think that's always going to be a problematic space. There are very few contexts today where an image can use the visual language of documentary and reportage and not potentially lose its message. I think it's almost impossible not to be circumvented by style.

CT: I think there's an economic problem with that. The galleries could love it but won't show it because they can't make any money off of it. They can't sell it. That almost eliminates the gallery, unless the work has a huge, social impact. The museum might be the place for that.

CC: Possibly, particularly when it comes to socially aware work. But the time has gone where the world wants idiosyncratic individuals portraying social issues in photographic styles—say black-and-white and 35mm reportage. Our media environment is such that we deal with lots of different perspectives on the same issue. I think generally and culturally we are open to a lot of different interpretations of a world issue—and expect that to be part of an artists' engagement with the social world. It's more likely and certainly more popular within art today to support digital video forms of documentary—typically with multiple screens or monitors and an ideological world away from the still, single, iconic photograph.

CT: There has always been the desire for making pictures for fashion by certain artists.

CC: I think fashion is a culturally degraded and undervalued form of photography. I developed quite strict beliefs about the difference between fashion photography and independent practice in the mid-1990s when I began curating projects directly about the process of making fashion imagery. I feel perfectly at home with my admiration for a practitioner who works in a way that feeds fashion

and advertising in a spectacular way. It's a tough, relentless, obsessive as well as collaborative form of photographic practice. But I also have a particular dislike for the way that photographers who have enjoyed a lucrative career as a fashion or advertising image-maker may turn to the art world for a form of validation or redemption when they have not really worked as artists. The true greats of commercial image-making, in my experience, don't see the fashion context as having lesser value than an art context and do not consider themselves artists—failed or otherwise. And as a curator that's one of the fine lines that I've really enjoyed exploring—how do you give cultural value to a photographer who has helped shape the high-production imagery that we all see without turning them into a bad artist in the process?

CT: You feel that's the curator's job?
CC: The job of a curator of photographs? Yes, I do. Being a curator of photography only as contemporary art is not for me. If you don't examine photography's industries as well then I don't see how you are engaging with the medium. In the 1990s there was a collision of the production values and methods of fashion photography and the "directorial" or "constructed" style of high-profile art photographers. There is this belief that somehow the two are very close together. Art institutions more readily showed fashion photographs—printed up to the new, large sizes of art photography—because they kind of looked like what was pertinent within contemporary art. There was an economic prerogative to do that with the potential for support from the fashion industry and sponsorship from corporations. Institutions were looking to have their names attached to much more fashionable and glamorous social elites. Museums' press and marketing departments were on the ascendance. As a curator of photographs who was actively researching fashion photographs, I was able to circumnavigate some of the more cynical aspects of why fashion photography was getting a cultural profile and, I hope, say something meaningful.

CT: How about the other way around? What about photographers who have been artists and get the opportunity to make something more commercial?
CC: At a certain point in someone's development as an artist, which is normally when they're in their forties or fifties, their sense of who they are really is beyond debate. Once you are secure about your own voice, taking on commercial work means something entirely different from when you're starting out. One of the big worries for emerging practitioners is that by getting involved with commercial photography (even though the term "commercial" has a degree of irony to it given that you're not really getting paid, you're probably barely covering your costs) is that you are going to corrupt your independent practice. Personally, I think at an early stage in your career it's all about the experiment. You will learn things about yourself by doing so-called

commercial work or assignment work. Some people will learn that it isn't what they want to do ever again. Some people will learn that there is a gratification from having a shoot for two days and in a month seeing the pictures in the press, which is entirely different from producing—alone—a body of work every two years. I think these can be good opportunities for an emerging photographers and a part of their discovery of their abilities. And I think that an established artist who occasionally takes on assignments is probably able to enjoy the gratification of the fast and social pace of this work without much concern about if they are being corrupted in some way.

CT: Unfortunately, there can be a real compromise for the artist who wants to adapt their work for both commercial and editorial purposes.
CC: The odd thing about fashion photography is there's no way to be a great "aspiring" or "occasional" fashion photographer. Either you go fully into it and are driven by it, or you're not. But I imagine there are more tales of woe for an art photographer seeing their art images recontextualized as advertising than there are for an art photographer dabbling in assignment.

CT: Over the past couple of years, it seems there is increased pressure to professionalize one's practice early on. Can you talk more about the pressures of having a "career" as an artist and what that means today for an emerging photographer?
CC: "Career" sounds like it is more about being organized and getting paid than what really motivates interesting artists. It's the wrong word, but because there is a mechanism and infrastructure of publishers, galleries, and archives, you have to at least engage with a level of professionalism if you want dissemination and appreciation of your photography. When I think of a "career" as a photographer, I'm not thinking of a desk job, more of a responsibility to yourself to make sure that when you're ready to present a body of work, you don't short-change yourself. You know that you have put all of the rigor that you possibly can into the making, and the editing, and deciding what its context is and then you have to somehow detach yourself and develop the third-person voice. Before you can afford the studio or the assistants, or attract an agent or gallerist, you have to take on these roles yourself. You need to make sure you can deal with all the knocks that will come your way when presenting your work and have inner confidence that you have applied a rigor to your practice, and you know what you're doing.

CT: Do the people you admired and learned about in your studies and curatorial experience have common traits to be emulated?
CC: I don't think it's about personality exactly, and I'm slightly suspicious of that. When you meet some of our most successful artists, their charm is so impressive

that you understand it's an element of their success. It's not about a preferred working method either. I know artists who barely take a photograph between their very preconceived ideas; so, it may be one picture every six months. And I know artists who can't contemplate not taking ten photographs a day. I admire photographers who are curious and preoccupied by the same images and subjects their whole lives, but probably connect more personally to photographers who are driven to shift their vision into new territories and areas of experimentation. But I think they share the degree to which they just literally wouldn't survive if they didn't create.

> *CT: Obsession always comes up. It's almost the key word. It leads to voyeurism, not in the negative sense of the word, but the desire to collect the world visually. You mentioned something earlier about the artist/photographer needing to have a conversation with themselves.*

CC: The conversation is most useful when you feel that the work is no longer so private and ready to be seen beyond your safe circle. The conversation is really about what you want, and almost what you want from life. I have to say, it's okay to be a photographer who does not want to be part of that whole mechanism of art and publishing. But you must never hold that mechanism in disdain if you didn't want to be part of it. You must never feel that you both resent and also have expectations of photography as an industry and a business. You can't. I know very contented photographers who are relaxed with their choice to do group shows now and then, or put some pictures on the walls and invite friends around. That's their way of having a public discourse. For others the hunger is really about producing books or exhibitions or editorial in high-profile spaces and to make a bid for cultural status in their lifetime.

> *CT: One thing I'm constantly struck by is how often students lack a historical framework to understand the diversity of the medium. Photography is still young and only now is it being thoroughly explored. A book like yours [* The Photograph as Contemporary Art *(2004)] would have been unimaginable in the past.*

CC: I know. It's still quite difficult to convince a publisher to have so few well-known photographers in a book, and to produce a survey book that is 50 percent women practitioners. It's not possible to talk about a contemporary survey of photography and think that everyone is going to be a high-profile name. That would be a perpetuation of an over-privileging of a few at the expense of many, and that's been part of photography's history long enough and absolutely does not reflect the current climate of contemporary art photography. What was tough and at times unsatisfying for me given that I come from a museum and historical photography background, was writing a book that gave few historical precedents from before the 1960s for what is happening now. But all books have

the confinement of their page limits! And I ultimately wanted to see if I could write about photographic practice in the last five years without too much historical alignment.

CT: Why would you find it unsatisfying?
CC: Because, even though I was careful not to suggest this, it implies that photography's history is developmental, then we reach the 2000s and it's somehow an exceptional time for photography. It suggests that the previous 170 years of photographic practice were building to today. If you think that contentious or intellectually profound photographic ideas began in this century, you're really missing out on how sophisticated the medium has always been.

CT: Which leaves us a void because we don't have a good history of that time period.
CC: When I was curating shows that deal with the whole chronology of photography, it was very exciting but also frustrating. We have a relatively linear history of photography up to the early postwar period and then it becomes a very difficult history to write or exhibit. Either you proceed with a canon that distinguishes a few innovators from the vast number of "others" or you have to find ways to invest your interpretation of that history with ideas about networks and structures, the constant re-appraisal and re-thinking of photography's history, the significance of contexts on the meaning of photography.

CT: Certainly, it is essential that we understand groups, networks, relationships, and influences. Don't you think there is a lack of historiography in the medium?
CC: I suppose the contemporary art world's interest in photography is driven mainly by what came out of conceptual art-making in the 1960s and early 1970s. This was a shift from the values of the canonical history of photography—from the messenger being the message to the medium being the message. It becomes an ideological act to be a connoisseur or a modernist or a post-modernist. But I think the crucial point is that photography has more than one axis, methodology, set of motivations and histories and this—in and of itself—supplies photography's infinitely rich terrain.

Section Four

Guides for the Uneducated:
Higher Education
and Photography

HISTORY OF PHOTOGRAPHIC EDUCATION WITH AN EMPHASIS ON ITS DEVELOPMENT IN THE UNITED STATES
Nathan Lyons

Research into the history of photographic education has been limited. An organizing founder of the Society for Photographic Education, Lyons gives us an investigation to stimulate further work.

The noted historian James D. Horan, in his study of the life of Mathew Brady, suggested that after Samuel F. B. Morse returned from France in 1839 and subsequently perfected the use of the daguerreotype process, he opened what was "perhaps the first school of photography in America, charging twenty-five to fifty dollars for taking and developing daguerreotypes." Among his first pupils were Edward Anthony, Samuel Broadbent of Philadelphia, Albert S. Southworth of Boston, and a young Mathew Brady.

Through numerous newspaper accounts as well as the rapid appearance of Daguerre's manual in the United States by September 20, 1839, photographic instruction begins to proliferate in response to growing public interest. Instruction is made possible through published sources or by direct study with a skilled operator.

An apprentice model is strongly suggested by [S.D. Humphrey], the editor of *The Daguerrean Journal*, in 1851 when he observes that "those desirous of becoming proficient in this art, with a view of making their calling, will find it a matter of economy to spend a few months in one of the leading or most respectable establishments in the country, where they may be an eyewitness of, and take part in the regular business of the day..."

By 1851 the *Photographic Art Journal* and Humphrey's journal have a joint circulation of 5,000 copies. They provide extracts and translations from England and France, providing an active exchange of information, and by

1853, one hundred Daguerrean establishments are flourishing, employing two hundred fifty men, women, and boys.

Through the 1850s the publishing of photographic texts and periodicals include *The Photographic Art Journal*; *The Daguerrean Journal*; *A Dictionary of Photographic Art* by H. H. Snelling; *The Photographic Primer* by Joseph Cundall; and Hill's two-volume *Treatise on the Daguerreotype*; and by May 1851 S.D. Humphrey, editor of *The Daguerrean Journal*, establishes a book sales department as a service to subscribers.

Subsequently an ad for Earl's Daguerrean Institute appears in the *Daguerrean Journal*. Founded in Cincinnati, Ohio, its faculty includes Austin T. Earl assisted by E. C. Hawkins, and in theory and chemistry by Prof. J. Milton Sanders. By 1860 H. H. Snelling announces the establishment of The American Photographic Institute for the teaching of "the art in all its branches" in New York City.

Most of these early schools seem to be short lived; by 1869 the noted photographer M. A. Root, writing in the *American Journal of Photography*, makes a passionate appeal for the establishment of a Heliographic School. Its purpose would be to cultivate as well as promote photography's recognition, "as being one of the fine arts, instead of a mere mechanical process." A comparable concern is registered throughout the 1870s and by 1898 the Imperial School of Photography of Vienna, Austria, is proposed as a model for the development of a school of photography in America. The Vienna school, directed by Dr. Eder, was divided into two departments, designated as Departments "A" and "B." "A" was the Department of Instruction and "B" was the Department of Investigation and Original Research. Department "A" was subdivided into six departments, from drawing to a progression of course work in photography and reproduction processes. Its fifth department incorporated practical instruction in photography for amateurs (artists, scientists, etc.). Its sixth department was established for practical instruction in the making of books and illustrations. The purpose of Department "B" was to conduct original research, with the testing of new methods in photography and the testing of apparatus and materials in support of individuals, and business.

It would be some time before such a highly developed program would find support in the United States. However, in the late 1880s the Chautauqua program embraced the establishment of a school of photography that stressed avocational interests. As described in the August 29, 1890, issue of the *Photographic Times*, "Chautauqua means intelligence for the masses; it means the profitable use of leisure moments..." The programs were designed "to facilitate the study of natural sciences, of botany, biology, and a multitude of others, to learn more distinctly of nature's beauties and marvels, to better educate our eye and heart..." It maintained two instructional sites, one during the summer at the assembly grounds in Chautauqua, New York. The other location was headquartered in New York City. The program also incorporated

a corresponding class that by 1890 provided instruction for some eighty-one students. While most students were from the United States, they did have participants from England, Turkey, Canada, Dutch Guyana, and Japan. Total enrollment for all programs by this time was one hundred fifty-seven students ranging in age from fifteen to sixty-four years. Forty percent were women students and sixty percent were men. The *Photographic Times* was the official publication of the school; a special school supplement was issued monthly with each issue.

By the turn of the century one begins to see the active continuation and development of camera clubs supporting the development of members' activities, holding classes, demonstrations, exhibitions, and lectures. The primary emphasis in most training is again of a technical nature. Or else it promotes an aesthetic grounded in compositional values that were first purported in Burnet's *A Treatise on Painting*, published in 1822. This was, of course, years prior to the invention of photography, but was subsequently published as *Burnet's Essays on Art*. The last edition I have been able to locate was published by Scovill in 1917, intended primarily for photographers. It relied exclusively on classical paintings to demonstrate compositional values. After the turn of the century some of the discussion begins to shift. O. W. Beck, writing in the journal *Camera Notes*, issued quarterly by the Camera Club of New York, observed that "Art has not yet been 'taught' in photography. To teach it requires conformity to conditions peculiar to photography. It has been commonly understood that such training as is given to students of painting is one of the best suited to him who uses the camera. That plainly is a circuitous route to follow." He concludes that "In an institution in which photography is to find art-development both the teachers and the school must grow out of photography itself." This becomes an important distinction, but it will take years before this idea becomes more fully embraced.

At the turn of the century, a definite momentum begins to develop at the university level, with courses being offered at the Massachusetts Institute of Technology; the University of California; Cornell University; Ohio State University, Columbus; the University of Rochester; the Brooklyn Institute; and the University of Chicago, as well as the U.S. Military Academy at West Point. Again, most, if not all, training is based on the technology of the medium.

Photographic education begins to be recognized in a broader context than that of the university. Writing in the *Photographic Times* in August 1908, Lewis W. Hine, a teacher at the Ethical Culture School in New York City, proposes, "Why are we not using the camera to help in the education of children?" He proceeds to discuss the activities of the Commerce Camera Club, making records that would be pertinent to "their study of commerce, in which they were engaged in the geography class." Building on the camera club experience, Hine then established the Camera Class for more "serious work" than the club could do. "During the year, about one hundred hours are devoted to class

work in the darkroom and in the field to say nothing of the time voluntarily spent outside of school hours. The fundamental aim of the course is to help pupils to a better appreciation of good photography and how to attain it, in short, to give the artists a point of view..." It was out of this program that Paul Strand received his early training. In his concluding remarks, Hine observed that "The use of photography in the schools is in its infancy. Many lines of connection with other studies are possible. Its social effects are manifold."

A central figure in the subsequent development of photographic education is a founding member of the Photo-Session, Clarence H. White. He begins to lecture in photography in 1907. Three years later White establishes a summer school in Maine and by 1914 he founds the Clarence White School in New York City. The school lasts for some twenty years, and among the students are a list of distinguished alumni including: Margaret Bourke-White, Anton Bruehl; Laura Gilpin; Dorothea Lange; Karl Struss; Doris Ulmann; Paul Outerbridge; and Ralph Steiner.

The presence of pictorial considerations in photography can be traced from 1844, when William Henry Fox Talbot, in *The Pencil of Nature*, suggested the "beginnings of a new art" when he included in his discussion of the practical uses of photography the photograph entitled "The Open Door," presented solely for its "picturesque" quality. Eventually, Pictorialism becomes inbred in the photographic societies and camera clubs; as a reactionary force it wages war against the active production of the "moderns." This transition begins to take place just prior to World War I and emerges fully by the end of the war. Sibyl Moholy-Nagy observed that "The only lasting evidence of the anguished transition survives in new art forms, and in changed relationships between artist and society... The visual world had to be stripped of its anthropocentric symbols before new ones could be created. The battle cry was: 'Back to fundamentals.'" The New Vision and the New Society were to be integrated in the same sense that artist and craftsman were to be philosophically and actually ranked as equal. An interrelationship of art and technology was what formed the basis of the Bauhaus Program begun by Walter Gropius in 1919. László Moholy-Nagy integrated photography into the programming of the school although no photographic workshop was in existence until 1929, a year after Moholy-Nagy resigned from Bauhaus. In 1932 his affirmation concerning the significance of the photographer and photography's social and educational significance are to be acknowledged. "Thanks to the photographer humanity has acquired the power of perceiving its surroundings, and its very existence, with new eyes..." He concludes by stating "... in photography we must learn to seek the 'picture,' not the aesthetic of tradition, but the ideal instrument of expression, the self-sufficient vehicle for education."

The optimism with which the school was founded began to erode and by 1928 Gropius resigned as head of the Bauhaus, followed by a number of its key faculty, due to the mounting political pressure that came with Hitler's rise to power in 1933. It's important to recognize this development in these remarks

concerning the history of photographic education in America because of the subsequent influence that the Bauhaus program had through the migration of many of its faculty to colleges and universities in the United States prior to World War II. The pedagogical influence was pronounced and transformed art education for generations.

With America in the depths of the Great Depression two programs begin to evolve that exhibited somewhat different lines of development in photographic education. The first was in relation to the formation of Black Mountain College, where "the arts were to be given a position equal to that of other subjects; and for the beginning student, they were to be the most important courses in the curriculum." This holistic approach to education was an application of the principles of democracy, "not just to the classroom, as was usually the case in progressive schools, but to the entire structure of the college. There were no legal controls from the outside: not trustees, deans, or regents. The college was owned and administered by the faculty..." Its commitment was to prepare students for life, resonating a similar concern of the Bauhaus.

Shortly after its founding, Joseph Albers, one of the faculty whose teaching contract had been terminated at the Bauhaus, was invited to teach at the college. While there was not a full time faculty person teaching photography until 1949, Albers was an avid photographer and in a letter to the editor of *U.S. Camera* in 1942 he noted that "Black Mountain College is one of the few colleges where photography is considered as a branch of the arts and where, therefore, instruction in, and criticism of, photography have been as an official activity." In the same year exhibitions of the work of Barbara Morgan and Clarence John Laughlin were held, as well as the work of the summer faculty. During the summer of 1947, Beaumont Newhall was invited to teach the History of Photography and Nancy Newhall taught a course in photography. By 1951 the school sponsored a seminar in photography with Aaron Siskind, Harry Callahan, and Arthur Siegel organized by Hazel Archer, who joined the faculty to teach photography in 1949.

The second program began in 1937 when Moholy-Nagy was offered the directorship of the New Bauhaus in Chicago, founded by the Association of the Arts and Industries. The school was to close within a year. However by 1939 he opened his own School of Design and by 1944 the School of Design was reorganized and renamed the Institute of Design.

In New York City a somewhat different point of view toward photography and photographic education begins to evolve as an outgrowth of the Film and Photo League, founded as a branch of the Workers' International Relief. Workers' Camera Leagues were formed throughout Europe and the United States. Their efforts were directed toward producing films and photographs that documented the conditions of workers. Eventually the New York group divided into two separate organizations and the Photo League was founded in 1936. H. H. Nicols had been responsible for developing courses at the Photo League in the early to

mid-thirties, and its mandate was not to teach techniques as an end in itself but to "remove the barriers which prevent the beginner from expressing his ideas effectively in photography." By 1938 Sid Grossman would lead the Documentary Group and its list of lecturers during the summer included Paul Strand, Berenice Abbott, Elizabeth McCausland, Leo Hurwitz, and Roy Stryker.

In addition to the development of the school, the League sponsored exhibitions and a monthly bulletin called *Photo Notes*, with an emphasis on promoting documentary photography, and in this regard the League felt a strong affinity with the work of the Farm Security Administration. By 1948 classes ran for twelve weeks, with a tuition of $30. In December of 1947, the Photo League found itself listed by the U.S. Attorney General's office as a subversive organization. This accusation may have had more to do with the League's beginnings than its recent history; however, the stigma that this had on the organization subsequently forced the League to close its doors.

In 1954 the University of Rochester and the George Eastman House held a fifteen-week session of a "non-technical" course in the History and Aesthetics of Photography. Guest lecturers included Paul Vanderbilt of the Library of Congress as well as Wilson Hicks, one of the original editors of *Life* magazine.

A comparative analysis of the growth of photographic education may be understood from looking at an early survey conducted by Dr. C. William Howell in 1964 and one taken some twenty years later. The number of schools offering photographic instruction had risen from 155 to 1,043. The number of departments that taught the education of photographers in a fine arts context rose from 47 to 384. The teaching of photography in journalism departments was relatively stable, showing a slight decline from ninety-nine to ninety-five. The number of Master of Fine Arts degree programs rose from one to forty-nine and the number of programs offering Bachelor of Fine Arts degrees rose from two to ninety-four.

A significant momentum can be traced to the effects of the GI Bill and the return of so many veterans after the Second World War. However, a major transition begins to take place in the early 1960s with the formation of the Society for Photographic Education, which brought to the field, for the first time, a focused attention to the needs of photographic educators.

Three events occurring shortly after one another provided the momentum to bring attention to the issue of photographic education. A pilot conference organized by Henry Holmes Smith at Indiana University was held in the summer of 1962. The second was a conference organized by Sol Mednick and sponsored by the Philadelphia Museum College of Art and the American Society of Magazine Photographers. The third was when the George Eastman House called an Invitational Teaching Conference in November. Reports on each of the conferences were contained in the Eastman House final report.

A steering committee was appointed to formalize the structure of such an organization to be presented at a conference to be held in Chicago in 1963. It

was out of this meeting that the Society for Photographic Education was founded. Within two years the membership grew from the original 28 to 120 and through the years has reached as high as 1,800 members.

Paralleling these developments within the university, and to some extent at the high school level, was the development of numerous independent workshops. In the November and December 1961 issues of *Popular Photography*, several photographers, from Alexey Brodovitch to Sid Grossman, are featured and in volume 9 of *Aperture* magazine issue number four an article entitled "The Workshop Idea in Photography" explored the teachings of Ruth Bernhard, Minor White, Nathan Lyons, Henry Holmes Smith, and Ansel Adams. Subsequently extended workshop structures began to be developed. Cheri Hiser founds the Center of the Eye in Aspen, Colorado, for short-term workshops. Peter Schlessinger founds Apeiron Workshop as a residential program in Millerton, New York, and the Visual Studies Workshop in Rochester, New York, retaining the workshop structure within the context of a university program. It also established an extensive publishing program with its critical journal *Afterimage* and its artist press. It developed an exhibitions and traveling exhibitions program, a research center, media center, and outreach programs.

Through the next two decades programs grew and expanded. Challenging students and faculty pushed the boundaries of accepted practice. At the same time greater public acceptance seemed evident. Publishing flourished, galleries developed, photographic criticism and theoretical discourse evolved, museum programs began collecting and exhibiting photographs, and above all else there were plenty of jobs for recent MFA graduates entering the field. Inevitably the vacuum that existed previously became filled. Jobs that were plentiful created large application loads for the diminished positions available.

While a synthesis of photography into the larger arts community promoted the integration of almost every arts discipline, from printmaking to installation work, to artist books, to sculpture. The emergence of new technologies has expanded the "tool kit" within arts practice in general, incorporating a series of additional challenges to be pursued by those entering the field. Currently very few teaching positions are posted that do not require multiple skills involving photographic and computer-based skills as essential job qualifications. Digital environments in many programs are actively replacing traditional darkroom facilities.

We are facing one of the most challenging times in the field of photography as well as image-making in general. There is a definite need to reevaluate the presence of photographic education with all its implications in the broader context of media or visual education.

Two priorities need to be considered at this time. The first, that the curricula in the future not be media specific, but reflect the integration of cross-disciplinary concerns, and, secondarily, that we seriously entertain a total integration of "tools" as applied to the expressive potential of images and text in our future attempts to

manage, explore, exploit and interpret the proliferation of images that represent the genetic code of culture.

Certainly it is not just simply a question of photography or film or video or electronic imaging systems, but our development of visual sign systems that is crucial. Dumb and manipulative images can be made by utilizing any of the above, have been, and usually are. Visual sign systems should not be domesticated by language, nor should new imaging technologies be dominated by their predecessors. Imposing the values of one upon that other does not enhance, but subverts the unique attributes of each. The advent of photography enabled painting, literature, and printmaking to shift their historic agendas. New technologies can free and inform preceding ones.

COMMITMENT
John Szarkowski

In this speech from George Eastman House's Invitational Teaching Conference in 1962, Szarkowski gives us an enduring challenge for teaching photography.

I would like to talk about commitment: about the photographer's or the teacher's acknowledgment of his function—his purpose. I don't think that commitment is an optional thing for the creative person. I don't even think it's an optional thing for a productive person. I think it's an indispensable thing. In one form or another, only commitment can rescue us from boredom and frustration. I believe that commitment implies content in the work that is produced.

When we talk about "non-content" photographs, we mean pictures in which the objects represented are not important for themselves—pictures in which a certain configuration of shapes and tonalities achieve a meaning, which is satisfactory in its own terms. (This is what we mean at best. At less than best we perhaps mean pictures that copy, not the aspect of a first-hand experience, but the aspect of an accepted tradition of picture-making.) But to the degree that these pictures are in fact lacking in content, they must be considered failures; and to the degree that their content is concerned only with known art values, they must be considered academic.

I recall a conversation that I had many years ago with a modern jewelry maker. I complained to him that I felt that modern jewelry was weak because it lacked the great symbolic content of traditional jewelry; I felt that traditional jewelry was more than decoration, because it symbolized the possession of rank, the possession of a secret language. It identified the owner in some very rich and humanistic way, whereas modern jewelry was simply an ornament. He listened to me very patiently. He was working on a dangling, skeletal earring with many moving parts, and finally he held up this earring and said, "You're wrong. Do you know what the content of this earring is to the woman who wears it? It proves to all of her friends that she knows who Alexander Calder is."

I am afraid that much contemporary photography expresses a similar desire to be associated with creative solutions, rather than the desire to face new problems creatively. I think that we all agree that the form and the content of a work of art are indivisible, and that if no two works of art look exactly alike that means that no two of them have exactly the same content, or grew from exactly the same commitment. But it is perhaps possible without oversimplifying too much to define broad areas of commitment that have shaped our artistic tradition.

Artists have committed themselves to the glorification of God and his works; to the exploration of the physical world; to the recording of man, his social relationships, his trials, aspirations, successes, follies; to an understanding and a projection of the tradition of their own medium; to a search for the

assumed, basic, rock-bottom properties of their medium. And finally, more recently, they have committed themselves to an expression of the presumed unique and inimitable beauty of their own individualities. I would be less than honest if I claimed to believe that all of these areas of commitment are equally fertile—in the historic sense, equally potential. Nevertheless it is certainly true that no one can define for the individual artist what his own commitment should be. The best commitment for him is to that content that is of greatest concern to him, and from which he can make a picture—for the artist after all is a maker, he is a hand-worker. He creates things. Granted that this requirement is satisfied, his commitment, whatever he chooses, is the best commitment for him.

Nevertheless I think that the teacher is committed to open for the student as wide as possible a world of concern, and not confine him to a formal and closed concept of what art is, now and forever. This is a function that I don't think photographic education is completely succeeding in fulfilling. And I mean photographic education at its best, as it is represented here.

I believe that we often define serious photographic education in terms of what is safe and respectable, in terms of contemporary art criticism and in terms of the values held by the social microcosm that is known as the art world. I think that on one hand we suffer from what to me seems an inexplicable inferiority complex in the company of both modern painting and ancient academicism. In colleges, in art schools, and in museums we are not quite sure that we are wanted, and I'm afraid that sometimes we adjust our art accordingly. On the other hand, we are embarrassed by the non-serious photographers, by our glib, tricky, commercial, easily compromising, bandwagon-jumping colleagues. In consequence we seek respectability in the world, protective coloration in our schools and in our departments, and quick results with our students.

As Beaumont Newhall demonstrated this afternoon, the concerns of modern painting are due certainly in no small part to the fact that much of painting's historical commitment has been preempted by photography. For creative photography, having rid itself of an attitude of servility to nineteenth-century painting, to now confine its concerns to those compatible with the aesthetic of twentieth-century painting, seems to me to be at least a paradox, and at worst a farce.

As to our embarrassing colleagues, certainly there are millions of photographers in the world, and most of them are undistinguished. But we cannot profitably abandon all areas of concern that have been treated crassly or ineptly by our poor relations. We cannot assume that sunsets, babies, nursing mothers, swans on reflecting pools, etc., are forever forbidden to our sensible, creative concern. Rather we should regard creative photography as the most revealing, the most honest, the most perceptive work to grow out of photography's total effort. I think we tend to regard creative photography as a specialty, as a special category of work. I don't think it is that. I think that's a narrowing

way to regard it. It is not a hot-house plant. It's the top of a great ancient tree and it gets nourishment from all of its healthy leaves.

I am sure that you are all familiar with the exhibition upstairs, "The Art of Photography." It's a great exhibition, and each time I have seen it, I have left feeling proud of the fact that I am involved with photography. But it's necessary to remember the cohesiveness apparent in this exhibition is made [visible] by historical perspective. It was surely less evident to those who made the pictures. In fact, every man that is represented in the exhibition is there because he *redefined* what creative photography was. I think this nourishment, this new blood that allows any creative field to become something new and something richer, must come from *outside* of the medium. An art medium is not like the snake with its tail in its mouth. We cannot expect to find all of the nourishment that we need within the works of the tradition.

Revolutions in art come from concerns that are outside and beyond art. I believe that dedication to the subject, with all of its non-photographic, all of its humanistic implications, is not a handicap to the young photographer. I feel that it is a profound advantage, and it is a function of the teacher to encourage such dedication. All we know about art is its history. Where the impulse will come from that will create the next change in art we do not know, but we do know that new art comes from the fact of tradition meeting and mingling with the fact of a new life experience, not merely from the re-shuffling of achieved solutions.

New ideas have always been greeted with suspicion by the academy, and I think that it is time to admit that we are perhaps now the academy. Modern art and the movement of which we are a part is not a new movement. It's older than most movements were when they fell. I think that we should make a special effort to admit new fertilizing ideas from life—ideas that do not yet have a form.

As teachers our own commitment will, in large measure, be adopted by our students. If this commitment is worth defending, it must finally become integral—become one thing. But for pedagogical purposes we can divide it:

If as teachers we have an understanding and a disinterested love of photography's rich tradition, we will communicate this understanding and love to our students.

If we believe that an honest and precise description of significant fact is a worthy objective, so will many of our students.

If we are anxious that our work will be instantly identifiable as ART, our students too will be crippled by a concern for pedigrees.

If we commit ourselves to using our pictures, or having them used, in a morally responsible manner, then our students will become aware not only of how the picture looks, but of what it says.

If we commit our work, then our students may commit theirs, to the business of probing and exploring life, including all those intuitively sensed realities for which we have not yet found formal expression.

VALENTINE
Stephen Frailey

Photographer and educator discusses the future of photographic education and looks with hope to the next generation.

Of all the visual arts, photography is the most accessible. Advancement in technology, visual literacy, and cultural affluence have contributed to the medium's penetration of all aspects of commerce, culture, and daily life. Contemporary life increasingly involves the seeming desire to document and observe and celebrate daily life photographically. And the photographic medium is elastic, accommodating the vast multiplicity of ideas, references, uses, contexts, genres, and agendas that construct this age of information.

One of the advantages, then, of working within the medium is its availability: at its threshold, photography is an egalitarian medium that is seductive and appealing.

The gradual education of a photographer, however, is contrary to this accessibility. To achieve a degree of significance and originality involves an unusual degree of commitment and rigor, and an embrace of this contradictory toggle between the vernacular of photography and its ambitions as an individual or cultural voice.

Photographic education proposes a shift from the assumed importance of the subject, to the significance of the interpretation. It often privileges the mundane and ephemeral and achieves relevance not through the literal subject matter, but the attitude, passion, and conviction of the photographer.

The premise of a strong photographic education is the assumption that all individual voices can be amplified, and that the potential for photographic distinctiveness is as axiomatic as our status as individuals. And that photographic practice can accommodate many different approaches, from the methodical to the impulsive, the cerebral to the instinctive.

The best photographic education is as interested in the inquiry as in the resolution, and the medium as a vehicle for the lifelong accumulation of information and knowledge. Curiosity fuels most photographic endeavor; memory and fear often provide the heat.

An institution engaged in photographic education must remain responsive and flexible in its hiring and curriculum to insure that courses are relevant and inventive, and reflect issues and interests in the professional photographic community. It is through the course curriculum and faculty that ideological diversity is encouraged, and a vigorous and deliberate dialogue between student work and contemporary photographic ideas. Students of photography can be empowered by seeing their work as part of a cultural matrix, as entering into a conversation with the professional and historical community.

The best photographic education is no longer segregated by opposing photographic genres, identities, and ambitions, but is rather an education that seeks a plural and overlapping and fluid combination of forms, vocabularies, and contexts—paparazzi still life, for example. The barriers that have traditionally separated different photographic practices will continue to erode and the best photography, whatever the genre, will be informed by an inventive and unpredictable self-expressive motivation. Photographic education accepts all forms of the medium, from the theoretical to the practical, from both the heart and the mind.

I have written to the students: you are the future we could never predict. You will subvert all our tired assumptions, our clichés, and conventions. You will redraw our maps; from our seeds unfamiliar and disorienting forms will sprout. Our caution will become your risk. When we seek the reassurance of answers you will commit to the elegance of inquiry. You will outdo us, confuse us, and approach the unknown future with an open heart.

THE DOS AND DON'TS OF GRADUATE STUDIES: MAXIMS FROM THE CHAIR
Charles H. Traub

For years, the editor has willed these maxims upon his students. They were inspired by those of his own teacher, the cantankerous Arthur Siegel, at the Institute of Design.

THE DOS
Do something old in a new way
Do something new in an old way
Do something new in a new way; whatever works, works
Do it sharp—if you can't, call it art
Do it in the computer—if it can be done there
Do fifty of them—you will definitely get a show
Do it big—if you can't do it big, do it red
If all else fails, turn it upside down—if it looks good, it might work
Do bend your knees
If you don't know what to do, look up or down—but continue looking
Do celebrities—if you do a lot of them, you'll get a book
Connect with others—network
Edit it yourself
Design it yourself
Publish it yourself
Edit—when in doubt, shoot more
Edit again
Read Darwin, Marx, Joyce, Freud, Einstein, Benjamin, McLuhan, and Barthes
See *Citizen Kane* ten times
Look at everything—stare
Construct your images from the edge inward
If it's the "real world," do it in color
If it can be done digitally, do it
Be self-centered, self-involved, and generally entitled and always pushing—and damned to hell for doing it
Break all rules, except the chairman's

THE DON'TS
Don't do it about yourself—or your friend—or your family
Don't dare photograph yourself nude
Don't look at old family albums
Don't hand-color it

Don't write on it
Don't use alternative processes—if it ain't straight, do it in the computer
Don't gild the lily—a.k.a. less is more
Don't go to video when you don't know what else to do
Don't photograph indigent people, particularly in foreign lands
Don't whine, just produce

THE TRUISMS
Good work sooner or later gets recognized
There are a lot of good photographers who need it before they are dead

If you walk the walk, sooner or later you'll learn to talk the talk
If you talk the talk too much, sooner or later you are probably not walking the
 walk (don't bullshit)

Photographers are the only creative people who don't pay attention to their
 predecessors' work—if you imitate something good, you are more likely to
 succeed
Whoever originated the idea will surely be forgotten until he or she's dead—
 corollary: steal someone else's idea before they die
If you have to imitate, at least imitate something good
Know the difference

Critics never know what they really like
Critics are the first to recognize the importance of that which is already known
 in the community at large
The best critics are the ones who like your work

Theoreticians don't like to look—they're generally too busy writing about
 themselves
Given enough time, theoreticians will contradict and reverse themselves
Practice does not follow theory
Theory follows practice

All artists think they're self-taught
All artists lie, particularly about their dates and who taught them
No artist has ever seen the work of another artist (the exception being the post-
 modernists, who've adapted appropriation as another means of reinventing
 the history)
The curator or the director is the one in black

The artist is the messy one in black
The owner is the one with the Prada bag
The gallery director is the one who recently uncovered the work of a forgotten
	person from his or her late spouse
Every gallerist has to discover someone
Every curator has to rediscover someone
The best of them is the one who shows your work

Every generation rediscovers the art of photography
Photography history gets reinvented every ten years
New galleries discover old photographers

Galleries need to fill their walls—corollary: thus new talents will always be found
Gallerists say hanging pictures is an art

There are no collectors, only people with money
Anyone who buys your work is a collector—your parents don't count

All photographers are voyeurs
Admit it and get on with looking
Everyone is narcissistic—anyone can be photographed

Photography is about looking
Learning how to look takes practice

All photography, in the right context at the right time, is valuable
It is always a historical document
Sooner or later someone will say it is art

Any photographer can call himself an artist,
But not every artist can call himself a photographer

Compulsiveness helps
Neatness helps too
Hard work helps the most

The style is felt—fashion is fad

Remember, it's usually about who, what, where, when, why, and how
It is who you know

Many a good idea is found in a garbage can
But darkrooms are dark…and dank, fuhgeddaboudit

The best exposure is the one that works
Expose for the shadows, and develop for the highlights
Or better yet, shoot digitally

Cameras don't think, they don't have memories
But digitals have something called memory
Learn to see as the camera sees—don't try to make it see as the human eye
Remember, digital point-and-shoots are faster than Leicas

Though the computer can correct anything, a bad image is a bad image
If all else fails, you can remember, again, to either do it large or red
Or, tear it up and tape it together
It always looks better framed on the wall

If they don't sell, raise your price
Self-importance rises with the prices of your images on the wall

The work of a dead artist is always more valuable than the work of a live one
You can always pretend to kill yourself and start all over.

A HANDY KIT FOR DO-IT-YOURSELF CRITICS
Ralph Hattersley

Another piece from George Eastman House's Invitational Teaching Conference in 1962. Though dated, this offers advice that is still relevant for how to conduct a critique and question not only one's own work, but also that of one's peers.

WHAT QUESTIONS SHOULD A CRITIC ASK A PICTURE?
Some time ago, I made a list of ideas and questions to stimulate the flow of my critical ideas. By looking at the pictures and my list I had no difficulty in forming opinions or deciding what I should say. By knocking out the vulgarities and curse words, and by getting some of the ideas right end to, I made up a kit you may find useful.

WHY AM I CRITICIZING PICTURES?
1. To learn more about photography
2. To learn more about myself
3. To develop my powers of self-expression
4. To help other photographers understand themselves
5. To help them understand their own photographs
 a. So that they can eliminate their weaknesses
 b. Capitalize on their strengths
 c. And get more satisfaction out of photography
6. To help photographers understand their audience
7. To help the audience understand photography
8. To expand the audience for good photography
9. To help improve the general level of photography

1. *Kind of picture*—is this picture photojournalism, advertising, design or decoration, experimentation, salonism, sociology, or what?
2. *Goal*—what is the photographer trying to do?
3. *Value*—was this goal worth bothering with? Why, or why not?
4. *Situation*—what was going on during the half-hour during which this split-second picture was taken? How must the photographer have fitted into the situation? Did he cause it, control it, partially control it, or observe?
5. *Understanding*—did the photographer understand what he was photographing?
6. *Interpretation*—is his interpretation reasonable, unreasonable, inspired, mundane, accurate, inaccurate?
7. *Sensitivity*—how sensitive a person is the photographer?
8. *Visual literacy*—how much does he know about the language of vision?
9. *Timeliness*—is his pictorial idea a timely one, or a dinosaur from the primeval bog?

10. *Alternative goals*—what other things could be done with the same subject matter? Are they better or worse than what this photographer did?
11. *Great photographers*—what would some of the great photographers have done?
12. *Control of medium*—does this photographer have any control over his medium, or does he aim, pray, and click?
13. *Limitations*—what were the factors which must have limited his freedom of action?
14. *Compromises*—how successful were his compromises with factors over which he had little or no control?
15. *Photographer's personality*—what kind of person would make a picture like this one?
16. *Ideals*—what does he apparently believe in?
17. *Routes to goal*—how did he get where he wanted to go (choice and use of equipment, materials, models, location, techniques, etc.)?
18. *Attainment of goal*—or did he actually get there? If not, where did he miss and why?
19. *Alternative routes*—what are some alternative routes? Did the photographer make the best choice?
20. *Audience*—to whom does the photographer address his picture: to people in general, a special group or type of people, or to himself alone?
21. *Intentions with respect to audience*—what does he want from his audience: praise, understanding, emotional upset, money, belief, action?
22. *Photographer's understanding of picture*—what is the evidence that he does not understand his own picture?
23. *Critic's understanding of picture*—what are my grounds for believing I understand this picture well enough to criticize it?
24. *Photographer as communicator*—does he know how to "speak with pictures"?
25. *Picture as communication*—can this picture be considered as a statement about something?
26. *Responsibility for picture*—did the photographer make it, or did it make itself?
27. *Photographer's feeling about own picture*—how does he feel, and what evidence can I find in the picture which tells me he feels this way?
28. *Why*—why would anyone want to make a picture like this?
29. *Invention*—does it show inventiveness, or is it a sodden rehash?
30. *Meaning*—what does the picture mean, if anything?
31. *Gimmicks*—are there disguised gimmicks, hidden persuaders, clever tricks, design devices, and so on, in the picture? What do they accomplish?
32. *Translation*—how can I translate the picture into words? What is my basis for thinking my translation valid?

33. *Critic to photographer*—what clues does the photographer give me in his picture to indicate the kind of critical commentary he would understand?
34. *Photograph as art*—is the picture art? What is art? What is art as this picture defines it?
35. *Criticism as art*—what can I do to schmaltz up my criticism to make it obvious I'm doing more than blindly using Hattersley's Do-It-Yourself Criticism Kit?

In using this ponderous list I found it very boring to go over all the points carefully with every picture. The differences in pictures caused me to emphasize different points (three or four) with each.

My reason for wanting you to try my kit is that it will lead you to think of pictures from many points of view, some of which you might not have thought of without help. You will probably be asked from time to time to informally criticize the photographs of others. If so, the kit needs a further addition: a credo.

The unstated credo which seems to underlie most amateur criticism I've heard—and I've heard a lot—can be formally stated as follows: 1) shoot 'em down, 2) steamroller any complaining survivors, 3) prove that they're so dumb and photography so tough that only a genius like me can learn it, 4) any picture I don't understand is, naturally, an idiot-piece, 5) let everyone understand what a brilliant hero I am and 6) there is only one proper way of doing anything: my way. The temptation to spout the Gospel According to Malice is very great, but it does untold damage to American amateur photography.

Let's be proper boy scouts about this criticism business. One thing about boy scouts: they always intend to get those old ladies safely across the street.

I will endeavor to help the visual communicators expand the photographic language, define its grammar, and increase its poetry.

I will encourage the beginner.

I will respect each picture as a revelation of the photographer's self, remember the timidity and frightened uncertainty which may accompany such a revelation, and be continually aware of the great value to myself and others of such self-sharing.

I will respect each picture as a photographer's search for truth, beauty, happiness, self-expression, a means of communicating with his fellow men, and a way of sharing with others the delightful or interesting things he has seen. Whether the picture is successful or not, I will remember the photographer's intention.

I will try to avoid critic traps, or, having fallen in one, will climb out as soon as I can. I will tell the photographer I'm criticizing what has happened, so that he will not take on himself the blame for my error.

I will try to bring my entire life experience to bear on the problem of criticizing.

HALF-BAKED CRITICISMS
Criticism itself should be criticized. I've done this throughout the article. Though the following are every-day types of comments which pass for sensible criticism, they are undercooked and nonsensical. Don't be taken in by them.

"Great portrait! Best skin texture I ever saw."
"Terrific picture, the sharpest one I ever saw."
"Man, oh man, *peak action!*"
"That girl in the red jacket really *made* this landscape."
"Available light—oooooh!"
"Look at that *great* blurred action!"
"Out-of-focus foregrounds are really *it* these days."
"Speedlight is the only thing."
"The picture is great because the photographer achieved his purpose."
"Never put a subject in the middle of a picture."
"A picture shouldn't need a title."
"All cliches are bad."
"The 35-mm is the *only* camera nowadays."

CRITICISM OF SELF-CRITICISM
When you criticize yourself you are probably the world's worst critic. Let me show you some of the atrocities you commit against yourself.

You do a picture with one thing in mind, then criticize yourself bitterly for not achieving an entirely different goal (*the error of unconsciously shifting your goals*).

You criticize yourself for not making a picture as good as "others you have seen," not, however, bothering to define these other pictures or to find a specific example of one and compare it with your own work (*error of the ill-defined prototype*).

You feel yourself a complete failure for something you did do, or did not do, which had little influence on the success or failure of your picture (*error of dramatizing an inconsequential*).

You are lousy because you don't make pictures like those of a particular photographer whose equipment, mentality, geographic location, economic means, and photographic opportunities are entirely different from yours (*error of measuring yourself with the wrong ruler*).

You measure a small print just back from the drugstore against someone else's 16 × 20 master print, call yourself a poor photographer (*error of criticizing a preliminary photograph as if it were a finished piece of work*).

You moan because a picture you snapped just for the hell of it is not a masterwork (*error of unjustly criticizing yourself for not always being in dead earnest*).

You weep over your inadequacies after showing a picture to someone who dislikes both you and photographs (*error of choosing an ill-qualified critic*).

You club yourself for doing a bad lighting job, when the real problem is not the lighting but that you don't like your model's looks or personality (*error of not isolating the element in a picture which is the real cause of your concern*).

Having seen some beautiful high-contrast pictures in a fashion magazine, you flop by trying the technique on a photojournalistic picture (*error of assuming that a technique will lead to the same result in dissimilar situation*).

During a freak, three-inch fall of snow in Southern California you shoot pictures like mad, but later on scream wildly because none of them look like winter in Antarctica (*error of allowing enthusiasm for the unusual make you over-inflate its significance or pictorial potential*).

You carefully enlarge every picture on a 36-exposure, 35-mm roll, then gnash your teeth because most of them are sort of indifferent (*error of not calculating success or failure on a percentage basis*).

Disappointed in a bad set of pictures you attempt to save them by trick cropping, fancy mounting, or cute titles, but continue to be disappointed, calling yourself a failure (*error of refusing to recognize and walk away from your failures*).

In a state of high good humor you photograph everything in sight. You review the pictures while in a morbid mood, burn them, and put your camera up for sale (*error of reviewing pictures in a mood completely incompatible with that which gave rise to them*).

After stubbing your toes on many of the problems (people, mostly) which afflict photographers, you try to escape from it all by doing a photo essay on doorknobs, for which you have little real interest. The results, naturally, discourage you very much (*error of allowing desperation to force you down the wrong escape route*).

In addition to making the above mistakes in judgment, you probably at one time or another make most of the others mentioned previously. If so, you do yourself serious damage as a self-critic. No one can hurt you as badly as you hurt yourself.

Much to your surprise perhaps, you've found yourself reading a formal essay on photographic criticism. You are a critic anyway, whether you know it or not. If you've given the subject no study or thought, you are a bad one, maybe even a dangerous one. With a little study you can be a reasonably good one. A good critic can teach himself everything of importance about photography, using his critical judgment to lead himself through the morass that confronts photographers today. Make your choice: good or bad.

UNPRECEDENTED PHOTOGRAPHY
László Moholy-Nagy

If Moholy-Nagy was a great artist, he was an even greater thinker and educator. By intrinsically understanding photography as a technology and realizing how a new way of seeing was embedded in that technology, Moholy-Nagy anticipated the radical changes brought by the digital revolution.

Until now, all the essays and commentaries about the paths and aims of photography have been following a false trail. Again and again, the question singled out from all the various possible approaches as the most essential has been that of the relationship between art and photography.

But the *fact* of photography does not grow or diminish in value according to whether it is classified as a method of recording reality or as a medium of scientific investigation or as a way of preserving vanished events, or as a basis for the process of reproduction, or as "art."

The photographic process has no precedent among the previously known visual media. And when photography relies on its own possibilities, its results, too, are without precedent. Just one of its features—the range of infinitely subtle gradations of light and dark that capture the phenomenon of light in what seems to be an almost immaterial radiance—would suffice to establish a new kind of seeing, a new kind of visual power.

But the subject of photography involves infinitely more. In today's photographic work, the first and foremost issue is to develop an integrally photographic approach that is derived purely from the means of photography itself; only after a more or less exact photographic language has been developed will a truly gifted photographer be able to elevate it to an "artistic" level. The prerequisite for this is: no dependence on traditional forms of representation! Photography has no need for that. No ancient or contemporary painting can match the singular effectiveness available to photography. Why the "painterly" comparisons? Why Rembrandt—or Picasso—imitations?

One can say without utopian extravagance that the near future will bring a great transvaluation in the goals photography sets itself. The investigation is already under way, although frequently along separate paths:

Conscious use of light-dark relationships. Activity of brightness, passivity of darkness. Inversions of the relationships between positive and negative values.

Introduction of greater contrasts.

Use of the texture and structure (facture)[*] of various materials.

Unknown forms of representation.

[*] "Facture" was the term used by many constructivist artists and critics to refer to the specific visual characteristics of a material's surface texture.

The areas that have yet to be examined can be established in line with the new elements of photographic practice, as follows:

1. Unfamiliar views made by positioning the camera obliquely, or pointing it up or down.
2. Experiments with various lens systems, changing the relationships familiar to normal vision, occasionally distorting them to the point of unrecognizability. (Concave and convex mirrors, funhouse mirror shots, etc., were the first steps.) This gives rise to a paradox: the mechanical imagination.
3. Encircling the object (a further development of stereo photography on *one* plate).
4. New kinds of camera construction. Avoidance of the foreshortening effect of perspective.
5. Adapting experiences with X-ray—aperspectivity and penetration—to the uses of photography.
6. Cameraless photographs, made by casting light on the sensitive surface.
7. True color sensitivity.

Only a work that combines all possible interrelationships, the synthesis of these elements, will be recognized as true photography.

The development of photography is receiving a powerful impetus from the new culture of light, which is already highly cultivated in many places.

This century belongs to light. Photography is the first means of giving tangible shape to light, though in a transposed and—perhaps just for that reason—almost abstract form.

Film goes even further—generally one might say that photography culminates in film. The development of a new dimension in optical experience is achieved to a still greater degree by film.

But the spadework accomplished by still photography is indispensable for a developed cinema. A peculiar interrelationship: the master taking instruction from the apprentice. A reciprocal laboratory: photography as an investigatory field for film, and film as a stimulus for photography.

The issues raised by cinema provide lessons that serve as guiding principles for the practice of photography and can enrich the photographic results themselves: changing light intensities and light tempos, variations in spatial motion engendered by light, the extinguishing, and flashing forth of the whole organism of motion, the triggering of latent functional charges in us, in our brain. Chiaroscuro. Light-palpability, light-movement. Light-distance and light-proximity. Penetrating and cumulative light rays. —The strongest visual experiences that can be granted to man.

Translated by Joel Agee

WHEN A STUDENT ASKS
Minor White

Never have I seen a classroom whose blank walls and rows of seats did not remind me of a garden at the end of winter. Nor have I seen one filled with new students that did not remind me of an orchard before the buds had broken in the spring sun. And meager botanist that I am I could not distinguish one tree from the other. In a few weeks they have all blossomed; then I can tell the flowering almond from the elm, the willow from the oak. And I can estimate the destiny of each. Not precisely, no man shall trace the future twistings of each career; but the point of the compass each man faces is almost prophetically clear. In a class for photographers for instance the potential documentarian, the future photo-reporter, the picture editor of twenty years hence, tomorrow's hack, the promising photographer-artist, the ones to whom photography could only be a hobby, all point in their own directions. They resemble a collection of compasses each with a secret North.

Should any instructor demand that these potential differences conform to a present norm? Or rather encourage them to contribute their respective talents? No one expects the apple tree to bear oranges; yet we often, much too often, demand that the potentially great landscapist, for instance, turn his camera towards the human elements of the world. Why do we rarely demand the opposite? It seems that we forget that the inner direction of people runs in a rocked ribbed river; for we persistently do the equivalent of asking all trees to bear oranges when we demand that all photographers devote their efforts to a documentation of the human scene. In spite of Milton saying that the proper study of mankind is man, photography is so protean that it includes both photographing *people* for people and photographing the *whole visual world* for people. People at large have as much need for the Cartier-Bressons who hold up a mirror to themselves as it does the Adamses who offer them goodness, or the Strands who offer them beauty, or the Eugene Smiths who offer them truth.

In front of a classroom full of bubbling personalities I am doubly sure that the temperament that turns one man towards the social scene is far different from the genetic inheritance that turns another towards the natural scene. They are in effect, two genera. And genera, biologists inform us, if they mate at all, produce only sterile seed.

Or take another example, one less over-simplified, the difference between the photo-reporter and the photographer-artist. The outward-going drive of the first leads him to an active world; where anything less than a crisis gets scant attention. The inward-going drift of the second leads towards a world of contemplation; where violence violates an active life. While the difference between photo-reporter and photographer-artist is great, the difference may not be found specifically in their selection of subject matter, for both may range the entire

world of cities, people, nature, the entire world of machines, fishing poles and doughnuts. Nor may the difference between them be found exclusively in their treatment of their subject matter, in their treatment of sealing wax, cabbages and kings. The difference will appear only when we are able to find the secret North that they stamp upon their photographs.

When the student asks why we make an issue out of the distinction between the photo-reporter and the photographer-artist, we often answer that it is simply to put up a signpost over the tangle of confusion that ensues when the word "artist" is used to laud accomplishment of a high order, regardless of field, rather than to label a difference in temperament and kind. The mirror-to-life photo-reporter does not have the same purpose that the beauty evoking photographer-artist has, and to cross or mix their purposes is to cloud the truth of each.

When the student asks which is better, we can point out which is more popular. When he asks which is for him, we can repeat after T. S. Eliot that salvation is making the most out of the mess in which one finds oneself.

A BRIEF LIST OF SELF-ASSIGNMENTS FOR ARTISTS
Mary Virginia Swanson

GET TO KNOW:
1. YOURSELF. Define your interests, your abilities, your budget, your limits. Find your focus, in all aspects of your life, and stay on track.
2. YOUR SOURCES OF INSPIRATION, in the works or words of other creative individuals or the forces of nature. It may be knowledge of that place near your home or in your mind that brings clarity to your ideas. Experiment—find ways to access inspiration when and where you wish. There are no barriers to imagination unless you put them there.
3. YOUR VOICE as an artist. A hundred artists will depict a tree in a hundred different ways. Find the one that speaks your voice. Until you do, experiment with your materials, and by all means take risks. Only you can decide what you have to say through your artwork and only you can determine how to best interpret that voice through your final art object.
4. YOUR INDUSTRY and its history. It is essential to understand the evolution of your medium and its masters, as well as what drives key decision makers. Take time to study the history of collecting art, publishing photography—past and present, commercial commissions and licensing. Know the role of the curator to their institution and constituency, and the role of the gallery to collectors and art makers. Learn as much as you can about all aspects of our field.
5. YOUR GOALS. Don't try to be all things to all people. Time and money are necessarily limited, so work hard to make solid decisions towards what is important and essential to your creative life. These decisions may determine where you live, the environment you work in, and the company you keep.
6. YOUR MARKET. Define through research what audience is most likely to respond to your work. If your work has a definable subject, that is the gateway to a much larger audience. If more abstract in nature, a smaller yet perhaps more sophisticated audience awaits you. Once you know to whom your work speaks, you can better clarify your path to that audience.
7. YOUR PROFESSIONAL IDENTITY. With the work completed, and audience and aspirations defined, present yourself as an artist with the utmost professionalism and clarity of purpose. All promotional materials should have a unified style and coherent message, whether in print, CD-ROM, or Web site format. There is only one chance to make a first impression.

8. YOUR TOOLKIT. You are an amalgam of what you know. Take command of your materials; strive to be no less than an expert with your resources. Embrace the WWW. Listen and learn from other practitioners. Challenge yourself technically and intellectually. Join professional organizations, subscribe to related publications, and keep an open mind, always. Never stop learning.

9. YOUR COMMUNITY. Scale will not matter, from a small group of neighbors, to a large number of like-minded people throughout the world. Access can be face-to-face or via technology. You can participate in a dialogue anywhere, anytime. Do not allow yourself to work in a vacuum, however habit forming; there is much to gain from interaction. Partake of many communities.

10. YOUR GIFTS. Give back to your community and your industry. Become a mentor or an intern sponsor. Teach. Volunteer your services to non-profit organizations. Donate prints to support causes that matter to you. Never forget to credit those who helped you become the artist and person you are today. Give back and you too will receive.

SHARED WISDOM

SOLVING PROBLEMS
An Interview with Aaron Siskind

This interview by one of our editors took place in 1979. In this interview, and the one with Harry Callahan that follows, these photographers reflect on their experiences as the great mentors of the Institute of Design in Chicago—the legacy of the New Bauhaus. As noted earlier, this institution was seminal in the teaching of fine-art photography and spread such teachings throughout the world.

Charles Traub: When you got to the Institute of Design, you inherited a number of "problems" that were rooted in the Bauhaus. What about them do you think was important and how did you change them?

Aaron Siskind: The foundation courses were there when both Harry [Callahan] and I taught. They were rigid, but they gave people good grounding in the concerns of color, form, shape, design and composition. They were rigid though and photographers need to adapt to what they see and not to follow rigid concepts.

Harry and I wanted to give problems that accompanied the learning of basic technical procedures and how to make decisions about them. For instance, the "sky problem." Make something interesting out of the sky using ¾ of the negative. More difficult than it sounds. Sky is pretty predictable—but imaginative students always came up with a way to disrupt it. The technical problem was that you needed to learn how to keep the negative clean and tones even.

I also gave them a "copy problem." They had to copy something flat. Something that was black and white with continuous tones—like a photograph. And then something that was not continuous tone—like a color print. By comparing the original with their interpretation, they could learn about their mistakes in exposure and lighting—how to get things parallel and straight, how to develop for tone, texture, and line.

Another problem was called "significant form." I had them go to a greenhouse and photograph the exotic plants. I showed them examples of such photographs. How you can make a plant look like a plant or how you could make it look like a human form. The trick was for them to transform it, to make it something else, to deal with geometry, composition, abstraction, and the basic concern of art to be expressive.

A similar problem had to deal with "house numbers"—I loved it. You do the same thing. You turn it into something else. It was a problem from Moholy from

the Bauhaus. There were other problems like dealing with contiguous frames. Learning how to relate the content of two frames together. It taught sequencing. Photographing moving automobiles or dancers taught virtual volume. Following on that kind of motion study, you were already talking about sequences in time space. You would make them do a series of similar forms, a series of similar subject matter, or similar places. Or then make them do ten pictures of buildings. They would have to see that each must relate to one another, but must be different in order to be interesting.

These problems not only teach the students control and composition, but it gets them away from taking random imagery with no intent.

CT: What about that famous "evidence of man problem"?
AS: I think that's one that Harry introduced, but I think it was rooted in the Bauhaus. That was a marvelous one. The student had to photograph something that showed man was present, but it could not have anyone in the picture. It taught them about metaphor and symbols. Again, it kept them focused on an idea. Harry gave another one to stand on the street. He called it meeting a stranger—a "portrait problem." Photograph the first ten people that walk by. You go out and meet some and get them to let you take their picture. You have to make a lot of decisions and it takes a lot of convincing.

CT: What happened after these foundation problems were dealt with?
AS: Well you see, that's when it gets complicated. They are no longer dealing with the fundamentals; they are searching for ideas, motivations, things that can be explored in depth. But the structure of a school, like the Institute of Design, where they get all these assignments was problematic. The graduate students would come in sometimes with no work. I'd say, "What is going on here? Why can't you guys bring in something?" They'd say, "We have so much to do." You see. In other words, they were being pounded by so much information from every side they had no time to work. And if they did, whom did they work for, the teachers that threatened them. I was not going to do that, but I told them I would talk to them about their work if they didn't.

But the good ones knew what they had to do. The guys who were very savvy could do all this god damn crap, but others were very confused. To me though the point was that very being has to have a center and you have to find it in your work. And when you are at school you have to have a center of interest and all your other interests radiate from that and all your perceptions of the other areas radiate from that and all your values radiate from that center. This is the center in which you are proficient, in which you know a great deal, on which you have a basis for evaluation. The pedantics try to destroy that center.

As photographers we must learn to relax our beliefs. Move on objects with your eye straight on, to the left, around on the right. Watch them grow large as you approach. Group and regroup themselves as you shift your position. Relationships gradually emerge, and assert themselves with finality. And that is your picture.

—Aaron Siskind, from "The Drama of Objects,"
Minicam Photography, 1945

LEARNING FROM THE BAUHAUS
An Interview with Harry Callahan

Charles Traub: You came to the Institute of Design in 1949. Were you comfortable in an atmosphere where there was all this structure and formal ideas?
Harry Callahan: I never felt comfortable in that school. I never felt a part of all that stuff—Bauhaus this and Bauhaus that! But, I really did like the foundation course. If it had not been for that, I would not have lasted. You see—I didn't and I still don't think you can teach anyone to be creative. All you can do is give them an environment.

The foundation course in photography allowed you to talk about photography and you didn't have to go into a lot of BS about what art is and all that stuff. Is that texture? And so on and have you got good tone and so on. What you have to do is make a good picture. How to solve the problem is what you talk about.

CT: Looking back on it do you think there was an identity—was there something called "ID [Institute of Design] photography" or "Chicago photography?"
HC: When I first came there, there was something you would call Bauhaus photography—light and motion studies, look up and look down, photograms— a lot of experimentation.

But there were other schools at the time too. Minor White photography had its look. His students made pictures in a kind of way. There weren't a lot of schools—but personalities affected the schools, the plans and places where they taught. It wasn't until the last few years, when so many young people became interested in photography and became students. They didn't really follow their teachers—even myself or Aaron. They would simply follow someone they idolized. Sometimes it was someone like Robert Frank or Walker Evans. And sometimes it was something even broader and that's the way it's supposed to be. I don't like these stiff plans that students have to follow.

CT: Finally, Harry, I know that the "series" was an important part of the New Bauhaus teaching and indeed for your own work.
HC: Yeah, for sure. I think I was working in series all the time—relating one theme to the next. When I got to know Stieglitz he told me something about "groups." I don't know if it's groups, themes, series or what, but you try to work something out until it's done. So I don't work in series per se. It's a good thing to get students to do it in the beginning, but it gets too rigid. I think what photography can do really well is allow you to make a life's work.

Maybe you could collect all of Beethoven's work on records—you might be able to understand it. But with painting, like van Gogh, how do you get to see all that. But photography lends itself beautifully to the organization of a collection of work. Say take a hundred or two hundred pictures of someone who has

worked and you can see the life thing. You've got one expression. You've got to work at it though. So theoretically—the series is first, then the group is next and the whole life's work is the grand finale.

I photograph continuously, often without a good idea or a strong feeling. During this time the photos are nearly all poor but I believe they develop my seeing and help later on in later photos. I do believe strongly in photography and hope by following it intuitively, when the photographs are looked at they will touch the spirit of people.

—Harry Callahan, from *Statement*, 1964

The following interviews reflect the philosophy and teaching points of view of four influential contemporary teaching photographers.

THE NARRATIVE
An Interview with Gregory Crewdson

Charles Traub: What do you think is central thing that drives the student of photography?

Gregory Crewdson: I would say that, ultimately, that the central thing to have is a sense that they have a story to tell. That they are compelled to attempt to make pictures through some sense of self-expression. Because if you don't have that to begin with, then I think there's probably other, easier ways to live your life.... So, let's just say start with a story and then I think what the artist attempts to do is try to tell that story through pictures, and this is almost like a contradiction, attempting to give physical expression to a story that's internal. That's the difficulty and, as teacher, that's what I am most interested in terms of trying to help a student locate that story in pictorial form.

CT: You've made it clear that a sense of narrative is essential. What about photography feeds that narrative?

GC: I'd say that one of the great things about photography is that it's a conduit to almost everything. Photographs are a currency of our culture and that, unlike other mediums in art, let's say painting or sculpture, photography is accessible and democratic in a way that the other forms of art aren't. It's really important to understand not only the tradition of art photography and that history, but it's also equally important to understand how photographs exist in our culture, and understand how art photographs relate or do not relate to other forms of popular culture like advertising, fashion, and film.

CT: How do you guide your students? What do you show them? What do you talk about?

GC: Because photographs exist so predominantly in our culture and also because they are connected to so many forms of other expression it's important to cast the net wide open and have the students absorb as many ways of picture-making as possible whether that's film or, as I said, through other commercial forms of representation and the history of photographic image-making. I attempt to do that in my seminars. I not only screen films but also show a broad view of a particular subject. I tend to explore larger subjects, rather than particular ways of making pictures. I talk about the meaning of landscape or narrative in all of art. I definitely do not speak about my own work. First and foremost, I make it clear that I am an artist and not an academic, and what I bring to the students is just my own self-knowledge or my own interests, and

my own preoccupations. I think the student is aware that what they are getting from me is very subjective. I don't pretend to be an art historian, or an academic, or a theorist. I am an artist.

CT: What kind of assignments do you give students?
GC: Like many teachers in the field, I make them follow up on my presentations of other photographers and artists. I frequently assign readings. More often than not it's a short story or a work of fiction. Again, it gives them a sense of narrative. I assign them short stories by Joyce Carol Oates, Raymond Carver, or John Cheever. They learn great lessons from these kinds of writers about how something ordinary can be shaped by a master in a particular way to give something unexpected important meaning.

Every student has his or her own story to tell. I don't mean that it is literal, but there is a subjective story there that I try to help them pull out. If I think back to your first question, it is really important that they have an obsessive need to construct something, to understand something from their own experience.

CT: Do you think your own work, which clearly has its own narrative, is particularly influential?
GC: Well, it is not that I recommend my work per se, but rather the examples of what it represents. It is constructed out of a set of values and how I get to those values is something that I try to show by example. All teachers of art have enormous influence on their students. We all have to be aware of that and hopefully steer them clear of being mimics. It is important for the young artist to find their own identity and their own subject. I do everything I can *not* to shape them in direct ways. Whatever happens, there will inevitably be osmosis. My job is not to talk about my own work, but to talk about pictures.

CT: What motivates you to teach?
GC: The reason I teach is because it is a privileged atmosphere, where you can talk about photographs in a place where the people really care about them. That's rare and unusual.

It's important to always be in touch with the next generation of artists. Frankly, with every year that passes, they think in very different and new terms than I. They are always changing. They are obviously a product of the culture in which they live and I try to understand their worldview because it has effects on me.

I always wonder at what point it is still useful for me to still teach; I also wonder at what point you've just repeated yourself too much—you've said it a hundred times. I constantly consider how much I get from it and how much they can get from me.

CT: Do you think that students are more image savvy today?
GC: Yes. Young photographs seem to have an innate understanding of how pictures work in our culture. They are more highly self-conscious and critical about what the picture means than say you and I were at their age.

CT: Don't you think it's more difficult to make original pictures today?
GC: Exactly. There are always the questions of how to make something new in this world where there are millions and millions of images made everyday. They must ask themselves—how can my photographs move the tradition forward in some way?

CT: To your thinking, has technology changed the process?
GC: I would just say that students have grown up with the computer and understand perfectly well in a self-conscious way how photographs can be manipulated and transformed. There is a narrative there, revealed in the tools, that draws the student back to the original point that images tell stories. Photography has always been a technological medium. The real equations have not changed. There might be new tools, but at the end of the day the problems are always the same. How to make a photograph tell, reveal, a particular subject in a particular way.

CT: Obviously, the new technology has welded photography to the moving image. Video plays an important role in my teaching. How about yours?
GC: I agree. Some of the most interesting work in my department is being done in video. It expands the narrative. Young students of photography have again a self-conscious relationship to film and video—to their hyper-reality.

CT: Do you think this has affected their political consciousness?
GC: I think they are working with political intent and that needs to be a part of their story, but it's very subjective and not necessarily a transparent view into a political reality.

CT: Given the self-conscious awareness you have noted in your students, they must all know that their work contains some kind of fiction of their own making. But how is photography different than say painting, writing, or filmmaking?
GC: I think the great advantage of photography is its accessibility. You can do it easily. Unlike filmmaking, it's one moment in time—there is no beginning in time. The student just has to be absorbed in that one moment. It's a limitation, but it's also strength.

REMEMBERING LIFE THROUGH PHOTOGRAPHS
An Interview with Randy West

Adam Bell: Can you talk a little about your relationship with photography and what attracted you to the medium?

Randy West: As a young person I never considered photography as an art form. Photography was something my parents did on vacations or holidays. However, I believe I was drawn to photography as a very young child as I would rummage through a tin box that contained my family's photograph from the 1920s. As a child I had a habit of seeing things very literally. Since the pictures were in black and white I believed that everyone at that time only wore black, gray, or white clothes. Houses were only painted white and cars were black. This was an odd perception because I knew trees were green and the sky was some shade of blue. Aside from my reading of the lack of color in life, I was mesmerized by the people and their objects in the pictures. I tried to grasp that they really existed in a time and space. But they appeared as fiction to me. Through my questions to my relatives about the pictures, or the people posing, I gradually understood that the scene depicted actually took place.

I studied drawing (lithography and etching) as a college student and it wasn't until my last year of school that I took a photography course. The photographic process (mixing and measuring chemistry, working in "dark" rooms with light projected) is what captured my attention. The transition of printing from a stone or metal plate to that of printing with a light sensitive paper seemed logical. The difference was in how to record an image.

When I started to consider what I wanted to photograph I realized that I still was fascinated with the real. Since questioning the validity of my family's pictures, I wanted to believe that everything in a photographic print actually existed, that the image wasn't imagined. I understood that I could place actual things in front of a lens and record it exactly. I've since learnt that "exactly" is a questionable description. This is when I realized my ideas translated and communicated better in this reality-based medium.

AB: From your Chalkboards *series (1997) to* Pretty *(1998), your work often contains obvious references to abstract painting. What is the relationship between your work and painting? How has your relationship with painting influenced your understanding of photography?*

RW: Many people's understanding of photography (and certainly mine as a young artist as I stated above) is grounded in the belief that what is seen in a picture is true. As a student using a drawing instrument I found I was inter- preting what I saw. There seemed to be an obvious translation happening in order to get an image on paper. I imagined the process of drawing as mentally digesting what I was seeing, finding its way from my eyes, to my mind, to my

arm, down to my hand and then onto paper or a stone or copper plate. There was an incredible amount of altercation happening in this process. I now know that this is quite absurd and that a camera also has translation process. But at this time I perceived photography as a way of recording exactly what I was seeing. I have tried to hold on to this belief of the "real" being recorded.

My sensibility as an artist has always been romantic. So it was a given that I would use the same sense of imagery I used prior to photography. Many photographers before me have mimicked painters. And like them I have referenced many artists from the mid-twentieth century because I respond to their use of form, color, and perception of light. I feel it is interesting to compare photography to painting because of a need to recognize that which is in the picture (whether abstract or not). In order to bring attention to this idea I've chosen objects that may not seem initially recognizable as photographic. I think this is why my imagery is perceived as paintings. We are familiar with the language of abstract painting. However once a viewer knows my imagery is photographic the question becomes, what did I photograph. I find this question fascinating because it reminds me that our perception of photography is traditionally that of reality.

Many think my work is abstract. Even critics write about the belief of photography is an abstract medium. But if that is true then I believe everything translated is abstract. Even the most basic translation of using our eyes to interpret could be thought of as abstracting. I've resisted the word abstract to my work because I never manipulated what is in front of the camera. The chalkboards are photographs of chalkboards. They do begin to look like water but never the less they are what they are. The *Pretty* series is photographs of fabric. Both mimic color field paintings because they have subtle tones and textures. And this carries over from the already established language of minimalist paintings. But again, once my images are defined as photographs the question that arises is "what did you photograph?" re-emphasizing that we want to know what is "real." To me abstract photography has been a desire to erase or alter the subject beyond recognition. I like the questioning of the photograph because it makes our minds switch our perception, or our reading, of what we're looking at.

AB: Learning to transcend and work through one's influences is a challenge for any artist. As a teacher, how do you challenge your students to not only learn to see through the work of other artists, but develop their own voice?

RW: My teachers were incredibly important to me. I studied with John Baldessari, Jo Ann Callis and Jeremy Gilbert-Rolfe. They were the reasons why I went to graduate school. In my first year of studies I made bad attempts at making Jo Ann Callis pictures. I worked with conceptual ideas (again not successfully) attempting the wit of John Baldessari. And I was just treading water to keep up with, but was captivated by, Jeremy Gilbert-Rolfe. I soon learned that mimicking was not going to get me anywhere and that I need to define my own interests. It was through them that

I learned a visual poetry. And they also taught me that an artist had to engage his or her entire life in the act of seeing. To look at everything and from many different angles or perspectives. I try to encourage these same principles in my students.

What I have come to understand is that it is obvious that the greatest of artists referenced those that came before them. As stated in your question, it is difficult to go beyond the art we study and admire. My students come to school with experience in making imagery. It is not new for them. However, the process of stepping back and analyzing their work is where they fall short. I find this analysis crucial. It is here that they can compare their strategy with those that came before them. And, it is during this period of analysis that many struggle and eventually succeed in finding their own voice. It can be a paralyzing process. I suggest they consider the world they live in and the situations they experience today. Since centuries and decades have changed what and how we see things it is important to bring attention to our current ways of living. A case in point that I give them (as silly and romantic as it may be) is that stories of love and war have been expressed as far back as we have a record. We still seek out new stories and most times don't recognize that they are new versions of old ideas. However, we want them updated so that we can engage with our contemporary views of life. It is here that artists can look at the present-day world and, not only add to the vocabulary of thoughts being expressed, but find new meanings or discoveries. Many times it is a marriage of ideas of different cultures, thoughts, or beliefs. Photography has changed incredibly fast with new technology of the late-twentieth century. And it is changing even faster in the twenty-first. One obvious way is that digital technology has become accessible to the general public. Students need to focus their ideas with technology in mind (this not unlike the changes that the industrial age brought to art). I see students resisting technology every year. Not only will they become antiquated in their skills but their ideas won't progress.

AB: What are the necessary disciplines that a practicing artist must be willing to submit to in order to survive and sustain a creative life?
RW: I tell my students that it is their job to educate (or entertain) the viewer. Through education an artist can keep an audience's attention and therefore begin or sustain a dialogue. It is extremely important to become engaged with the people they want to talk to—to get feedback from their attempts and revise the work or ideas when not fully recognized by the objective viewer. Otherwise they work in a vacuum. Also important is that artists need to understand that they've chosen art to be their job. A job requires daily work habits. It is not when the creative mood or inspiration comes to them.

All that being said, I want them to understand that they need to define what a "creative life" is for themselves. And with this definition will come an understanding of the work necessary to communicate successfully.

THE MEDIUM AS SUBJECT
An Interview with Penelope Umbrico

Adam Bell: You were originally trained as a painter; what was it that attracted you to photography? And what have you learned from your own experiences that you can pass on to students?

Penelope Umbrico: At first what was interesting to me about photography was that it was referential and allowed for a kind of pictorial veracity—the authority of "having-been-there," the act of taking versus making something. Second, I was interested in how this pictorial veracity could replace the subjectivity of the hand. I was tired of the concerns of painting. My paintings were getting physically flatter and flatter, and at the same time more symbolic in their reference to images in popular culture. Somehow I equated this with questioning the illusionistic surface in painting. And the completely transparent, super-flat, photographic surface seemed to perfectly satisfy, and complicate, this question of flatness and illusion. Photography opened up a much more interesting way to make images for me that allowed for a critique of representation, using the medium of representation itself. Specifically, it allowed me to comment on the impact of the tremendous influx of images in our lives and how those images affected our subjectivity.

So, really my practice in photography was born out of a problematic relationship to painting, where I was interested in destabilizing the viewers' expectations of painting as much as those of photography. I began to view myself as a collector/photographer but one who travels through the world of consumer marketing media taking inventory—a sociologist in a grand catalog of sellable items and constructed desires. Though my practice was (and still is mostly) appropriative, in fact, in a strange way, to me, there was/is little difference between pointing the camera out a window, and pointing it at a television or a brochure advertising the perfect vacation. In both cases photography most expediently excises and decontextualizes the content that points to the concerns one is interested in.

AB: Since you also act as a teacher, what pedagogical strategies do you use to help your students not only challenge and engage in the diverse potentials of photography, but generate appropriate forms for their work? And how do you challenge your students to not only learn to see through the work of other artists, but develop their own voice?

PU: For me, photography's potential is rooted in concept. I am interested in photography as subject matter rather than medium, so I tend to focus on conceptual concerns over the formal or technical issues when addressing photographic work in any context.

In critique, I encourage an analytical view of students' work, treating the class as a laboratory—anything is possible—believing that what is presented for

critique was produced for a reason. I see my role as teacher as trying to focus on that "reason," with the responsibility to be as open to the student's idiosyncratic voice as possible. Though I understand the importance of being aware of other artists' work, too often comparisons shut down resonant meaning in student work and inhibit the development of an individual's own relationship to the content at hand. To me, one of the most limiting types of remarks is "that has already been done." The comparison to previously made work this way negates intentionality and the broader contexts that the work can, and should, function in. It gears the discussion towards classification, denying any purpose, meaning or nuanced reading of the work. It also denies process, truncating the creative, culturally collaborative practice that making art is. I am not interested in classifying students' work. It is important to know one's references, but something that means one thing within one context should mean something completely different produced by another within another context. So I do provide reference to others' work, but it is always conditional, and often the relationship isn't to photography. Photography is a great medium in that it is so relational—as a subject it can intersect with writing, painting, sculpture, film, video, sound… creating truly interesting contexts and problematics.

AB: What advice do you have for young artists given the changing nature of today's art world?

PU: Of course, the most important thing is the discipline to continue one's work: to work every day on your project, or at least something like a few days a week, with the goal to find and develop what inspires you. A part of that is to always challenge yourself. Ideally one should reach the point where one's creative work comes out of a place of necessity—the point at which one cannot help one's self from making it.

Perhaps the second most important thing might be the emotional discipline of not taking rejection too personally, or success, for that matter (after the obvious routine discipline of sending your work out there).

One thing that I'm thinking about these days is how art functions differently in the "art world" than it did when I was first entering it. The parameters are becoming so extended and shifting so fast that one almost can't say where one fits in at any given point or time. The idea of creating an audience is more important now—by which I mean, in fact, that there isn't an audience any more at all—there is a public and the artist has to find a way to engage with it somehow. One has to find or create a vital context for one's work. The ubiquity and digitalization of photography has created a new kind of crisis, where everything has opened up, there is room for almost anything, and with very few boundaries—it is a fantastically exciting, but disorienting, place to work.

OBJECTS OF DESIRE
An Interview with Sarah Charlesworth

Adam Bell: What drew you to photography? How does it meet your expressive needs?
Sarah Charlesworth: I have been interested in photography for a number
of reasons. As a young artist I initially became interested in photography as a
primary language of contemporary culture, a medium through which our society
knows and describes the world. My work is not photography per se but rather
explores photography as a way of negotiating or organizing the world around us.
Photography is integral to the way we think. It informs every aspect of modern
experience—our values, ideas, political views; in short, our ideas of ourselves and
our world. As I am interested in exploring the ways in which we as a culture
shape our ideas, photography provides a rich terrain of shared experience. I am
also interested in the formal language of photography: how color, shape, scale,
placement, and juxtaposition become the elements through which meaning itself
takes form.

In addition to the more conceptual interest in the language of photography,
I am fascinated with the more metaphysical nature of the medium. I am con-
tinually mystified by the agency of light and by the ways in which photography
affords, via light, glimpses into distant time and space.

*AB: As an artist, you were briefly aligned with the Art and Language group and
closely connected with the development of Conceptualism in the United States. How
did your formative encounter with Conceptualism and subsequent creative engage-
ment in the movement shape your relationship with and use of photography?*
SC: My relationship with photography has several facets. I have been an artist
my whole life. In college I was still painting and learned photography initially to
do my thesis in art history. I was very influenced by the emergence of concep-
tual art and both Douglas Huebler and Joseph Kosuth were mentors and had a
strong influence on me as a young artist. While I was interested in art as a kind
of philosophical practice and particularly one which explored the very ways in
which visual and linguistic convention informed thought and action within a
culture, I became interested in the idea that photography, in press, journalism,
and TV, organizes and orders the world around us. My earliest series explored
the imaging of news in newspapers. I developed a kind of exploratory practice
which examined the ways in which we are positioned in relation to events as
well as the ways in which values and expectations are articulated within a culture
through a shared language of images. I was extremely interested in exploring the
languages of common visual culture. This work was later called "deconstuctive"
and all work with existent images later called "appropriation." The idea, however,
never concerned the borrowing of existent images, but rather the original work
of uncovering relations between images, patterns, and conventions of represen-

tation, which order the way in which we see and think about the world. I first started exhibiting work in the late 1970s. While my artwork at the time drew from images within the culture at large, I supported myself during this period doing freelance photography. While I studied briefly with Lisette Model, I was not interested in pursuing traditional fine-art photography. I was more interested in exploring photography as a subject of my art than as a medium per se.

AB: Along with artists and contemporaries such as Richard Prince, Sherrie Levine, Cindy Sherman, and Laurie Simmons, your work often uses photography to challenge and deconstruct the ways that images not only shape how we see but imagine the world. As a teacher, what pedagogical strategies do you use to challenge and force your students to critically engage in the diverse potentials and meanings of photography?

SC: There has been a great shift in the way artists use photography as well as the way in which photographers have challenged the assumptions of their discipline over the last twenty years. Photography and video have moved from being peripheral art forms to being primary media for contemporary art. Given the ubiquity of photography as a language in contemporary society, it is appropriate that it should be likewise a primary medium of critical and expressive art practice.

As a teacher, I impose no rules on my students and encourage them to define for themselves a relationship to their world through their artwork. Each generation of artists or photographers must reinvent a practice of art, just as each artist and photographer must as an individual. There really are no rules. Neither convention nor context are permanent, but are created by artists working in a time and place. The strongest work takes the known world, its art and photography, and ways of communication only as a jumping off point. The challenge of inventing a practice takes place within a culture of ideas. I think it is valuable to be well-informed about art history and photo history and then to move beyond that to use one's art as a way of exploring the world anew.

AB: Unlike many photographers who use photography to record or document the world, your work draws upon a variety of symbolic images (sometimes appropriated) from art history to popular media. What sources do you draw upon to create your work and how do you sustain your creative practice?

SC: My early work, which draws primarily from existent sources, does not *use* symbolic images as much as it explores the way in which images function as symbols. Many of my series explore the architecture of ideas or icons by isolating images or fragments of images from their customary context in order to see how they give shape or form to attitudes or points of view. For instance, in the *Objects of Desire 1* series (1984), I examine the articulation of sexual and gender codes by silhouetting clothing from fashion, bridal, and pornographic magazines, and so on, to see the ways in which female and male figures

pose—the body in clothing serving as a kind of shared language—What is sexy? What is powerful? What is innocent? Through the different bodies of work I explored the experience of living—in part—in a world of representations. This shared landscape of images is as much part of our psychic and political world as is our physical environment.

In the *Renaissance Paintings and Drawings* series (1991) I imagined myself as a kind of subject of psychoanalysis and Renaissance painting as a sort of family album. Figures from Renaissance paintings were reassembled as collages which were then rephotographed and printed as photographs, as are all my "appropriated" works. In this series I examined the classic psychoanalytic constructs: family, love, sexuality, and so on, using fragments drawn from these paintings to re-image or reinvent my own relations with these archetypes. During the period in which I worked with found images I built vast archives of images and books. I drew frequently from these files but often also sought out particular types of images to create specific works.

As my work became more personal and less deconstructive in the early nineties, I eventually began to shoot my photographs in the studio. Each series takes on a specific style and palette appropriate to the idea I am exploring. In almost all cases, photography itself is an underlying subject. In the *Natural Magic* series (1993), for instance, I created images of magic tricks which played on assumptions of truth; or more recently in the *0+1* series (2000), barely visible white photographs explored thresholds of both "meaning" and "image." One of the difficulties of working in series is that each series necessarily reinvents its own methodology. While there are stylistic and conceptual themes and patterns in the work, the rules and look change from one body of work to the next. Sometimes it takes several years of loosely working with ideas before they emerge into a fully developed body of work.

AB: How do you sustain and develop your creative life?
SC: Like most artists, I go to work every day, usually in the studio, but sometimes around town looking for props or going to labs. When you work for yourself and you're constantly in a state of exploration, trying things out, responding to your own curiosity, your emotional or visual drives, it's a very existential sort of commitment. I never know whether I am going to like what I am working on, or whether it will eventually become "work." This uncertainty, this willingness to commit to the engagement, the responsibility of working with no guarantees, no guidelines, no rules, is a step into the unknown. It is both frightening and liberating. It not only "goes with the territory," it *is* the territory.

A PHOTOGRAPHIC THESIS

AT/TENSION: THE ESSENCE OF PORTRAIT PHOTOGRAPHY
Rachael Dunville

A contemporary graduate student speaks about her motivation and aspirations in an exemplary way.

Just as ripe anticipation awaits the development of a roll of film, a similar eagerness is present in the preliminary moments before making a photograph with another person. I bask in the fertile scene, paying intimate attention to my subjects, moving fluidly and thoughtfully around the physical hurdles that define their space. Hardly aware of my own automatic dialogue, I listen to their nervous verbal rambling, their secret body language and the chord being plucked by the sensual composer inside of me. The determined sound of the shutter's kerPLUNK and the successive crank of the film advance serve as mechanical percussion to the emotionally melodic ballad that I am conducting. Our moment of creation has begun.

With empathy ushering my keen eye and innate senses, a harmonic composition evolves among the electrical, euphonic, and aesthetic impressions to which I am most sensitive. I dare to satisfy my subliminal strategy—the playful command and improvisational dance of a spider on his deliberate lattice. Upon mental tiptoe, I orchestrate the event, diffusing any lingering hint of apprehension, yet maintaining the vulnerability that fuels the self-conscious performance both behind and in front of the camera. The glistening silk of my web is spread. I am anxious, full of controlled delight. I have butterflies.

There is a distinct and profound pleasure in making portraits. In an attempt to engage in this mysterious delight, I create artworks that convey and nourish a complex human essence expressed though the intensity, humor, surrealism, and grace of photography.

I approach the transaction of making a photograph of and with another person as an intuitive, magical exchange—a subtle seduction between willing participants. Each image is based on a mutual regard for looking and for being seen, confirming our existence as subjects. We've all encountered it: the coquettish glance of flirtation; the courting, cherishing stare from a lover or intimate; the shocking and exhilarating visual acknowledgement from a stranger. Whether flattering or frightening, a potent gaze strikes at our humanity and self-awareness. It creates tension. It highlights desire.

The foundation of my photographs is established in the active crescendo of impulse and the evolving rapport between photographer and subject. This oscillating event displays the complexities of human desire and tension as fundamental to the act of making photographic portraits. Desire often stems from a mutual admiration or identification with the other. Sometimes, an unabashed charge of attraction and palpable lust is exhibited in the dance of cause and effect between the image-maker—loaded camera in hand—and the willing subject.

Tensions are further heightened by the presence of my Hasselblad camera, a physical and psychological barrier between photographer and subject. The large black mass of the camera body and loud interrupting noise of its shutter release emphasize the scrutiny of its gaze. More importantly, my subjects acknowledge and respond to my presence as voyeur, as I am aware of their attention on me. I regard *attention* as a pure form of human electricity, animated by the broadcasting and receiving of focused energy. Often, my photographs record the suspenseful choreography of wanting, needing, diverting, giving, absorbing and distracting our concentrated attention. From this exquisite and complex ensemble, the photographs disclose a delicate, lascivious friction.

> *Conscientiously recording this scene of visual spell and constant chiaroscuro, my eye—the animated periscope of my compulsion—becomes a zealous collaborator with my heart and the shutter release. kerPLUNK. I observe with the impunity granted only in dreams. My subjects, often unaware of this brimming synergy, respond with a stare of intolerable tenderness and penetrable human depth that makes me ache with the paroxysm of desire that throbs at a poet's core. This sustained pinnacle of our engagement is transfused on the film itself, leaving an indelible imprint of the immortal mystery and humanity of each photographic encounter.*

Music, specifically jazz, deeply influences my photographic process. Improvisation expresses a kaleido-phonic arrangement of the artist's unique recipe of intuition, skill, intellect, and emotion. The creative potential is rich inside the orchestration and visceral reactions between photographer and subject. Within this exchange, I trust the spontaneous to materialize. It's the narcotic kernel, the falling in love.

The camera offers me a unique opportunity to explore and communicate a raw moment of humanity—one human to another. The magic and pleasure of making a photograph with another person lies simply in the enigmatic fusion of the sacred human exchange between artist and muse with the intrinsic wonder of photography itself. The people I photograph can look straight into the camera, and therefore, straight into me. What is unveiled in this hushed interface is a distilled state of emotional undress. The honest curiosity to explore the conditions of looking into someone becomes something sacred and intense. We blush.

Afterword

At times, the education of a photographer can be a double-edged sword. Passion and determination often stand in contradiction to the endless courses and readings that are central to one's education. Yet it is naïve to think that emerging fully formed is possible. Photographers and artists must learn their tools in order to transcend and manipulate them. At the same time, the rules are made to be broken. The fact that photography has been thoroughly integrated into the academy further demands that its rules be broken again and again. Making it through art school takes both the courage to ignore one's teachers and the wisdom to heed their advice. Reaching that point can take time, but it is an essential lesson.

We all take pictures and assume we understand their complexity. However, the ease and accessibility of photography often belies the hard work and decisions that create great and meaningful work. While camera technology is virtually omnipresent in our lives, the scrutiny and insight of intelligent practice are often missing. For the serious practitioner, the opportunities, competition, and rewards are greater than ever before. At the same time, the global art market and the increasing popularization of photography have raised the stakes in potentially damaging ways for emerging photographers. The demands of the art market often run counter to methodical and serious practice. As photographers, we must take charge of our work, not only to create appropriate venues and forms, but also to challenge the changing nature of the medium and its potential.

Ultimately, we must foreground the creative impulse and remain grounded in the compulsion that drives us to pick up a camera. Whether seeking an audience, pursuing formal studies, or surviving financially, balancing our work with the demands of the art world or school and life remains a challenge. Given these difficulties, the rewards of an art education—acquiring the tools, community, and strength to follow creative obsession—can be great.

Despite the challenges, my love for and dedication to the medium have been nurtured by outstanding teachers and a community of peers. While this book offers advice and a few signposts for the photographer who is beginning this journey, the real education of any photographer lies in taking the risks, pursuing one's passions, looking and, above all, making the work.

—Adam B. Bell

Biographies

Berenice Abbott (1898–1991) is best known for her work documenting New York City architecture and life in the 1930s and 1940s. During a brief time in Paris, Abbott worked as an assistant to Man Ray and discovered the photographic archives of Eugène Atget. Shortly after his death in 1930, Abbott published Atget's work, and helped promote his work throughout her life. In 1938, Abbott began teaching at the New School for Social Research, where she remained for twenty years. She is a twentieth-century master and her work continues to influence students today.

Originally an English professor, **Robert Adams** (b. 1937) has worked most of his life as a photographer documenting the development of the American West. An eloquent writer, Adams's essays and interviews have been collected in three anthologies, *Beauty and Photography* (1981), *Why People Photograph* (1994) and *Along Some Rivers* (2006). A contemporary master, his many books include *The New West* (1974), *Summer Nights* (1985), *Los Angeles Spring* (1986), and *What We Bought: The New World: Scenes from the Denver Metropolitan Area 1970–1974* (1995).

Joel Agee (b. 1940) is the author of *Twelve Years: An American Boyhood in East Germany* (2000) and *In the House of My Fear: A Memoir* (2004). In addition to translating numerous German texts, Agee has written essays that have appeared in *Harper's Magazine*, *Esquire*, the *New York Times Magazine,* and other publications. In 1999, he won the Helen and Kurt Wolff Prize for his translation of Heinrich von Kleist's verse play *Penthesilea*.

The portraits and photographs of **Diane Arbus** (1923–1971), one of the key figures of twentieth-century photography, have influenced generations of photographers. The creator of some of photography's most iconic images, Arbus's work explored the margins of photography with unflinching honesty and compassion.

Adam B. Bell (b. 1976) is a photographer based in New York City. He received his MFA from the School of Visual Arts' Photography, Video, and Related Media Department in 2004. His work has been published and exhibited widely.

Wendell Berry (b. 1934), poet, farmer, essayist, conservationist, and teacher, has taught, lived, and worked in Kentucky since birth. An acclaimed author, he has written over twenty-five books of poetry and fifteen books of essays, including *The Unsettling of America: Culture and Agriculture* (1978). A tireless advocate of rural life, Berry's poetic voice speaks eloquently to the rewards and virtues of agrarian life. Berry is the recipient of a Guggenheim fellowship and a Wallace Stegner fellowship, as well as the T. S. Elliot award and a grant from the National Endowment for the Arts.

Born and educated in Germany, **Elisabeth Biondi** (b. 1944) is a preeminent visuals editor. Since 1996, she has worked as the photo editor for *The New Yorker*. Prior to her experience at the *New Yorker*, she was the director of photography for *Stern* in Germany from 1991–1996 and for *Vanity Fair* from 1984–1991.

Henri Cartier-Bresson (1908–2004) was a towering figure in the history of photography. His photographs of the "decisive moment" have influenced generations of photographers around the world. Along with David "Chim" Seymour, George Rodger, and Robert Capa, Cartier-Bresson founded the cooperative Magnum in 1947. Cartier-Bresson's legacy is continued through the work of the Fondation Henri Cartier-Bresson (founded 2003), which supports photographers and photographic education.

The clean layouts **Alexey Brodovitch** (1898–1971) created for *Harper's Bazaar* radically shaped the face of American graphic design and of modernism itself. In addition to his work as a graphic designer, Brodovitch worked with and taught some of the greatest photographers and artists of the twentieth century, including Richard Avedon, Irving Penn, Garry Winogrand, Henri Cartier-Bresson, and Jean Cocteau, among others.

John Bowlt (b. 1943) is currently professor of Slavic languages and literature at the University of Southern California, specializing in the history of late nineteenth- and early twentieth-century Russian art. He is the author of *The Russian Avant-Garde: Theory and Criticism, 1902–34* (1976), *The Silver Age: Russian Art of the Early Twentieth Century and the "World of Art" Group* (1979), and *Laboratory of Dreams: Russian Avant-Garde* (1996).

From the time he was appointed to teach at the Institute of Design in Chicago and later at the Rhode Island School of Design, **Harry Callahan** (1912–1999) had a major influence on American photography. His portraits of his wife and daughter helped to define a modern formal sensibility that has been an exemplary model of exactitude for contemporary students. From his retrospective at MoMA to his numerous monographs, Callahan remains an enduring and towering influence on photography.

Along with other artists whose photo-based work came to prominence in the 1980s, **Sarah Charlesworth** (b. 1947) has explored issues concerning the language of photography within contemporary culture. In 1997, Charlesworth's work was the subject of a traveling retrospective (organized by SITE, Santa Fe) and has been included in over forty exhibitions. In addition to her photographic work and other teaching positions, Charlesworth is on the thesis faculty of the MFA Photography, Video and Related Media department at the School of Visual Arts.

Curator and author **Charlotte Cotton** (b. 1970) is currently the director of cultural programming at Art+Commerce, New York. Formerly the head of programming at the Photographers' Gallery, London, and curator of photography at the Victoria & Albert Museum, London (1993–2004), Cotton has curated a number of exhibitions on contemporary photography. In addition to articles published in *Aperture* and other magazines, Cotton is the author of *The Photograph as Contemporary Art* (2005), *Guy Bourdin* (2003), *Then Things Went Quiet* (2003), and *Imperfect Beauty* (2000).

Teacher and photographer **Gregory Crewdson** (b. 1962) works with elaborately staged photographs explore the disturbing dark side of suburban life. Crewdson's work has helped revitalize the staged narrative within contemporary photography and has been widely published and exhibited. Crewdson is currently a professor of photography at Yale University.

Yolanda Cuomo (b. 1957) is the founder, principal, and art director for the award-winning Yolanda Cuomo Designs. For over seventeen years, she has designed countless books, magazines, CDs, and exhibitions. Cuomo recently designed the exhibition catalog and exhibition design for *Diane Arbus: Revelations*. The firm's art direction for *Aperture* was recently awarded the 2004 National Magazine award from the American Society of Magazine Editors (ASME). In addition to lecturing widely, Cuomo also teaches in the School of Visual Arts' Photography, Video and Related Media Department.

Tim Davis (b. 1969) is a photographer based in New York. Davis's writings have appeared in many publications and his work has been exhibited widely. Davis is the author of *Lots* (2002) and *My Life in Politics* (2006), which was the subject of a recent show at the Bohen Foundation, New York. Davis currently teaches at Bard College.

Rachael Dunville (b. 1979) is a freelance and fine-art portrait photographer based in New York. Dunville received her MFA from the School of Visual Arts' Photography, Video and Related Media Department in 2005 and has exhibited her work widely.

Dave Eggers (b. 1970), editor of the acclaimed literary journal *McSweeney's*, was a staff photographer for the *Daily Illini* during college. He has written and edited numerous books, such as *A Heartbreaking Work of Staggering Genius* (2000), *You Shall Know Our Velocity* (2002), and *How We Are Hungry* (2004). He is also the founder of 826 Valencia, a McSweeney's store and drop-in writing center for children.

Vilém Flusser (1920–1991) was born in Prague; he studied philosophy while living there and later emigrated to Brazil. He published his first articles on philosophy and linguistics in 1961, and continued to publish works until his death. A member of the Brazilian Institute of Philosophy and coeditor of the *Brazilian Philosophical Review*, Flusser was also professor of the philosophy of communications at FAAP (School of Communications and Humanities) in São Paulo, Brazil. Flusser was the author of such influential texts as *Towards a Philosophy of Photography* (1983), *Lingua e Realidade* (1963), and *Vampyroteuthis infernalis* (1987).

Stephen Frailey (b. 1957) is an educator, photographer, and writer. He was the photography chair of Bard College's Milton Avery Graduate School of the Arts from 1998 to 2004, and has been the chair of the BFA Photography Department at the School of Visual Arts in New York since 1998. The recipient of two MacDowell Colony fellowships, a National Endowment for the Arts grant and an Aaron Siskind Foundation grant, Frailey has had his work exhibited and published internationally.

Since the 1960s, **Lee Friedlander** (b. 1934) has remained a towering figure within photography. Prodigious and inventive, Friedlander has created an enormous body of work that crosses genres. Friedlander's work has been published in countless monographs and exhibited around the world, and was the subject of a retrospective at the Museum of Modern Art, New York, in 2005.

Peter Galassi (b. 1951) has been the chief curator of the department of photography at the Museum of Modern Art, New York, since 1991. During his time at MoMA, Galassi has curated influential exhibitions that have embraced the many roles that photography plays in contemporary art-making. Exemplary shows include *Pleasures and Terrors of Domestic Comfort* (1991), *Andreas Gursky* (2001), *Thomas Demand* (2005), and *Lee Friedlander* (2005).

Helen Gee (1910–2004) was a pioneering and tireless promoter of photography who helped showcase the work of such photographers as Berenice Abbott, Robert Frank, Julia Margaret Cameron, and many others in her photography gallery/café, Limelight Photography Gallery (founded 1954). Gee was there first at a time when little attention was paid to photography. She helped sustain many artists, both creatively and financially, through the sale and exhibition of their work.

Perhaps Italy's most important twentieth-century photographer, **Luigi Ghirri** (1943–1992) is known for his groundbreaking color snapshots, which pre-dated may postmodern trends. He is unfortunately little known in the United States. In addition to publishing over thirty books of his work, Ghirri also taught at the University of Parma and helped to promote many of his con-temporary Italian photographers.

Ralph Hattersley (1921–2000) was an educator and author who wrote various technical/educational books about photography, as well as critical essays about individual photographers. Hattersley was also the founder of the short-lived photography magazine *Infinity*. The author of over ten books and teacher for many years at Rochester Institute of Technology, Hattersley influenced a gen-eration of photographers.

A photographic historian specializing in nineteenth-century and contemporary architectural and landscape photography, **David Harris** (b. 1950) has authored many articles, essays, and books. Harris's books include *Eugène Atget: Unknown Paris* (2003), *Of Battle and Beauty: Felice Beato's Photographs of China in 1860* (1999), *Gabor Szilasi: Photographs, 1954–1996* (1997*)*, and *Eadweard Muybridge and the Photographic Panorama of San Francisco, 1850–1880* (1993). He is cur-rently assistant professor at Ryerson University.

Steven Heller (b. 1950) is the art director of the *New York Times Book Review*; co-chair of the Designer as Author graduate program at the School of Visual Arts; and editor, author, and co-author of over one hundred books on graphic design, popular culture, and satiric art.

Daile Kaplan (b. 1958) is a curator, author, historian, and vice president and director of photography at Swann Auction Galleries. She is the author of *Pop Photographica: Photography's Objects in Everyday Life* (2003) and *Premiere Nudes* (2001), and two books on Lewis W. Hines. Kaplan is on the Board of Direc-tors of the Appraisers Association of America, Fifty Crows Foundation, and the Alexandria Foundation in addition to the Board of Advisers of the Palm Beach Photographic Workshop. She is also a member of the Authors Guild and ArtTable.

One of the masters of twentieth-century photography, **William Klein** (b. 1926) rose to prominence in the late 1950s after the publication of the books *New York* (1956) and *Rome* (1959). Rejecting the easy platitudes of post-WWII photog-raphy exemplified by Steichen's *Family of Man* exhibition, Klein's photographs employed stark lighting, heavy grain, and confrontational angles to explore the underbelly of modern life. Klein has lived abroad for the majority of his life and has yet to receive the accolades he deserves in the United States for his great films and photographs.

Max Kozloff (b. 1933) is a photographer, art historian, and freelance writer based in New York. Kozloff was formerly the art critic for *The Nation* and the executive editor of *Artforum* from 1974 to 1976. He has published several books on art and photography, including *The Privileged Eye: Essays on Photography* (1987), *Lone Visions, Crowded Frames: Essays on Photography* (1997) and *New York: Capital of Photography* (2002).

Ken Light (b. 1951) is a social documentary photographer whose work has been published in the monographs *Texas Death Row* (1997), *To The Promised Land* (1988), and *Delta Time* (1995). Light has also edited the anthology *Witness in Our Time: The Lives of Social Documentary Photographers* (2000). In addition to teaching at the Center for Photography at the Graduate School of Journalism, University of California, Berkeley, Light is also the founder of the International Fund of Documentary Photography, which awards grants to photographers worldwide.

Vera Lutter (b. 1960), German-born and trained as a sculptor, began making large-scale camera obscura images of the New York urban landscape after receiving her MFA from the School of Visual Arts' Photography, Video and Related Media Department. Lutter has traveled around the world making her unique camera obscura images of industrial landscapes and interiors. She is widely exhibited around the world and currently represented by Gagosian Gallery in New York City.

Nathan Lyons (b. 1930) is the consummate educator, photographer, and curator. He has played a key role in the development of photography and photographic education in the United States. Founder and longtime director of the Visual Studies Workshop, Lyons also worked as the associate director and curator of photography at the George Eastman House. Lyon also helped organize its Invitational Teaching Conference in 1962. Widely exhibited, Lyons is the author and editor of numerous books, including *Notations in Passing* (1974), *Riding 1st Class on the Titanic!* (1999), and *After 9/11* (2003).

One of the most important contemporary photographic gallerists, **Peter MacGill** (b. 1952) is the president of Pace/MacGill. Formerly a Director of Light Gallery, Pace/MacGill currently represents such important photographers as Irving Penn, Philip-Lorca diCorcia, Harry Callahan, and Robert Frank.

An optician by trade, **Ralph Eugene Meatyard**'s (1925–1972) stature has grown enormously since his untimely death in 1972. Best known for his psychologically evocative images of his own masked children, Meatyard created a diverse and startlingly original body. Meatyard's work was recently the subject of a major retrospective at the International Center of Photography in 2005. He was also a founding member of the influential Lexington Camera Club.

Susan Meiselas (b. 1948) has been a leading member of the prestigious Magnum Agency since the early 1980s. Meiselas rose to prominence due to her work photographing the political turmoil in Central America in the late 1970s and early 1980s. She is the recipient of a MacArthur Foundation fellowship and the author of numerous books, including *Carnival Strippers* (1976), *Nicaragua* (1982), and *Kurdistan: In the Shadow of History* (1997).

Lisette Model (1901–1983), born in Vienna, was an enormously influential teacher and photographer who helped to define a new, humanistic street photography. Following her first solo show in 1941 at the Photo League, Model's work was shown extensively in gallery and museum shows. From 1951 until her death in 1983, Model taught at the New School for Social Research, New York where Diane Arbus, Rosalind Solomon, Larry Fink, and Bruce Weber were among her many students.

Hungarian-born **László Moholy-Nagy** (1895–1946) was a central figure in the development of avant-garde photography, or "New Vision," following World War I. As a key teacher in the Bauhaus, Moholy-Nagy helped to formulate a new language of photography that exploited the use of light, radical angles, and the lessons of modern painting. The author of the influential text *Painting Photography Film* (1925), Moholy-Nagy also helped found the Institute of Design in Chicago, where he continued his work and became a seminal figure in American photographic education.

Vik Muniz (b. 1961), born in São Paulo, Brazil, has lived and worked in New York since the 1980s. Muniz began his career as a sculptor and quickly moved to photography. Often constructed from simple materials, Muniz's inventive and whimsical pictures explore the illusionistic potentials of photography and its crossover into other forms of representation.

Cynthia Oznick (b. 1928) is a highly regarded writer whose work often explores the dynamics of Jewish-American life. The recipient of a National Endowment for the Arts grant and a Guggenheim fellowship, Ozick's most recent novel, *Heir to the Glimmering World* (2004), was short-listed for the Man Booker Prize in 2005. She is also the author of many famous books such as *The Shawl* (1989) and *Levitation: Five Fictions* (1982).

Brian Palmer (b. 1964) graduated from the first class of the School of Visual Arts' Photography, Video and Related Media MFA Department. He became a committed and successful working journalist. Having worked for the *New York Times* and other publications, Palmer became bureau chief for the *U.S. News & World Report* Beijing office. From 2000 to 2002, Palmer was an on-camera correspondent for CNN. Since 9/11, he has been photographically documenting the world's current conflicts, from Afghanistan to Iraq.

Irving Penn (b. 1917) has been working as a fashion and fine-art photographer for over sixty years. In additional to his revolutionary work for *Vogue*, Penn has made photographs that have transcended that genre, making him one of the great photographers of the twentieth century. Penn has published eleven books of his photographs, including *Moments Preserved* (1960), *Worlds in a Small Room* (1974), and *Passage* (1991), as well as two books of his drawings.

Philip Perkis (b. 1935) began photographing while enlisted in the U.S. Air Force in the late 1950s, and continued his studies at the San Francisco Art Institute, where he studied with Ansel Adams and Dorothea Lange. For years Perkis was the Chairperson for Pratt Institute's Photography department, and he is presently teaching in the School of Visual Arts' MFA Photography, Video and Related Media Department. He is the recipient of a Guggenheim fellowship and his text, *Teaching Photography: Notes Assembled*, is widely read by aspiring photography students.

Robert Pledge (b. 1942) is the president of Contact Press Images, which he founded with American photographer David Burnett in New York in 1976. Pledge has edited many highly acclaimed books and curated exhibitions throughout the world. A major presence in the photographic community, he has conducted master classes in Bangladesh, China, India, Mali, Turkey, and Switzerland, and has sat on many juries, including the W. Eugene Smith Fund in the United States, the CNA Mosaïque program in Luxembourg, and the World Press Photo Foundation in Amsterdam, which he chaired in 2001.

A writer, lecturer, and design historian, **Kerry William Purcell** (b. 1971) writes regularly for such magazines as *Baseline* and *Eye*. His books include monographs on *Alexey Brodovitch* (2002), *Weegee* (2004), and *Josef Müller-Brockmann* (2006). He lives in England.

Shelley Rice (b. 1950) is a critic, historian, curator, and educator. Her essays have appeared in *Artforum, Art in America, Aperture*, and *The Village Voice,* among others. Rice is the author of *Parisian Views* (1997) and *Inverted Odysseys: Claude Cahun, Maya Deren and Cindy Sherman* (1999), as well as the co-author and editor of several books. In addition to curating several important exhibitions, including *Inverted Odysseys*, Rice is the recipient of a Guggenheim fellowship, a Fulbright Research grant, and two National Endowment for the Arts grants. Rice currently teaches at the MFA Photography, Video and Related Media department at the School of Visual Arts and at New York University's Tisch School of the Arts.

Alexander Rodchenko (1891–1956) was the central figure in the Russian constructivist movement. Rodchenko was a painter, photographer, sculptor, and graphic designer. His work and writings promoted the use of radical angles and perspectives as a means to transform perception. Rodchenko's cross-disciplinary work helped redefine the role of the artist in the early twentieth century. In 1920,

he began teaching at VKhUTEMAS (Higher State Artistic-Technical Work-shops), the principal state arts school in the former Soviet Union. Closed in 1930 by Stalin, the school's mission was to train the new breed of artist-technicians who would shape the visual and material environment of the new society.

Leo Rubinfien (b. 1954) is a writer, curator, and photographer whose photo-graphs and essays have been published and exhibited widely. A regular con-tributor to *Art in America*, Rubinfien has written numerous essays on the work of photographers such as Robert Adams, August Sanders, and Walker Evans. Rubinfien is the author of *A Map of the East* (1992) and *10 Takeoffs 5 Landings* (1992); most recently, he co-authored *Shomei Tomatsu: Skin of a Nation* (2004) with Sandra S. Phillips.

David Shapiro (b. 1979) is a painter who lives and works in Brooklyn, New York. Shapiro holds a BA in Art History from Columbia University, where he was the editor of *Museo*, the school's contemporary art magazine. Shapiro teaches at Pratt Institute and Parsons School of Design, and his work has been exhibited widely in New York and elsewhere.

Stephen Shore (b. 1947) began his career in the late 1960s, photographing Andy Warhol's Factory, and he has continued to affect the medium. His color 8 × 10 formalist landscape photographs helped to legitimize and popularize the use of color photography by fine artists. Currently the director of the undergraduate Photography Department at Bard College, he is the author of the seminal *Uncommon Places* (1982).

Aaron Siskind (1903–1991) was one of the great teachers and photographers of the twentieth century. Siskind was closely aligned with the Abstract Expressionists, such as Franz Kline, Barnett Newman, and Ad Reinhardt. Siskind is best known for his abstract photographs, but his documentary work with the Photo League in the late 1930s was seminal to that discipline. As a teacher at Chicago's Institute of Design and also at the Rhode Island School of Design, he was a beloved and important influence on three generations of students.

Clarissa Sligh (b. 1942) uses books, prints, and constructed installations to explore the complexities of memory, cultural representations, and history. The recipient of numerous awards and grants, including an Anonymous Was A Woman (2001) and an International Center of Photography Infinity Prize (1995), Sligh has had her work exhibited and collected widely.

Larry Sultan's (b. 1946) important book, *Evidence* (1977), with Mike Mandel established the central role of conceptualization in photography. His own color photographs from *Pictures from Home* (1992) and *The Valley* (2004) explore the dynamics of contemporary life through large-format, real-world witness. Sultan

has been the professor of photography at California College of Arts and Crafts for many years and has mentored countless photographers.

Mary Virginia Swanson (b. 1953)—consultant, educator, and author—helps photographers advance their careers. The founding director of both the American Photography Institute at New York University and Swanstock, a landmark alternative agency managing licensing rights for fine-art photographers, Swanson has also worked at Magnum and the Friends of Photography, in Carmel, California. An active member of the Society for Photographic Education (SPE) and numerous other arts/photography organizations, Swanson has taught and lectured at art schools around the country.

John Szarkowski (b. 1925) was the director of photography at the Museum of Modern Art from 1962 to 1991. Szarkowski was arguably the most important curator in photography's history. During his tenure, his critical thinking and astute presentations claimed for photography its rightful place within the world of the arts. His essays and most importantly his book *The Photographer's Eye* (1966) are essential readings for all photographic students.

Gael Towey (b. 1952) has worked as the chief creative director for Martha Stewart Living Omnimedia since 1990. Prior to working with Martha Stewart, Towey has worked as an art director for *House & Garden*, as well as Clarkson N. Potter and Viking Press, Inc. Overseeing all aspects of Martha Stewart Living Omnimedia, Towey has been instrumental in shaping one of the decade's most successful brands. The recipient of the 1999 DaimlerChrysler Design award and other awards, Towey has also lectured widely on graphic design and is a frequent juror to design competitions.

Charles H. Traub (b. 1945) is the chair of the School of Visual Arts' Photography, Video and Related Media MFA Department. Former director of the Light Gallery, Traub has edited and authored numerous books, including *Beach* (1977), *Italy Observed* (1988), *Angler's Album* (1990), *In The Realm of the Circuit* (with Jonathan Lipkin), and *In the Still Life* (2004). The president of the Aaron Siskind Foundation and co-founder and organizer of the exhibition *here is new york*, Traub is a tireless educator who has influenced a generation of young photographers.

Penelope Umbrico (b. 1957) is a teacher and artist who has exhibited extensively and is in the collections of numerous major institutes and museums. Her appropriated photographs explore the problems of illusion, perception and desire. In addition to teaching in the School of Visual Arts' Photography, Video and Related Media MFA Department, Umbrico is currently the photography chair of Bard College's Milton Avery Graduate School of the Arts.

Jeff Wall (b. 1946), who trained as an art historian, pioneered the use of staged narratives within contemporary art. An eloquent critic and image-maker, Wall's radical images and writings have contributed greatly to our understanding of how photography is constructed in the postmodern world. In addition to many monographs, a catalog raisonné is currently being published of his work from 1978 to 2004.

Randy West (b. 1960) is an important photographer whose work with minimalism and installation is reinvigorating our concerns for beauty and the sublime. Widely published and exhibited, West's work was recently exhibited at the Houston Center for Photography, Texas. West currently teaches in the School of Visual Arts' Photography, Video and Related Media MFA Department.

Minor White (1908–1976) was a publisher, author, teacher, and photographer. His work, teachings, and writings have influenced generations of photographers. As cofounder and editor of *Aperture* magazine, White emphasized a spiritual/intuitive approach to photography that drew on the mystical teachings of G. I. Gurdjieff and Zen Buddhism. During his tenure at *Aperture*, he made the magazine the premier voice of fine-art photography.

Garry Winogrand (1928–1984) defined modern street photography during the late twentieth century, creating densely layered images of the urban social landscape. Though his life was cut short, he was a prodigious and influential photographer and teacher. His most important books are *The Animals* (1969), *Women Are Beautiful* (1975), and *Public Relations* (1977).

Peter Wollen (b. 1938), film theorist and historian, is currently a professor in the Film, Television, and Digital Media Department at the University of California, Los Angeles. Author of the influential text *Signs and Meaning in the Cinema* (1969), Wollen has also organized numerous art exhibitions, including the first retrospective of Frida Kahlo at Whitechapel Gallery (1982).

Index

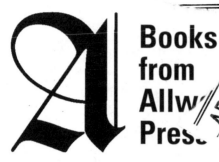